In Search of the Neanderthals

CHRISTOPHER STRINGER

CLIVE GAMBLE

In Search of the Neanderthals

SOLVING THE PUZZLE OF

HUMAN ORIGINS

With 183 illustrations

THAMES AND HUDSON

To George and Evelyn,
and the memory of Harry and Lily
and to Joan and Marc

© 1993 Christopher Stringer and Clive Gamble

First paperback edition 1994

British Library Cataloguing-in-Publication Data
A catalogue record for this book is available
from the British Library

ISBN 0-500-27807-5

Printed and bound in Slovenia by Mladinska Knjiga

Contents

Preface

Just south of Samarkand, in the mountainous southeast corner of Uzbekistan there is a small cave, the cave of Teshik Tash. The name means 'stone with an opening', and it was here in this remote region of Central Asia that the remains of the skeleton of a child were excavated by archaeologists more than 50 years ago. They were immediately recognized as the bones of a Neanderthal.

Caves such as Teshik Tash are indeed stones with openings. Their contents provide us with a window to the past, to another world where the people were physically different from ourselves, and survived for tens of thousands of years without many of the aspects of culture – such as art and perhaps even language – that we often regard as essential elements of our common humanity.

In this book we will examine these remarkable people, the Neanderthals. Remarkable because they seem so like us in many ways, yet different in as many others. Remarkable because no other people in prehistory has received so much attention, either by being turned into figures of fun, such as half-witted club-wielding cavemen, or by being vilified. 'They had all the manners of a Neanderthal' is akin to labelling someone's behaviour as that of a wild animal. Currently, the scientific disciplines that have been piecing together the evidence for the Neanderthals are locked in a fierce debate. The issue revolves around the Neanderthals' place in our ancestry. Quite simply, are they insiders or outsiders? Close kin or distant relatives?

It has taken two of us to write this book because the evidence is of two general types: biological, ranging from anatomy – derived from fossils – to recent genetic data; and behavioural, the record of past life-styles contained in the archaeological record.

On current evidence, the Neanderthals lived between about 230,000 and 30,000 years ago – a huge span of time by any reckoning. Their world was confined to Eurasia, stretching from the mountains of Uzbekistan in the east to the Iberian plateau in the west (fig. 1). To the south, the boundary runs along the northern shores of the Mediterranean and goes no further south than the gates of Jerusalem. The northern limits of their territory have been blurred by the successive advances and retreats of Ice Age glaciers that have obliterated nearly all the traces of Neanderthal settlement. Such traces would have included skeletons and stone tools, camps and caves. Just occasionally a remnant is found, for example in north Wales, but such discoveries are rare.

The Neanderthals were not isolated. They were not the only human populations present in the world during that 200,000-year epoch. They were surrounded to the south in Africa and to the east in Asia by other closely related but physically distinct populations. The New World lay undiscovered and unpopulated. All these peoples made their stone tools in a comparable manner

and to similar patterns. The way they used the landscape and its resources was conditioned by the kinds of plants and animals available in any one region. For simplicity, we will refer to the Neanderthals and their anatomically pre-modern neighbours as the Ancients. Their anatomically modern successors – known in Europe as the Cro-Magnons, after the site of their first discovery – we shall designate the Moderns. We now know that for some considerable time the Moderns coexisted with the Ancients. It is even likely that for many thousands of years physical differences meant nothing when it came to the art of survival, the use of technology and the organization of society. It seems that the Moderns – people like us – literally behaved like Neanderthals for very long periods of time indeed. Why and how we changed is bound up with the Neanderthals' fate.

The remoteness of Teshik Tash today also reminds us of the antiquity of the evidence it contains. When we are familiar only with the few decades of our own existence, and perhaps with the hundreds or few thousand years of written history, how can we begin to contemplate the tens of thousands of years that the Neanderthals lived on planet Earth? It may help to substitute distance for time. In these days of air travel the world has shrunk and the idea of 'one thousand leagues and more' no longer sends us reeling as it would have done our medieval ancestors. Let us see how this substitution helps. To accomplish a journey from Teshik Tash to London, a distance of some 5,000 km, would on the 200,000-year Neanderthal timescale be immensely slow, about 1 km every 40 years. After 50,000 years we would only have reached Astrakhan on the shores of the Caspian Sea, and after 100,000 years the Ukrainian capital of Kiev. Continuing at the same snail's pace, it would take us another 100,000 years to reach western Europe where the last Neanderthals are found.

A glance at the Neanderthal world (fig. 1) reveals a size and shape that is reminiscent of the so-called civilized world of Classical Greece and Rome. The comparison is not trivial. In the first place, one of the continuing interests in the Neanderthals is the opportunity they provide for the examination of Europe and its peoples. Just as the contribution of Greece and Rome to modern civilization has been minutely picked over by scholars and commentators, so too with the Neanderthals and their relation to us. Secondly, these ancient folk are so bound up with questions of identity and heritage, breeding and potential that scientific observation is even less likely than normal to be able to divorce itself from present contemporary opinions. Forget claims of scientific objectivity. We inherited many of these opinions from the Classical world. One in particular stands out: Aristotle's concept of a natural slave. His working definition that guided Athenian society can be summarized as follows: 'Ideally the natural slave should always be equipped with a powerful body capable of performing the labours nature has assigned to him. He should always be a slouching beast of great physical strength, while the natural master, in keeping with his superior powers of reason, should be both delicate and well proportioned.'[1]

Here is a distinction that scientists would flesh out 2,000 years later with the

8

bones of Neanderthal and Cro-Magnon peoples. This is the heart of the debate about the origins of modern humans. We have to ask: what role did nature have in shaping adaptations, both physical and behavioural? What curtain of intellect, ability and appearance separates the primitive from the advanced, the savage from the civilized? What do we mean by these terms and how can a study of the past assist us in our quest for self-knowledge? To what extent do we still attempt to create and relate to the very ancient past by furnishing it with the familiar faces of social and ethnic categories from our present?[2]

The Neanderthal world is therefore very much our world. We deliberately stress this at the outset since the route to understanding the Neanderthals need not be hedged around by difficulties such as huge timespans, complicated terminology and the arcane procedures of stone tool typology. Strip these away, or at least try to understand them, enter that 'stone with an opening', and an opportunity emerges to undertake a sociological analysis that is normally regarded only as the preserve of the imagination.

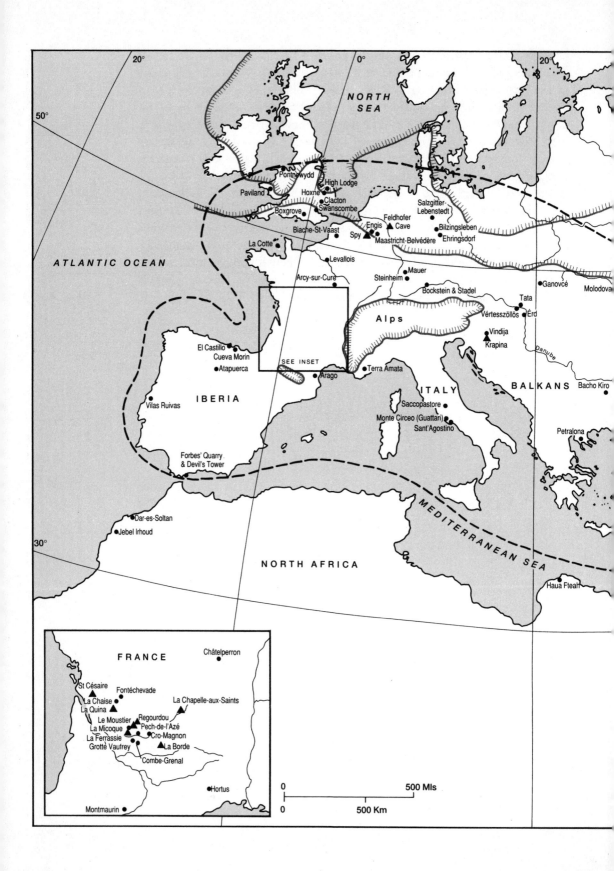

20°
0°
20°

NORTH SEA

50°

ATLANTIC OCEAN

Pontnewydd
High Lodge
Hoxne
Paviland
Clacton
Boxgrove
Swanscombe
Biache-St-Vaast
La Cotte
Spy
Levallois
Arcy-sur-Cure
Salzgitter-Lebenstedt
Feldhofer Cave
Engis
Bilzingsleben
Maastricht-Belvédère
Ehringsdorf
Steinheim
Mauer
Bockstein & Stadel
Ganovcé
Molodova
Tata
Vértesszöllös
Érd
Alps
Vindija
Krakina
Danube

SEE INSET

El Castillo
Cueva Morin
Atapuerca
Arago
Terra Amata
ITALY
BALKANS
Bacho Kiro
IBERIA
Saccopastore
Vilas Ruivas
Monte Circeo (Guattari)
Sant'Agostino
Petralona
Forbes' Quarry & Devil's Tower
MEDITERRANEAN SEA
Dar-es-Soltan
Jebel Irhoud
30°
NORTH AFRICA
Haua Fteah

FRANCE
Châtelperron
St Césaire
Fontéchevade
La Chaise
La Chapelle-aux-Saints
La Quina
Le Moustier
Regourdou
La Micoque
Pech-de-l'Azé
Cro-Magnon
La Ferrassie
Grotte Vautrey
La Borde
Combe-Grenal
Hortus
Montmaurin

0 500 Mls
0 500 Km

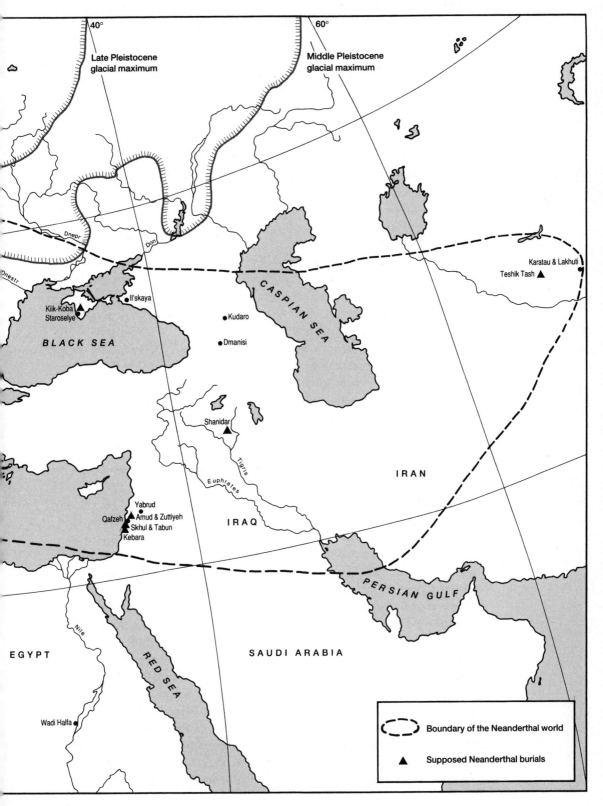

1 The Neanderthal world, showing the key sites discussed in the text and the extent of the ice sheets across Europe during the middle and late Pleistocene.

CHAPTER 1

Who Were the Neanderthals?

Introduction

Until the mid-nineteenth century, the quest for human origins began and ended – at least for the Western world – in the Garden of Eden. In Biblical terms, God created Adam and Eve as fully human, indeed perfect, beings. There was no semi-human, pre-Adam stage: how could there be when the perfect couple had been brought into existence at the creation of the world, which itself had taken place by some reckonings only in 4004 BC? Then, over a century and a half ago, geologists began to argue that the world was much, much older than this, and Charles Darwin subsequently put forward the theory of evolution. If animals had evolved from some 'primitive' earlier state, surely human beings had done so as well? Darwin himself believed that we should look to Africa to find the ultimate cradle of humanity.

Research over the last 40 years has proved Darwin right. Thanks to intensive fieldwork we now know that the very first upright-walking, tool-using creatures whom we can classify as members of the genus *Homo* lived in Africa south of the Sahara over 2 million years ago. Together with his wife Mary, Louis Leakey, pioneer discoverer of our African ancestors, christened these creatures *Homo habilis* ('handy man'). Other even older upright-walking species, possibly tool-users as well, have been found in southern and eastern Africa – hence their genus name *Australopithecus*: 'southern ape', although they are not strictly speaking 'apes' like chimpanzees. The australopithecines (*A. Africanus, A. afarensis, A. robustus*, to name their principal constituent species) are grouped by scientists with the genus *Homo* into the *Hominidae* or hominid family. Quite what role – if any – the australopithecines played in human evolution is currently much debated, but there is no doubt that some of them coexisted not only with *Homo habilis* but also with the successor species, *Homo erectus*, before becoming extinct.

Homo erectus emerged around 1.7 million years ago in Africa and by 1 million years ago was the only surviving hominid species on earth. It is at this point that we pick up the narrative, for it was *Homo erectus* (once known as *Pithecanthropus* or 'apeman') who first migrated out of Africa. Fossil finds of this species have come from Georgia, Java and China, while stone tools thought to be their trademark have been discovered scattered across Africa and Europe. The subsequent story of these Ancients, particularly the Neanderthals of Eurasia after 230,000 years ago, is the subject of this book. At issue is a fundamental question for evolutionary studies: to what extent did various populations of Ancients such as the Neanderthals contribute to the evident physical and cultural diversity of anatomically modern humans? Put another

way: where did the Moderns, among whom we number ourselves, come from, and when and how?

As we shall see, today there are two main competing scientific camps, each believing it holds the solution. Both accept that there was a migration out of Africa by *Homo erectus* populations beginning around 1 million years ago ('Out of Africa 1' as we shall call it). One camp, however, argues that there was at least one other major wave of migration ('Out of Africa 2') around 100,000 years ago, this time of anatomically modern humans – *Homo sapiens* – people who had evolved in Africa from *Homo erectus* stock and subsequently replaced all other populations in the world including the Neanderthals. Against this model of *population replacement*, the rival camp sets its model of *regional continuity*. For the followers of this latter school, there was no pronounced Out of Africa 2 migration. Instead, modern humans evolved semi-independently in different regions of the world from independent populations of Ancients (Neanderthals in Eurasia, *Homo erectus* in China and Java), with continual gene flow or interbreeding between geographically contiguous groups so that a single but racially diverse modern human species was the result.

It becomes clear that the Neanderthals – for whom we have a wealth of evidence greater than for any of our other fossil relatives – are central to this argument. Did they evolve into people like us, as the multiregionalists would have us believe, or were they an evolutionary dead end, as the proponents of population replacement would argue?

The first step towards an answer is to ask why, almost 150 years after they were first identified, the Neanderthals still occupy so much space in scientific debates between palaeoanthropologists? And why have they stuck in the popular imagination as the archetypal cave-dwellers, surrounded by prehistoric beasts of varying authenticity? There is obviously more to Neanderthals than their fossil remains and the associated archaeological evidence of chipped stones and broken animal bones. We begin therefore with the known history of their discovery.

Discovering Neanderthals

Neanderthals hold a special place in the story of the unearthing of our fossil ancestors. The 1856 discovery of a partial skeleton in the Feldhofer Cave in the Neander Valley (Neanderthal in German) near Dusseldorf, marked the real beginning of palaeoanthropology as a separate field of study.[1] Although related finds had already been made at Engis in Belgium (a child's skull in 1830) and at Forbes' Quarry in Gibraltar (a woman's skull in 1848), their significance was not recognized until long after the Neander Valley discovery had been described and discussed by various authorities. While numerous scholars early on regarded the Neanderthal skeleton as representing an ancient European race, it was an Irish anatomist, William King, who in 1864 took the major step of identifying the find as the type of a new species of humanity, *Homo neanderthalensis*. Further discoveries before the First World War from sites in

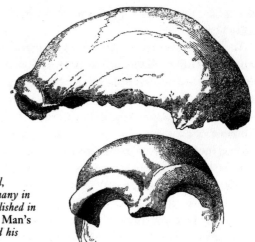

2 The first identified Neanderthal skull, excavated in the Neander Valley, Germany in 1856. The drawing shown here was published in Thomas Huxley's famous 1863 volume, Man's Place in Nature, *in which he expounded his theory of human evolution.*

Belgium, Croatia and France (see table below) were quickly recognized as representatives of this same fossil group. Some scholars were prepared to regard these finds as potential ancestors for modern Europeans, but most considered them too primitive or too specialized to be closely related to living humans, particularly the supposedly highly advanced white European race. Others, such as Rudolf Virchow, even regarded the Neanderthals as diseased or degenerate, a view which has occasionally been revived, but with little success.

As the table shows, further discoveries of Neanderthals took place between the two world wars. The most important were made at the Mount Carmel caves

THE FIRST PHASE, 1914 AND BEFORE		THE SECOND PHASE, 1920–39	
Belgium		**Crimea**	
Engis	1830	Kiik Koba	1924–26
Gibraltar		**Israel**	
Forbes' Quarry	1848	Mount Carmel, Tabūn cave	1929
Germany		**Italy**	
Neander Valley	1856	Saccopastore	1929–35
Belgium		Guattari	1939
Spy Caves	1886	**Central Asia**	
Croatia		Teshik Tash	1938
Krapina	1899–1906		
Germany			
Ehringsdorf	1908		
France			
Le Moustier 1	1908		
La Chapelle-aux-Saints	1908		
La Ferrassie 1	1909		
La Ferrassie 2	1910		
La Quina	1911		
La Ferrassie 3 & 4	1912		
Le Moustier 2	1914		

3 The first major discoveries of Neanderthal remains.

outside Haifa, by Dorothy Garrod and her team; in the Crimea by G.A. Bonch-Osmolovsky; and in Central Asia by A.P. Okladnikov. These finds set what still remain the geographical limits for the distinctive Neanderthal fossils (fig. 1): despite certain previous claims, Neanderthals proper are not found in Africa, India or any part of eastern Asia south of the great mountain chains. We shall see in later chapters how the last 50 years have witnessed several important discoveries in Europe, Iraq and Israel and a greater precision to their chronology.

Since the Feldhofer find in 1856 archaeologists have turned up numerous Neanderthal skeletons, a few reasonably complete but most reduced to small remnants.[2] In addition, many other fragments of skulls, jaws and teeth have been found. Of the known skeletons nearly half are from children. Several sites – La Ferrassie and La Quina (France), Shanidar (Iraq) and Krapina (Croatia) – have produced quite reasonable samples of either skeletons or skull and dental fragments. The remains probably represent something less than 500 individuals in total – seemingly little to show for perhaps 200,000 years of human evolution. Several hundred thousand stone tools from the same period seems rather better, although most of these are not directly associated with the fossil remains. However, in a subject often dependent upon small and incomplete scraps of evidence, a total of 500 individuals is a respectable sample and makes the Neanderthals attractive for the geographical study of fossil populations at both the local and regional level, and for biological and cultural comparisons by age and sex.

There is one Neanderthal who, for historical reasons, is more important than all the rest. This is the so-called 'old man' from La Chapelle-aux-Saints in southwest France, found in 1908. We learn from his history that Neanderthals are what we make them. In order to understand his significance, we must look briefly at the career of one of the great archaeologists of the nineteenth century, Gabriel de Mortillet (1821–98). This French polymath made numerous attacks in his youth on the church, state and bourgeoisie, which led to a self-imposed exile from France between 1849 and 1864 to escape a prison sentence. A champion of evolution governed by progressive laws, de Mortillet proposed that the Neanderthals *did* have a place in our ancestry. He was one of the first to show that one could place fossils and their associated stone tools in a chronological sequence, oldest to youngest.[3]

As more discoveries were made, it became possible to argue that the Neanderthal skulls from Gibraltar, the Neander Valley and Spy fell neatly into chronological position between the skull cap from Java, today recognized as *Homo erectus*, found by Eugene Dubois in 1891, and the entirely modern-looking skulls that had been dug up in the Cro-Magnon rockshelter in southwest France in 1868. De Mortillet's death just before the flurry of finds in the early years of this century (see table above) presaged an opportunity to bury his ideas with him.

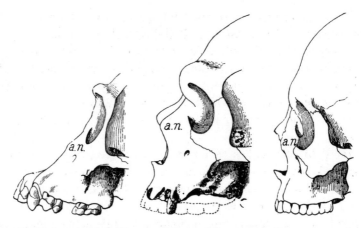

4 *Marcellin Boule assigned the Neanderthals to a different species from our own primarily on the basis of their skull morphology. Here he compares the facial bones of the Chapelle-aux-Saints Neanderthal (centre) with those of a chimpanzee on the left and a modern Frenchman on the right.*

Boule's Neanderthal

In 1908 three French clerics – the Abbés Jean and Amédée Bouyssonie and the Abbé Bardon – discovered the nearly complete skeleton of a Neanderthal at the small cave of La Chapelle-aux-Saints, in the Corrèze district of France. On the advice of another priest, the Abbé Breuil (soon to be the doyen of French prehistory), the skeleton was sent for study not to de Mortillet's successors at the Ecole d'Anthropologie – firm believers in a Neanderthal phase of our ancestry – but to Marcellin Boule, at the Museum of Natural History in Paris. Boule and his associates did not recognize an earlier, Neanderthal phase in human ancestry. The stage was set for a major reinterpretation, and Boule did not disappoint.

After a preliminary account, delivered only a few months after the Abbés' discovery, Boule's exhaustive study of the skull and skeleton appeared promptly in three monographs of the *Annales de Paléontologie* published between October 1911 and March 1913.[4] The work set new standards for describing and reporting human fossils, and its conclusions dominated human evolutionary studies up to and just beyond Boule's death in 1942. We shall deal with his conclusions in more detail in later chapters but it is worth noting the main points here. In the first place, like William King, Boule classified the skeleton as a separate species – *Homo neanderthalensis* – rather than as a sub-species of *Homo sapiens*, our own species. His reasons for doing this were various but depended largely on his assessment that the skull lay outside the variation that might reasonably be expected for a local variety of *Homo sapiens*. His comparison of the skulls of a chimpanzee, the Chapelle-aux-Saints Neanderthal and a modern Frenchman (fig. 4) served his point well. His use of the scientific name first put forward by King established a separate branch rather than a lineal ancestor.

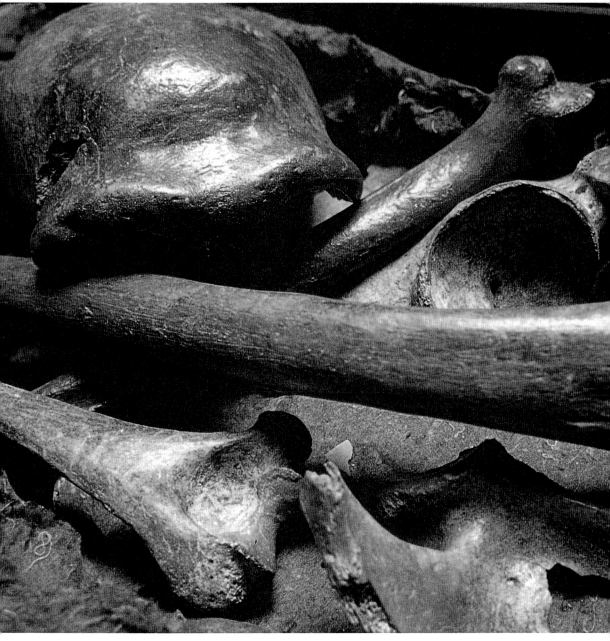

1 The discovery of these bones in 1856 in the Neander Valley near Dusseldorf, Germany, triggered one of the fiercest debates in scientific history: were the people represented by these fossil remains our direct ancestors or were they evolutionary dead-ends?

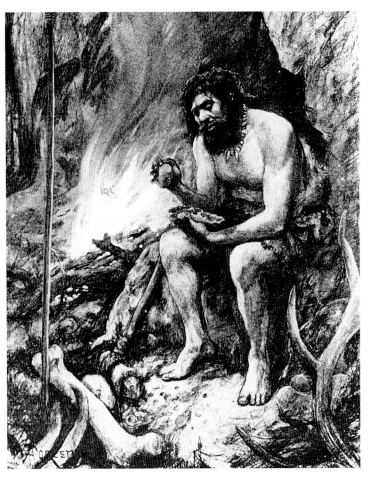

2,3 Two reconstructions of the same skeleton which illustrate how widely interpretations of the Neanderthals can differ. (*Below*) The image which expelled the Neanderthals from human ancestry, depicting an ape-like, hairy creature. Based on Marcellin Boule's scientific study of the Chapelle-aux-Saints skeleton, and apparently approved by him, this reconstruction was widely published in France and England in 1909, shortly after the discovery at La Chapelle-aux-Saints. (*Left*) Neanderthals as close kin. The respected anatomist Sir Arthur Keith commissioned this very sympathetic reconstruction of the Chapelle-aux-Saints remains in 1911. Note that a few of the archaeological details are wrong: for instance, no ornaments or necklaces have been found with Neanderthal fossils. Interestingly, Keith later rejected the implications of this image; following the discoveries at Piltdown (now known to be fraudulent), he joined the camp which expelled the Neanderthals from our ancestry.

Changing images of the Neanderthals

4 A 1915 picture of Neanderthal life, supervised by the American palaeontologist Henry Fairfield Osborn. Although it claims scientific accuracy, the illustration clearly relies on traditional artistic conventions to depict primitiveness: wielding clubs and nearly naked, the Neanderthals are slouched and bent-kneed.

5 (*Below*) In 1905 the Cambridge anatomist W.L.H. Duckworth supervised Bucknall's vision of Old Stone Age life that illustrated Henry Knipe's poem 'Nebula to Man'. These lines accompanied the picture:

Primeval men are now upon the scene,
short, thick-boned hairy beings of savage mien,
with ape-like skulls; but yet endowed with pride
and power of mind to lower brutes denied.

As the picture and the poem both propose, evolution will be in an upward, progressive direction.

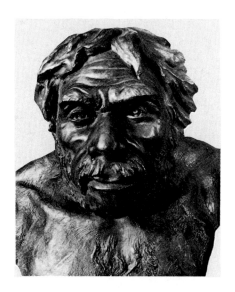
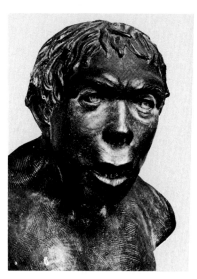
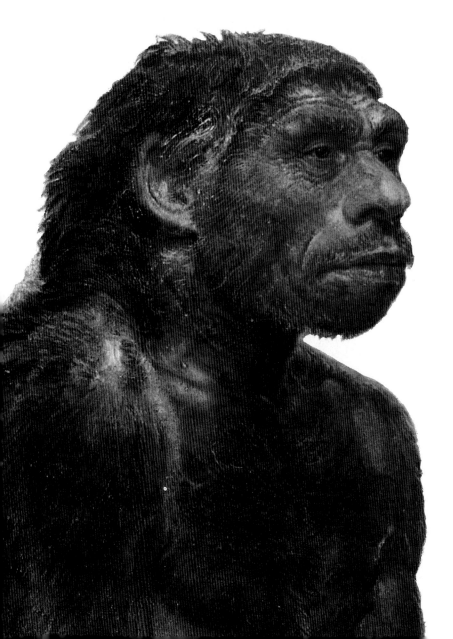

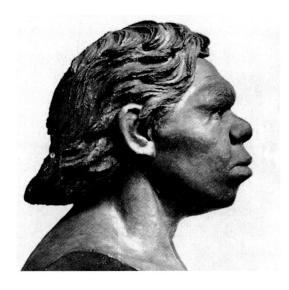

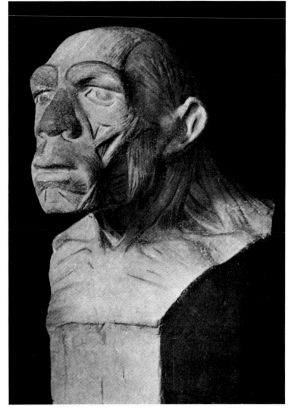

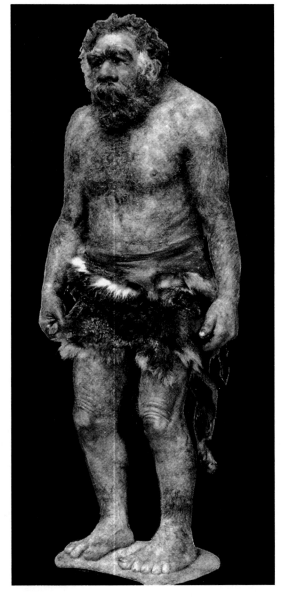

Reconstructing the Neanderthals

Many attempts have been made to overlie muscles and skin on Neanderthal skulls and to reconstruct the form of the face, and these frequently reflect changing views on human evolution.

FACING PAGE

6–8 (*Above left*) Mikhail Gerasimov devoted a life time to the creation of life-like portraits from hominid skulls. Here is his representation of the 'Old Man' of La-Chapelle-aux-Saints. Compare it with other reconstructions of the same skull: plates 9 and 10. (*Above right*) Gerasimov's 1940s reconstruction of the youth from Le Moustier. (*Left*) Zdeněk Burian's portrait of a Neanderthal male probably gives a good facial likeness, but the figure is too dark and hirsute.

THIS PAGE

9,10 (*Above left*) Heberer's view of the 'Old Man' of La Chapelle-aux-Saints. (*Above*) Bust of the Chapelle-aux-Saints Neanderthal, with its musculature exposed, sculpted under the supervision of Marcellin Boule.

11 (*Left*) Constructed at much the same time as Boule's model, this life-size figure of a Neanderthal male was exhibited in a Chicago museum. It fleshes out many popular misconceptions about the Neanderthals, portraying this character as a hairy, apish brute.

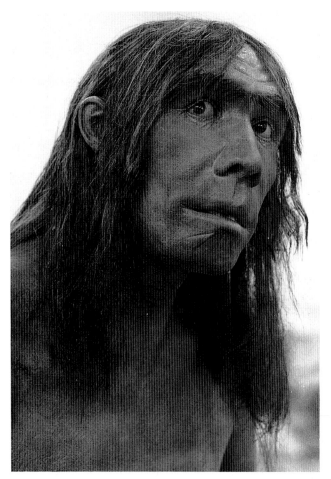

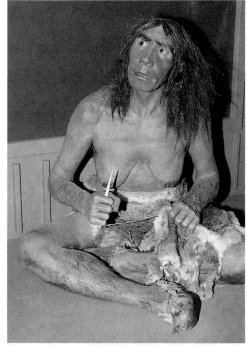

A recent view of the Neanderthals

Over the last few decades, attempts have been made to humanize portraits of the Neanderthals, to bring artistic representations into line with current scientific thought. This model of a Neanderthal family constructed for a touring exhibition, 'The Human Story', emphasizes some recent changes in attitude.

12–14 (*Above, left* and *right*) A Neanderthal woman. (*Right*) Overall view of the exhibit. Although these figures have far less body hair than earlier depictions, in certain other respects this reconstruction promulgates traditional gender-specific ideas about the Neanderthals.

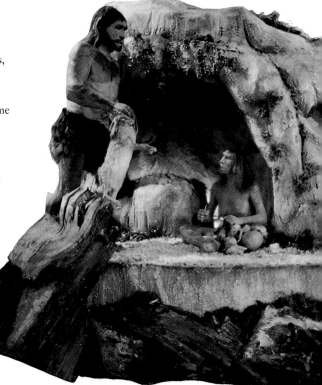

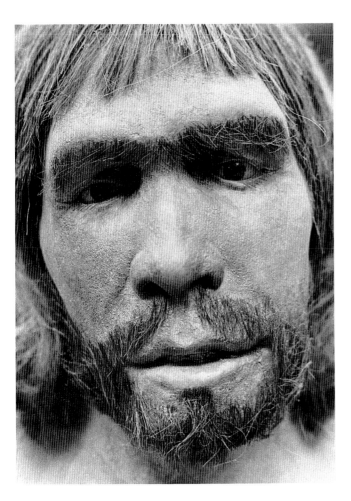

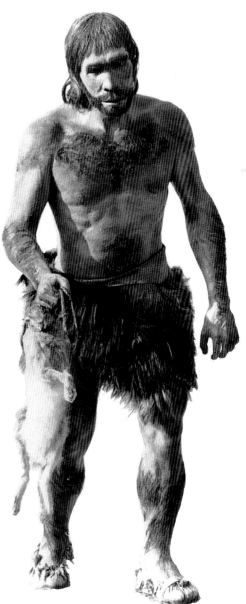

15,16 (*Above* and *right*) This depiction of a male –
which suggests the humanity, even modernity, of the
Neanderthals – represents Neanderthal men as the
active, tool-bearing members of the population.

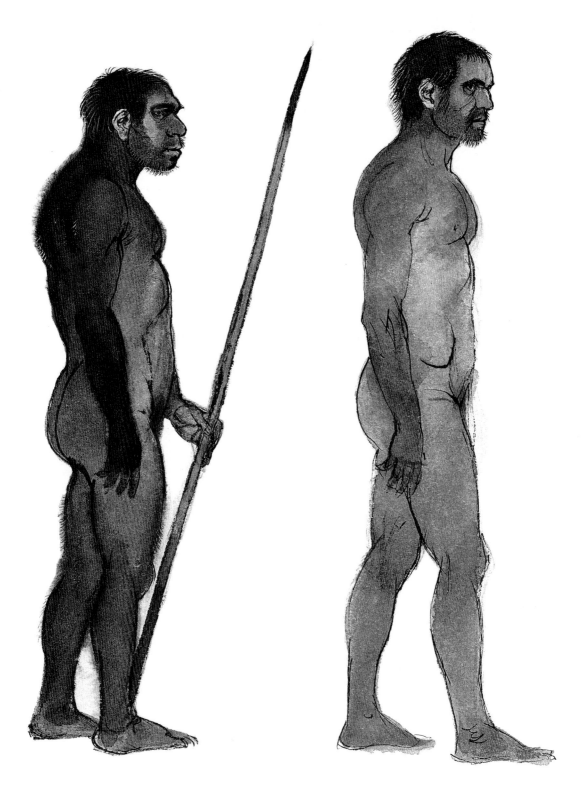

17,18 Maurice Wilson's comparison of a Neanderthal and an anatomically modern Cro-Magnon. The Neanderthal male has an appropriately stocky build, with shorter, stronger limbs than his more modern successor.

From that starting point the evidence for differences, both qualitative and quantitative, was piled up. A cast of the inside of the skull (an endocast) was revealed to have a 'coarse' appearance, with the imprints of the brain convolutions showing a general simplicity of design.[5] Boule and his colleagues wrote that these indicated 'rudimentary intellectual faculties. The relative development of different parts of the grey matter testify to this fact.'[6] Even the relatively large size of the Chapelle-aux-Saints brain was used to support the view that large heads are not always the best heads. After all, the brain of their countryman, the eminent philosopher Anatole France, was only two-thirds the size of the average male Neanderthal and smaller even than the female![7]

Boule then proceeded to put this low intelligence, imprisoned behind bars of brow-ridge bone under a low dome, onto a stooped and rigid skeleton. One of the most frequently reproduced figures from his work (fig. 5) compares the posture of the Chapelle-aux-Saints skeleton with that of an Australian Aborigine. The significance of this comparison should not be lost: Boule would have regarded the latter as an example of one of the so-called 'lowest races' and hence by imputation closer to the apes and some notional human ancestor. Many of his contemporaries believed that the Aborigines were *en route* to extinction as civilization rapidly replaced their living prehistory. Boule used the fact that the Neanderthal skeleton seemed so different from that of its supposedly closest descendant to support the exclusion of the Neanderthals from *Homo sapiens*. His summary of the Neanderthal skeleton was succinct:

5 Boule's famous comparison of the Chapelle-aux-Saints skeleton with that of a modern Australian Aborigine. The difference between the Neanderthal and the Aborigine (thought by Boule to be one of the most primitive of living peoples) was judged so great that the Neanderthal could not possibly belong to Homo sapiens. *Quite apart from its implied racism, the portrait is also inaccurate: there is no evidence that the Neanderthals stood with the slouched posture depicted here.*

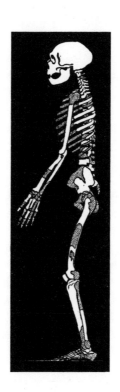

'Vertebral column and limb bones showing numerous simian characters and indicating a less perfect bipedal or upright carriage than in modern Man. Legs very short.'[8] The implication was that the disparity between Neanderthals and modern humans would have appeared even greater if Boule had compared the Chapelle-aux-Saints man with a skeleton from one of the 'higher' races, such as a modern Frenchman.

Differences rather than similarities were what interested Boule, and his yardstick was the Caucasian ideal which greeted him every morning in his shaving mirror. The contrast between this ideal and the Neanderthals was simply too great for Boule and his contemporaries. Samuel Laing, in his hugely popular *Human Origins* published in 1895, conveys the casual racism of the times based on an effortless sense of European superiority:

> The form of the chin seems to be wonderfully correlated with the general character and energy of the race. It is hard to say why, but as a matter of fact a weak chin generally denotes a weak, and a strong chin a strong, race or individual.[9]

What hope then for Neanderthals, the original chinless wonders, on this scale of values? Short legs, a projecting face and a 'coarse' brain fitted the Chapelle-aux-Saints fossil into a grade of life from which, under the watchful eye of his scientific creators, he could not progress.

Today we are keen to say that we have repudiated such racist views, which were part of the discredited science known as social darwinism with its 'scientific methods' such as eugenics. But old ideas die hard. While no scholar today seeks to find links between intelligence, technology, skull shape and genetic patterns among living peoples, such proposed associations do lie at the heart of the Neanderthal controversy, as we shall see in later chapters. Some scholars, including ourselves, believe the Neanderthals *were* a separate species from modern humans, but for entirely different reasons than Boule's. Our theory is based on the special nature of the Neanderthal fossils, rather than the features they supposedly shared with apes.

The Neanderthal image problem

The Neanderthals come with their own cultural baggage. No other group of prehistoric people carries such a weight of scientific and popular preconceptions or has its name so associated with deep antiquity and the lingering taints of savagery, stupidity and animal strength. Behind the lace curtains of civilization, it seems, lies a long, dimly lit cave which the civilized world uses to scare itself when it looks into the abyss of its own making. The Neanderthals, according to some, stand with their hands on that flimsy curtain, their shadows falling across the nursery wall.[10]

One of the reasons why the Neanderthals have been the focus of so much attention lies in the strength of visual images of them.[11] As we will see, such portraits are not casual sketches, but significant expressions of rival theories

about human ancestry.[12] But this tradition is not a new one: it extends back to medieval and even classical times, with images of wildmen living outside the codes of civilization and chivalry. Hence in medieval manuscripts of the Roman author Pliny, we find illustrations of monstrous races. A particularly good candidate for the power of the Neanderthal image (later fleshed out by scientists such as Boule) was that of the Blemmyae, who lived according to Pliny in the deserts of Libya.[13] Their heads did not appear at the top of their bodies, but were found instead on their chests, as a rather glum Blemmyae from the thirteenth century shows. Note the eyes on the chest, the nakedness and the club. A small sketch from Thomas of Cantimpré's *De Naturis Rerum* of 1425 has a distinctly Neanderthal-like Blemmyae sandwiched between two other mythical individuals, a Sciopod and a Cyclops. Appropriately enough from the viewpoint of civilization, they appear in the margin.

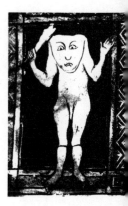

6 *A club-wielding Blemmyae from a thirteenth-century bestiary of Pliny's races.*

Compare these creatures with the vivid reconstruction authorized by Boule to illustrate his scientific findings at La Chapelle-aux-Saints (pl. 3), incidentally one of the earliest illustrations of our fossil predecessors. It first appeared in 1909 in the French magazine *L'Illustration*, and later in the same year as a centre spread in the *Illustrated London News*. This excessively hairy, Stone Age mugger has quite obviously been exiled from the mainstream of human ancestry.

But in 1911, only two years later, the *Illustrated London News* printed quite the opposite view: that of an equally eminent anatomist, Sir Arthur Keith. Keith had commissioned another reconstruction of the same fossil skeleton, which was published under the heading 'Not in the "Gorilla" stage'. Noble and thoughtful, sitting by the fire after a hearty lunch, here is an ancestor we do not have to be ashamed of (pl. 2). Civilization is just a haircut away.

Another portrait of the Neanderthals appeared in 1915, this time by the artist Charles R. Knight (pl. 4). Supposedly based on scientific evidence, the picture appeared as the frontispiece to Henry Fairfield Osborn's *Men of the Old Stone Age*. Osborn explains their aim was to make the reconstruction 'as human as the anatomical evidence will admit. The principle is based upon the theory for which I believe very strong grounds may be adduced, that all these races represent stages of advancing and progressive development ... in our restorations we should indicate as much alertness, intelligence, and upward tendency as possible.'[14]

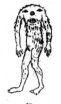

However, in spite of such claims for scientific objectivity, Knight undeniably drew on traditional imagery to make his portrait of the prehistoric past more accessible. Depicted in wild surroundings, with bad posture, their eyes slumped towards their chests, wielding clubs and nearly naked, the Neanderthals were once again excluded from human evolutionary history. There is still no archaeological evidence whatsoever that the Neanderthals carried clubs or strolled around naked, and we will see in Chapter 4 that they did not slouch either. But, just like his medieval predecessors, Knight equated nakedness, clubs and caves with outlaws.[15] The Neanderthals were thus cast as outlaws from, rather than inlaws to, civilization.

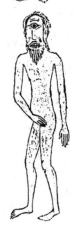

7 *This Blemmyae (centre) from 1425 shares many features with depictions of the Neanderthals.*

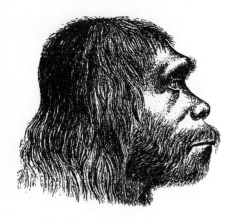

Imagining the Neanderthals

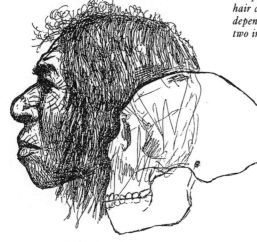

8–13 Over time, artists have put flesh on the bones of the Neanderthals in a remarkable variety of ways. (Clockwise from top left) One of the earliest artists' impressions of a Neanderthal, made in 1888; a 1927 reconstruction; a 1927 comparison of a Cro-Magnon and a Neanderthal typical of the misconceptions then prevalent – note the stooped, simian appearance of the Neanderthal and his cave-like abode; Carleton Coon's very human-looking 1939 portrait put the Chapelle-aux-Saints individual into modern dress and gave him a hair cut – his aim was to show that impressions of the Neanderthals depend largely on such superficial criteria as hair styles and clothing; two images published in a 1957 volume.

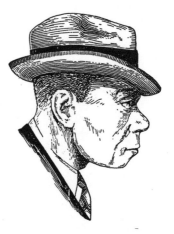

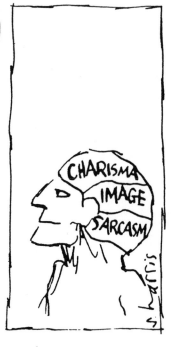

JAVA MAN NEANDERTHAL MAN MODERN MAN

Figures of fun

14–16 (Above) The evolution of the human brain, according to cartoonist Sydney Harris. (Right) One of Gary Larson's Far Side *cartoons. (Below) A vignette spoofing stereotypes of brutish, naked, and bone-gnawing Neanderthals; published in 1957 as part of a volume celebrating 100 years of Neanderthal research.*

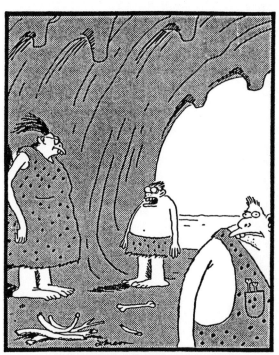

"Mom! The kids at school say we're a family of Nerdenthals! ... Is that true?"

The other means by which the remote past was characterized relied on an equally basic approach: the appeal to comedy. The comic cavemen were given to us by the Victorians, as in E.T. Reed's *Mr Punch's 'Prehistoric Peeps'* (1894) which features 26 full-page cartoons ranging from a 'Prehistoric Lord Mayor's Show!' and the 'Unsociable Mammoth' to a 'Bank Holiday of the Period'. This is a romp through prehistory and geology, with dinosaurs and fabulous beasts appearing side by side with shock-headed, bandy-legged males in fur wraps and driving contraptions, usually made in stone, all worthy of Heath Robinson. The result is a marvellous tilt at masculine pomposity. These cartoons have been copied ever since in movies such as Buster Keaton's *Three Ages*; in the 1960s cartoon comedy, *The Flintstones*, with Betty and Wilma, Fred and Barney; and in the movie *1 Million Years BC*, which pitted Racqel Welch against the pterodactyls (except here the men had less paunch and more bicep).

Poor chronology and an even worse grasp of what goes with what in prehistory has never stood in the way of a good joke. No one today knows this better than Gary Larson with his *Far Side* cartoons. What Larson manages time and again is to tweak the strings attached to the icons in the caveman image. The success of his cartoons indicates the strength of this visual tradition, which relies on a few props, caves, clubs, fur wraps and bad posture.

But the image-makers are not confined to artists. Good guys and bad guys, one of us or not one of us: these themes also appear in novels about the past. For instance, J.H. Rosny-Aîné painted a very unflattering picture of the Neanderthals in his best-selling short story, *La Guerre du Feu* (1911) and H.G. Wells passed an equally unflattering sentence on them in *The Grisly Folk*, published in 1921. But attitudes towards the Neanderthals softened as the twentieth century progressed, with William Golding (*The Inheritors*) and Isaac Asimov (*The Ugly Little Boy*) presenting a more sympathetic portrait of these folk in the 1950s. And, by 1980, Jean Auel was describing some of her Neanderthals in *The Clan of the Cave Bear* in glowing terms. These images are discussed in detail in the box opposite.

The links between scientific interpretation, discovery and popular images are often not difficult to trace. For example, the uncompromising descriptions of the Neanderthals from the first half of the century undoubtedly reflect the expulsion of the Neanderthals from human ancestry by scientists such as Boule. To us, the force of the expulsion either by word or picture seems excessive. However, they influenced opinions. Even Sir Arthur Keith changed his mind about the reconstruction he authorized in 1911 and expelled the Neanderthals. William Golding's Neanderthals, on the other hand, appeared after Boule's death, when a re-examination of the Chapelle-aux-Saints skeleton led to a major rethink (Chapter 4). Occasionally, as with Bjorn Kurtén's *Dance of the Tiger* (1980), scientists attempt to address the popular market. And part of the success of *Clan of the Cave Bear* can be put down to the careful research upon which Jean Auel built her story. Mostly, however, the scientific and popular worlds seem set on separate paths, with little exchange.

The Neanderthals in Fiction

Many authors have used the Neanderthals to explore the present. Their short stories and novels emphasize just how close the link is between scientific interpretations of the past and the prevailing climate of opinion about such contentious issues as human nature, other people, power and gender.

Here are five famous portraits of Neanderthals from some of the most popular writers of the twentieth century. We start with J.H. Rosny-Aîné's 1911 *La Guerre du Feu*, for which sales of three million are claimed. This tale of Nature (better known today through the movie *The Quest for Fire*), where the fittest survive, culminates in the defeat of Aghoo the hairy by the 'warrior' Naoh, after returning from his search for fire. On their travels, Naoh and his two companions pick up some useful tricks (such as how to use spear throwers to propel their javelins and how to make fire) from the Thin Men, as payment for lending their muscle in a fight against the Little Men. Despite these technological advances, the inevitable show-down takes place between Naoh and Aghoo as it becomes obvious that the rockshelter is no longer big enough for both of them. Naoh eventually deals a mighty blow to emerge victorious.

Rosny-Aîné presents an unrelenting vision of primeval passions, albeit Neanderthal passions, as the following description of the treacherous Aghoo reveals: 'Nothing of his face was visible but a mouth bordered by raw flesh and a pair of murderous eyes. His squat stature exaggerated the length of his arms and the enormous width of his shoulders. His whole being expressed a brutal strength, tireless and without pity.'[16]

Here is a creature worth slaying and expelling from the human race, as Boule did following the discovery of the skeleton at La Chapelle-aux-Saints. What separates the hero Naoh from the beast Aghoo is his love for a good woman. In the novel she becomes his prize for returning fire to the group. She is given to him with these ominous words from her father:

> 'She shall kneel before her master. She shall go in search
> of the prey that you kill and shall bring it back on her
> shoulder. If she disobeys you, you may put her to death.'
> Naoh, placing his hand on Gammla, gently raised her up,
> and what seemed like time without end stretched out
> before them.[17]

There are no surprises here about who will still be doing the housework in 50,000 years time!

Some of the hairy passions in *La Guerre du Feu* may be put down as part of the psychological prelude to the First World War. Once the slaughter was over, H.G. Wells continued to expel the Neanderthals and such 'unnatural' behaviour in his classic 1921 short story, *The Grisly Folk*. Wells was the consummate image-maker for the Neanderthals. 'Can these bones live?' he cries at the start of his story. By its end their popular fate is sealed. The big, shambling ▶

▶ creatures he described were eventually hunted down and exterminated by the 'True Men' from whom we trace descent, and so the Grisly Folk became a part of our forgotten past. For who would want this individual as an ancestor?

> Hairy or grisly, with a big face like a mask, great brow ridges and no forehead, clutching an enormous flint, and running like a baboon with his head forward and not, like a man, with his head up, he must have been a fearsome creature for our forefathers to come upon . . .[18]

The impact of Boule's Neanderthal is very clear in Wells' descriptions. He declares we cannot begin to understand them since 'we cannot conceive in our different minds the strange ideas that chased one another through those queerly shaped brains. As well might we try to dream and feel as a gorilla dreams and feels.'[19] Thus Neanderthals were stupid and morally degenerate because they looked stupid. Wells was only reiterating the wisdom of his time that the entire non-civilized world functioned at the level of the child.

Rehabilitation, both scientific and artistic, came in the 1950s. The Neanderthal novel of this decade is undoubtedly *The Inheritors* (1955) by William Golding. He opens with a quotation from Wells' short story about the Neanderthals' repulsiveness and undesirable character, but then proceeds to show through them how much we have lost by developing humanity without their contribution. The modern humans in the book compare badly with these creatures who were only carnivores through necessity, and lived lives of noble simplicity. When we are finally allowed to see the main character, Lok, alone and dying of a broken world we find that he

> . . . was a strange creature, smallish and bowed. The legs and thighs were bent and there was a whole thatch of curls on the outside of the legs and the arms. The back was high, and covered over the shoulders with curly hair . . . The mouth was wide and soft and above the curls of the upper lip the great nostrils flared like wings. There was no bridge to the nose and the moon-shadow of the jutting brow lay just above the tip. The shadows lay most darkly in the caverns above its cheeks and the eyes were invisible in them. Above this again, the brow was a straight line fledged with hair; and above this there was nothing.[20]

This Neanderthal dies of grief rather than at the end of a club. The change from Wells' *Grisly Folk* is as complete as that seen recently with the gorilla, in its transition from ferocious breast-beating beast to an endangered species of cuddly vegetarians. The modern people who have either killed or kidnapped the rest of Lok's group are now the villains of prehistory.

Kidnapping – or rather plucking a Neanderthal child from the past to satisfy curiosity in the present – is the subject of Isaac Asimov's *The Ugly Little Boy*, first published in 1958. The story tells of the indifference of scientists to Timmie the Ape-boy, as the Press dub him. First impressions, indeed, are not encouraging:

the boy, who seemed to be something over three years in age, hunched low and backed away rapidly. He lifted his upper lip and snarled in a hissing fashion like a cat . . . It was the ugliest little boy she had ever seen. It was horribly ugly from misshapen head to bandy legs . . .[21]

And yet this little boy is taught to speak, and during his long stay he captures the maternal instinct of his nurse ('I know your name is Miss Fellowes, but – but sometimes, I call you "Mother" inside. Is that all right?'[22]), so that she eventually thwarts the scientists and returns with him to his own time. All that separates us from the past are our prejudices. What unites us are our instincts.

Jean Auel's saga of Earth's Children *The Clan of the Cave Bear* (1980) came at the right time for a modern heroine to experience the Neanderthal way of life. Her theme is one of seeing how the intellect copes with a world where change in the social order is mistrusted, and strength is power. This feminist problem is illustrated not in our own society but in one where both Nature and humans conspire to stifle the creative rewards of natural endowment by hidebound tradition. In her novel the male Neanderthals generally live up to their popular image. Apart from regular wife beating, rape and killing cave bears, the men assembled at big gatherings and

> vied in wrestling, sling-hurling, bola-throwing, arm strength with use of a club, running, more complicated running-and-spear-stabbing races, tool-making, dancing, story-telling, and the combination of both in dramatic hunt re-enactments.[23]

This veritable highland games for male flat heads, as Auel endearingly calls them, only emphasizes their marginal role if stripped of their strength. The injustice of their dominant position in the Clans is underscored. While the males are male, especially in their treatment of the heroine Ayla (who regularly comes up with bright ideas to enhance survival only to be regarded with suspicion for trespassing on their territory), the females are presented with sympathy and respect as a civilizing, if repressed, force. Ayla – a Cro-Magnon orphaned by a natural disaster – is adopted by Iza, who at 20

> was just over four and a half feet tall, large boned, stocky, and bow-legged, but walked upright on strong muscular legs and flat bare feet . . . She had a large beaky nose, a prognathous jaw jutting out like a muzzle, and no chin. Her low forehead sloped back into a long, large head, resting on a short thick neck . . . Big, round, intelligent, dark brown eyes were deep set below overhanging brow ridges.[24]

We have come a long way from Aghoo's 'murderous eyes' and Lok's 'dark caverns' to Iza's gaze of natural wisdom.

The lesson from *Clan of the Cave Bear* is that the beneficial qualities of females should be encouraged since they contribute to progress by challenging the existing social order. If anything needs expulsion from human ancestry, it is the qualities of the male.

Rival theories

As we saw above, within the halls of scientific debate two main theories of later human evolution have dominated discussion: *regional continuity*, where Neanderthals have a place in human ancestry, and *population replacement* where they do not. What is the background to this controversy?

Models of regional continuity

The Neanderthal phase of Weidenreich and Coon. Apart from de Mortillet, chief among the early proponents of a Neanderthal phase in the evolution of modern humans were two nineteenth-century scholars: a German, Gustav Schwalbe, who assigned the Neanderthal and Spy remains to an ancestral species called *Homo primigenius*, and a Croatian, Dragutin Gorganovic-Kramberger, who studied the extensive fossil material from the cave site of Krapina.[25] The idea that the Neanderthals were ancestors to modern humans was a minority view for the first half of the twentieth century, being supported mainly by the physical anthropologist Ales Hrdlička and the anatomist Franz Weidenreich. The former argued the case mainly on the European evidence,[26] but Weidenreich studied the remains of *Homo erectus* discovered during the 1920s and 1930s in the Zhoukoudian cave in China (pl. 95). Weidenreich's familiarity with many other fossils made it possible for him to produce in 1943 a model of the world-wide origin of the modern races which was to form the basis for the subsequent ideas of Carleton Coon, Loring Brace and Milford Wolpoff.[27] The European and Asian Neanderthals, and their supposed evolutionary equivalents in regions such as Africa ('Rhodesian Man') and Java ('Solo Man'), were seen as the direct ancestors in their respective regions for the modern peoples who live in those areas today, hence the title of regional continuity.

Coon's development of Weidenreich's ideas was presented in his book *The Origin of Races* (1962).[28] Using the more detailed fossil records available by then he ran into accusations of racism over his concept of the evolution from *Homo erectus* to *Homo sapiens*, since he believed that African and Australian populations had made the 'transition' to *Homo sapiens* much later than those in Europe and mainland Asia.[29]

The rise of the theory of regional continuity in its present form can be traced to a paper by Loring Brace in 1964 entitled 'The fate of the "Classic" Neanderthals: a consideration of hominid catastrophism'.[30] Brace and other followers of Weidenreich saw no reason to abandon certain fossils to the flood as Noah's ark set sail with only modern humans on board. Marcellin Boule, who had exiled the Neanderthals from our ancestry, was now recast as the villain of the story of human evolution and the pendulum swung back in favour of earlier workers such as de Mortillet and Hrdlička, as well as Weidenreich.

The multiregional model of Thorne and Wolpoff. The issue of racism has been skirted round in the most recent version of Weidenreich's scheme, now dubbed 'multiregional evolution'. The addition of the 'centre and edge' model of Alan Thorne and Milford Wolpoff allowed it to be argued that interbreeding or gene

Theories of Human Evolution

Over the years the two camps favouring regional continuity or population replacement have labelled themselves and each other with a variety of names. Some of these are listed below.

Population replacement	Regional continuity
Noah's Ark	Neanderthal phase
Garden of Eden	Multiregional evolution
Gardeners	Sons of Noah
Out of Africa 2	Candelabra theory
Centre and dispersal	Centre and edge
Mitochondrial 'Eve'	Gene Flow

In the tradition of sound box-office policy, we will use the geographically correct term Out of Africa 2 to refer to the model of population replacement. Out of Africa 1 refers to the earlier dispersal of the hominid *Homo erectus* from Africa to other parts of the Old World about 1 million years ago. Out of Africa 2 occurred some time between 130,000 and 50,000 years ago. The term 'Garden of Eden' highlights the importance to this theory of a centre for modern human origins or – if you prefer – a Noah's Ark, which contained a special genetic variety of humans which would later populate the world. Judging by the number of different cradles put forward over the last 200 years (everywhere from the North Pole to Australia, the Pampa to the Lena River), it is just as well to keep such a centre mobile! The search for human origins thrives on discoveries and as a result new centres may yet emerge. Evidence from the study of variation in our genetic make-up now provides supporting evidence for this model. We will see in Chapter 6 that genetic scientists have attempted to trace human origins back to a single, putative mother, hence the title of Mitochondrial 'Eve', also known as the 'lucky mother'.

To opponents of population replacement, on the other hand, the Garden of Eden suggests a never-never land, a fools' paradise. These critics prefer to be called by serious-sounding scientific names which stress the Neanderthal phase and hence continuity in regional populations scattered over the Old World following Out of Africa 1. Such multiregional evolution does indeed look like a candelabra as William Howells once observed. But in order to distance themselves from racist interpretations that different levels of advancement exist in the different human branches, the adherents of continuity stress the horizontal connections between the branches, which represent inter-regional gene flow. 'Centre and edge' refers to the different rates of genetic and anatomical change that occurred in prehistoric human populations, and the visible effects of these changes. The argument goes that changes in peripheral or edge populations will be more marked but less frequent than for those in central locations. The difficulty is that these centres and edges are constantly on the move. It seems impossible either to predict or find them. Hence the other standby, ▶

▶ gene flow. This can be used to explain away facts that do not fit a theory of geographically isolated populations who nevertheless shared many traits in common. 'Let the genes do the walking, if the bones won't play' would perhaps be a suitable motto. A theory with such supple methods is obviously very difficult to test or disprove.

All the name-slinging just goes to show that there are serious contemporary issues behind the study of the stones and bones of human evolution.[31] Those supporting continuity accuse the other side of justifying extinction, while adherents of replacement criticize their opponents for accepting that racial differences are original and historical. Matters frequently come to a head. The 1990 meetings of the American Association for the Advancement of Science saw just such a battle between the two rival palaeontological camps. 'Blood ties to Neanderthals', thundered one headline in the British Press (*Guardian*, 19 February 1990), while another countered with 'Theorists clash over human origins' (*Independent*). Clash they certainly did, with competing sessions putting forward the views of the two apparently irreconcilable camps.

> Dr Stringer's address on the emergence of modern humans was countered by traditionalist American scientists who put on a rival show – the fossil evidence for human origins – from which all traces of the modernist heresy were excluded. The American group flatly dismissed the rival views and claimed that there was no evidence for Dr Stringer's views either in the fossil record or in studies of similarities and changes in DNA that have suggested a common origin for modern humans in Africa.... Professor Milford Wolpoff ... said that no one who understood fossils could accept it. (*Independent*, 19 February 1990)

Sometimes, as we will see, it is all too easy to lose sight of the actual data behind the theories and models which support the two views.

flow between wide-ranging Ice Age human populations was always sufficient to match the tendency of peripheral ones (e.g. in Europe, Java and South Africa) to diverge significantly from each other (see box above). Thus the evolution of 'racial' variation, while ancient, was always within the context of a single polytypic species (i.e. a species which can exist in several different-looking physical variants), leading to the radical suggestion that only one known species (*Homo sapiens*) has existed since the early Ice Age.[32]

According to Thorne and Wolpoff, the Neanderthals did indeed represent ancestors for modern Europeans, but gene flow could have introduced some characteristics of modern Europeans from outside the area. Variations on the Neanderthal ancestor theme included an explanation for the appearance and disappearance of Neanderthal facial and dental specializations. According to Loring Brace, who christened it the culinary revolution, the changes in facial

features were primarily related to the importance of the front teeth in Neanderthals, since they made great use of their incisors as a vice for manipulating objects and even making tools. As stone tool technology improved, selection for large front teeth declined, and with it the need to maintain big faces and Neanderthal-shaped skulls – or so the story goes.[33]

Less all-inclusive than the Neanderthal phase model of widespread local continuity is the model which derives both late or 'classic' Neanderthals and modern humans from a generalized form of early European or western Asian *Homo sapiens*. For some, this common ancestor was simultaneously both more primitive and more 'modern' than the overspecialized late Neanderthals, who became extinct. Others included the supposedly less specialized 'early Neanderthals' in the common ancestral group. The reasons behind Neanderthal specialization were not always presented, but it was sometimes attributed to isolation and the climatic stress of the last glaciation.[34]

The spectrum hypothesis of Weiner and Campbell. As concepts of polytypic species developed and genetic knowledge progressed, Joseph Weiner and Bernard Campbell proposed the 'spectrum hypothesis' to explain past human variation.[35] They argued that just as variation exists among modern populations, so it did in the past, within both the earliest species of *Homo erectus* and the early forms of *Homo sapiens*. Thus forms such as the Neanderthals, 'Rhodesian Man' and 'Solo Man', were sub-specific variants of *Homo sapiens*, showing different blends of characteristics. Modern *Homo sapiens sapiens*, the surviving subspecies, inherited certain features from the preceding subspecies, but the hypothesis is distinctly vague about exactly how modern humans evolved. According to this model, the Neanderthals – particularly through their early forms and those in the Middle East (*Homo sapiens palestinus*) – had contributed to the evolution of modern people.

Models of population replacement
The presapiens model of Boule. Marcellin Boule, as we have seen, denied the Neanderthals an ancestral role in the evolution of modern populations. This was the 'presapiens' model further developed by Boule's student and successor, Henri Vallois.[36] In their view, the advanced features of modern humans must have had a long gestation period, and the Neanderthals were a relict species from an ancient common ancestor, probably at least one million years old. The unique combination of primitive (even ape-like) and specialized features in the Neanderthals left no possibility that they were closely related to their successors and terminators, the modern-looking and highly sophisticated Cro-Magnons of Europe. Instead the Cro-Magnons must have derived from small-browed and gracile (lightly built) ancestors represented in the early European fossil record. Their lineage evolved and co-existed with that of the Neanderthals, who had instead evolved from more primitive and large-browed forms. This model allowed the Neanderthals to be replaced by their successors, but Europe to remain central to the origin of modern humans.

The Out of Africa model. The final hypothesis we will discuss is a variant of a general model termed 'Noah's Ark' by the American scholar William Howells.[37] The Noah's Ark model proposes that there was a recent, single ancestral population of modern humans in only one region of the world, and that all modern people derived from this common ancestral group by evolution and dispersal. 'Out of Africa', as the name implies, selects Africa as the original homeland of modern humans and gives no ancestral role to the Neanderthals. The model has been developed over the last 15 years by several researchers, including Chris Stringer and Peter Andrews, as studies seem to point increasingly to Africa as the continent where modern humans, and perhaps also aspects of modern behaviour, first evolved.[38] Out of Africa has been greatly favoured by the attention of geneticists in the last few years,[39] but has also met strong resistance, particularly from a vociferous group of American scholars.

Ancients and Moderns

The Ancients (the term we are using to describe all pre-modern humans) were widespread in the Old World. They apparently left Africa over a million years ago and developed into several regional populations, of which the Neanderthals are only one example (Chapters 3 and 4). Their culture and societies, campsites, use of landscape and contacts between groups are the subject of Chapter 7. The Moderns – people who physically looked like ourselves – appear much later, probably less than 150,000 years ago (Chapters 5 and 6). However, it is not until after 60,000 years ago that we see a massive expansion in their numbers and geographical range. Furthermore, we have to wait in some parts of the world until after 40,000 years ago to find the full suite of material culture, including art, that is – like global colonization – another hallmark of modern behaviour (Chapter 9). Modern anatomy is not necessarily synonymous with modern behaviour and we shall see that in Western Eurasia the archaeological evidence points to a critical phase of development between 60,000 and 40,000 years ago. Finally the fate of the Neanderthals is spelt out in Chapters 8 and 9.

The study of the Neanderthals inevitably focuses attention on the question of what we mean when we use the term 'modern human'. Any such definition rests on an understanding of the enormous physical, social and cultural differences which make up our *present* world, with its mosaic of multi-cultural societies. The ability to set down what is important about ourselves then allows us to identify – from the anatomy of fossil hominids and their archaeology – alternative patterns of behaviour and survival which we believe stand outside the reasonable limits of our definition of modern humans. The interest in the Neanderthals is therefore as much in ourselves and where we draw the line of humanity as in them. Are they just an earlier reflection of ourselves, seen through the distorting mirror of time, or are they a negative to our positive, polar opposites in body and behaviour?

CHAPTER 2

The Ice Age World

On the northern fringes of the inhabited Ice Age world the repeated glaciations of the last 1.6 million years, known as the Pleistocene epoch, had some of their greatest impact. In this chapter we will examine the European evidence for early human habitation and begin to look further afield.

Understanding Ice Age geology is important to our story for three main reasons. Firstly, it can help us to reconstruct the habitats in which the Ancients and Moderns lived. The evidence from animal bones, pollen grains, sediments, insects, molluscs and many other materials give us an invaluable insight into human existence at the local level. Secondly, it is possible to derive a sequence of long-term fluctuations in the earth's climate from evidence of successive ice advances. This can then be related to changes in faunal and floral communities, to provide a relative chronological framework for the period. During the Pleistocene such changes were considerable; many animal species appeared and became extinct. A good example is the giant deer, *Megaceros*, which had an antler span of 3.6 m (*c.* 12 ft). These Ice Age animals failed to survive the last post-glacial warming that began 10,000 years ago (and continues in our present warm interglacial period). Thirdly, Ice Age geology gives us the opportunity to examine the forces at work behind human evolution. How important were climate and environment in shaping the biology and behaviour of the Ancients and the Moderns?

Traditional Pleistocene frameworks and their problems

The early history of investigation into past ice ages was dominated by work in Europe. Geologists such as Agassiz, Lyell, Geike, Penck and Brückner not only established that large areas of Europe had been formerly glaciated, but also provided estimates of the time involved and the number of successive glaciations.[1]

Most importantly it also proved possible in Europe to establish the high antiquity of human ancestry through the association of stone tools with extinct Ice Age animals like mammoths. Such discoveries were being made in 1859 in the gravel deposits of the Somme and Thames by Prestwich and Evans, as well as at Brixham Cave and, earlier, at Kent's Cavern.[2] In North America the glacial deposits were also studied in great detail but, despite continuing claims, none of them has produced any Palaeolithic (Old Stone Age) artifacts irrefutably older than 15,000 years.[3]

Until recent decades, the favoured geological model for the Pleistocene was

of four ice ages separated by three much longer interglacials, when the climate was similar to that of today. Two geologists, A. Penck and E. Brückner, set down this system in their great three-volume work *Die Alpen im Eiszeitalter* published in 1909. Their fieldwork was in the Alpine Foreland of southern Germany, in the region around Munich. This area bears many traces of the effects of the Alpine glaciations. The low, round hills and long thin lakes running north–south are just two examples. The former were created from the mounds of debris (moraines) left behind after the retreat of the ice sheets, while the finger lakes – similar in origin to those in upper New York State, which lie to the south of the former North American ice sheet – occupy hollows either gouged out by the ice or trapped between two parallel moraines.

Brückner and Penck named their four ice ages after the river terraces of four tributaries to the Danube: the Günz, Mindel, Riss and Würm, the last being the most recent.[4] The origin of these terraces was shown to be climatic: extensive sheets of gravel were built up by sluggish meltwater streams at the edge of the ice sheets which were then cut by the more active rivers of the interglacials. The step effect of the river terraces was therefore a guide to the number and relative duration of the Pleistocene ice ages.

The entire span of the four ice ages was estimated from the amount of time thought necessary for the rivers to lay down and then cut through these terrace deposits. Penck and Brückner calculated some 600,000 years in total, of which 240,000 years was taken up by the great interglacial which separated the Mindel and Riss glaciations.

The Pleistocene epoch is now known to have lasted much longer than this. It is currently subdivided into early, middle and late stages, which are dated to 1.6 million–730,000 years ago, 730,000–130,000 years ago and 130,000–10,000 years ago respectively. Changes in animal and marine faunas were very important for recognizing these larger subdivisions.

The Alpine model was devised at much the same time as the discovery of Neanderthal remains at the cave sites of La Chapelle-aux-Saints, Le Moustier and La Ferrassie. Using the Alpine chronological system, scholars were able to compare animal fossils from the river terraces with those from cave sediments to establish a framework for relative dating fossils and stone tools found at cave sites.[5] More recently, work by Henri Laville on the climatic conditions reflected in the composition and structure of the cave sediments has led to an elaborate dating scheme for many of the key French Palaeolithic cave sites, its relative chronology still underpinned by Penck and Brückner's model of 1909.[6]

However, there are problems with all these frameworks. The main difficulty is that they have been constructed from discontinuous data. River terraces and moraines could have been removed by later glaciations and river action. No cave contains a complete sediment sequence through the Pleistocene: all have seen periods when the sediments either stopped accumulating or, worse still, were eroded away. Moreover, dating the sequences has always been a problem. In some cases distinctive stone tools have been used to date particular layers and in others e.g. in northern France and southern England, sequences have

The Creatures from the Deep-Sea Cores

Cores drilled into the soft sediments of the ocean floor contain skeletons (made from calcium carbonate) of many different species of microscopic animals, known collectively as foraminifera. The foraminiferal lifespan is short, and a constant rain of these creatures falls onto the sea bed to create sediments of 'foraminifera (or Globigerina) ooze'. Over periods of millions of years, these skeletons can accumulate to form sedimentary masses such as the chalk hills and cliffs of southern England, now uplifted from their original positions under the sea.

But how can such microscopic creatures help us to establish a chronology for the Pleistocene? When alive and living at the surface of the ocean, foraminifera absorb two isotopes of oxygen contained in the sea water. As the numbers indicate, ^{18}O and ^{16}O differ in isotopic 'weight'. When the oceans are small, as happens during continental glaciation, moisture which is drawn off to build the ice sheets takes with it the lighter ^{16}O isotope. This leaves an ocean that is isotopically 'heavy' in terms of ^{18}O. As the ice caps melt, as they seem to be doing under the Greenhouse Effect today, the returning water swells the size of the ocean and makes it isotopically 'lighter'. The fluctuating ratios of the two isotopes are recorded in the skeletons of the foraminifera.

Cesare Emiliani was able accurately to measure the amount of each isotope within the minute skeletons using a mass spectrometer. When enough specimens had been analysed from a long core it was possible to plot the differences in the ratio of the two isotopes against time. Fig. 17 shows the $^{18}O:^{16}O$ ratio in the standard core V28-238, measured on the planktonic foraminifera *Globigerinoides sacculifera*.

What does this tell us? On the basis of earlier cores, Emiliani argued that the changing ratios of ^{18}O and ^{16}O revealed a repeated pattern of interglacial and glacial climates, indicated by odd and even numbers for the isotopic stages. Using the isotopic curves from the Caribbean and equatorial Atlantic, he then translated his findings into a generalized curve of Ice Age temperatures. These were only estimates of temperature and, while many species in the Globigerina-ooze are sensitive indicators of sea temperature, this is not expressed directly in the isotopic ratio. Many experts today feel that oxygen isotope ratios are more representative of the relative sizes of the oceans and ice caps than of actual ocean temperatures.

In his 1955 paper 'Pleistocene temperatures' Emiliani interpreted the 14 isotopic stages in terms of the Alpine system. His age estimates for the late Pleistocene were remarkably good, but he shoehorned the period between 100,000 and 300,000 years into too short a chronology. Absolute dating of later cores such as V28-238 has shown that stage 14 in Emiliani's generalized curve would be at least 530,000 years old, in the middle Pleistocene, and therefore 200,000 years older than the first estimates.

been subdivided according to the position of the artifacts on a scale of crude to fine artistry. This progressive scale was translated into a chronology with crude execution indicating an early age and fine technique a date nearer the present.[7]

The modern Pleistocene framework from deep-sea cores

Today the course of the Pleistocene is believed to be best defined by the stratigraphic record obtained from cores drilled into the sediments of the ocean floor. This revolution in Pleistocene studies was begun by Cesare Emiliani in 1955 when he scientifically analyzed the tiny marine organisms contained in the muds and oozes from deep-sea cores and deduced varying oxygen isotope ($^{18}O:^{16}O$) ratios from them (see box on p. 41). The challenge to the traditional schemes of Penck and Brückner came from Emiliani's discovery that the deep-sea cores contained a much more continuous record of the Pleistocene ice ages. This was in contrast to the piecemeal and discontinuous nature of the Pleistocene record on land.

The full significance of this approach was recognized by (among others) Nick Shackleton, who refined the procedures and made a more accurate interpretation of what the saw-toothed curves meant for describing and understanding the Pleistocene period.[8] Shackleton pointed out that the oxygen isotope curves charted the size of the oceans relative to the land-based ice caps throughout the Pleistocene.[9]

Dating these cores was the second innovation to transform Pleistocene geology. The top few centimetres of the cores could be dated by radiocarbon techniques. However, ages older than 35,000 years could hitherto only be estimated since they were either beyond the effective range of conventional radiocarbon dating, or did not contain suitable materials for other techniques such as Potassium/Argon (K/Ar) dating, which also measures time through the predictable decay of isotopes in volcanic rocks.[10] The solution to the problem came from the geomagnetic studies of terrestrial rocks which had also been absolutely dated by such methods. As part of the post-war revolution in crustal geology known as plate tectonics, it was found that polarity changes can be measured in many volcanic rocks. For reasons not yet understood, the earth's polarity has on numerous occasions completely reversed so that the magnetic north pole becomes the south and vice versa. Many of these reversals are short-lived, but the major epochs of reversed and normal (today's) polarity were constant for very long periods of time and so provide the principal chronological blocks determining the internal partitions of geological epochs such as the Pleistocene.[11]

The two magnetic polarity epochs which concern us here are the Brunhes (normal) and Matuyama (reversed). The boundary between them is dated absolutely to about 730,000 years ago. This is accepted as a world-wide marker between the early and middle Pleistocene.[12]

The oxygen isotope ratio has now been measured in many hundreds of cores. The output is characteristically saw-toothed in shape with the zig-zags

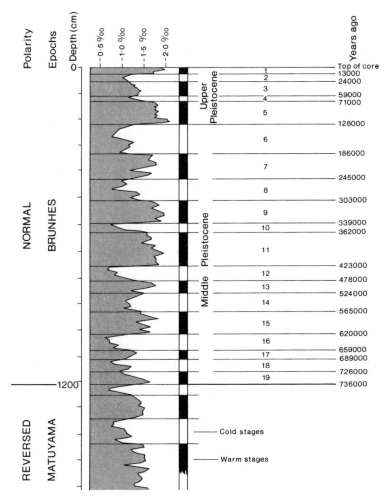

17 The Pleistocene climate, as recorded in deep-sea core V28–238 taken in the Pacific Ocean. The tint shows how the amount of the heavy ^{18}O isotope varies with the depth of the core. At 1,200 cm the sediments show a change in magnetic polarity which can be dated by absolute methods to c.730,000 years ago. The other dates shown are estimates based upon their depth within the core.

recording, from a single location, the relationship between ice and ocean volume. The standard core V28-238 for the middle and late Pleistocene is shown above. It contains eight climatic cycles – each consisting of a glacial and interglacial stage – in the last 730,000 years.[13] The single cycle of the late Pleistocene extends back to 130,000 years ago while the middle Pleistocene contains seven full climatic cycles back to 730,000 years ago. The early Pleistocene runs, as we have seen, from about 1.6 million to 730,000 years ago and contains a further 20 shorter cycles.

The new cycles

The new Ice Age chronology is much more complicated than the old, four glaciations system of Penck and Brückner. Instead of short, convenient names like Würm or references to the 'Great Interglacial', we are faced instead with a string of stage numbers, and letters denoting sub-stages. Remembering the age of such stages will never be easy. Moreover, there is still much work to be done

when it comes to assigning Pleistocene archaeological sites – many of which do not yet have absolute dates – to any one of these stages. Neither has it been possible to accommodate to everyone's satisfaction the old regional Pleistocene sequences in Europe into the new chronology.

The important concept to grasp is that a full climatic cycle in the Pleistocene is made up of two major parts: a glacial and an interglacial. As a result the saw-toothed curve is divided into interglacials (odd numbers) and glacials (even numbers). There are exceptions to this rule, the most significant being the last cycle, the late Pleistocene. Because of greater resolution between the deep-sea cores and evidence left behind on the land, more stages can be recognized.[14]

The ages of each stage are shown in fig. 17. When a full cycle is considered we can see that as we get closer to the present the cycles get longer. From the start of the Pleistocene 1.6 million years ago to 900,000 years ago a full cycle was completed every 40,000 years. In the transition from the early to the middle Pleistocene (900,000–450,000 years ago) the duration of a cycle stretched to 70,000 years, before hitting a 100,000-year rhythm in the last four full cycles, the most recent of which is the late Pleistocene.

Such a lengthening of stride has implications for several evolutionary questions. Elsewhere attempts have been made to link the appearance of new hominid species to these changes in climatic pace,[15] and the timing of the *Homo erectus* radiation from Africa about 1 million years ago (Chapter 3) is also put down by some to a climatic push.[16] While the changes in the duration of long-term climatic cycles are intriguing, it is difficult at the moment to see exactly how they might be responsible for the appearance of regional populations of Ancients, such as the Neanderthals.

The climatic cycles produced a succession of contrasted environments, some of which were longer lived than others. Their variable duration must have had a considerable impact on the selection for adaptive solutions to survival problems. If we look at the late Pleistocene we can see that, far from a simple division into interglacial/glacial (warm/cold), there were rapidly fluctuating

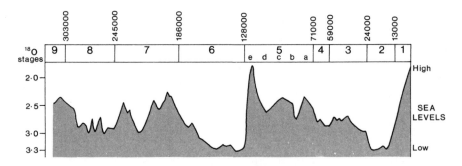

18 Ice and ocean levels, as recorded by the proportion of ^{18}O in this core, have greatly fluctuated over the past 300,000 years. The last interglacial (isotopic stage 5e) stands out as a brief episode of exceptionally large oceans. The maximum ice conditions (i.e. low sea levels) in stages 6 and 2 are more prolonged. During most of the past 300 millennia, however, the climate evidently rested between the two extremes of interglacial and full glacial.

conditions. Sometimes it has also been possible to match the peaks in the cores with changes in tree cover as indicated in the pollen record.[17] Rather than a twofold division of each climatic cycle, the combined evidence points to at least four and possibly five major environmental phases, some of which – on a Pleistocene timescale – did not last for very long.

	Climatic conditions	Estimated years ago	Isotope stage	% of last cycle
1	**Interglacial**	130,000–115,000	5e	13
2	**Early glacial:** temperate/cool	115,000–75,000	5d–a	34
3	**Early glacial:** cool/glacial	75,000–30,000	4,3	38
4	**Full glacial**	30,000–13,000	2	15
5	**Late glacial**	13,000–10,000		
1	**Postglacial** (present interglacial)	10,000–present		

19 The last full climatic cycle (the late Pleistocene) and the early stages of the present cycle.

The table above[18] indicates that the two shortest-lived phases are the interglacial and full glacial. If we estimate how much of the last 730,000 years (the middle and late Pleistocene) has consisted of phases comparable to 1 and 4, we find it is only 8 per cent and 36 per cent respectively. In fact, for the majority of time that Ancients were in Europe, environments and climatic conditions were somewhere between these two extremes, represented by phases 2 and 3 of the early glacial and the transition to the succeeding interglacial.[19] In a northern continent such as Europe, these phases were mostly characterized by open landscapes with herds of large mammals living off the rich herb layers and vegetation mats. These were the conditions which shaped Neanderthal adaptation. It was in these long-lived, highly productive open landscapes that they made a living for many millennia.

Climate and environment in the Neanderthal world

What long-term conditions did the Neanderthals have to cope with? To answer the question we first need to establish the chronology of their evolution. The defining anatomical features of the Neanderthals are discussed in detail in Chapter 4. Suffice it here to say that some of these features first appeared about 230,000 years ago, with the full suite present by *c*.130,000 years ago (Chapter 3).[20] We can be more precise about their demise since the last known Neanderthals, found in France, are currently dated to about 35,000 years ago, suggesting that by 30,000 years ago there were no more Neanderthals.[21] What happened climatically during their 200,000-year existence?

A quarter of a million years ago was the beginning of an interglacial stage (fig. 18) but in fact conditions were not those of a peak interglacial.[22] This contrasts

with the extreme nature and high sea levels of the last interglacial which started 130,000 years ago and lasted for a mere 15,000 years or so.[23] The early Neanderthals on the other hand lived through a variety of repeated climatic phases. The temperate cool (phase 2), and sometimes glacial (phase 3) climates, were probably critical in selecting for some of the classic Neanderthal features that many believe are related to coping with low temperature and aridity. The climates and landscapes of the Neanderthal world were dominated by phases 2 and 3 of the early glacial (see table on p. 47) which, together, prevailed during about 70 per cent of the time the Neanderthals existed. The very instability of climate, the relatively short duration of each individual phase and the rapid transition from one phase to another provided strong selective pressure on the anatomy of the robust European Ancients from which the Neanderthals are descended (Chapter 3).

The last climatic cycle: a world-wide view

What happened to global climate during a single climatic cycle? What were the Ancients, including the Neanderthals, up against in terms of the size and frequency of environmental changes? To provide an answer we will examine the late Pleistocene, the most recent complete cycle. The last 130,000 years provide the best available evidence for reconstructing Ice Age habitats since no subsequent glaciations have obliterated the traces of Pleistocene environments, and data for this epoch have been most studied.

In concentrating on the last cycle we are not suggesting that every detail was identical to earlier cycles. But many of the conditions – e.g. aridity, periglacial conditions close to ice sheets, the appearance of continental shelves as the oceans shrank in size – *would* have been similar and appeared at roughly the same stage in other cycles. Earlier populations would have had to respond to these recurrent changes. We will first look at the global changes faced by the Ancients in general before turning to the Neanderthal world in particular.

Phase 1: the interglacial (130,000–115,000 years ago)

The last cycle began abruptly as sea levels rose quickly and the maximum ice advance of isotopic stage 6 swiftly retreated.[24] The pace of animal migrations to match these rapidly changing conditions is striking. Hippopotami lived not only along the Thames (a nice specimen came from Trafalgar Square), but as far north in England as Victoria Cave in Yorkshire where an absolute date of *c*.120,000 years ago puts it firmly in the interglacial.[25] The pollen records all point to heavily forested conditions, with the northern deciduous forests and equatorial rain forests at maximum extent. Lake levels were generally high, as this was a period of moist conditions. Sea temperatures, as indicated by higher proportions of warm-loving foraminifera species in the deep-sea cores show that sub-tropical waters almost reached the British Isles.[26] There is also evidence for higher sea levels even after local tectonic uplift has been taken into account, perhaps 5 m (16 ft) above the modern global mean.

Climatic conditions	Estimated years ago	Isotope stage	Hominid evolution	
			Western Eurasia and Africa	Far East
Mainly temperate or cool, with some glacial intervals. *Large oceans, small ice caps*	250,000–180,000	7	Transitional 'archaic *Homo sapiens*' to early Neanderthals in Europe, late 'archaics' in Africa	Late *erectus* and 'archaic *Homo sapiens*' in China; late *erectus* in Java
Full glacial with some milder intervals. *Small oceans, large ice caps*	180,000–130,000	6	Early Neanderthals, fixation of many Neanderthal features in Europe. Transitional archaic to early Moderns in Africa?	'Archaic *Homo sapiens*' in China; late *erectus* in Java?
Last interglacial, warm conditions. *Large oceans, small ice caps*	130,000–115,000	5e	Neanderthals in Europe and perhaps also in Middle East; first Moderns in Africa and possibly in Middle East	'Archaic *Homo sapiens*' in China; late *erectus* in Java?
Temperate/cool	115,000–75,000	5d-a	Neanderthals (?) and Moderns in the Middle East	'Archaic *Homo sapiens*' in China; late *erectus* in Java?
Cool/glacial *Ice caps increasing*	75,000–30,000	4–3	Neanderthals extinct at end of this period; Moderns appear in Europe	Moderns appear in Far East

20 *Climate and chronology for the Neanderthals and other hominids.*

Compared to the present warm period this last interglacial was a world of megafauna. Hippopotami, straight-tusked elephants and narrow-nosed rhinoceroses were found in the British Isles, while in the far north the arctic fauna would have been enriched by woolly mammoths and woolly rhinos as they sought refuge from the forests and warmer temperatures of the south. Elsewhere in the world (inhabited by contemporaries of the Neanderthals) there were changes in the fauna. In China the panda and the *Stegodon*, an extinct elephant, apparently moved north, and there were crocodiles in large rivers such as the Yangtze. At this time, before humans had reached Australia, the antipodean fauna included the *Diprotodon* marsupials which were roughly the shape and size of rhinos. These grazed alongside giant kangaroos, over 3 m (10 ft) tall, while the large marsupial carnivore *Thylacoleo* must have been a formidable predator.

Phase 2: early glacial, temperate/cool (115,000–75,000 years ago)
The downturn in temperature after 115,000 years ago must have helped to thin out some of the megafaunal species in the more northerly latitudes inhabited by Neanderthals. These hominids were ideally suited to such open environments. In Europe the more broken, but still wooded, conditions started to favour herds

of grazing species such as red deer and horse. In the middle latitudes this phase saw severe disruptions to tree cover and vegetation as climate fluctuated wildly.[27] Elsewhere in the world inhabited by other populations of Ancients (as well as by some of the oldest anatomically modern humans), this temperate/cool phase saw a lowering in temperature and the appearance of limited amounts of continental shelf as the seas fell due to the build-up of the ice sheets.

Phase 3: early glacial, cool/glacial (75,000–30,000 years ago)

The exposed area of continental shelf increased dramatically in the next, much colder phase of the early glacial. In northern latitudes tree cover was reduced to refuge woodlands along well-sheltered valleys, while the high moisture content and cold temperatures produced large frozen ground features such as ice wedges which were driven down into soft sediments. Today such ice wedges can be traced by the different deposits which filled the cast when the ice had later melted.

In Central Asia and China the period of soil formation that had reached its height during the interglacial and continued through phase 2 of the early glacial, now ceased abruptly. The soils were covered by a mantle of loess – wind-blown sediments – which signals a lack of covering vegetation in such continental areas. The appearance of ice sheets both in the north and more locally on mountain chains produced large quantities of ground-up rock or 'rock flour', which was also moved by rivers at the edge of these ice sheets and spread into fans. Such unvegetated areas in front of the glaciers formed another source of material for wind erosion. The massive deposits of sediment in parts of central Europe formed a sort of Pleistocene dustbowl, and point to the arid, open environments at this time.[28] If we follow the trail of loess from western Europe to Central Asia we find 200-m (650-ft) high loess hills, e.g. at Dushanbe in Tadzhikistan. Equally impressive sections can be found in China.

Between 75,000 and 32,000 years ago the deep-sea and ice cores point to rapid oscillations in ice to ocean volume. The climate generally was in a state of flux (fig. 18). From 70,000 to 60,000 years ago there was a major cold period and some ice advance.[29] Around 40,000 years ago there was a series of small climatic ameliorations before the trend towards a rapid and continuing climatic decline took hold.[30]

Research in the Negev Desert has shown that in the Middle East, phase 3 enjoyed periods of wet and humid conditions. Water sources were more permanent, as at Far'ah in the Negev Desert around 40,000 years ago,[31] and in the central Negev at sites such as Boker Tachtit.[32] Even the well-named Wadi Arid – 200 km (125 miles) east of Lake Nasser in Egypt and one of the driest places in the Sahara – has evidence for lakes, indicating wetter conditions some 45,000 years ago. These, however, were short-lived and variable episodes, comparable in this respect to the interstadials (minor warm periods within the glacials) of northern latitudes.

In some areas the moister conditions were more stable, due in part to local hydrology. Wetter conditions prevailed at the now dry Willandra Lakes in

western New South Wales (Australia).[33] Between 50,000 and 25,000 years ago these lakes were full and supported a rich diversity of fish and shellfish, acting as a magnet for human settlement as shown by the thousands of tools, camp fires and occasional burial and cremation around the former Lake Mungo.

Phase 4: full glacial (30,000–13,000 years ago)

The final, full glacial phase changed all this. There was a marked downturn in northern climates between 30,000 and 20,000 years ago. The rapid growth of continental and mountain ice sheets led to a world-wide drop in sea levels. The last glacial maximum, which saw the full exposure of the continental shelves can be dated to 18,000 years ago (perhaps earlier), long after the last Neanderthals had perished. However, similar conditions must have prevailed at the previous glacial maximum some 160,000–140,000 years ago, when the Old World *was* peopled by Ancients such as the Neanderthals.

In northern latitudes, at the last glacial maximum 18,000 years ago, the unglaciated part of southern England was joined by dry land to what is now the continent of Europe. At the same time the continental shelf between northeastern Siberia and Alaska was exposed over an area of at least 1 million sq. km (400,000 sq. miles).[34] This formerly dry land is known as the palaeocontinent of Beringia. In the mid latitudes of Southeast Asia, the Sunda shelf was exposed when the sea dropped by as much as 150 m (500 ft) below present levels. Together with the 600-km (370-mile) wide plain that appeared in the East China Sea, this added 2.5 million sq. km (nearly 1 million sq. miles) of land to Southeast Asia. Across the Sunda trench this same lowering of sea level united Papua New Guinea, Australia and Tasmania into the super-continent of Sahul. Finally the continental shelf around the Cape of southern Africa was also exposed to a maximum width of 100 km (62 miles).[35]

As might be expected, the exposure of such shelves and the reduction in vegetation on the continents had dramatic effects. In many parts of China, Central Asia and central and eastern Europe there was intensified accumulation of loess. The impact of the last glacial maximum 18,000 years ago produced geographical refuges for plants, animals and in many areas human popula-tions.[36] The tropical rain forests of Southeast Asia, Africa and Amazonia were reduced to relatively small refuge areas as the savannahs expanded. In western Eurasia people focused on hunting reindeer and horse while a similar tight concentration, this time on red-necked wallaby, is known from caves occupied at the height of the last glacial maximum on the other side of the world, in southwest Tasmania.[37] In Europe, the areas closest to the ice sheets were at most settled intermittently by humans, such as in Germany,[38] and were frequently abandoned, as was apparently the case in Britain during the last glacial maximum.[39]

Phase 5: late glacial (13,000–10,000 years ago)

The final phase of the glacial corresponds with the upturn in climate and the recolonization by plants and animals of many hitherto abandoned areas. This

climatic process is known as the late glacial. The timing and speed of this process varied with latitude.[40] In northern Europe there was a burst of activity after 13,000 years ago and forest regeneration dating from this time can be traced in the pollen record.[41] The deep-sea and ice-cap cores both point to the very rapid change in ice:ocean ratios. These were faster than the onset of glacial conditions. The changes in lower latitudes were no less dramatic. In Australia, the Willandra lakes became closed and highly saline, and after 15,000 years ago they dried up completely. A similar trend towards drier conditions is repeated in other arid regions, such as in southern Africa and throughout the Middle East.

The speed of this climatic change is perhaps one reason why so many animal extinctions took place in the late glacial phase. Species never emerged from their geographical refuges. This produced a very different animal world in most of the inhabited continents.[42] Climate was almost certainly not the only cause of these extinctions, however, and its effect may well have been compounded by increased predation by modern humans, as in North America where the mammoth abruptly disappeared about 10,500 years ago. The onset of the postglacial (Holocene or recent epoch) after 10,000 years ago also saw many significant changes to the world's fauna. Animal extinctions did occur in earlier cycles but the role of the Ancients in such extinctions was probably minimal.

Resources in the Neanderthal world

Within the Neanderthal world (map pp. 10–11) it is generally agreed that animal resources were very important for survival. While we do not doubt that plants were consumed when they were abundant and readily available, it does seem that the criteria for occupying seasonal habitats at higher latitudes lay in the exploitation of animal resources. We will discuss later (Chapter 7) how these resources were obtained, whether by hunting, scavenging or a combination of such foraging techniques. At this point we will concentrate on the variety of animals available, to indicate the range, in both time and space, of such basic food sources within the Neanderthal world.

The sites we have chosen to review are widely dispersed throughout the Neanderthal world. They consist of both caves and open sites. The oldest occupation was probably in the cave site of Tabūn, with one of its levels – level E – dated by electron spin resonance (ESR: see box on pp. 58–59) to between 220,000 and 150,000 years ago. A number of the sites date to climatic phase 2 – the temperate conditions of the early glacial – from 115,000 to 75,000 years ago (Combe Grenal, La Borde, Il'skaya and Tabūn levels C-B). Phase 3 sites, between 75,000 and 30,000 years old, are well represented as colder climates with less tree cover took hold (Combe Grenal, Stadel, Guattari cave, Érd). Occupation of the caves of Teshik Tash and Kudaro may also date to this phase.

The sites are also located in a variety of settings. Teshik Tash is in rugged mountains at a height of 1,500 m (c. 500 ft). Kudaro is situated in the Caucasus

mammoth

woolly rhinoceros

hippopotamus

aurochs

bison

musk ox

horse

steppe ass

giant deer

red deer

reindeer

fallow deer

ibex

chamois

saiga antelope

wild sheep

roe deer

gazelle

cave bear

brown bear

cave lion

leopard

lynx

wild cat

hyena

wolf

badger

fox/jackal

wolverine

21 A Neanderthal bestiary.

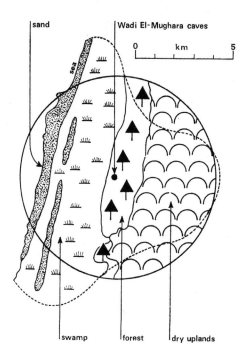

sand Wadi El-Mughara caves

0 km 5

swamp forest dry uplands

22 The inhabitants of Mount Carmel (Wadi el-Mughara) exploited a variety of different environments. The dotted line represents territory within a 1-hour walk from the cave. Over time the shifts in forest and dry steppe influenced the animals available for hunting within a 5-km radius.

range. Shanidar lies at an altitude of 765 m (2,500 ft), but in plateau country rather than heavily dissected terrain. Tabūn, in the Mount Carmel cave complex outside Haifa, is close to the sea and at a relatively low altitude. As the sea rose and fell during the long periods it was occupied, so the catchment of the site – the territory potentially exploitable within walking distance – changed dramatically (see figure above). This was also the case at the Italian cave complex of Monte Circeo in which Grotta Guattari is located, but here the coastal shelf is more limited. Continental open sites are found at Il'skaya in the Russian plains to the northeast of the Black Sea, Érd in Hungary, and the cave of Stadel – part of the Hohlenstein complex – located at 470 m (1,540 ft) in the southern German uplands. Finally, two sites that would have enjoyed the ameliorating effects of a maritime climate, the cave of Combe Grenal and the open site La Borde, are both in the rolling limestone plateaux country of southwestern France.

Variety in space

The table opposite shows how the local fauna – identified from their bones – differed between sites in the Middle East and Central Asia (Tabūn, Shanidar, Teshik Tash) on the one hand and those in Europe on the other.[43]

The greatest differences are amongst the carnivores and the megafauna. This is not surprising when we consider the range of climates – maritime, continental, mountain and arid – covered by these sites. Distinct faunal provinces cannot be found, just a gradual increase in some steppe species as we move east.

But there is more variety to be unearthed in our sample. When we examine

	Europe	Middle East and Central Asia
Carnivores	Cave bear, lion, hyena, wolf, leopard, arctic fox, red fox, lynx, wolverine, badger, wild cat, caucasian dhole	Wolf, hyena, jackal, tawny fox, brown bear, extinct fox
Herbivores	Aurochs, bison, giant deer, horse, red deer, reindeer, pig, roe deer, ibex, chamois, steppe ass, saiga antelope, wild sheep, musk ox	Red deer, fallow deer, gazelle, wild sheep, wild goat, pig, roe deer, onager, steppe ass, hartebeest
Megafauna	Mammoth, woolly rhino	Hippopotamus
Large rodents and lagomorphs	Porcupine, hare, rabbit, marmot	Beaver, marmot, pika, hare, rock hyrax

23 Variation in the types of animals inhabiting the two major areas of Neanderthal settlement, Europe and the Middle East, c.200,000–35,000 years ago.

which species and groups of animals dominate the faunal collections excavated from these sites, we find some interesting geographical patterns. In the first place, carnivores – particularly those which use dens to hibernate or raise their young, such as bears and hyenas – are more common in the centre of the Neanderthal world (fig. 21) than at its edge. This distribution may help to explain why complete Neanderthal skeletons are mostly found in areas such as the Middle East and France (Chapters 4 and 7), for carnivores seem to be rarer in these regions, and destruction by them of skeletal evidence is therefore much reduced. Érd, Kudaro and Stadel are all dominated by the remains of the many thousand cave bears that died during winter hibernation. It is also common at these sites to find hyena associated with the bones of horse and woolly rhino. The extent to which such den-users as hyenas and wolves brought bones to the sites, so creating their own 'archaeological' record, is a point we examine further in Chapter 7. These carnivore-dominated bone collections suggest that life in the centre of the Neanderthal world was probably under more intense selection pressure, as a result of competition from other predators for basic resources, than that in the Middle East and western Europe, France and Iberia.[44]

When we look at the dominant herbivores at Neanderthal sites, the east–west division becomes much clearer. The high-level sites of Teshik Tash and Shanidar have yielded abundant bones of wild sheep and goat. Tabūn is dominated by fallow deer and gazelle. Evidence from European sites, where carnivores were rare, shows that the auroch (giant extinct cattle) was the main species predated at La Borde, while at Il'skaya it was bison. At Combe Grenal it

was red deer and reindeer. At the carnivore sites the picture is less dramatic: no one species is usually so numerically dominant. At Stadel, Érd and Kudaro, horse, steppe ass and red deer are, respectively, the most common herbivore species in the faunal record. At Guattari the emphasis is on red deer, with large bovids and horse in second and third place.

Variety in time

Three of these sites – Combe Grenal, Stadel and Tabūn – have long sequences which span at least two climatic phases. As the table below shows, the changing climate is reflected in the faunal remains. The transition from temperate to glacial conditions at Combe Grenal favoured open country reindeer rather than the woodland red deer. At Stadel horses were always the main herbivore, but red deer were replaced by woolly rhino, bovids and reindeer as the climate worsened. Finally, at Tabūn dominance swung between fallow deer and gazelle, reflecting wetter and then drier conditions.

Site	Date	Number of Species		Dominant Carnivore	Dominant Herbivore
		Carnivores	Herbivores		
Combe Grenal	115,000–75,000	5	11		Red deer, bos/bison, horse
	75,000–40,000	5	10		Reindeer, horse, red deer
Stadel	115,000–75,000	10	9	Bear	Horse, red deer
	75,000–40,000	7	8	Bear, hyena	Horse, rhino, bos/bison
Tabūn Level E:	220,000–150,000	4	7		Fallow deer, gazelle
Level D:	170,000–120,000	5	12		Gazelle
Level B:	110,000–80,000	4	11		Fallow deer

24 Changes in the faunal remains at the sites of Combe Grenal (France), Stadel (Germany) and Tabun (Israel).

Dating the Palaeolithic

The variety in the fauna of the Neanderthal world, which we have touched on in the last section, will become clearer as more detailed chronologies become available. At the moment we are still hampered by rather broad chronological schemes, many of which still rely on the typological dating of artifacts. As we shall see in Chapter 7, this is a dangerous procedure and should be discouraged.[45] Moreover, using the faunal and floral evidence to provide a relative date can also be hazardous now that we have abandoned Penck and Brückner's four ice ages, because particular associations of animals and plants probably recurred many times in the Pleistocene; we must instead try to

correlate our terrestrial evidence with the more continuous records from the deep sea.

The European Palaeolithic or Old Stone Age – an archaeological as opposed to a climatic term like the Pleistocene – does, of course, embody a chronological model in its internal divisions. For the past century it has been divided into three stages like the Pleistocene (but usually entitled Lower, Middle and Upper rather than early, middle and late), and these divisions form the building blocks for classifying archaeological materials in Europe and Asia. (In Africa, the stages are known as the Early, Middle and Late Stone Age.[46]) The Lower Palaeolithic's trademark artifact is the hand axe, complemented by the pebble tool/chopping tool (pp. 56–57). The Middle Palaeolithic generally lacked such large stone implements (see Chapter 7) and instead contained many tools classified according to their probable function as scrapers, which involved retouching or modifying the edges of struck flakes (pp. 144–45).

Early excavations in the rockshelters above Le Moustier in southwest France gave rise to the general term Mousterian for the European Middle Palaeolithic. In the decade before the First World War several finds of Neanderthals were made with these Mousterian/Middle Palaeolithic stone tools. This led some authorities to declare that Neanderthals were exclusively the people of the Mousterian culture,[47] a view which recent evidence has disproved (Chapter 7).

The third great stage was the Upper Palaeolithic, also defined by its technology. Stone-working tools now included a predominance of long, thin parallel-sided blanks known as blades. Art and ornament appear for the first time in the archaeological record of this stage. In 1868, E. Lartet and H. Christy discovered the skeletons of several anatomically modern people in the rockshelter of Cro-Magnon, above the Vézère village of Les Eyzies. They were found with the distinctive elements of Upper Palaeolithic technology.

Science-based dating techniques are now available to date the entire Palaeolithic.[55] Refinements in radiocarbon dating have extended the European

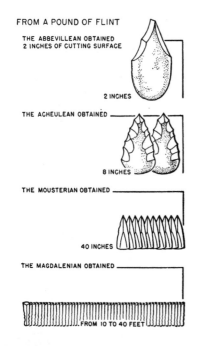

FROM A POUND OF FLINT

THE ABBEVILLEAN OBTAINED
2 INCHES OF CUTTING SURFACE

2 INCHES

THE ACHEULEAN OBTAINED

8 INCHES

THE MOUSTERIAN OBTAINED

40 INCHES

THE MAGDALENIAN OBTAINED

FROM 10 TO 40 FEET

25 The transition from Lower Palaeolithic (Abbevillean) hand axes, through Middle Palaeolithic (Mousterian) scrapers, to Upper Palaeolithic (Magdalenian) blades. This diagram presents a very progressive view of technology, indicating the increasing efficiency of Palaeolithic tool makers.

Stone Technology of the Lower and Middle Palaeolithic

The manufacture of stone artifacts starts with a lump of raw material. This might be a nodule of flint grubbed, for example, from a collapsed chalk cliff or picked up as a pebble from a riverbed. Flint is a particularly good raw material since it flakes in a predictable manner and has a very sharp natural cutting edge due to its fine grained structure. As a result it is common to talk of conchoidal, or shell-like, fracture patterns which produce distinctive flake forms.[48]

There are two starting conditions: the quality of the raw material and its size. Beyond this the requirements and techniques of the knapper take over. Knapping experiments have produced a number of insights into the process whereby a stone nodule is reduced either to a core tool or a set of flakes for further modification.[49] The experiments have shown that the reduction sequence involves three major steps. First, the shape of the core or tool is defined through the removal of a series of roughing-out flakes. This is usually best achieved by using a hard hammer to detach the flakes, many of which will carry cortex, the outer skin of the nodule, on their surface. A small pebble makes an ideal hard hammer. Then follows a succession of shaping flakes which perfect the form of a core tool or, in the case of flake production, the core from which they will be struck. These flakes are much thinner, and frequently a soft hammer of antler or possibly wood will be used for this second stage. The soft hammer provides greater control, evident from the slender, more delicate flakes which are produced. The third stage consists either of finishing the artifact with a series of sharpening flakes or of resharpening the tool. It also involves preparing the striking platform on a core for the removal of flakes. The blows are very controlled and these finishing flakes are often very small indeed. The soft hammer is almost obligatory for the final stage.

The most distinctive core tool of the Lower Palaeolithic is the hand axe. Hand axes vary enormously in size, weight, shape and degree of finishing. They may be pointed, ovate or triangular, while others have been described as bottle, ficron, lanceolate and almond-shaped.[50] Hand axes are often, but not invariably, bifacially worked. With such careful working on both faces a clear profile is produced, and this is often regarded as the working edge of the implement. The earliest hand axes appeared 1.5 million years ago in Africa and are part of the Acheulean stone industry, named after the town in France where they were first recognized in the last century. The Acheulean is widespread throughout the Old World following the first dispersal of hominids out of Africa about 1 million years ago. The Middle Palaeolithic generally lacks such large bifaces although smaller, more knife-like hand axes are common in the period after 200,000 years ago.

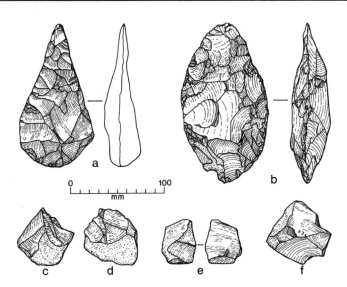

26 A Lower Palaeolithic tool kit. Two Acheulean hand axes: a pointed axe from Swanscombe, b ovate from Boxgrove. Pebble tools and flakes: c,d pebble choppers or cores; e flake; f chopper or core.

Other Lower Palaeolithic core tools consist of cleavers with a transverse cutting edge, and pebble tools. The latter were formed by a few simple blows which produced an irregular cutting edge. Such a tool probably took only a few seconds to make, while one of the highly finished hand axes might have taken up to 10 or 15 minutes.

The flakes produced in these reduction sequences are of course perfectly serviceable. They may be irregular in shape and size, but they possess razor-sharp cutting edges. The inspection of these edges under low-power microscopes can reveal traces of edge damage resulting from use.[51] Higher magnification reveals distinctive polishes which experimental work is attempting to identify with working particular materials, among them wood, meat, plants and bone.[52]

Detaching flakes from a core can take several forms. When rotated during successive flake removals, a distinctive piece known as a disc core is often produced. Flakes of various sizes will have been produced during the process and these will generally be broad in relation to their total length. (The length is always measured from the point of impact which may be preserved on the edge of the flake as a platform, while on its underside a pronounced cone of percussion and radiating ripple scars can often be seen.) Disc cores are common in both the Lower and Middle Palaeolithic. An alternative means of flake production involves the Levallois technique (explained on p. 149). When used abundantly it is sometimes considered a hallmark of the Middle Palaeolithic, as in the Levalloiso-Mousterian industries of the Middle East[53] which we shall encounter in Chapter 7.

Absolute Dates for the Middle Palaeolithic

Radiocarbon provided the first breakthrough in dating human occupation in the recent Pleistocene up to 35,000 years ago. Potassium/argon (K/Ar) techniques did the same for the earliest Pleistocene and Pliocene in East Africa at sites such as Olduvai Gorge, between 1 and 2 million years old.[54] In the middle there stubbornly remained a long period of about 1 million years which proved difficult to date absolutely (aptly named by archaeologist Glynn Isaac the 'muddle in the middle'). New techniques are rapidly changing this situation, as the dates in Appendix 1 show.

Recent developments in **thermoluminescence (TL)** dating of burnt flint and loess sediments are very important. TL works as follows: rocks and sediments contain small amounts of natural radiation, which causes damage to crystalline substances such as flint by displacing electrons. When flint is heated in a fire or sediments are exposed to sunlight, the damaged electrons are 'neutralized' by the energy and the radioactive clock is set to zero. Then the process of accumulating radiation damage begins afresh. To obtain a date, the amount of radiation damage which has been absorbed since zeroing is measured by heating the sample in a laboratory to 500°C or more, to release the energy of the displaced electrons. As the name of the technique implies, the energy emitted is expressed as a glow curve.

A related technique to TL is **electron spin resonance (ESR)** dating which measures accumulated natural radiation damage in crystalline substances such as carbonates and tooth enamel. Microwave radiation causes displaced electrons to give off a signal which is proportional to the amount of radiation damage incurred. The method has been particularly important in dating fossil mammal tooth enamel associated with Middle Palaeolithic human fossils such as those from Kebara, Qafzeh and La Chapelle-aux-Saints.

Uranium-series dating of carbonates has proved extremely reliable for flowstone deposits in caves, and travertines deposited by springs at open sites. What is measured here is the radioactive decay following the uptake of uranium into the carbonate as it forms. The amounts can be measured and an age derived by using the known decay rates for uranium and thorium isotopes. Since Palaeolithic materials are often found in caves and are even, on occasion, actually encased by travertine or stalagmitic concretions, this technique has proved extremely useful in areas such as Europe where volcanic materials for K/Ar dating are limited.

Uranium-series dates are increasingly cross-checked by ESR techniques applied to teeth and bone material.

Dating technique	Range of technique (years ago)	
	upper limit	lower limit
TL (burnt flint)	?2,000	100,000–500,000
TL (unburnt sediments)	5,000–10,000	50,000
ESR	Present	More than 1 million
U-series (for thorium-230)	5,000	350,000
¹⁴C (Radiocarbon) using Accelerator Mass Spectrometry (AMS)	Present	50,000, possibly 70,000 in the future
¹⁴C (Radiocarbon) conventional methods	Present	40,000

27 *The chronological range of various dating techniques.*

A good example of the uses of such dating techniques comes from Pontnewydd cave in North Wales where recent excavations by Stephen Aldhouse-Green have unravelled the complicated history of the site. The cave was covered by the last two ice sheets, the first of which – about 160,000 years ago – had sludged deposits into the cave from its entrance outside. Once this debris flow was inside, however, it was safe from further erosion by the last ice sheet 18,000 years ago. As a result the fragmentary hominid remains and hard rock tools contained in the cave were preserved. Dating these finds has proved possible from the stalagmitic flowstone adhering to the walls of the cave, and from lumps found in the sediments. That these stalagmites were formed under warmer, moist conditions is confirmed by thorium/uranium dates of about 200,000 years ago. This places Pontnewydd firmly in the interglacial stage 7, and perhaps more precisely in the warmer phase 7a that reached its peak about 215,000 years ago.

Pontnewydd also produced burnt flint for TL dating. Joan Huxtable has produced consistent figures of 200,000 years ago for these samples. The different materials and methods of dating are therefore in excellent agreement. We discuss Pontnewydd further in Chapter 7.

Upper Palaeolithic back to more than 40,000 years ago.[56] Uranium-series dates on carbonates, ESR dates on mammal teeth and thermoluminescence dating of sediments and burnt flint (see box pp. 58–59) have confirmed the antiquity of the Middle Palaeolithic and pushed the age of Mousterian industries back to more than 200,000 years ago. Indeed, the division between the Lower and Middle Palaeolithic has become harder rather than easier to define with the advent of absolute dates and we shall discuss why in Chapter 7.[57] The Lower to Middle Palaeolithic transition probably occurred between 250,000 and 200,000 years ago. Beyond this the Lower Palaeolithic, as traditionally defined, stretches back to the first colonization of the European continent which had taken place by at least 700,000 years ago and possibly much earlier.[58]

We have compiled a short list of dates for the Middle and Lower Palaeolithic (Appendix 1). While these dates are still too few – and in some cases too uncertain – to permit elaborate interpretation, we can nonetheless now derive a world-wide chronology for the Ancients that was not possible even 20 years ago. The few absolute dates for Europe currently point to occupation by the Ancients in the open phases 2 and 3 of the repeated climatic cycles (see tables pp. 45 and 47). No doubt as our chronologies and techniques are refined, we will see that human populations ebbed and flowed in northern Europe and other areas close to the ice sheets as conditions approached those of phase 4 in the last cycle. Using data on the animal communities which inhabited the Neanderthal world, we would suggest that such fluctuations in human settlement were more frequent in those central and northern areas where we have already drawn attention to competition from other carnivores as a result of harsher conditions.

Neanderthal distribution

The 'centres' of the Neanderthal world, as defined by continuity in settlement and fossil material, are very much at the edge of the distribution of the skeletal evidence: the Middle East and western Europe. As the story from the fossil evidence unfolds in the next three chapters we will see a very different prehistory in these two areas. In the west the classic Neanderthals emerge. In the east there is a long period when Neanderthals coexisted or overlapped with anatomically modern-looking populations, both making similar Middle Palaeolithic stone tools. Finally, despite the rarity of long archaeological sequences, the central region in the Neanderthal world has yielded evidence of many interesting changes (Chapter 9) in their life-style.

This chapter has shown us, however, that we are not going to find easy environmental answers to our question of how or why the Ancients were different from the Moderns, or even if the former were ancestral to the latter. The way to understand these fossil populations is to place them in the sweep of human evolution starting about 1 million years ago with the first dispersal out of Africa and ending with the appearance of the Moderns. It is now time to look at these Ancients in more detail as an example of evolution in action.

CHAPTER 3

Neanderthal Beginnings

There is nothing obvious in the prehistoric record. There are no simple answers, just a cornucopia of discoveries, observations, ideas and theories. These are the resources with which to investigate our long-term ancestry.

The problem has always been knowing where to begin. At what point do we break into the cycle of research into human origins? We will start with the fossil evidence because our focus is on a particular population of Ancients, the Neanderthals. When we have looked at the current data and ideas concerning their European origin and their even earlier African ancestry we will turn to the issues of how evolution works, as a prelude to the debate in later chapters between explanations for regional continuity and population replacement (box pp. 35–36).

African genesis

Fieldwork has shown us that the earliest humans were restricted to only one continent, Africa. Notwithstanding occasional claims for areas such as China, Java and, most recently, Georgia,[1] the earliest members of our genus *Homo* – dated to between 1.5 and 2 million years ago – seem to have lived in southern and eastern Africa. The species *Homo habilis*, 'handy man', was identified on the basis of fossils found between 1959 and 1961 by Mary and Louis Leakey in Beds I and II at Olduvai Gorge (Tanzania).[2] The concept of this earliest human species was that it represented the first toolmaker, and consequently possessed a larger brain than the more primitive and contemporaneous australopithecines. (These australopithecines lived between *c.* 5 and 1.3 million years ago in parts of south and east Africa. In a number of respects they were intermediate between apes and humans, and they combined ape-sized brains with an upright bipedal stance. They are not regarded as fully human by most experts because of features such as their small brains, large teeth, big projecting faces, flat noses, ape-like body proportions and apparent lack of human behaviour.)

The original Olduvai *habilis* fossils date between 1.5 and 1.8 million years ago, but the geographical and chronological range of the species was soon extended by other finds from Olduvai, Omo (Ethiopia), Koobi Fora (East Turkana, Kenya) and Sterkfontein (South Africa), which was also an australopithecine cave fissure site.[3] However, as the range and extent of the fossil samples increased in space and time, so too did the degree of variation. Thus while the concept of a very primitive species of human with a relatively small brain and big teeth gained general acceptance, the feeling also grew that the pattern of human evolution was even more complicated than it had originally appeared.

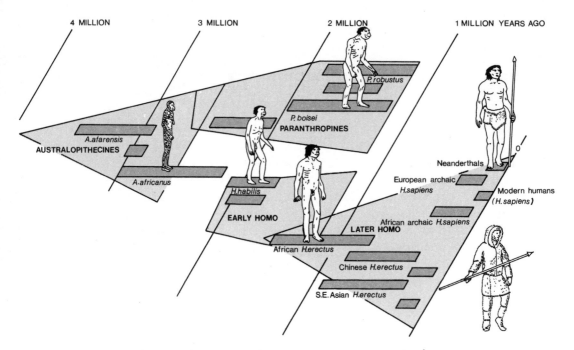

28 Diagram illustrating one of many possible interpretations of human evolution over the last four million years. According to this view, the human family tree consists of four adaptive radiations: the australopithecines, paranthropines, early Homo *and later* Homo. *The use of the term 'archaic* Homo sapiens' *is currently in some doubt.*

How many early humans are there?

Many researchers now feel that there is not just one kind of *Homo habilis*. Instead there seems to have been a large- and a small-bodied species, the large one represented by fossils such as the skull known as ER-1470 (East Rudolf, now East Turkana, specimen number 1470), and the small one by fossils such as the ER-1813 skull.[4] Both types can be clearly distinguished from both the australopithecenes and from the subsequent species of *Homo erectus*. However, it is not at all clear which one should be regarded as the 'real' *Homo habilis* and which one needs a new species name. Several names have been suggested, among them *Homo ergaster* or 'work man', and *Homo rudolfensis*. It is also unclear from where these early humans first evolved, and which of the species, if either, was the ancestor of *Homo erectus*.

While some of these early humans had brains no larger than australopithecines, the skull shape as a whole was somewhat longer, with signs in some specimens of a stronger brow ridge and a more angular back to the skull. These features clearly foreshadow the skull form of *Homo erectus*. In addition the face, while still large and transversely flat, was tucked under the skull to a greater extent, and some fossils show a more projecting nasal region – a proper nose – as in later humans.

There is some dispute about what the rest of the body was like in the earliest humans. There are leg bones and a hip bone from Koobi Fora which are large

enough to have come from a *Homo erectus* skeleton, but which are more likely to derive from the same large-bodied *habilis* population as ER-1470. Of about the same antiquity, 1.8 million years, is a tiny skeleton from Olduvai – Olduvai Hominid (OH) 62 – which resembles that of the well-known australopithecine 'Lucy', found in Ethiopia, which is over one million years older. The resemblance is not only in the small estimated stature of OH 62, barely over 1 m, but in the non-human limb proportions. Like Lucy, OH 62 has long arms and short legs, but has been assigned to *Homo habilis* on the basis of its jaws and teeth.[5]

So, both above and below the neck, there is now ample evidence that more than one species of early human must have existed in East Africa between 2 and 1.5 million years ago, and also that they lived alongside surviving robust australopithecines of the species *Paranthropus boisei*. Known as the 'near man of Boise', after a benefactor of the Leakeys, the best-known example was discovered at Olduvai by Mary Leakey in 1959. Moreover, there was a *habilis*-like species in South Africa, which may be related to the East African forms. And here too there is evidence of coexistence with robust australopithecines, this time of the species *Paranthropus robustus*.

Enter *Homo erectus*

But as *Homo habilis*, in its various specific guises, faded from the scene by 1.5 million years ago in East Africa, a new kind of hominid was already present, one whose membership of the genus *Homo* is not subject to any of the doubts which still pervade the earlier fossil material. This new kind of hominid was either the earliest form of the species *Homo erectus*, or a more primitive ancestral form which requires a new species name. Some workers, such as Bernard Wood, prefer to call this hominid *Homo ergaster*.[6] But to keep this account as simple as possible, we will refer to this particular early East Africa material as 'early' *Homo erectus*, as long as the reader bears in mind that the important issue of classification is by no means resolved.

The early Kenyan *Homo erectus* is represented by a nearly complete skull (ER-3733), a braincase (ER-3883), jaws and jaw fragments (e.g. ER-992, for which the species name *H. ergaster* was given[7]), and several bones from the rest of the skeleton. Some of this material may be as old as 1.8 million years, thus overlapping with *Homo habilis* specimens as well as *Paranthropus*.

By far the most spectacular find has come from the west side of Lake Turkana in Kenya. This was a chance discovery in 1985 by a member of Richard Leakey's field team, following the recognition of a small fragment of skull as human. Careful searching and sieving, followed by a controlled excavation, eventually revealed the most complete skeleton of an ancient hominid over 1 million years old yet discovered. The skeleton, dated at 1.6 million years, belonged to a boy of about 11 years old, who was already *c.* 1.62 m (5 ft 4 in) tall. The find dispelled the notion that all *Homo erectus* individuals were short and stocky, since this West Turkana boy (WT-15000) was certainly

very muscular but also long-limbed, possessing similar body proportions to people living in East Africa today.[8] Still younger in date are finds from Olduvai Gorge, such as the braincase known as OH 9 which is about 1.2 million years old.[9]

Out of Africa 1 and regional developments

Homo erectus continued to evolve in Africa during the middle Pleistocene, giving rise to later forms represented by fossils such as Bodo and Broken Hill (see Chapter 6). However, *Homo erectus* is believed to have been the first hominid species to have spread from the original African homeland to the continent of Asia, and perhaps also Europe. The conventional wisdom is that this occurred around 1 million years ago. But in 1989 a human jaw was discovered from the site of Dmanisi in Georgia which could be as old as 1.6 million years.[10] If this date is confirmed by further study, it would imply that *Homo erectus* had dispersed much earlier, and might even call into question whether *erectus* had actually originated in Africa. The Dmanisi find is particularly interesting in the light of recent claims for artifacts as old as 2 million years in Pakistan.[11]

As we shall see, for some palaeoanthropologists – particularly those favouring regional continuity – this dispersal is the beginning of the process which culminated in the modern human races. By the time *Homo erectus* was established in the Far East, after 1 million years ago, the skull form had become significantly more robust than the early African examples. These more 'typical' Asian *erectus* populations had long and flattened skulls with heavy brow ridges, thick skull walls, and strong buttresses around the braincase (especially along the top, a sagittal ridge) and, across the back, an occipital ridge or torus.[12] A comparison of the early *Homo erectus* African skulls with late Asian *erectus* specimens from China and Java, over 1 million years younger, shows a 25 per cent increase in average brain size, as measured from the inside volume of the braincase (1150 ml compared with 850 ml). Whether the increase is entirely related to an increasing intelligence rather than some other factor, for example an increase in body size, is still uncertain. A larger body size could be due to changes in life-style, or adaptation to cooler environments with a corresponding increase in body weight. Certainly the little material we have from *erectus* skeletons throughout the Old World after the West Turkana boy suggests that these were very robustly built people with large joint surfaces and thick-walled limb bones. These fragmentary data lend some support to climatic adaptation as a possible explanation for a number of these changes.

By 730,000 years ago, at the beginning of the middle Pleistocene (Chapter 2) – and perhaps earlier still according to the Dmanisi fossil and controversial archaeological evidence elsewhere[13] – *Homo erectus* had colonized the Middle East and southern Europe. But the earliest archaeological sites in the Mediterranean regions of Europe have yielded no fossil material. The evidence is almost exclusively stone tools (see box pp. 56–57). We have to wait some 200,000

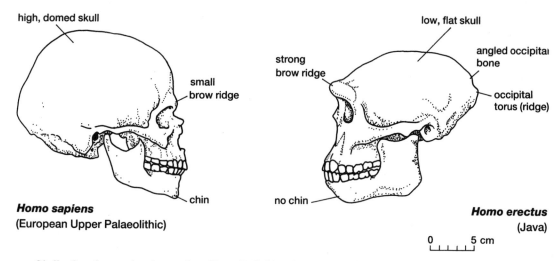

high, domed skull

small
brow ridge

chin

Homo sapiens
(European Upper Palaeolithic)

low, flat skull

strong
brow ridge

angled occipital
bone

occipital
torus (ridge)

no chin

Homo erectus
(Java)

0 5 cm

29 *Skulls of a robust modern human from Kostenki (left) and a reconstruction of* Homo erectus *from Java, illustrating important differences between the two species: the earlier specimen features a more prominent supraorbital torus, a lower more receding forehead, a highly angled occipital bone, a greater facial projection, and lack of a chin.*

years before our first view of the earliest Europeans, and even then the material comes only from the northern regions of the continent. There is no secure evidence that they reached more northerly areas such as Germany or peripheral areas such as Britain until 500,000 years ago, at the earliest. By this time there is some evidence that *Homo erectus* had evolved into a new species in the west while maintaining the more typical *erectus* morphology in the Far East, as at Zhoukoudian – the 'Peking Man' site – occupied episodically over the period from more than 500,000 to 250,000 years ago, and at Ngandong (where the Javanese 'Solo Man' was found), settled perhaps as late as 100,000 years ago.

The western forms were developing subtly different braincase shapes; several specimens possess a fully modern-sized brain and a less robust skull architecture. These changes are thought by many scholars to signal the first appearance of our own species, *Homo sapiens*, in an early form called 'archaic' *Homo sapiens*. Others prefer to designate a species distinct from both *erectus* and *sapiens*; they have called it *Homo heidelbergensis* after the Mauer lower jaw, believed to be about 500,000 years old, found in a sand pit near Heidelberg in 1907.[14] Some of these changes in European skull morphology can be seen as foreshadowing that of the Neanderthals, whose origins we will now discuss.

The origins of the Neanderthals

Most palaeoanthropologists accept that the Neanderthals evolved from European middle Pleistocene ancestors who were either a late form of *Homo erectus* or a descendant of that species.[15] This would be either *Homo heidelbergensis* or 'archaic' *Homo sapiens*. The development of many of the features that later characterize the Neanderthal face, skull bones and mandible

(Chapter 4) had certainly occurred by the end of the middle Pleistocene. The fossils from Biache-St-Vaast and the Abri Bourgeois-Delaunay (part of the La Chaise complex of caves in southern France) date from that period, more than 125,000 years ago (table p. 47).

Even more ancient, according to recent dating by uranium series and electron spin resonance, are the skull, jaw and other skeletal parts of several individuals – including at least one child – from the site of Ehringsdorf near Weimar in Germany.[16] A rich flora and fauna thrived in and around the warm springs of this region, and the well-preserved remains of plants, leaves, snails and large mammals have been recovered from the thick travertine (carbonate) deposits laid down by the springs, along with those of 'early' Neanderthals and their tools. Occupied about 230,000 years ago, it was presumably a prime site for game and plant foods even in the winters of a temperate stage (Chapter 2). If the Neanderthals did split from the lineage leading to modern humans, then the Ehringsdorf date of 230,000 years ago also gives a minimum age for the beginning of the separate lineage of modern people.

Although the fragmentary Pontnewydd specimens from Wales (see box pp. 58–59) are arguably even more securely dated at about the same age, 225,000 years ago, as the Ehringsdorf fossils, they can only really be linked to the later Neanderthals by the common trait of molar taurodontism, a condition of unseparated tooth roots and expanded pulp cavities (Chapter 4).

However, it is considered probable by several research workers that the origins of the Neanderthals lie even further back in the middle Pleistocene, amongst the populations represented by fossils found at Swanscombe (England), Steinheim (Germany), Arago and Montmaurin (France), Atapuerca (Spain) and Petralona (Greece). The status of the Swanscombe skull fragments has changed considerably from the time when the find was allied with the hypothetical ancient presapiens lineage leading exclusively to modern people (Chapter 1). These three parts of the back of a (probably female) skull, were found on separate occasions in 1935, 1936 and 1955, in a gravel pit in north Kent. Yet they fit together nearly perfectly (pl. 22). Thousands of flint hand axes have been found in the same levels (Chapter 7). The features of the cranial base and occipital torus are reminiscent of those of the Neanderthals, while the parietal bones are rather short and flat. Particularly important, there is a central depression in the occipital bone (the suprainiac fossa) which is present in Neanderthals generally.

The Steinheim skull, found in a gravel pit near Stuttgart in 1933, is a more problematic specimen, with a much smaller brain size than Swanscombe (estimated at 1100 ml, compared with Swanscombe's 1325 ml). The skull is rounder and thinner, but the forehead – not preserved in Swanscombe – is low and narrow, with a strong brow ridge (pls. 23, 24). The upper jaw is flat with a rather modern-looking and hollowed cheek region, but this might be partly due to the crushing and twisting which the skull underwent during fossilization. The back of the skull seems to show a suprainiac fossa, like Swanscombe. Is Steinheim thus a very primitive Neanderthal, its differences from other

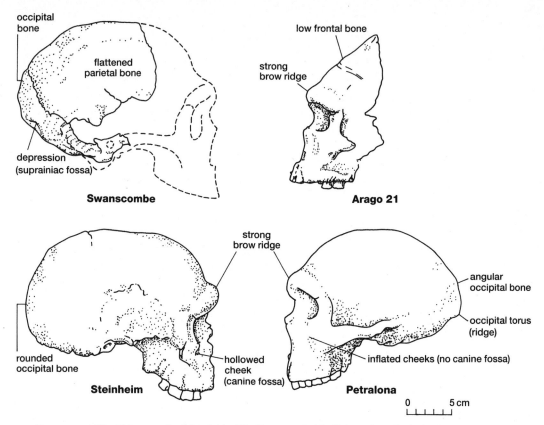

occipital
bone

flattened
parietal bone

depression
(suprainiac fossa)

Swanscombe

low frontal bone

strong
brow ridge

Arago 21

strong
brow ridge

angular
occipital bone

occipital torus
(ridge)

rounded
occipital bone

hollowed
cheek
(canine fossa)

inflated cheeks (no canine fossa)

Steinheim

Petralona

0 5 cm

30 European middle Pleistocene fossil hominids. The Swanscombe 'skull' has a hypothetical reconstruction based on the Steinheim specimen.

Neanderthals accentuated by its small size and gracility (due to its female gender), as well as its antiquity? This is a difficult question to answer, and it partly depends on how we view the controversial Petralona cranium (see below).

The large sample of fossil hominids from the Caune de l'Arago, Tautavel, in southern France is probably more ancient than the specimens from Swanscombe, Steinheim and Pontnewydd, and is dated at about 400,000 years old.[17] There are about 60 specimens. Many of these consist of fragmentary dental and postcranial parts, but there is a nearly complete hip bone, two jaw bones and the front, face and right side of a skull (pl. 20). The hip bone is strongly built, and its robusticity is more like that of much earlier African *Homo erectus* fossils than that of the Neanderthals. The jaw bones show a considerable difference in size, probably reflecting differences in sex, with the larger one resembling *Homo erectus*, and the smaller one Neanderthals. The partial skull (Arago 21) is distorted, but has been reconstructed to display a considerable facial projection, perhaps somewhat exaggerated. However, there are certainly other 'primitive' features such as the very strong brow ridge, narrow frontal and low brain size (probably less than 1200 ml). In these and other features – the flat face, low broad nose and low orbits – the skull is like a larger version of Steinheim, but the cheek bones are not hollowed and in this sense are more Neanderthal-like. The right parietal bone is very like that of Swanscombe, but with an especially thick area at the back, called an angular torus, often found on

Homo erectus skulls. Some workers actually prefer to classify the Arago skull as *Homo erectus* on the basis of the projecting face, small brain size, strong brows and angular torus, but the shape of the braincase is also reminiscent of fossils like Swanscombe, Steinheim and Petralona, which may be related to the ancestors of the Neanderthals.

Other European sites which have produced comparable fossil remains from this period include Montmaurin (France) and Atapuerca (Spain). The latter site has yielded a large but fragmented sample of parts of skeletons of many different individuals, which probably date to over 200,000 years ago.[18] They were concentrated in a small chamber deep within a complex of caves, and it is still unclear whether they represent the oldest known evidence of deliberate disposal of the dead by early humans or a secondary deposit derived from a carnivore den or a natural catastrophe. Excavations are continuing at Atapuerca, with the very recent discovery of two well-preserved skulls. Current estimates put the minimum number of individuals represented at 23, and the total number of bones or fragments at over 700.

The most complete and informative of these middle Pleistocene fossils is the cranium from Petralona Cave in Greece.[19] Its exact age is still a matter of great controversy, and even its ownership has been the subject of long wrangles in the Greek courts. Although found in 1960, a year after the cave itself was discovered by local villagers, the significance of the skull was not realized internationally until over a decade later. Initially described as a Neanderthal, it was clear to Chris Stringer on first viewing in 1971 that in its unique combination of features it was unlike any Neanderthal skull he had ever seen. It reminded him strongly of the Broken Hill ('Rhodesian Man') skull with which he was familiar from his research at the Natural History Museum in London.

The Petralona skull is very large and robust, with a thick angular occipital bone, carrying a centrally strong transverse torus (pls. 27–29). These occipital features are characteristic of the species *Homo erectus*, yet the overall shape of the skull is unlike that of *erectus* since the braincase is expanded higher up on the parietal region, and there is no angular torus at the back corner of the parietals. While the brow ridge is consistently thick, as in *Homo erectus*, it has a double-arched shape above the orbits very like that of Neanderthals. The cheek bones are inflated rather than hollowed out and the nose is also rather Neanderthal-like in size, although the nasal bones are less projecting. However, the middle of the face and nose are not pulled forward as in the Neanderthals. Instead, they are somewhat flatter and the large, upper face is also relatively broad compared with the narrower shape of Neanderthal skulls. It does not jut forward from the braincase, as also is the case in Neanderthals and modern humans. The brain volume was about 1,220 ml, at the overlap of the largest *Homo erectus* and smallest Neanderthal specimens, and the cast of the inside of the braincase is less narrow and flattened at the front than that of *Homo erectus*.

The classification of the Petralona cranium is made difficult by its mosaic (mixed) morphology, but the combination of an *erectus*-like back to the skull and Neanderthal-like front suggests that Neanderthal characteristics were first

established in the facial region and brow ridge. However, the Steinheim skull appears to tell a different story, for there the back of the skull looks more Neanderthal-like than the front! It may be that the Steinheim face, which is now distorted after being crushed in the sediments where it lay, was originally more Neanderthal-like, or it may be that Neanderthal features did not evolve in an orderly fashion and ancestral populations existed with different combinations of features. It would help if we knew the relative ages of Petralona and Steinheim, but we cannot say with any certainty which is the older, although we suspect it is Petralona. It has even been suggested that the two could be approximate contemporaries and represent a male and a female,[20] but the degree of difference in size, cranial thickness and occipital morphology between them seems to preclude this interpretation. When the many bones from Atapuerca have been assembled and studied, we will be in a much better position to answer such questions.

Neanderthals on the scene

Until recently, scientists believed that the fossil humans discovered in Ehringsdorf from 1908 onwards dated from the last interglacial stage, about 120,000 years ago. As we saw earlier, however, they are now thought to be almost twice as old, dating from the interglacial stage 7, some 100,000 years earlier. The human remains from this site show certain clear Neanderthal characteristics, especially at the back of the skull, as well as some more primitive features (such as thick skull bones, pl. 26). So, based on the new dates, we currently believe that 'early' Neanderthals had evolved in Europe by 230,000 years ago.[21]

More 'early' Neanderthals are known from the long cold period, stage 6, which occurred between 180,000 and 130,000 years ago (table p. 47), including the two Biache partial skulls (pl. 21).[22] These consist of the upper jaw and back of a probable female skull, and parts of the front of the skull and face of a probable male. Unfortunately, the two skulls have been studied by rival teams of French researchers, which does little to help our understanding of the material as a whole. Also from the same cold stage come the enigmatic Fontéchevade remains which were once a cornerstone of the 'presapiens' hypothesis, and remains from other French caves e.g. Lazaret and Abri Suard.

Material dating to the last interglacial proper – 130,000–115,000 years ago – from caves such as Bourgeois-Delaunay in France and the Saccopastore gravel pit in Italy, predominantly display anatomical features characteristic of the late Neanderthals, although even these remains are not unambiguously Neanderthal. Both the Saccopastore skulls, for instance, have a relatively small brain size like earlier hominids, and the face of Saccopastore 2 resembles a scaled-down version of the Petralona face. Some of the large body, in both senses of the words, of material from Krapina in Croatia may also date from this time.[23]

By 70,000 years ago, Europe was in the grip of the last Ice Age, and there is no clear evidence that the area was inhabited by any people other than

Neanderthals for the next 30,000 years or so. However, the situation in Africa was very different, as we shall see in Chapter 6. The period from 115,000 to 35,000 years ago is the time of the classic western Neanderthals. These are represented not only by remains from the French sites of La Chapelle-aux-Saints, La Ferrassie and now Saint-Césaire, but also by less certainly dated finds such as the early ones from Engis and Spy in Belgium, Gibraltar, and the original Neander Valley skeleton. Further east there is the material from the Amud and Kebara caves in Israel, and the Shanidar skeletons from the mountains of northern Iraq. The partial skeletons we referred to in Chapter 1 almost all come from this time range, and they form the basis for our detailed description in Chapter 4. The material available for investigating the origins of these much later Neanderthals is, as we have now seen, rather scattered or fragmentary. Prior to the Atapuerca discoveries, anthropologists William Howells and Erik Trinkaus conducted a census of some 19 'early' Neanderthal findspots and showed that the remains must have come from at least 75 individuals.[24] By comparison, fossils from the 52 sites where the later Neanderthals have been found could be added up to a minimum of 200 individuals. Some of these are represented by just a few teeth while others are fairly complete skeletons.

Some evolutionary models

Having presented the data on Neanderthal ancestry it is now time to look at them in terms of the models of human evolution. As we have indicated, the palaeontological record is often obscure, not so much from a lack of information but from conflicting ideas about how it should be organized and what explains its various patterns. These ideas are what make the subject both endlessly fascinating and frustrating for those who expect some sort of final answer.

There are two concepts at the heart of the evolutionary process which need to be examined. The first deals with how we recognize a species. Species are generally regarded as the basic units of both taxonomy (the naming and ordering of fossils) and evolutionary change. Although not an evolutionist, the eighteenth-century naturalist Carolus Linnaeus produced a system for naming species which is still in use today. He proposed that species should be identified by an individual name given to a representative specimen, the name to be written lower case (and normally italicized). This name would be joined to a genus name, written with an initial capital letter, which grouped together similar species. Linnaeus' binomial system operates in the case of our species as follows: we all belong to the species *sapiens* ('wise'), with the type being self evident to Linnaeus ('know thyself' was his comment). Linnaeus placed us with some other weird and wonderful species (all now invalid or non-existent) in the genus *Homo*. As we saw in Chapter 1, today *Homo sapiens* is usually grouped with only two other species in the genus *Homo*: *Homo habilis* and *Homo erectus*. There are further groupings of genera into families, ours being *Hominidae*, which also includes our closest fossil relatives, members of the

Pliocene genera *Australopithecus* and *Paranthropus*.

The methods used to name species raise implications for taxonomy, as well as what we consider significant in order to understand human evolution. We have already seen in this chapter the disputes that attend the interpretation of some fossils. This is usually due to disagreements over the extent of variation in a species, and how different fossils should be grouped to accurately reflect the underlying process of evolutionary change.[25]

The second issue concerns the mechanics of evolutionary change. According to current scientific thinking, speciation – the process by which new species are formed – is most commonly a product of the geographic isolation of an interbreeding group or population. Set out by Ernst Mayr, this geographical model of speciation is known as allopatry, and in the case of human evolution may draw on genetic, anatomical and archaeological evidence.[26] Isolation can be produced either by geographical barriers, such as mountain formation or a rise in sea levels, or by new behavioural or morphological obstacles to interbreeding within a previously continuous population. The multiregional and replacement models for speciation disagree over the extent of isolation present in widely dispersed early human populations.

Multiregional evolution emphasizes continuity in both time and space.[27] According to this model, isolation was never sufficient to allow allopatric speciation, since genes (the basic units of heredity) were circulated and exchanged between all the human populations of the Pleistocene. There could be no speciation because throughout the last 1 million years there was really only one species: *Homo sapiens*. This judgment implies that since the first dispersal of hominids out of Africa a million years or more ago, all the observable variation is within this one species. Multiregionalists argue that the mechanism of change was predominantly behavioural, with anatomy eventually evolving to accommodate progressive changes in behaviour that usually involved improvements in technology. These changes, like the genes, circulated around the inhabited world. The different regional lineages responded in similar ways to these universal forces, directing change globally towards modern-looking humans. Nevertheless, certain local differences were, at the same time, being maintained. Selection for specific features in particular environments kept them in local populations as they gradually became more modern, e.g. the large noses of Neanderthals were maintained throughout the transition to modern Europeans, probably in response to the European climate, and the strong cheek bones of Javanese *Homo erectus* were maintained in the transition to modern native Australians, perhaps due to behavioural or dietary factors. The mechanism of interregional gene flow is all-important in multiregional evolution, to continually introduce new characteristics which can be worked on by local selection, and to counterbalance the tendency to local specializations which would increase divergence between geographically remote populations.

The population replacement camp has not so far produced a comparable theoretical dogma to account for evolutionary change.[28] Certainly, it is argued,

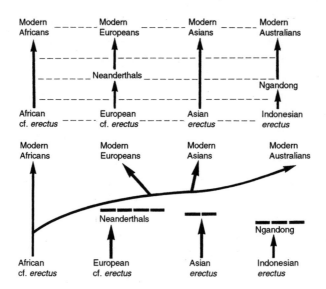

31 Two views of the origins of modern humans: the multiregional model (top) and the Out of Africa model. Each interprets the same fossil evidence in a radically different way. The dashed lines in the multiregional model represent gene flow between regions.

geographical isolation is implicated in the separation of Far Eastern *Homo erectus* populations from those in the west generally referred to as 'archaic *Homo sapiens*', and is further implicated in the succeeding north-south divergence which led to Neanderthals and Moderns respectively in Europe and Africa. Some Neanderthal features can be linked to adaptation to the cold, and others to continuing selection for physical strength. For the inferred African origin of modern *Homo sapiens*, we can guess that behavioural changes lay behind the reduction in skeletal robusticity which characterizes modern people, but precisely what they were (language? planning depth? technology?) remains uncertain.[28]

The mechanism behind the spread around the world of this modern morphology and any accompanying behavioural pattern would have been population growth rather than any deliberate pioneering spirit. Successful and more intensive use of resources would have demanded a continual quest for further resources and new territories, and the gradual extension of such boundaries was possible because of these same adaptive abilities, even where there were already resident populations of Ancients. Economic competition for the available resources would be the mechanism of replacement of one population by another where there was coexistence, perhaps coupled in some areas with a small degree of interbreeding (in which e.g. a few Neanderthal genes would have been taken into the much larger modern human gene pool).

Such processes would have taken place over many millennia, and probably occurred in fits and starts in the face of continuing climatic change throughout the late Pleistocene. Such climatic changes would sometimes have aided the process of expansion – by extending open country and eliminating geographical barriers such as water or ice – and sometimes hindered it, by re-establishing old barriers or creating new ones, e.g. deserts or thick forests. However, the cyclical nature of such environmental changes meant that the early Moderns were continually being offered new opportunities for dispersal and adaptation.

CHAPTER 4

Portrait of a Neanderthal

About 120,000 years ago we find a great change in the quality of the fossil record. After this time archaeologists have available a number of fairly complete skeletons, both of Neanderthals and Moderns. Maybe this is because the early humans in Europe and western Asia developed a new method of dealing with their dead around this time. Hitherto they may not have cared about their dead or, perhaps, as is possible in the case of Atapuerca in Spain, they merely abandoned the bodies in a cave. As we will see in Chapter 7, the question of whether the Neanderthals ritually buried their dead is an extremely complex one. Carnivores, for instance, may have played a decisive role in determining the presence or lack of reasonably complete skeletal remains. But whatever the explanation for the improvement in the skeletal record, we are now in the fortunate position of having a number of skeletons of Neanderthal men, women and children to study. There are more of these than we have yet found of any earlier people or of their contemporaries from elsewhere in the world, who either did not bury their dead or interred them in places much less suitable for the preservation of bones than the caves of Europe and southwest Asia. The sample of Neanderthal skeletons is still not large: about a dozen tolerably complete examples of skulls and limb bones found together. However, new discoveries are reported all the time, including in the last decade the most complete trunk and upper limb skeleton of a Neanderthal yet found, from Kebara Cave in Israel, and perhaps the youngest in terms of antiquity, from the Saint-Césaire rockshelter in France.

Putting the Neanderthal finds together, we can build up a picture of what these people looked like, what they were capable of doing with their bodies, how they developed physically, what diseases they suffered from and, in rare cases, what might have caused their deaths. Using data from modern people, we can estimate the height and weight of Neanderthals, reconstruct how their muscles worked, tell the size and shape of their brains (but not how well they functioned compared with our own), and make educated guesses about how well they might have spoken. It is even becoming possible to tell how quickly Neanderthal children grew up, and there has been speculation about the length of pregnancy in Neanderthal women – could it have been longer than in women today?

Starting with the head, we shall now make a tour of the Neanderthal body looking at the way palaeoanthropologists are trying to piece together the jigsaw-like evidence, sometimes from scraps of bone, to build a portrait of these remarkable people who lived from over 120,000 to 35,000 years ago.[1]

An Excursion Around the Sites of the Neanderthal World

Neanderthal sites generally fall into two categories: those, mainly caves and rockshelters, which have yielded actual Neanderthal remains – sometimes even complete skeletons; and those, largely open and rockshelter sites, which have produced evidence primarily of Neanderthal material culture (e.g. the Mousterian stone tools traditionally thought to be Neanderthal handiwork) and only few fossil finds.

Within the Neanderthal world, the two main areas in which skeletons and stone tools have frequently been found together are southwest France and the Middle East. The major sites in the west are the rockshelters of La Ferrassie, Le Moustier and La Quina. These have been dug over many years, and their stratigraphic sections are still important for unravelling the changes in Mousterian assemblages as discussed by François Bordes (Chapter 3). The surviving deposits at all three sites have been re-excavated in recent years to clarify climatic and chronological sequences, and at La Quina to recover information about the spatial use of the rockshelter.

In the Middle East, the caves of Mount Carmel outside Haifa have been excavated on several occasions, particularly Tabūn. And in Iraq, the deeply stratified and rich deposits of Shanidar Cave have proved immensely important for investigating Neanderthal anatomy. Current work at Kebara Cave and Amud, combined with the application of an absolute dating programme, has helped to clarify the relationship in this area between the earliest anatomically modern humans and the Neanderthals.

Sites with such rich archaeological deposits and fossil remains, however, are rare. Surrounding them are many open sites and

The Neanderthal head and brain

From the time of the original Neander Valley find in 1856, as we saw in Chapter 1, anatomists recognized that they were dealing with a large-brained creature, whose skull and brain shape differed from our own.

Brains and brows

The Neanderthal skull was long, but peculiarly flattened on top, a feature which we now know to have been common in early humans, and one which the Neanderthals inherited from their *Homo erectus* ancestors. Also inherited from them was the bar of bone above the eye sockets, but in the Neanderthals – as in the earlier Petralona skull – the eyebrow ridges were formed into two arches and were lightened internally by large air spaces called the frontal sinuses. Although Neanderthal brow ridges were strong even in some females (such as

rockshelters (known in France as *abris*) which have yielded just stone tools of Middle Palaeolithic form or much more fragmentary fossil material. One of the most important sites from a chronological viewpoint is Combe Grenal in southwest France. Others include the Grotte Vaufrey and La Chaise, where more complete fossil remains have been found.

In other parts of the Neanderthal world, artifact sites are rarely so prolific. In central Europe, sites in southern Germany such as the Bockstein and Klaussenische Caves have produced only small assemblages of stone tools. This is also the pattern in Hungary at the open-air site of Érd, near Budapest, and in sites from the north European, Russian and Ukrainian plains such as Salzgitter Lebenstedt and Molodova. The last site has seen large-scale excavations of multiple horizons and the recovery not only of substantial numbers of artifacts but also the remains of structures (Chapter 9).

Sites rich in artifacts can be found in northern Europe, but they are rare. On the island of Jersey, large collections of Middle Palaeolithic artifacts were excavated at the headland site of La Cotte de St Brelade. Here an impressive sequence starts 250,000 years ago and continues through to the last glaciation. The piles of mammoth and rhino bones found in two levels have been interpreted as separate hunting episodes in which small herds were stampeded over the cliff (Chapter 7).

There are many Mousterian sites in southern Europe: in the Iberian peninsula, France, Italy, Croatia and Greece. The Neanderthal remains at these sites are often highly fragmentary as at Devil's Tower (Gibraltar), Hortus (France), Guattari (Italy), Krapina and Vindija (Croatia).

the Tabūn woman) and were already developing in children of about eight (e.g. the Teshik Tash boy), they were nevertheless considerably reduced at the sides compared with those of *Homo erectus* or their European precursors. The exact function of the brow ridge is still a matter of dispute,[2] and one of the most popular explanations (absorbing stresses and strains from the action of the jaws and teeth) has not been supported by experiments using monkey skulls. Perhaps it provided a signal, even a threat, to others, or maybe it just acted to fill a vulnerable space above the eye sockets. Whatever the reason, the size of the brow ridge was less important to Neanderthals than to earlier humans. This is also reflected in the large size of their frontal sinuses. In *Homo erectus* the brow ridges mainly consisted of compact bone, but by the time of middle Pleistocene humans such as those represented by the Petralona and Broken Hill skulls, the brow ridge was mostly an empty structure, a trend which the Neanderthals continued.

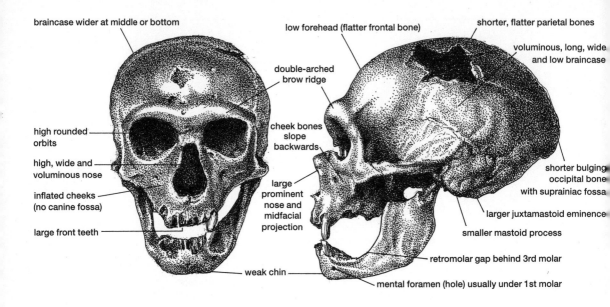

braincase wider at middle or bottom

low forehead (flatter frontal bone)

shorter, flatter parietal bones

voluminous, long, wide and low braincase

double-arched brow ridge

high rounded orbits

cheek bones slope backwards

high, wide and voluminous nose

shorter bulging occipital bone with suprainiac fossa

inflated cheeks (no canine fossa)

large prominent nose and midfacial projection

larger juxtamastoid eminence

large front teeth

smaller mastoid process

retromolar gap behind 3rd molar

weak chin

mental foramen (hole) usually under 1st molar

Large noses

Also important to the Neanderthals were their noses, which must have been remarkably prominent. In fact, in some cases the nasal bones jutted out nearly horizontally below the brows. Both the internal and external size of their nasal cavities was large. This has led to suggestions that they used their noses to warm and humidify the cold and dry air of their Ice Age environment. It has even been suggested that the Neanderthal nose was positioned far forward in order to distance the incoming cold contents of the nasal cavity as much as possible from the delicate and vulnerable brain tissues.[3] In comparison with earlier fossil skulls, those of the Neanderthals do indeed have relatively longer noses, although the wide breadth is consistent with that of possible ancestral forms such as the ones from Steinheim and Petralona. Compared with modern skulls, the Neanderthal combination of great nose length *and* breadth is unusual. Modern cold-adapted people, such as the Inuit of the Arctic, tend to have long but narrow nasal openings, while short, broad noses are mostly found in warm conditions. This suggests that the Neanderthal nasal form might reflect a unique combination of the effects of low temperatures and humidity on an archaically modelled skull. Finally, it has even been proposed that the Neanderthal nose was actually a means of *losing* heat generated by a very active life style,[4] but it is difficult to imagine that the Neanderthals were more active or liable to heat stress than earlier or contemporaneous tropical humans who did not have such large noses. (However, overheating and sweating, followed by freezing, would have been harmful in cold conditions.)

Neanderthal teeth and roots

The Neanderthals must have had special uses for their front teeth, for these are very large and often heavily worn compared with those of their probable

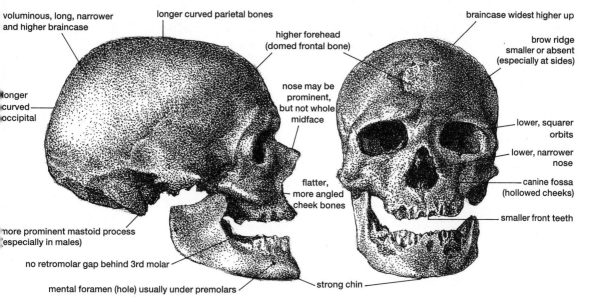

voluminous, long, narrower and higher braincase

longer curved parietal bones

braincase widest higher up

higher forehead (domed frontal bone)

brow ridge smaller or absent (especially at sides)

longer curved occipital

nose may be prominent, but not whole midface

lower, squarer orbits

lower, narrower nose

canine fossa (hollowed cheeks)

flatter, more angled cheek bones

smaller front teeth

more prominent mastoid process (especially in males)

no retromolar gap behind 3rd molar

strong chin

mental foramen (hole) usually under premolars

32 (Left) The Chapelle-aux-Saints skull, indicating Neanderthal features. (Above) The skull of anatomically modern Cro-Magnon 1, with the features characteristic of Homo sapiens *labelled.*

ancestors. The large size of their front teeth is particularly notable considering that the rest of their dentition was relatively reduced in size (although still larger than the modern average). It is thought these teeth may have been used as a vice to hold objects other than just food items. Evidence to support this idea has come from studies of the peculiarly heavy and rounded wear patterns and damage to the front teeth: they bear microscopic traces of material, presumably both animal and vegetable, pulled outwards across the clenched teeth. Such rounded wear has even been observed on a Neanderthal milk incisor from the French cave of La Quina, showing that such activities began early in life.[5]

Additional evidence of the importance of the front teeth in Neanderthals and their predecessors has come from other microscopic studies of the front surfaces of these teeth. In an early sample (Atapuerca) and several later Neanderthals from Europe, Iraq and Israel unidirectional scratches have been observed, which suggest that something held in the teeth was being cut with stone tools.[6] When these tools penetrated the material in question, they left a tell-tale scratch mark on the teeth which reveals the direction of cut, indicating that the tool was usually held in the right hand. Along with data on the brain shape of Neanderthals and the stronger development of their right arms, this implies that – like modern humans – most Neanderthals were right-handed. Furthermore, there is evidence that this behaviour started early, in both senses, since the characteristic scratches are present on a child's milk canine from the middle Pleistocene site of Atapuerca. It is possible to see the importance of the front teeth as a general feature of early human behaviour which was accentuated in the Neanderthals.

Like the front teeth of their ancestors and certain modern peoples (especially those from eastern Asia), the upper incisors of the Neanderthals were built up

non-taurodont tooth

taurodont tooth

33 Schematic cross section of a non-taurodont and a taurodont tooth illustrating the difference between the sizes of the two pulp cavities.

by ridges on the sides. This trait is known as 'shovelled' or shovel-shape, while the back teeth often had additional cusps.

One of the most unusual aspects of many Neanderthal back teeth is the presence of taurodont or 'bull-toothed' roots, as first recognized in the Neanderthal teeth from Jersey and Krapina in Croatia. The odd shape of these roots is produced by a delayed turning-in of the base of the roots during their growth, so that they are poorly- or unseparated from each other. The pulp cavity inside the tooth is also expanded into the large roots. This feature may be related to the heavy wear suffered by Neanderthal teeth, since a tooth with unseparated roots can continue to operate as an intact chewing surface even when worn through the crown. Taurodontism is found frequently in some modern populations such as the Inuit, and the unusual root growth responsible for the condition in Neanderthals also seems common in people with extra X (female) chromosomes.

Jaws and faces

Either side of the Neanderthal nose, the cheek bones were swept back, giving a streamlined appearance to the middle of the face, and the cheeks were inflated rather than hollowed. This morphology is unlike that of both *Homo erectus* and modern humans, but inflated cheeks are found in earlier European fossils such as Petralona. As the whole middle of the face was pulled out in relation to the sides, the upper jaw and teeth it contained were also pulled forward relative to the cheek bones and the back of the skull. Not surprisingly, the forward position of the teeth was reflected in the unusual shape of the lower jaw or mandible, with a space or retromolar gap behind the wisdom teeth before the bone of the mandible swept up towards the jaw joint (pl. 40).

All these features distinguish the Neanderthals from earlier and later peoples, as well as from their contemporaries in Africa and the Far East, and many palaeoanthropologists have viewed the characteristics as evolutionary specializations related either to cold adaptation or to the special role of the front teeth. However, some of those who favour the model of regional continuity regard the unusual shape of the Neanderthal face not as specialized, but as a logical intermediate stage between the big, projecting faces of earlier hominids, and the small faces of modern Europeans, which are tucked in under the braincase. According to this view, the musculature of the outer cheek region was reduced in the evolution of the Neanderthals, leading to a change in the orientation of the cheek bones relative to the still projecting front of the face; this resulted in the characteristic swept-back appearance of the Neanderthal cheeks. In time the front of the face itself became less projecting, perhaps due to the decreased importance of the front teeth, and this contributed to the appearance of the modern European facial shape.[7]

However, supporters of the multiregional continuity model for the Neanderthals have a problem to explain. The two-stage reduction they favour, which led to the modern European face *via* the Neanderthals, was unique to the Neanderthal area. Human evolution in other regions seems to have proceeded

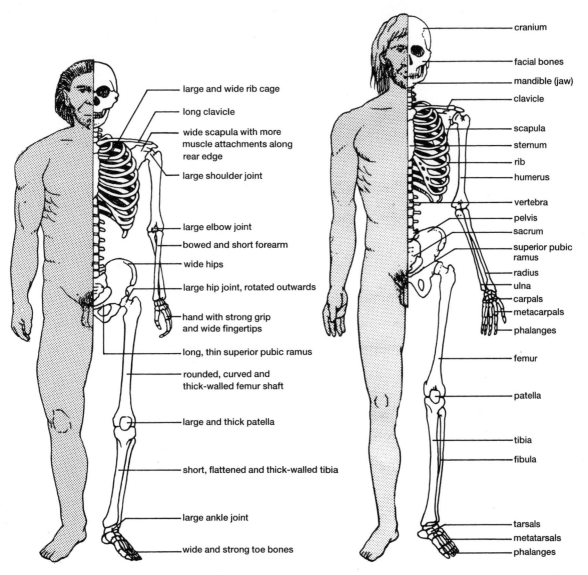

large and wide rib cage

long clavicle

wide scapula with more
muscle attachments along
rear edge

large shoulder joint

large elbow joint

bowed and short forearm

wide hips

large hip joint, rotated outwards

hand with strong grip
and wide fingertips

long, thin superior pubic ramus

rounded, curved and
thick-walled femur shaft

large and thick patella

short, flattened and thick-walled tibia

large ankle joint

wide and strong toe bones

cranium

facial bones

mandible (jaw)

clavicle

scapula

sternum

rib

humerus

vertebra

pelvis

sacrum

superior pubic
ramus

radius

ulna

carpals

metacarpals

phalanges

femur

patella

tibia

fibula

tarsals

metatarsals

phalanges

34 *Here the skeleton of a typical male Neanderthal (left) is contrasted with that of a modern male. The Neanderthal has a much more robust and stocky physique than his modern counterpart.*

directly from the robust faces of earlier humans to the modern face, through a single process of reducing the overall size of the face in concert with its gradual retraction under the braincase.[8] We therefore believe it is more probable that the latter process was responsible for the evolution of all modern human faces, and that this facial morphology then supplanted that of the Neanderthals in Europe.

Chins and shelves
We have already mentioned the forward position of Neanderthal teeth in the jaw and some of the characteristics of these teeth, but there are some other features of the Neanderthal mandible which should also be explained. One

Neanderthal Geography

The Neanderthals occupied many environments within middle and late Pleistocene Europe. We have seen in Chapter 2 the range of habitats and animal species they lived with and exploited, but reconstructing past population densities and other demographic patterns is more difficult. What we *can* see is that Neanderthals were not capable until after 60,000 years ago of colonizing the very seasonal environments of the Russian plains or indeed the high mountain areas. Their optimal habitats were in the western plains (where seasonal variation in temperature was moderated, as today, by oceanic climates) and on upland plateaux of modest elevation. In both environments – either on the northern plains of France, Belgium, England and Germany, or in the sheltered valleys which dissect the rolling uplands of southwest France, southern Germany and central Europe – sites were located to exploit the large, diverse herds of animals upon which the Neanderthals depended. The long sequences at sites such as Le Moustier or Combe Grenal in the Dordogne, rich in stone tools, point to the repeated use of such localities over many centuries and millennia.

If we take a north-south transect from England to Iberia, we can see that such rich assemblages in multi-level cave sites occur more frequently in the southern and Mediterranean regions of the continent. While this pattern is difficult to translate into numbers of people or density of population, what it does indicate is a long-term 'signature' of past settlement. We should not be surprised that the general trend is one of increasing population and greater continuity of settlement in the animal-rich southern latitudes of the continent;

concerns the hole or foramen which lies on the inside of the rear upright portion, the ascending ramus. This mandibular foramen carries a nerve which runs to the front of the jaw, but what is unusual is the bony lip which is formed across the foramen in two out of every three Neanderthal jaws examined. This lip is rare in modern human and ape jaws, as well as in earlier human fossils,[9] although it does seem to be present in about a quarter of Cro-Magnon jaws. The function of this bony lip seems to be related to the strong pull of the sphenomandibular ligament which runs from the ear region down to the vicinity of the mandibular foramen. In Neanderthals, and presumably in some Cro-Magnons as well, this ligament must have played an important role in holding the jaw steady during strong muscle actions.

One other feature of the Neanderthal jaw worth mentioning is the slight development of a chin in some Neanderthal specimens, particularly the later ones. The front of the jaw is a weak area in mammals, since this is where the two original halves of the jaw meet during growth, and eventually fuse together.

this trend is repeated in the Middle East according to data from Israel and the Negev Desert. We suspect from these patterns that Neanderthals in northern parts of the continent tended to abandon and re-occupy regions more frequently than their southern counterparts, as climate affected the abundance and predictability of animal resources; Neanderthal populations in this part of the world were therefore likely to ebb and flow. The data from open sites such as Érd in Hungary and Molodova on the Dnestr River in the Ukraine are more difficult to quantify and compare by means of such transects. But a glance at the distribution map of Mousterian sites (commonly associated with the Neanderthals) shows a reduction in population at sites in the southern and western parts of Europe, as continental climates start to present problems for survival.

What therefore emerges from this simple survey is that there were two demographic centres for the Neanderthals – western Europe and the Middle East – a conclusion supported by evidence both from Neanderthal remains and from the density of artifacts and the richness of cave and open site sequences. These centres are the loci of the key sites and classic sequences e.g. La Quina, Pech de l'Azé and Combe Grenal in the west, and Mount Carmel, Amud, Jabrud and Shubbabiq in the Middle East. Surrounding these areas, which we assume had near continuous occupation, was a hinterland of more intermittent occupation, where expansion took place at climatically favourable times but – when faced with a thinning of resources – populations became locally extinct rather than intensified to maintain a presence.

When the muscles at the base and sides of the skull work on the rear of the lower jaw, especially in skulls where the braincase is large as it is in Neanderthals and modern humans, the front of the jaw is put under constant pressure and needs to be reinforced. In apes, this reinforcement is achieved by the development of the 'simian shelf', a bony shelf across the front of the base of the jaw. In early hominids the strengthening is accomplished by the mandibular torus, an internal ridge of bone which runs across the back of the symphysis, while in modern humans and some Neanderthals the bony ridge forms on the outside of the lower jaw to form a chin.

Brain size

The shape of the Neanderthal braincase was directly related to the shape of the brain itself. Both were long, low and flattened in comparison with those of modern people, and more similar to those of *Homo erectus* and the middle Pleistocene ancestors of the Neanderthals. But in contrast to earlier and many

present-day humans, the Neanderthals were very large-brained, the breadth of the brain being especially developed.

We know this detail because, although we do not have a fossilized Neanderthal brain, we can make a cast in silicon rubber from the inside of a Neanderthal skull and recreate the general proportions of the brain it contained. While the largest *Homo erectus* brains were about 1,250 ml (2 imperial pints) and modern brains average about 1,200–1,500 ml in volume, female Neanderthal brains were about 1,300 ml and those of males about 1,600 ml, extending to 1,740 ml in the Amud man.[10] Curiously, a large brain size was also characteristic of the earliest modern people of Europe and Asia. The brains of both the Neanderthal 'Old Man' of La Chapelle-aux-Saints and the 'Old Man' of Cro-Magnon were over 1,600 ml in volume.

The significance of these large brains has long been disputed (Chapter 1). In the earlier years of this century it was believed that the Neanderthal brain was markedly inferior to a modern brain despite its great size, because it was larger at the back (the occipital lobes) – supposedly the location of the 'baser' functions – and smaller at the front (the frontal lobes), thought to be the seat of reasoned belief. But knowledge of brain functions was then even more rudimentary than it is today. Experts such as Sir Arthur Keith and Sir Grafton Elliot Smith believed they could recognize all manner of 'primitive' features in the Piltdown brain reconstruction, as well as in those of Neanderthals. Since we now know that the fraudulent Piltdown braincase actually came from a human skull which was only a few hundred years old, these so-called primitive features were largely in the eyes of the beholders. Furthermore, as both these great anatomists have at one time or another been implicated in the Piltdown forgery, we feel that to classify brains as primitive according to their external features is equally questionable scientifically.

As far as Neanderthal brains are concerned, the pendulum has swung to the other extreme, partly in reaction to previous errors of interpretation and partly in recognition of our present ignorance. Thus many palaeoanthropologists are now reluctant to judge the quality of Neanderthal brains at all, or are content to assume that there was little intellectual difference from modern humans. Opinions tend to fluctuate. Carleton Coon, for instance, dressed Boule's Neanderthal in a hat and coat to emphasize the similarities with modern people (fig. 11), but later described the Neanderthal brain as having 'a luxuriance of gorilloid features'.

The large size of the Neanderthal brain now tends to be seen as a correlate of their large body mass (the 'meat head' hypothesis[11]), and perhaps also of the cool environments in which many of them lived. Brain sizes in modern humans are related in a general way to both body size and the environmental temperature in which a population lives. These two factors are not independent of each other. Populations living in higher (cold) latitudes tend to be both larger brained and larger bodied, probably because in the past such physiques were selected for efficient heat conservation, than those living in lower (warmer) latitudes.

For all the recent swing of the pendulum, however, the incontrovertible differences in shape and proportion between Neanderthal and modern brains are certainly of unknown significance. We now know that people can survive adequately with extensive damage to some areas of the brain (brains deformed by disease or the cultural practice of head binding can assume very peculiar shapes, yet seemingly function normally), but very badly with only limited damage to certain key areas. It is evident that some parts of the brain are specialized for particular functions, such as those concerned with the senses, while other parts have an organizational role.

The areas which interlink and integrate the functions of the different parts of the brain are obviously key elements of intelligence in modern humans, but we know nothing – and probably will never know anything – in either quantitative or qualitative terms about such areas in the Neanderthal brain. So it is dangerous to assume that brains of different shape and proportions must necessarily be different in quality. This is not to say, however, that there were *no* quantitative or qualitative differences between Neanderthal and modern human brains, only that the evidence of endocranial casts is insufficient to judge, and we may be better off looking for evidence of brain capabilities in the archaeological record (Chapter 9).

An additional conclusion we can draw from endocranial casts is that Neanderthals and early modern humans – like people today – had cerebral dominance, i.e. the right and left halves of the brain were specialized for particular functions. In living people, there is a clear statistical relationship between having a larger occipital lobe on the left side, a larger frontal lobe on the right side, and right-handedness. Most Neanderthal and early modern human endocranial casts display a similar pattern, indicating the predominance of right-handers even in prehistoric times[12] – a conclusion reinforced, as we have seen, by their stronger right arms, by the cut marks on several Neanderthal front teeth, and by evidence from the resharpening of stone tools (Chapter 5).

Skull shape

Moving from the inside of the skull to the outside, the large size of the occipital lobes at the back of the Neanderthal brain is reflected in the common occurrence of a bulging occipital bone, often called an occipital chignon or bun, as in the Victorian hair-style. There were also some oddities in the neck musculature of Neanderthals which are shown by one or more pits (known as suprainiac fossa) in the middle of the occipital bone. In contrast, it is more usual in modern skulls to have a raised point of bone, the occipital protuberance, to mark the central limit of muscle attachments. Additionally, at the lower edges of the Neanderthal occipital bone – inside the ear region – there was usually a prominent crest known as the juxtamastoid eminence or the occipitomastoid crest.[13] This may reflect the great importance of muscles running to the lower jaw, which played a part in the special vice-like functions of the front teeth. The prominence of this crest was also accentuated by the fact that many

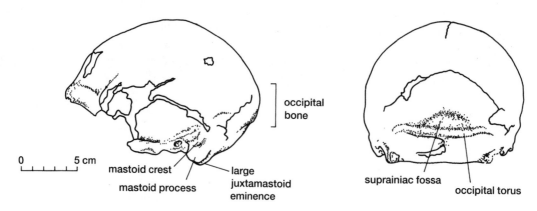

occipital bone

0 5 cm

mastoid crest

mastoid process

large juxtamastoid eminence

suprainiac fossa

occipital torus

35 The braincase of the Neanderthal skull from La Ferrassie, showing some of the key features that characterize the Neanderthals as a group.

Neanderthal skulls have relatively small points of bone, mastoid processes, in the ear region. In modern people it is usual for the mastoid processes to point down well below the level of the juxtamastoid eminence; this even occurs in females, where the mastoid processes are relatively small. But the juxtamastoid development of Neanderthals usually dwarfs that of the mastoid in both sexes.

Neanderthal growth

For a long time there has been speculation about the way Neanderthals developed during and after childhood, compared with modern people. Humans are different from the great apes in that we have much slower growth and development before maturity. For example, we take nearly twice as long to reach puberty. It has been assumed that this extended period of growth enables the developing child to absorb the complexities of its native culture through the medium of language, in order for the child to be adequately prepared for a human way of life.

Because we are different from all the apes in this important respect, it seems highly likely that the human growth pattern evolved after the last evolutionary split from the apes. This would have been some time within the last 5 million years. But was the extended human growth pattern developed soon after the evolutionary split from the African apes, or was it more gradual or late in its appearance? Whatever the answer, we might expect the Neanderthals to be quite similar to modern people in their developmental pattern, since they are clearly closely related to us, and are late on the evolutionary timescale. Moreover, the extended human growth pattern might also be necessary for the growth of a large brain, and this the Neanderthals certainly had. The only way that Neanderthals could be very different from us would be if the human growth pattern was in fact uniquely evolved by anatomically modern humans during the last 150,000 years. There are now techniques, some of them still

controversial, which allow us to estimate the age at death of prehistoric children. By comparing their maturity with those of modern children of the same age, we can begin to build up a picture of similarities and differences in development.

Hitherto, reconstructions of hominid growth patterns have been made using modern human comparative data; but such models are based on the assumption that hominids were like us in their basic biology. A new method of age estimation, however, based on the microscopic counting of incremental (i.e. periodically added) lines on the surface enamel of the front teeth, allows an age assessment which is *independent* of any preconceived model of growth.[14] These incremental lines or perikymata are the dental equivalents of tree rings, but they form at a rate of about one a week rather than one a year. Where a whole tooth crown is preserved unworn, it also preserves the record of its growth in its perikymata. And if a root has been formed, its growth too must be estimated and added to the crown development time. This means that for a tooth formed soon after birth, such as an incisor, it is possible to estimate the total development time. The death of a child, therefore, is indicated by the cessation of tooth development, and its age at death can thus be estimated.

The perikymata aging technique has already challenged the conventional view of growth in australopithecines (the early African hominids of 1.5–4 million years ago), which held that they were essentially human in their development. The technique distinguished the robust australopithecines from their more gracile counterparts, but neither show a modern human type of extended growth. Indications are that both the earliest known australopithecine, *A. afarensis*, and the later gracile form *A. africanus*, were very apelike in maturing dentally at nearly twice the rate of human children – thus the first known australopithecine fossil, the Taung child, would have been closer to three years of age at death than to the six years commonly estimated.[15]

Precocious children?
So far the technique has only been applied in detail to one Neanderthal fossil – that of the Devil's Tower child from Gibraltar which preserves an unerupted, but totally exposed, upper incisor, complete with a beautiful set of perikymata. The child's remains probably date from about 50,000 years ago and consist of parts of the skull, indicative of a very large brain size, and a lower jaw and part of the upper jaw, both containing teeth. Conventional aging techniques, based on the state of eruption and development of the teeth as well as the form of the skull bones compared with those of modern children, suggested an age at death of around five years.

One expert on Neanderthal children, Ann-Marie Tillier, re-examined the Devil's Tower bones and teeth, and surprisingly concluded that the remains of two different children were mixed up in the material.[16] Most of the bones and jaws did indeed belong to a five-year-old, as already generally believed. However, Tillier believed the temporal bone (which includes the ear region) to be less mature than the rest, belonging instead to a three-year-old.

Unfortunately, this conclusion could not be tested in the most straightforward way, by seeing if the bones would fit together as a single skull, because the different bones were not sufficiently complete. So Chris Stringer and his colleagues set out to test Tillier's hypothesis by applying the perikymata aging technique to the unerupted central incisor of the upper jaw (or, rather, an exact surface replica of it). The result clearly suggested an age at death of three to four years.[17] Since this is compatible with Tillier's estimate for the temporal bone, there is no longer any need to assume that more than one child is represented. The young age of the Devil's Tower child makes its brain size – estimated at about 1400 ml, close to the modern adult average – even more remarkable. The development of the child's molar teeth would also have been well-advanced for a three-year-old. This specimen thus suggests that Neanderthal children grew up quite fast.

This idea is supported by other data. For example, it has been observed that Neanderthal children had a greater robusticity and muscularity in their limb bones than their modern counterparts. This is noticeable even at an age before heavy exercise could have had any influence, indicating that it was originally inherited, even if later activity subsequently added to the effect. From the skull and dentition, some palaeoanthropologists had previously suggested that there was precocious dental development in Neanderthals, but it is only with the advent of independent age estimators that this idea can be properly tested. Further application of these methods to the study of Neanderthal children will teach us much more about their biology, but it is already evident that at any given age, they were likely to have been more robust, lower-skulled, larger-faced and as large or perhaps larger-brained than comparable modern children.

The hip and pelvis

Another unusual aspect of the Neanderthals concerns the front of the pelvis. Regardless of age or sex, the upper front part of the Neanderthal pelvis (known as the superior pubic ramus) shows an unusual structure. The superior pubic ramus is long, thin, and relatively flattened (pl. 41). Very unusually, therefore, this part of the Neanderthal skeleton actually seems more gracile or lightly built than that of modern humans. Several theories have been advanced to explain this feature, none of them entirely satisfactory. It was suggested, for example, that the unusual pubic length would have increased the volume of the birth canal by up to 20 per cent, allowing Neanderthal women to give birth to larger and more mature babies, which might have been advantageous for infant survival in a difficult environment. An increase in the size of babies could have resulted either from faster foetal growth over the same gestation length, or from normal growth over a longer period in the uterus, perhaps even as long as a year.[18]

Recent research on modern populations, however, has come up with another explanation. In modern populations such as the Arctic Inuit, where large heads are combined with small stature, it appears that in some ways they show a form approaching the Neanderthal pelvic condition. But these populations show no

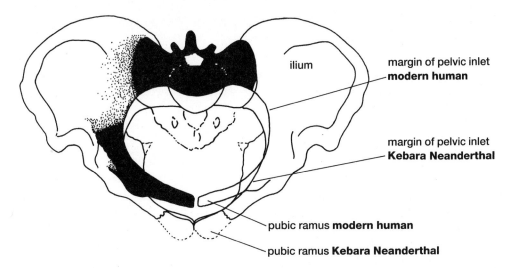

ilium

margin of pelvic inlet
modern human

margin of pelvic inlet
Kebara Neanderthal

pubic ramus **modern human**

pubic ramus **Kebara Neanderthal**

36 Superior view of the reconstructed Neanderthal pelvis from Kebara Cave in Israel. Like other Neanderthal examples, the pubic bone of the Kebara pelvis is relatively thinner and longer than it is in modern people. The most likely explanation for this pubic lengthening lies in differences between the locomotion of Neanderthals and modern people, rather than differences in gestation period or other developmental factors as some scholars have suggested.

noticeable difference in gestation length or foetal growth rates from other modern groups, which suggests that the trend towards having a longer pubic ramus in the Inuit and other similar peoples is because the mother is small and the baby's head relatively large. Perhaps the Neanderthals merely displayed an extreme version of this condition.[19] Their women were certainly relatively short in stature (see below) and their babies' heads were likely to have been large.

Unfortunately, this appealing idea is also unlikely to be the answer, because the most prominent cases of Neanderthal pubic ramus lengthening are found in big Neanderthal males such as the one from Kebara, which hardly supports the idea that it is something especially connected with female reproduction! The theory is further invalidated by the fact that young Neanderthals, well before puberty, show pubic bone lengthening[20]. The Kebara adult pelvis – the most complete Neanderthal pelvis yet found – also refutes such ideas since, although it is shaped differently from a modern one, it has no greater internal volume. The pubic bone differences serve primarily to widen the pelvis at the front, rotating the blades of the pelvis outwards along with the hip joint. This has little effect on the depth of the pelvis, front to back, which would be the important factor in altering the size of the birth canal.

If reproductive differences were not responsible for the peculiar pubic bone anatomy of the Neanderthals, what could have been? Yoel Rak, who produced the first detailed description of the Kebara pelvis, returns to the old idea – now generally out of favour – that Neanderthals walked differently from modern humans, and in this respect were retaining ancestral features of hip joint

function which modern humans have lost.[21] We shall discuss some other aspects of the pelvic anatomy later.

Care for the elderly

As well as speculation about the early stages of growth in Neanderthals, new data are also being gathered and interpreted about the other end of the life cycle: old age. There is continuing controversy about the applicability of methods used to estimate the age at death of elderly individuals in samples of skeletons from the recent past, so there are even greater problems in applying these procedures to fossils. Nevertheless, new or more sophisticated methods of aging older individuals by detailed studies of the surface of the pelvis and the microscopic examination of growth in the thigh bone (femur) have allowed the age at death of some of the older Neanderthal individuals to be estimated. One particular study has reassessed the age at death of important specimens from Iraq and France.[22] The surprising fact that has emerged from this work is that it is difficult to find a Neanderthal estimated at more than 40 years old at death; this includes the so-called 'old man' of La Chapelle-aux-Saints, in spite of his injuries, tooth loss and joint disease.

Of the entire Neanderthal sample, apparently fewer than 10 per cent were aged over 35. The comparable figure in recent non-industrialized groups, such as hunter-gatherers and tribal agriculturalists, is about 50 per cent. Thus few Neanderthals were likely to have reached beyond middle age in modern terms. Two important consequences of this would have been reduced information derived from long-term experience, and a greater number of 'orphan' children.

Significant survival beyond the reproductive age seems to be a special human characteristic not found in other great apes. Such longevity requires a particular sort of adaptation in which individuals change their roles as they get older and become more dependent on others (particularly younger relatives) for their food and survival. It is possible that such post-reproductive survival was a characteristic of Cro-Magnon societies but not of the Neanderthals. Such a crisp division between the Ancients and Moderns, however, is a little blurred by the fact that some recent research calls into question the techniques used to age the Neanderthals (they have underestimated the age of old individuals in certain modern cemeteries). Also, we have evidence that some Neanderthals *did* care for the older, infirm individuals, such as the crippled man from Shanidar (Shanidar 1; see below), who would have been unable to move far to find his own food.

Language

One of the most important features of modern humans is spoken language. From their sophisticated material culture, we usually assume the Cro-Magnons could also talk and communicate as modern people do. While we now know that apes can use symbols to build and arrange a large vocabulary, this is not the same thing as true language, which is a much richer, more complex and

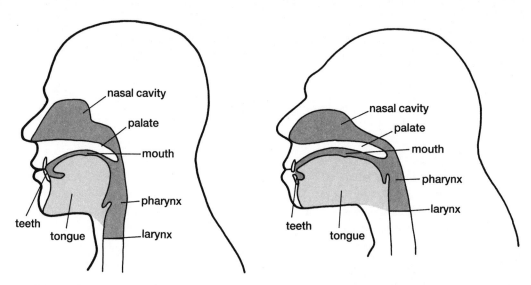

*37 Scientists have compared the vocal apparatus of modern adults (left) with that of the Neanderthals, to assess
the speaking ability of Neanderthals. Sounds are produced in the larynx, but to form words the tongue must vary
the size and shape of the mouth and pharynx. The Neanderthal pharynx is limited by the larynx, which sits higher
in the throat than in modern humans. Furthermore, since the tongue is long and rests almost entirely in the mouth
rather than in the throat, it can only alter the size of the mouth. This single-chamber acoustical system may have
restricted Neanderthals to a slow and limited form of speech.*

more structured means of communication than any animal possesses. The
discussion about the growth of Neanderthal children is important to the
question of whether they had a true language of modern type or not.

Language acquisition in modern children proceeds while the child is
learning fundamental facts about its environment and the society in which it
has been born. While the brain grows and important internal connections
between different areas are established, language is learnt, so that by the age of
six or seven – as the brain reaches its adult size – the child has acquired most of
the linguistic skills it will need thereafter. As many of us know to our cost, it is
never as easy to learn a language after this time. But if Neanderthal children
grew up more quickly, they might have had less time to learn the fundamentals
of a language and a complex way of life before their brain organization was
largely finalized. Or looked at from the opposite perspective, perhaps their
simpler way of life did not require such learning.

The possibility that the Neanderthals had a simpler system of communica-
tion than succeeding peoples is suggested by the anatomy of the base of their
skulls, which can be used to judge the type of vocal apparatus they possessed.[23]
In modern humans, the skull of a newborn child has a flat base, and the voice
box or larynx is positioned high up in the throat, near to the skull base. This
means that babies (like most other mammals) can eat or suckle, and breathe at
the same time without choking. However, as the child grows, and particularly
as language use develops, the larynx gradually descends to its adult position,
enabling the individual to produce a very wide range of sounds. Now the child

can no longer eat and breathe simultaneously; the danger of choking is the price we pay for possessing a human vocal tract and a long tongue. The descent of the larynx can be tracked by an accompanying change from a flat to an angled skull base. The interesting thing about the shape of the skull base in some adult Neanderthals is that it more closely resembles the infant condition in modern humans than that of adults, which suggests that some Neanderthals did not possess a vocal tract of modern type. In other words the apparatus for a modern range of sounds had yet to evolve.

The vocal potential of the Neanderthals is perhaps demonstrated in a more positive light by the first fossil hyoid bone of a Neanderthal ever found, part of the Kebara skeleton. The hyoid bone lies in the throat and is intimately linked with the structure of the vocal tract. The Kebara hyoid bone is rather small considering the very robust individual of which it was part, and is virtually indistinguishable from a modern one.[24] But the conclusions that can be drawn from this about the level of Neanderthal vocal abilities are hotly disputed. Some experts believe, for instance, that the similarities between the Kebara and modern hyoids must indicate that the Neanderthals had similar vocal skills to modern humans.[25] Others point out that even pigs have similar hyoids to us, and that the hyoid can therefore tell us nothing about language abilities.[26]

When Ed Crelin and Philip Lieberman began their pioneering work of reconstructing the vocal tract of a Neanderthal some 20 years ago, they suggested that the Neanderthals probably lacked proper language.[27] More recently, these conclusions have been modified to argue for a restricted vocal repertoire in Neanderthals rather than a fundamental lack of spoken language.[28] What they lacked phonetically they may have partially made up for with a gesture-based system of communication. It certainly seems difficult to believe that Neanderthals lacked language if they showed such complex behaviour as the intentional disposal of their dead (although, as we discuss in Chapter 7, it is debatable to what extent Neanderthal burials are indeed evidence of complex behaviour). Moreover, when considering the work done in reconstructing vocal tracts in early humans, it should be remembered that some pre-Neanderthal fossils show a cranial base of fundamentally modern type, and this includes fossils such as the Steinheim and Petralona skulls which, as we have seen (Chapter 3), may represent the ancestors of the Neanderthals. It seems very unlikely that the ability to produce a human type of language was present in the European precursors of the Neanderthals, with their smaller brains and less sophisticated behaviour, and yet was lost by their more advanced descendants.

So, given what we know about the Neanderthal brain and child development, about the likely shape of the vocal apparatus in Neanderthals, and their way of life, we can assume that the Neanderthals did have at least a rudimentary form of language, but that it was probably simple in construction and restricted in its range of expression. However, as we mentioned earlier, the ability to create and understand language rather than mere sounds is a function of the brain rather than the vocal tract, and the quality of the Neanderthal brain

(despite much speculation) is still unknown to us. We will examine in Chapter 6 what the archaeological evidence tells us about the sophistication of the Neanderthal brain and the scale and complexity of their societies, information which we shall then compare in Chapter 9 with that for the Moderns.

The shape of Neanderthal bodies

Comparative statistics

Living peoples in different parts of the world have different body shapes and sizes. Some of the heaviest peoples alive today come from Europe, North America and northern Asia, while people of lighter build are more common in tropical and sub-tropical areas. Some of these differences must therefore be related to the climatic environments in which people live – although of course one also has to take into account factors such as varying nutrition.

For example, young adult male Europeans tend to weigh between about 65 and 75 kg (143 and 165 lb) and females between about 55 and 63 kg (121 and 139 lb), whereas most males from Papua New Guinea are less than 60 kg (132 lb) in weight, and females less than 50 kg (110 lb) – at least 10 kg (22 lb) lighter in each case. Similarly there is a great range in height and body proportions. European males and females are mostly over 170 cm (5 ft 7 in) and 160 cm (5 ft 3 in) tall respectively. In comparison, their counterparts in New Guinea are likely to be less than 160 and 150 cm (5 ft 3 in and 4 ft 11 in) tall, a difference of at least 10 cm (4 in) in each case.[29]

Two rules were formulated in the last century by Bergmann and Allen to explain the variation in the weight and shape of living organisms.[30] Bergmann's rule postulates that body weight will tend to be larger in cold conditions, while Allen's rule suggests that body extremities will be relatively shorter. Both can be explained by the need of organisms in cold conditions to conserve heat. They can accomplish this by minimizing their surface area relative to their volume and weight. In this way they can more closely approximate the ideal shape of a sphere, which has the minimum surface area for its volume. These rules seem to operate in a general way in modern human populations when we compare tropical African populations with those of northern Europe or Asia. Since the Neanderthals lived in relatively cold climates, we would thus expect them to be heavy and to have short extremities such as limbs. Let us put these rules to the test, then, and compare the Neanderthal physique to that of the Moderns.

Neanderthal vital statistics

The bodies of Neanderthals were strongly built by the standards of living peoples, but they were not particularly tall. Various formulae have been worked out to estimate height in modern individuals where only part of the skeleton is known. These formulae can be applied to fossil remains as well. However, it can be difficult to judge how applicable these formulae are to the Ancients. If we use the formulae devised for modern people of European origin, then Neanderthal males would have had a height of about 169 cm (5 ft 6½ in) and females 160 cm

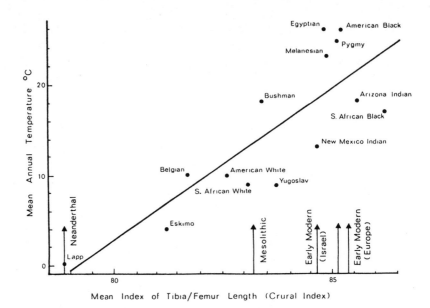

38 Here the limb proportions (measured as the crural index) of a range of recent populations of Homo sapiens *have been plotted against the temperature of their environment. Various fossil populations have also been placed on the graph, according to their mean crural index. Note how low the crural index of the Neanderthals is compared with other fossil samples; they thus appear to display the classic cold-adapted limb proportions that one would expect from Allen's rule. (Recent migrant groups such as South African whites have been plotted against a temperature based on their 'ancestral' place of origin – i.e. western Europe – rather than their present location, as they appear to approximate more closely their ancestral body proportions).*

(5 ft 3 in). On the evidence of ten partial skeletons from Europe and eight from the Middle East, the latter were slightly taller, the largest by far being the man from Amud (Israel) who was about 179 cm (5 ft 10½ in) tall. The smallest of the Neanderthal females came from La Ferrassie (France) and Shanidar (Iraq), both about 155 cm (5 ft 1 in) tall.[31]

Until the very complete skeleton was discovered at Kebara (Israel), we had little idea of what the entire middle part of a Neanderthal skeleton was like, but it seems that Neanderthals had very large, barrel-shaped chests and a long back, with relatively short legs. This short and stocky physique is reminiscent of that of modern Inuit, albeit more extreme, and by analogy it seems that adaptation to cold is at least partly responsible for Neanderthal body shape.

Estimating Neanderthal body weight is more difficult. It is only possible to make educated guesses, using formulae for certain body or skeleton measurements which express the stature:weight relationship of modern people. When these are applied to Neanderthal bones, some results indicate a greater weight than any living peoples, but others suggest that the Neanderthals weighed much the same as lean (*not* overweight) Europeans, who are themselves among the heaviest of living peoples i.e. about 65 kg (143 lb) for Neanderthal males and 50 kg (110 lb) for the females.

It is evident the Neanderthals had shorter forearms and lower legs than the

modern average. In modern peoples the shin bone (tibia) varies from being about 79 per cent of the length of the thigh bone (femur) among the Norwegian Lapps to 86 per cent in black African groups. So the average Neanderthal value of 79 per cent exactly matches the lowest modern value, and is even lower than the Inuit value of 81 per cent. In their relatively heavy bodies the Neanderthals seem to conform to Bergmann's rule, and in the shorter ends of their limbs to Allen's rule.[32] That the Neanderthal physique was partly determined by climate is further supported by the slight differences in limb proportions between the Neanderthals who lived in glaciated Europe and those who lived in the less extreme climates of the Middle East.

Strength

The bones of the Neanderthal skeleton were strongly built by modern standards (pls. 39, 42, 43).[33]. The joints of the elbow, hip and knee were large, and the walls of the leg bones were very thick. These features were also present in earlier humans. In fact it is our own rather puny bones which seem to be the exception. The skeletons of the earlier peoples were continually subjected to stronger forces than our own. This can be partly explained by the powerful muscles which moved the bones. Neanderthal muscles often left marks of deep or wide attachment areas on bone surfaces, while the thicker leg bones were probably to counter fatigue resulting from the constant stress under which they were placed.

Perhaps the robust anatomy of the Neanderthals is indicative of their life-style, with much more effort – and consequent wear and tear on the skeleton – required to obtain food than is the case among modern mobile foragers. Since, as we have seen, the greater muscularity and robusticity of the Neanderthals developed in children at an early age, it would seem that this feature was primarily inherited rather than purely the result of environment or life-style; it was part of their middle Pleistocene heritage.

Posture and movement

The way the Neanderthal skeleton operated was probably also distinctive, with particular movements and postures favoured.[34] There is evidence that Neanderthals often squatted on their haunches, as some living peoples do, since their shin bones show 'squatting facets'. Contrary to earlier ideas, their hands could perform delicate operations (although there is evidence that they were usually held in a more flexed position during manipulations) and their grip was very powerful. The structure of the shoulder blade was also different from that of most living people. The differences centre on the strength of the muscles attached to the upper arm bone, the humerus. These muscles may have been especially developed to keep the arm from twisting during strong movement. We have already seen that the pelvis was distinctive in Neanderthals, and this may be related to the different way in which the hip joint operated, putting emphasis on the strength of the sides of the thigh bones rather than their front and back, as in modern people. The leg, ankle and foot bones were also strongly

built to withstand hard use. None of these features, however, indicate that the Neanderthals had a bent-kneed and apelike posture compared with our own (*cf.* fig. 5).

Disease and death among the Neanderthals

Following the first Neanderthal discovery in 1856, some scientists believed that the bowed appearance of the limb bones was due to the disease of rickets (which we now know to be caused by a deficiency of vitamin D). These days this theory finds few supporters, for although most Neanderthal limb bones do show bowing to a greater or lesser extent, such features are found in earlier robustly built hominids as well as Neanderthals. Moreover, any other skeletal evidence of rickets is lacking. The bowing seems instead to be related to strong muscularity.

The Neander Valley skeleton displays unequivocal evidence, however, of another abnormality: the elbow joint was deformed, probably by a badly healed fracture. Indeed, evidence of injury or disease in some form or another is found in almost all reasonably complete adult Neanderthals.[35] The Shanidar 1 man from Iraq and an isolated arm bone from Krapina in Croatia also show similar serious arm injuries. Erik Trinkaus' study of the large sample from Shanidar revealed a whole catalogue of injuries and degenerative disease in the heads, arms, ribs, legs and feet.[36] The Shanidar 1 man, for example, may have suffered head injuries and extensive crushing of the right side of his body – possibly in a cave rock fall – followed by infections and partial paralysis. He was probably blinded in his left eye, and would have been considerably disabled, yet he must have lived with these injuries for several years (pl. 44). This unfortunate individual thus supports the argument that the Neanderthals sometimes took care of their sick. The Shanidar 3 man had a partly healed rib wound which could have been accidentally or deliberately inflicted by the weapon of another Neanderthal. This is a rare case in which we can be fairly confident that the wound was ultimately the cause of death, although the victim must have lingered on, perhaps for several weeks. The Shanidar 5 man had an extensive scalp wound which healed well, as did an individual from the Croatian site of Krapina.

The most famous of all diseased Neanderthals is the so-called 'Old Man' of La Chapelle-aux-Saints (France), originally studied by Marcellin Boule (Chapter 1). This skeleton has been restudied on a number of occasions, with much revision of Boule's unflattering conclusions about the subhuman nature of the individual concerned.[37] The idea has become widespread that many of the peculiar features of the specimen described by Boule were the result of its diseased condition, of which he failed to take account. However, a recent study concluded that Boule's interpretations – although flawed by present standards – were reasonable for their time and that he was in fact aware of some of the pathologies.[38] He judged the 'Old Man' degenerate on criteria other than his arthritis. The full list of maladies suffered by this poor character is very

impressive. It includes degenerative joint disease in the skull, jaw, spinal column, hip and feet, as well as a rib fracture and extensive tooth loss, accompanied by abscesses. All this and not yet 40!

The high incidence of degenerative joint disease in Neanderthals is perhaps not surprising given what we know of the hard lives they led and the wear and tear this would have produced on their bodies. But the prevalence of serious injuries is more surprising, and indicates just how dangerous life was, even for those who did manage to reach 'old age' in Neanderthal societies.

Neanderthal bodies and behaviour

Gathering together all the information presented in this chapter, we can create a reasonable general portrait of the average Neanderthal man, woman or child. Although we cannot reconstruct the colour of their skin or eyes, a reasonable scientific argument can be proposed that in conditions of low sunlight they may have had pale complexions. Neither is there any way to determine how hairy they might have been. What we do know is that they were large headed, with big noses, strong brows, low foreheads and little chin development. But although they were short, squat and powerfully built, even as children, the Neanderthals would have looked recognizably human as they carried out their daily activities.

The way they performed those activities, however, may have been less efficient than that of their modern successors. Although we have no reason to doubt that they had intelligence and memory, they may have depended more on biological than cultural solutions to the varied problems of survival in their world. The anatomy of both sexes shows they required more muscular effort and activity to survive – brawn was probably still as important as brain to the Neanderthals. They must at least have had a simple language ability, and although they probably aged quickly and died early by modern standards, there was undoubtedly some supporting social structure to care for children who had lost parents and for disabled individuals. Arguably, such care was even extended to a few individuals after their death (Chapter 7).

At the end we are left with a fascinating, even paradoxical, portrait: one that is so human in some ways, yet so different from us in others. We have come a long way from Boule's Neanderthal (pl. 3) and Osborn's 'upward tendency' (pl. 4). Just how different the Neanderthals were from modern humans will be examined in Chapters 7 and 9. But in the meantime, the question that still remains to be answered is whether it was the Neanderthal pattern of anatomy and behaviour which gave rise to that of later peoples of fully modern type. This is something we will discuss in Chapter 8, after we have looked in the next two chapters at the different peoples alive in the rest of the inhabited world at the time of the Neanderthals.

CHAPTER 5

Humans at the Crossroads: The Middle East Corridor

The Middle East has clearly been of great importance during the last 10,000 years in the early development of agriculture, pastoralism and other cornerstones of later Western civilization such as writing.[1] But it has been of similar importance in the story of human evolution for the last million years, being the crossroads between three continents and faunal provinces. As *Homo erectus* spread out of Africa over 1 million years ago, the Middle East would have been on the migration routes to Asia and Europe. Within the small area of the eastern Mediterranean known as the Levant, closest to Africa, a variety of environments have always survived the regular climatic assaults of the Pleistocene glacial-interglacial cycles; this area provided a refuge as the climate grew colder in the north or more arid in the south. So it was, 100,000 years ago, as a new phase of human evolution began.

The story of human evolution in the Middle East is very murky until about 150,000 years ago, when a rather primitive hominid population, neither modern nor Neanderthal, seems to have occupied the Levant. The only informative human fossil from this time is an enigmatic front of a skull with part of the face preserved below.[2] This specimen was found in 1927 by Flinders Turville-Petre, an army officer, in the cave of Zuttiyeh in the Wadi Amud (Valley of the Pillar, named after an unusual column of rock) near Lake Galilee. Despite its fragmentary nature, the specimen has been much discussed, for attempts have been made to link it to the evolution of either modern humans or Neanderthals. It has a strong brow ridge and a narrow frontal bone, both primitive characters, but a rather domed front, which gives a somewhat modern appearance to the profile of the forehead. The upper face is transversely very flat, and the fragmentary cheek bone is angled as in modern humans. So in this last respect, the fossil is quite different from Neanderthals with their swept back cheek bones. Arguments have centred on whether this therefore makes the Zuttiyeh fossil modern. Unfortunately the angled morphology of the cheek bone is an ancestral characteristic which modern humans have retained, and it is therefore impossible to say whether the Zuttiyeh fossil is fundamentally modern or – as seems more likely – primitive. Most probably it lies close to the evolutionary divergence of the Neanderthal and modern groups, which is why its affinities are so difficult to ascertain.

In this chapter we will first describe the fossil evidence from the key sites in the Middle East, evidence which we will then use to help us unravel the complex history of human evolution in the area.

Tabūn and Skhūl

A much larger group of fossils which has also been difficult to place in the evolutionary sequence is that from the two Mount Carmel caves of Skhūl (es-Skhūl, 'cave of the kids') and Tabūn (et-Tabūn, 'the oven').[3] Excavations by an Anglo-American team in the 1930s led to the uncovering of the remains of at least ten men, women and children from the small cave remnant of Skhūl, and a smaller sample from the much larger cave of Tabūn, including the partial skeleton of a woman. The caves faced down a valley called the Wadi el-Mughara (Valley of the Caves), which ran towards the Mediterranean coast. This valley would have held water in a river for part of the year, and occupants of the caves would also have had the choice of obtaining food resources from Mount Carmel itself, rising up to nearly 500 m (1,640 ft), or travelling through the valley to the wide coastal plain, over which they would have had an excellent view (pl. 55).

The Skhūl material included several apparent burials, the most complete being of adult males. The skeleton of Skhūl 4 was lying on its right side with folded arms and tightly flexed legs (pl. 54), while Skhūl 5 lay on his back with his head bent down on to his chest and his legs also tightly flexed (pl. 53). Within his arms was the jaw bone of a large wild boar.

The Tabūn material was less extensive and covered a much greater stratigraphic depth than the Skhūl hominids, which were all found in a single layer about 1 m thick. The Tabūn finds of a partially extended female skeleton and an isolated larger (male?) mandible were recovered from layer C. Both the Skhūl and Tabūn fossil hominids were associated with similar Middle Palaeolithic (Levalloiso-Mousterian) artifacts, which led scholars to conclude that the caves of Skhūl and Tabūn were inhabited at about the same time.

Thus when Ted McCown and Arthur Keith published their detailed two-volume report on the sites, they assumed that the fossil humans were approximate contemporaries and members of one population.[4] That population was clearly very variable, since the Skhūl people were predominantly modern-looking, while the Tabūn woman was rather lightly built but was otherwise very Neanderthal-like. McCown and Keith concluded that the Mount Carmel people were part of a human evolutionary radiation which was clinal (gradually changing) in nature. In Europe the radiation was towards 'classic' Neanderthal forms, in the east towards early modern humans (ancestors of the Cro-Magnons), while in the Levant an intermediate type had developed which could be called 'progressive' Neanderthal – not an evolutionary intermediate between Neanderthals and moderns, but a less specialized Neanderthal and therefore somewhat closer to the Cro-Magnons. Other interpretations followed, including the possibility that the Tabūn–Skhūl samples were the actual missing evolutionary link between Neanderthals and modern humans, or alternatively that they represented hybrids between separate contemporaneous Neanderthal and modern human populations. Yet another variation was the suggestion that, if the material was early in date, it

might represent the common ancestral stock for both Neanderthals and modern humans. Our views of the Mount Carmel fossils have developed as the fossil record has grown, but in the last few years all of these suppositions have been replaced by new hypotheses, as we shall see at the end of the chapter.

Qafzeh and Shanidar

The Qafzeh cave lies on the east side of a valley which runs south from the famous biblical town of Nazareth.[5] The cave looks rather ordinary when viewed from the valley, but it has proved to be one of the most important of all fossil hominid sites (pl. 59). The first series of excavations (1933–35) were directed by René Neuville, the French consul in Jerusalem. Although he found seven fossil hominids (two in Upper Palaeolithic levels, the others in the Middle Palaeolithic), the intervention of the Second World War and its aftermath in Palestine prevented the work from being published in detail before Neuville's death in 1952. Work was resumed there between 1965 and 1979 under the direction of Bernard Vandermeersch, and this produced remains of at least another 14 individuals from the Middle Palaeolithic. As at Skhūl, a number of men, women and children seemed to have been deliberately buried, and in the case of the child known as Qafzeh 11, the burial was accompanied by the skull and antlers of a large deer, presumably buried as a complete head. There was also a probable double burial of a young adult (Qafzeh 9) with a six-year-old child buried across its feet.

It was recognized early on that the Qafzeh hominids resembled those from Mount Carmel, in that some of the material showed a modern morphology, and yet was found with a Middle Palaeolithic industry. However, the inadequate dating of all these sites prevented real understanding of their relationships and, although the Qafzeh and Skhūl samples were called 'proto-Cro-Magnoids' in the 1950s, it was not until the Qafzeh finds were studied in detail by Vandermeersch and his colleagues that their real importance began to emerge, as we shall discuss below.

It is an Iraqi cave, Shanidar, that has produced the largest sample of Neanderthals from the Middle East (Chapter 4).[6] Nine Neanderthals – ranging in age from very young infants to relatively 'old' men, and in completeness from a few vertebrae to fairly complete skeletons – were excavated by a team led by Ralph Solecki between 1953 and 1960. These remains have been studied by various workers, but the most exhaustive and informative study was that of Erik Trinkaus, published in 1983. Some of these Neanderthals, at least, seem to have been deliberately buried, and it has even been suggested that the Shanidar 4 man was buried with flowers, although this has recently been seriously questioned (Chapter 7).

Amud and Kebara

No doubt inspired by the success of Solecki's team at Shanidar, a Japanese team under H. Suzuki began work in 1959 at Amud Cave in Israel, which lay in

A Cold Body in a Warm Cave:
Neanderthal Proportions

The Kebara skeleton is so well-preserved that it has provided the best data yet available on Neanderthal anatomy.[7] As we saw in Chapter 4, the discovery of this skeleton led scholars to reassess both the function of the Neanderthal pelvis and (following examination of the hyoid bone) preconceptions about Neanderthal vocal abilities.

Using the proportions of the upper limbs and trunk it has also been possible to look at the shape of the whole body, relating the width of the pelvis to the estimated height of the Kebara individual.[8] We have seen that in modern populations body shape can be related to climatic adaptation. In hot climates it is advantageous to maximize the surface area of the skin for heat loss, and this is achieved with a long thin body approximating the shape of a tall, narrow cylinder i.e. a tall stature with slim hips. (The skeleton of the *Homo erectus* boy from Nariokotome in Kenya has exactly this body shape, similar to modern east Africans.) In cold climates, however, stature is low relative to hip breadth (e.g. among the Lapps and Inuit); this creates a shorter, wider body approximating a sphere, to minimize surface area. How does the Kebara skeleton compare to these two body forms?

Well, the Kebara man most resembles cold-adapted populations in the height/hip breadth relationship; in fact his body proportions are even more pronounced than those of any modern examples. We conclude that even in the relatively warm climate of the Middle East, the Neanderthals were fundamentally cold-adapted people; this is in marked contrast to the early modern humans, both in this area (e.g. Skhūl and Qafzeh) and in Europe (the Cro-Magnons).

the same valley (Wadi Amud) as Zuttiyeh Cave. They were rewarded two years later by the discovery of a fairly complete but shattered Neanderthal skeleton, at the very top of the Middle Palaeolithic level – so high in the stratigraphy that it was mixed not only with Upper Palaeolithic artifacts, but even with pottery from the levels further above.[9] Three more fragmentary specimens were found in subsequent years. But nobody could take seriously the published absolute dates from the Amud Neanderthals, since one method suggested a date of only 28,000 years ago and a second method less than 20,000 years. Recent work at Amud by an Israeli team has produced further Neanderthal fossils and a re-evaluation of the dating is underway (see below).

Another Mount Carmel cave, Kebara, has recently been the focus of renewed international collaboration. It had previously produced a number of Upper Palaeolithic fossils in 1931, and a Neanderthal child in 1964. But the most spectacular find, made in 1984, was of a skeleton in an evident grave (see box above).[10]

The skeleton was virtually intact from the lower jaw to the pelvis, but the skull and upper jaw were missing except for one tooth; the skull was presumably present originally, but had been removed by subsequent human or animal activity.

Comparing the fossils

Understanding the complexities of the Middle East is no easier for the Middle Palaeolithic than it is for the present day. We will look at the physical variation in the fossils in this section, and then go on to discuss the dating evidence; the archaeological evidence will be surveyed in Chapter 7. Broadly speaking, the fossils, with one or two exceptions, can be divided into Neanderthal-like ones, and those similar to modern humans. The former include the remains from Tabūn, Shanidar, Amud and Kebara, whereas the more modern-looking specimens are from Skhūl and Qafzeh.

Middle East Neanderthals

The characteristics used to classify the Neanderthal specimens have already been detailed in Chapter 4. The Tabūn, Shanidar and Amud specimens generally have a long, broad and low skull, a large double-arched brow ridge, a big face with a particularly large nose and midfacial prognathism, and a large palate and lower jaw with little or no chin development.[11] This is certainly so for the Kebara lower jaw, which is one of the most massive human jaws known. Amud has the largest brain capacity of any fossil hominid, over 1,700 ml, while Tabūn is one of the smallest Neanderthals in this respect, with a volume of only

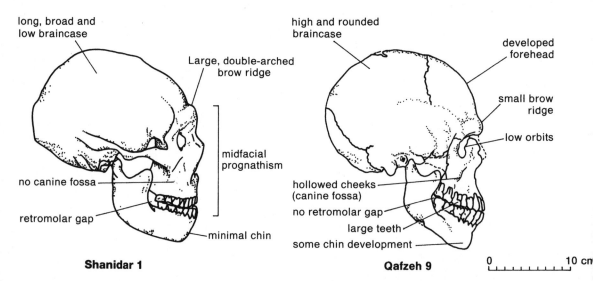

39 *A comparison of the Shanidar 1 Neanderthal and Qafzeh 9 early modern skulls. Both were found associated with Middle Palaeolithic artifacts, but the modern Qafzeh hominid is probably more ancient than the Shanidar Neanderthal. Note the comparatively large nose and low forehead of the Neanderthal.*

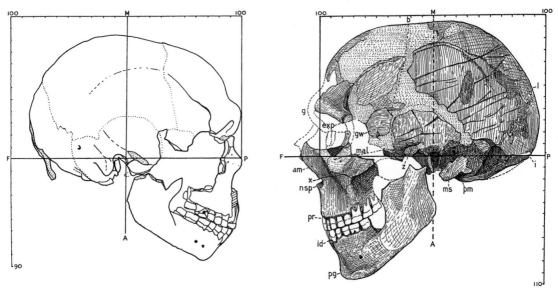

40 A comparison of the Mount Carmel finds; from the original publication by McCown and Keith: (left) the Tabūn Neanderthal and (right) the Skhūl 4 early Modern.

about 1,250 ml. Brow ridge thickness is variable, being massive in the small Tabūn female and surprisingly slender in the big male from Amud (pl. 50). Chin development varies too: it is minimal in Kebara, the Tabūn 1 woman, and the Shanidar jaws, but more marked in Amud and Tabūn 2 – even leading to suggestions that the latter fossil might be a primitive modern rather than a Neanderthal. In the rest of the skeleton, these Neanderthals have the stocky, cold-adapted body proportions of their European counterparts, but are on average a little taller, with Amud being by far the tallest Neanderthal known, at about 1.78 m (5 ft 10 in). Their pelvic structure is like that of other Neanderthals – in fact the distinctive Neanderthal extended pubic ramus shape was first recognized in the Tabūn woman, and the Kebara male has the longest pubic ramus ever found.

The 'Moderns'

The Skhūl and Qafzeh samples do look decidedly 'modern' when compared with specimens from sites such as Tabūn and Kebara.[12] The braincases are high and rather short, rounded in profile but, unlike Neanderthals, parallel-sided rather than spherical in posterior view (pls. 56–58). The brow ridges are moderate or small in skulls like Skhūl 4 or Qafzeh 9, but even where the brow ridge is strongly built (as in Qafzeh 6 or Skhūl 5), it is different in shape from that of Neanderthals. The face has a broad but low nasal opening, and mid-facial projection is not developed. The cheek bones are hollowed rather than flat or inflated, unlike the Neanderthals, and they do not retreat at the sides. The orbits are wide, but low, and the whole upper face is broad. The lower face is more projecting, particularly in Qafzeh 9, where the teeth are very large, and

the total prognathism of the face is strong – a distinctly primitive feature. Forehead development is well marked in most of the skulls, but less so in Skhūl 9. The lower jaws are relatively shorter than those of Neanderthals without the forward positioning of the teeth; tooth size is in some respects more primitive than that of Neanderthals, however, with large third molars in such fossils as Qafzeh 9.

The skeletons of the Skhūl and Qafzeh samples are even more modern than their skulls. And in contrast to the Neanderthals, their body proportions are tropical rather than cold-adapted, with long forearms and tibiae and an average stature of about 1.83 m (6 ft) in males and 1.70 m (5 ft 7 in) in females. However, as with Neanderthals, they were probably well-muscled, making them somewhat heavier for their height than living humans. This may explain why they, like Neanderthals, were larger-brained than us, their brain capacity averaging about 1550 ml. But distinct from Neanderthals, they had pelvic morphologies of modern type, suggesting that their hip joints functioned exactly like ours. Compared with the relatively short-legged Neanderthals, these early Moderns should have found long-distance walking a lot easier. And the fact that (so far at least) the skeletons reveal fewer signs of fractures and stress suggests that their life-style was less wearing than that of the Neanderthals.

New dates for old fossils

So what was the relationship between these Neanderthal and modern groups in the Middle East? As we have seen, an early view was that they represented a single, highly variable population, containing Neanderthal-like and near modern forms, which might lie close to the divergence of the Neanderthal and modern evolutionary lines. Alternatively, some scholars felt that they were perhaps the results of hybridization between contemporaneous Neanderthal and modern groups, or the actual evolutionary link between Neanderthal ancestors and modern descendants.

However, all these views depended on the fact that the sub-groups resembling Neanderthals and moderns were contemporaneous, and evidence began to emerge that this was not so. First there was evidence from animal fossils that the Mount Carmel site of Tabūn might be somewhat older than neighbouring Skhūl. This was supported by an analysis of stone tools from both sites, which suggested that the local stone knappers produced progressively narrower and narrower flakes at Tabūn and, if this was so, the Skhūl flakes logically followed on at the very end of the Tabūn sequence.[13] Thus the Tabūn people might represent the ancestors for Skhūl's inhabitants; so the latter would have continued to develop their stone tool-making skills in a regular way as they lived on Mount Carmel. According to this theory, the Neanderthals of Tabūn would have dated from 50,000–60,000 years ago while their more modern descendants lived in Skhūl (and Qafzeh?) about 40,000–45,000 years ago. But there were some problems with this reconstruction of

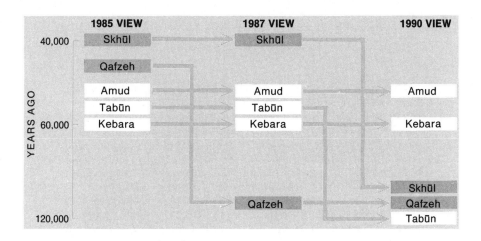

41 New dating techniques have recently upset the traditional understanding of the early modern (dark grey) and Neanderthal (white) remains from the Middle East. Until relatively recently, scientists had believed that Moderns succeeded Neanderthals in the area, and thus may have evolved from them (left). But the early results of thermoluminescence, electron-spin resonance and uranium-series dating placed Moderns both before and after the Neanderthals (centre). The current interpretation of the evidence, however, suggests that at times the two groups may have been approximate contemporaries (right).

events too. For one thing, not everyone was convinced that there was such a neat evolutionary sequence from the Neanderthals to the early Moderns in the Middle East. Additionally, while some analyses of the large mammals found at the sites supported the view that Tabūn preceded Skhūl, studies of the small mammals suggested that level C at Tabūn (which contained the Neanderthal woman's skeleton) was actually *younger* than the main hominid levels of early Moderns at Qafzeh.

It was impossible to test these views as long as the only applicable dating method was radiocarbon, which ceases to produce accurate results on materials over 40,000 years old – the critical time period in the Middle East. But things started to improve in 1987 when the technique of thermoluminescence (TL: see box pp. 58–59) was applied to burnt flints from the levels adjoining the Neanderthal burial at Kebara. The result – a date of about 60,000 years – was much as expected, and it was confirmed by electron spin resonance (ESR) dating of animal teeth from equivalent levels.[14] However, a real shock followed when the TL technique was applied to the early modern burial levels at Qafzeh. The date produced was about 92,000 years, implying that the Qafzeh early Moderns were not only about three times as old as the Cro-Magnons of Europe, but some 30,000 years older than the Neanderthal burial at Kebara![15] The evidence from the small mammals thus seemed to be endorsed, and this age estimate was further confirmed (even exceeded) by the ESR dating of associated mammal teeth from Qafzeh at 120,000–100,000 years old.[16]

The next logical step was to test the similar-looking hominids from Skhūl, and these too proved to be ancient: dated by ESR on mammal teeth at 100,000–

Evolution at the Crossroads

The hominid remains found at Tabūn and Skhūl in the Middle East were originally thought to be members of a single population, representing the gradual evolutionary transition of Neanderthals to early Moderns. But as more and more evidence accumulated that the modern-looking samples from Skhūl and Qafzeh were actually older than the Neanderthals of Amud and Kebara, this view became untenable. So how *can* we explain the complex pattern of evolution in the region? Three possible answers are presented below.

In one view, the Middle East is simply a zone of overlap between two evolving human lineages. One, basically European, is that of the Neanderthals; the other, African, is that of modern humans. At any one time during the period 120,000–40,000 years ago – prior to Neanderthal extinction in the area – either or both lineages could be represented there; but it is not currently possible to establish contemporaneity (for example the Tabūn Neanderthal could be older than, contemporaneous with, or younger than the Skhūl/Qafzeh specimens).[17] The fact that some of the associated animals at Skhūl and Qafzeh could be found in Africa and Arabia might support an influx of fauna, including humans, from the hotter, more arid south.

The second also views the Middle East as an area of overlap between two human lineages. According to this theory, however, it was the modern humans who first settled the region (at least 100,000 years ago), with the Neanderthals arriving only about 70,000 years ago – perhaps in response to the degenerating climate in Europe associated with the onset of the last glaciation.[18] The ESR dates for the Tabūn Neanderthal are accounted for by arguing that this individual was actually from layer B at the site. Thus the hominid sequence would be: Zuttiyeh (archaic) with a local late Acheulean over 150,000 years ago; the Skhūl and Qafzeh early Moderns with a 'Tabūn C' Middle Palaeolithic industry, about 100,000 years ago; and lastly the Tabūn, Kebara and Amud Neanderthals associated with a 'Tabūn B' Middle Palaeolithic industry between 70,000 and 40,000 years ago. It is further argued that the Neanderthals – with their superior adaptation to colder conditions – might have displaced the early Moderns. Both these explanations, therefore, assume that the Middle Eastern corridor was open in both southern and northern directions.

The third option – based on the fact that the early Moderns of the Middle East still show primitive or Neanderthal-like characteristics while the Neanderthals of the region are not as 'classic' as European examples – returns to the original concept of a single, variable population.[19] Thus, this population was a regional variant of *Homo sapiens*, with its own mixture of primitive, modern and Neanderthal features. The Qafzeh and Kebara people are merely extremes of a continuous range of variation, and only a part of that range (the 'modern' elements) were selected for, leading to the appearance of true anatomically modern humans in the area after 40,000 years ago.

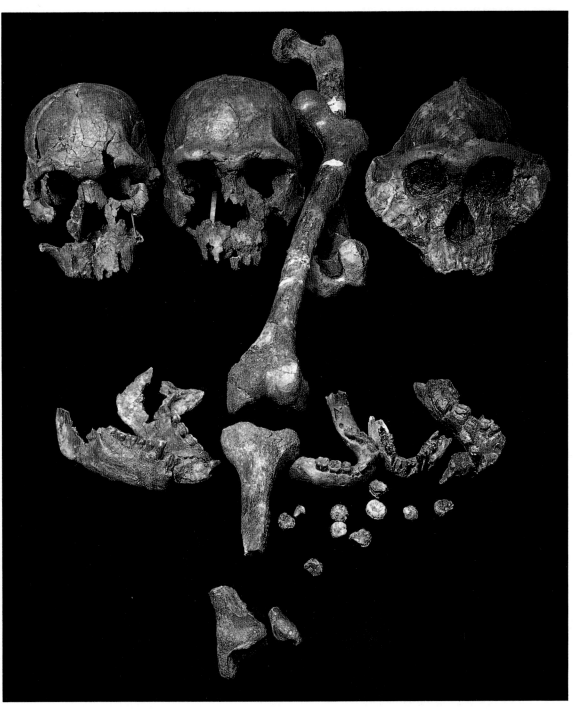

19 The East Turkana (formerly East Rudolf) area of northern Kenya has produced a wealth of fossil hominids dating from between one and two million years ago, representing (from left) *Homo habilis*, early *Homo erectus*, and robust australopithecines (*Paranthropus*).

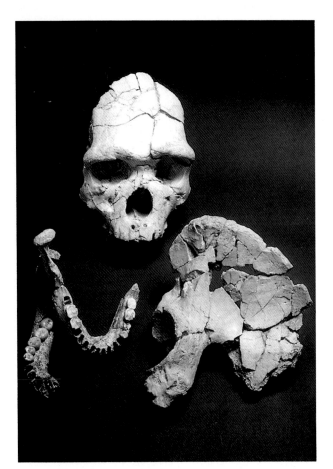

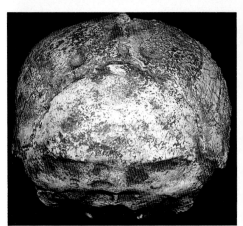

20 (*Above left*) Over 60 hominid fossils have been found at the Arago (or Tautavel) cave in France. About 400,000 years old, these fragments – the front of a skull, a left hip bone and two lower jaws – display features reminiscent of both earlier *Homo erectus* populations and later Neanderthals.

21,22 Rear views of the skulls from Biache-St-Vaast in France (*top right*) and Swanscombe in England (cast, *above right*). Perhaps representing early members of the Neanderthal lineage, these skulls have the same central depression in the occipital bone (suprainiac fossa) as their Neanderthal successors.

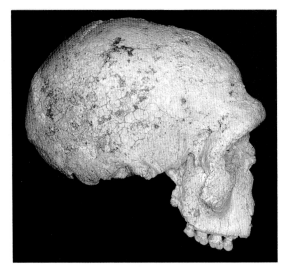

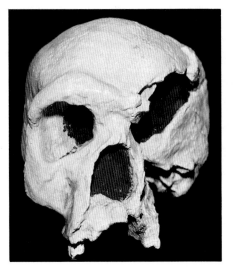

23,24 The skull from Steinheim in Germany displays a very prominent brow ridge, but it is small and gracile in comparison with other Neanderthals. Some scholars have attributed the modern-looking hollowed cheek region to distortion suffered during fossilization.

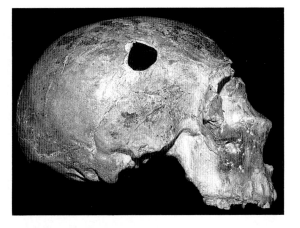

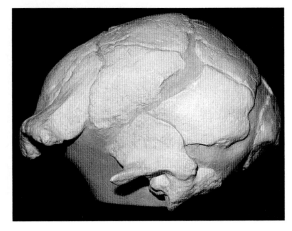

25 (*Left*) This skull from Saccopastore in Italy – dated to about 120,000 years ago – exhibits many Neanderthal features in the braincase and face, but has a relatively small brain capacity.

26 (*Below left*) A reconstruction of the most complete Ehringsdorf hominid skull showing a combination of advanced features (high skull and forehead, large brain) and primitive ones (strong brow ridge, angled occipital). Like Swanscombe, the occipital bone foreshadows that of the Neanderthals.

27 (*Below right*) The skull from Petralona, Greece, may be over 300,000 years old. In many ways the face resembles that of the Neanderthals, with its double-arched brow ridges and inflated cheeks, but the back of the skull is more like that of *Homo erectus* (see x-ray).

The origins of the Neanderthals

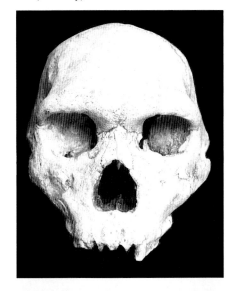

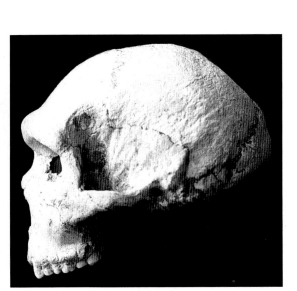

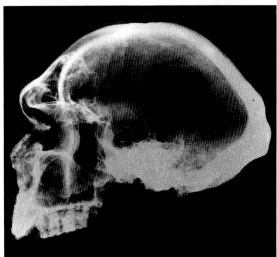

28,29 Side view of the Petralona skull and x-ray, showing its strong brow ridge and occipital torus.

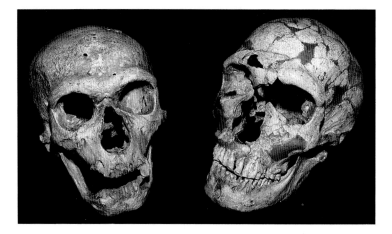

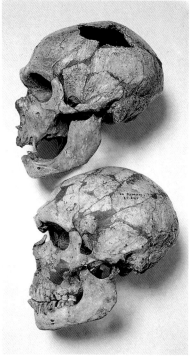

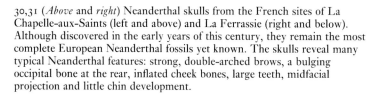

30,31 (*Above* and *right*) Neanderthal skulls from the French sites of La Chapelle-aux-Saints (left and above) and La Ferrassie (right and below). Although discovered in the early years of this century, they remain the most complete European Neanderthal fossils yet known. The skulls reveal many typical Neanderthal features: strong, double-arched brows, a bulging occipital bone at the rear, inflated cheek bones, large teeth, midfacial projection and little chin development.

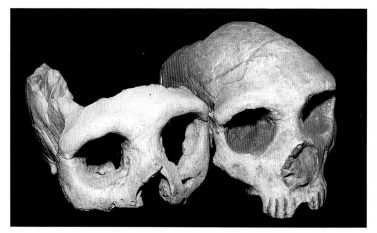

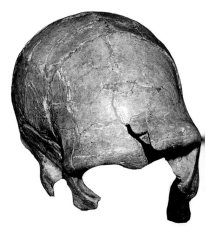

32 Casts of two partial female Neanderthal skulls from Krapina in Croatia (left) and Gibraltar.

33 (*Right*) Partial Neanderthal skull from the French site of La Quina.

34 (*Below*) This rear view of the Neanderthal skulls from (left to right) La Chapelle-aux-Saints, La Quina and La Ferrassie clearly shows their distinctive spherical profiles and suprainiac fossae (depressions in the centre of the occipital bone).

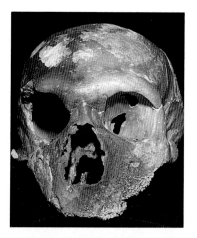

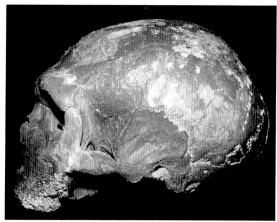

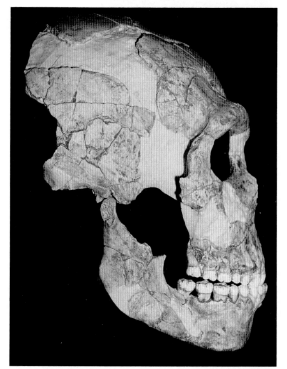

The Neanderthals in Europe

35,36 (*Above, left* and *right*) The Guattari (Monte Circeo) Neanderthal skull was found in 1939, reportedly in a circle of stones. Recent research suggests that it may have been brought to the cave by hyenas.

37,38 (*Left*) Cast of the reconstructed skull from Saint-Césaire in France. Representing one of the last Neanderthals, the remains were found with Châtelperronian artifacts, and dated at about 36,000 years ago. (*Below*) Cast of part of the Saint-Césaire skeleton as it was excavated from the rockshelter.

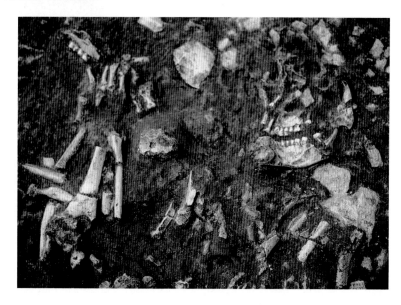

39 (*Left*) Humeri (upper arm bones) of the French Neanderthals from La Ferrassie (male and female), La Chapelle-aux-Saints and La Quina. The shafts may not be very thick, but they are strong. The bowing is probably related to the power of the muscles, and the large ends of the bones reflect their large joint surfaces.

40 (*Above*) Casts of the Neanderthal lower jaws from Amud in Israel (top) and Saint-Césaire, France. Both have the characteristic space behind the third molar, but also show slight development of a chin, a more modern feature.

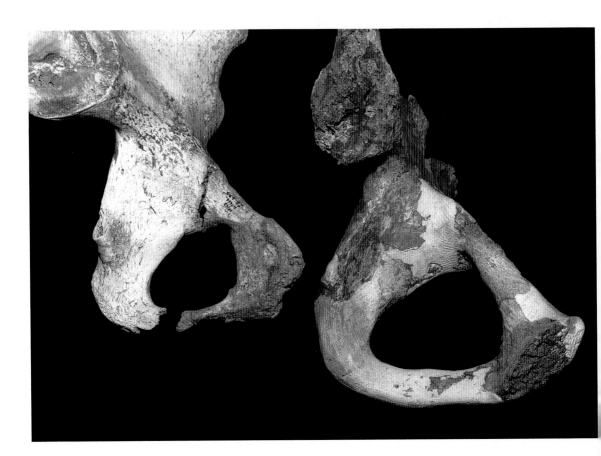

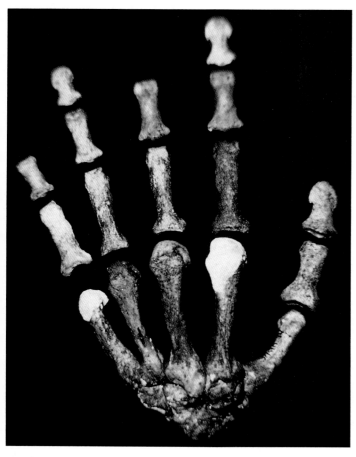

42 Hand bones of the Shanidar 4 Neanderthal, displaying the typical strong, broad finger bones, the particularly wide ends probably related to a powerful grip.

43 (*Below*) The beautifully preserved right foot of the woman from La Ferrassie. Neanderthal leg and feet bones were robust to withstand hard use.

Neanderthal anatomy

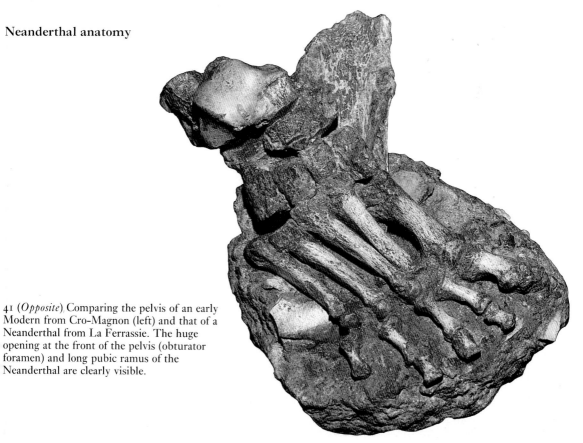

41 (*Opposite*) Comparing the pelvis of an early Modern from Cro–Magnon (left) and that of a Neanderthal from La Ferrassie. The huge opening at the front of the pelvis (obturator foramen) and long pubic ramus of the Neanderthal are clearly visible.

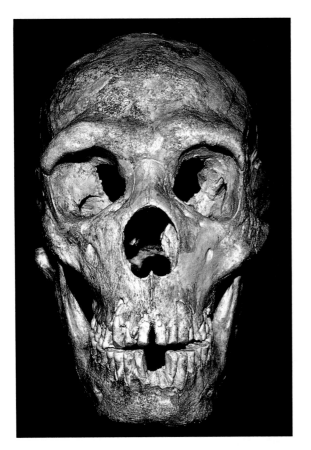

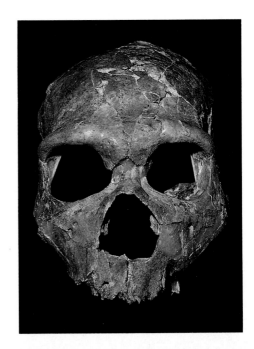

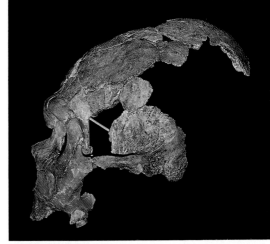

Neanderthals in the Middle East

44–47 (*Above left*) The Shanidar 1 man clearly suffered substantial injury, and was probably blind in his left eye. (*Above right* and *right*) The Shanidar 5 skull has an especially large nose and pronounced midfacial prognathism. (*Below*) Skulls of Shanidar 1 (cast, left), Zuttiyeh (cast, centre) and Tabūn. Zuttiyeh could be a pre-Neanderthal and Tabūn (about 110,000 years old?) an early Neanderthal.

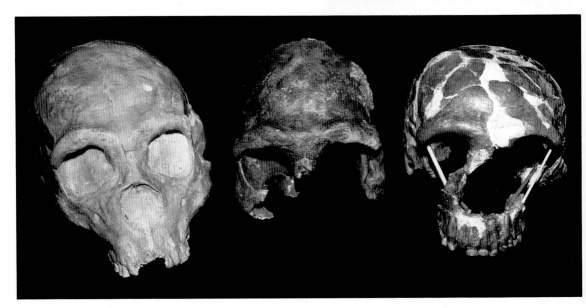

48,49 (*Right*) The Israeli anthropologist Yoel Rak (facing camera) at work on the site of Amud in Israel. (*Below*) A fairly complete Neanderthal skeleton was found in 1984 at the Mount Carmel cave of Kebara in Israel. It belonged to a large male individual, and dates from about 60,000 years ago. It is particularly famous for its pelvis – which has the longest pubic ramus ever discovered – and its massive lower jaw.

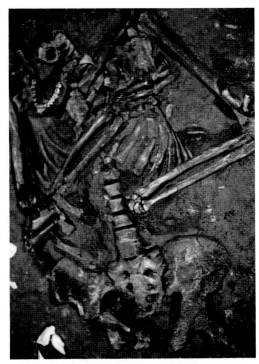

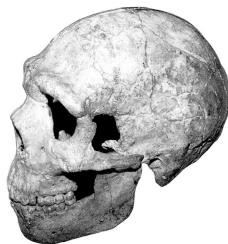

50 (*Above*) The Amud skeleton is the tallest Neanderthal yet known. It is thought to be a relatively late specimen, and is dated by electron spin resonance to about 50,000 years ago. Its skull has an enormous brain capacity (over 1,700 ml) and displays many features characteristic of the Neanderthals.

51 (*Below*) The site of Amud is on the left of this pillar (Amud) of rock, after which it has been named.

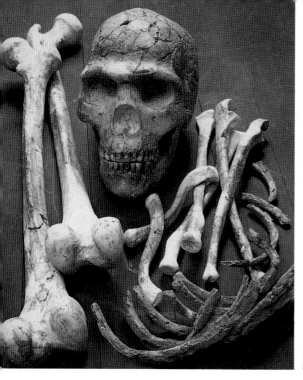

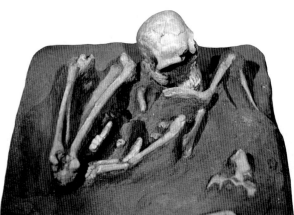

52,53 (*Left*) The reconstructed skull and skeletal remains of Skhūl 5, an early modern adult male. (*Below*) Reconstruction of the Skhūl 5 burial. The man was apparently interred with the jaw bone of a wild boar in his arms.

Early Moderns in the Middle East

54 The reconstructed burial of an early Modern, Skhūl 4, a strongly built male.

55 (*Below*) The small cave of es-Skhūl on Mount Carmel, Israel, yielded the remains of ten early modern individuals.

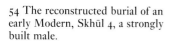

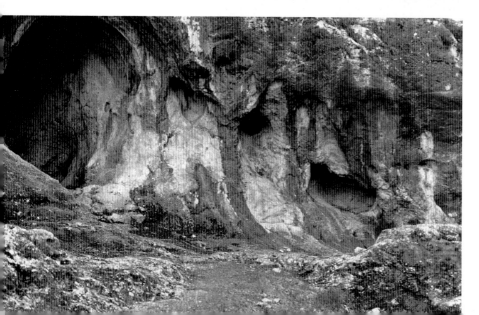

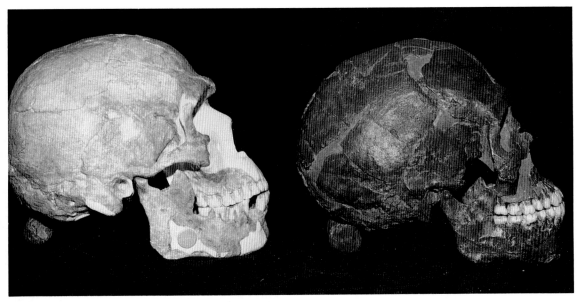

56 Skull casts of the early modern Skhūl 5 and Qafzeh 9. The shape of their braincase is distinctly modern, but this is combined with a rather large and more primitive projecting face.

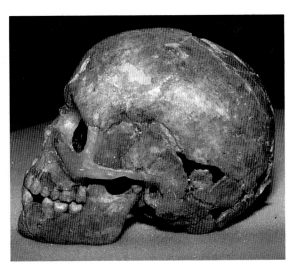

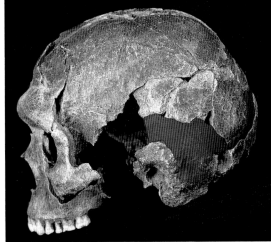

57 (*Above*) The Qafzeh 11 skull is remarkably modern in appearance. Belonging to a child of about 12 years old, it is one of the most ancient in the Qafzeh sequence.

58 (*Above right*) The braincase of Qafzeh 6 looks rather modern, but the skull has strong brows and a wide, flat face.

59 The Qafzeh cave, near Nazareth, has produced the largest sample of early modern humans from anywhere in the world. They are dated by thermoluminescence and electron spin resonance to between 80,000 and 120,000 years ago.

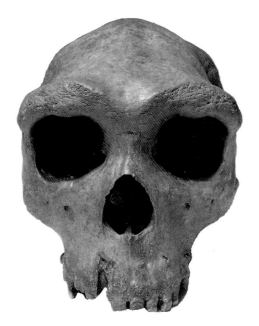

The transition to modern humans in Africa

60 (*Left*) Fossil skull excavated from the site of Broken Hill in Kabwe (Zambia). Known also as Rhodesian Man, the Broken Hill remains show features of both *Homo erectus* and *Homo sapiens* and are often consequently classified as 'archaic *Homo sapiens*'.

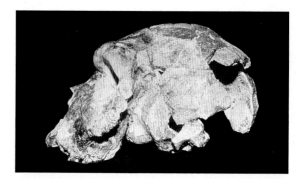

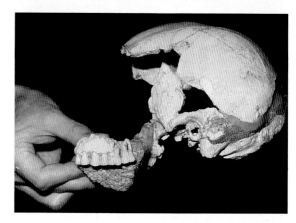

61 (*Right*) The Bodo skull from Ethiopia may be about 400,000 years old, and combines a massive face and a thick skull with a large face. It could be an early member of the Afro-European populations represented by the Broken Hill and Petralona fossils.

62 The Salé skull from Morocco is also about 400,000 years old. It is much smaller than specimens such as Bodo, and probably represents a female. The back of the braincase looks quite modern, but displays abnormal neck muscle attachments, probably caused by disease.

63 (*Below*) Casts of the two crania from Omo Kibish, Ethiopia. Both may date from the beginning of the late Pleistocene. Omo 2 (left) shows a number of archaic features in the braincase – including a broad angular occipital bone – but has a relatively small brow ridge, whereas Omo 1 is modern in its cranial vault but has a broad and quite flat frontal bone.

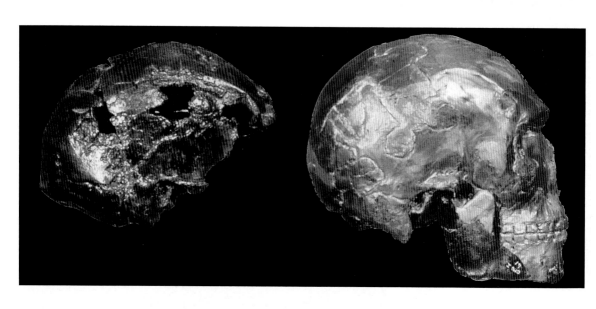

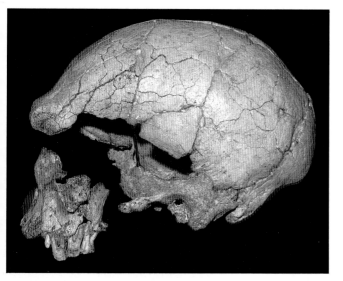

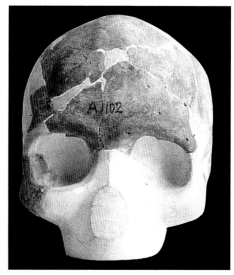

64,65 (*Above left*) The Ngaloba 18 skull from Laetoli in Tanzania may date from about 130,000 years ago, and belonged to a borderline Modern. (*Above right*) Border Cave 1 is a fragmentary skull and some possibly associated limb bones. Most experts accept it as an anatomically modern specimen, although many dispute the claims for an antiquity of about 80,000–100,000 years.

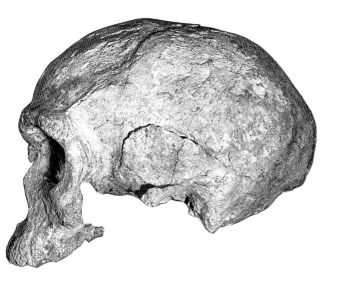

66,67 (*Left* and *below right*) The Jebel Irhoud 1 cranium from Morocco is a late archaic specimen, probably dating from between 200,000 and 100,000 years ago. It combines a rather primitive cranial vault with a large but more modern-looking face.

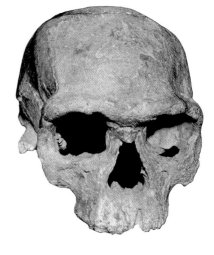

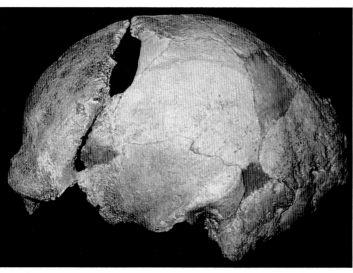

68 (*Left*) The Jebel Irhoud 2 skull. Consisting originally of only two parts, the differences between the modern front and primitive rear are so pronounced that the two pieces were once thought to have come from two different individuals, one an Ancient and the other a Modern.

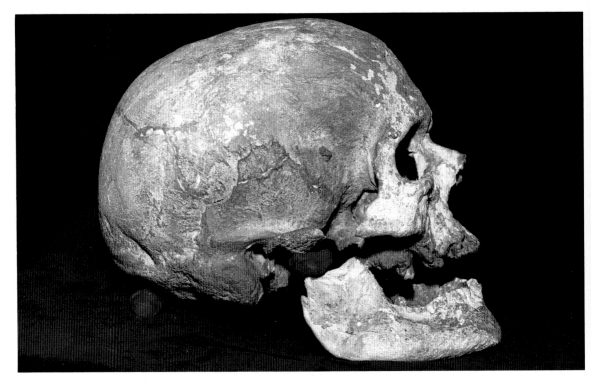

The Moderns arrive in Europe

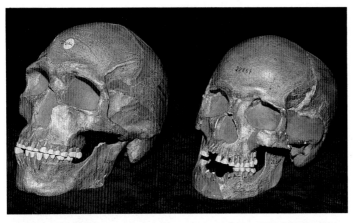

69–71 (*Top*) The 'Old Man' of Cro-Magnon is associated with late Aurignacian artifacts, and dates from about 30,000 years ago. Note the high forehead, small brows and hollowed cheek bones of this early Modern. (*Centre*) Probable male and female skulls from Předmostí in Czechoslovakia, dating from about 26,000 years ago. (*Bottom*) The cave site of Mladeč in Czechoslovakia yielded the remains of several early Moderns associated with the Aurignacian, including this skull which probably belonged to a female. Although the bulging occipital resembles some Neanderthal specimens, the facial features are distinctly modern.

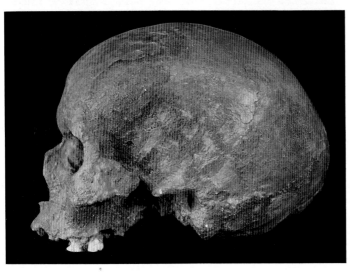

FACING PAGE

72–74 (*Top*) Three probably female early modern skulls from Europe: Cro-Magnon 2 (left), Abri Pataud (centre) and Předmostí 4 (cast, right). (*Middle*) These three skulls were found in the Cro-Magnon rockshelter in France in 1868. They probably came from two males (1, left and 3, right) and a female (2, centre). (*Bottom*) This view contrasts the facial form of two French Neanderthals (La Chapelle-aux-Saints on the left and La Ferrassie, right) with that of the Cro-Magnon 1 skull (centre). Notice the differences in forehead shape and brow ridge size, and the size and shape of the orbits, cheeks and nasal openings.

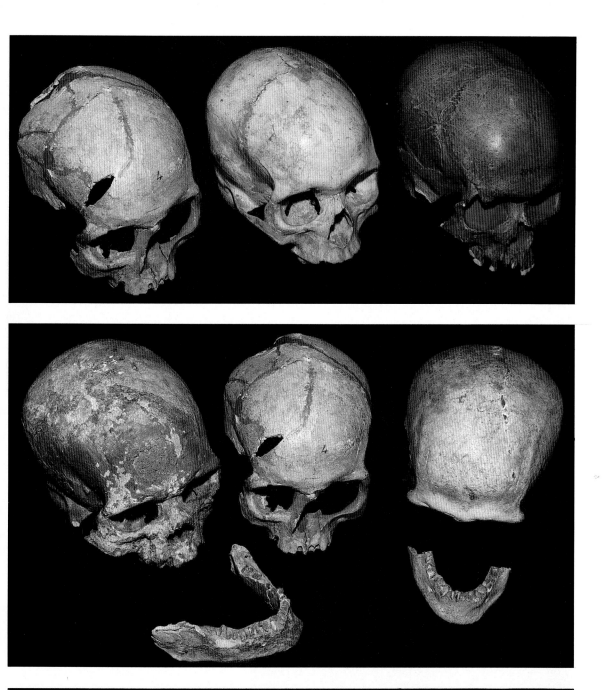
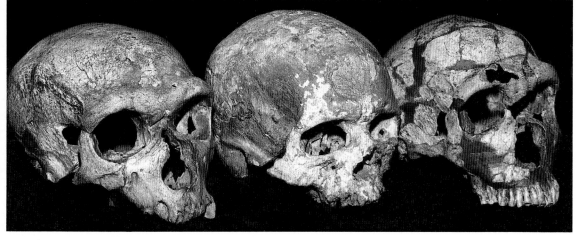

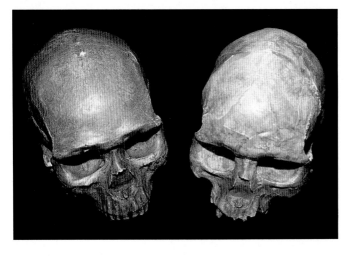

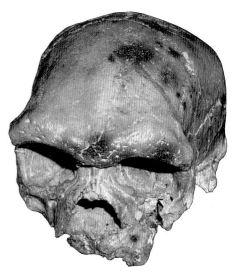

The transition to Moderns in the Far East and Australasia

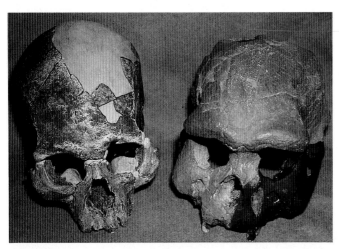

75 (*Top left*) Probable male (left) and female skulls from the Upper Cave at Zhoukoudian, China. Dated from associated fauna to about 25,000 years ago, these fossils are reminiscent of the European Cro-Magnons and are perhaps the oldest known early modern skulls from the region.

76 (*Above*) The Dali skull from China dates from the late middle Pleistocene. It combines large brow ridges and a thick, low braincase with a large but rather modern-looking face.

77 Cast of skulls from Kow Swamp in Australia (left) and Sangiran in Java (right). Followers of the multiregional camp believe the *Homo erectus* populations from Sangiran could have been ancestral to the inhabitants of Kow Swamp, living some 700,000 years later.

78 Two early modern skulls from Liujiang in China (left) and Keilor, Australia (right). Compare the gracile skull from Keilor with the much sturdier Kow Swamp specimen (plate 77).

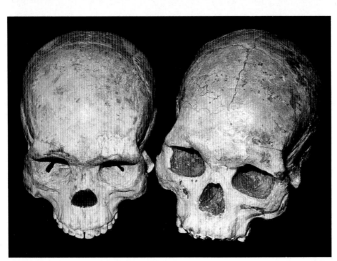

80,000 years,[20] and older still by the TL dating of burnt flints.[21] The Neanderthal sites of Tabūn and Amud have recently been dated by ESR: Amud to 50,000–40,000 years, and Tabūn ranging from 200,000 to 90,000 years old.[22] The Tabūn dates are some of the most challenging to conventional views, in that they date the whole stratigraphic sequence to about double the traditional age estimates (fig. 41). This means that the Tabūn woman found in level C is probably about 110,000 years old i.e. she was an early Neanderthal apparently living at around the same time as, or slightly before, the early modern Qafzeh people.

If the ESR chronology is correct, some major rethinking of our understanding of the later Pleistocene of the Middle East is called for. The whole archaeological sequence at Tabūn was thought to span hand axe industries made about 100,000 years ago, through Middle Palaeolithic industries made by Neanderthals during the middle of the last Ice Age about 60,000 years ago, to those made by the first early Moderns 40,000 years ago. Now it seems that the hand axe makers lived in Tabūn in an earlier interglacial period about 200,000 years ago, followed by early Neanderthals (including the Tabūn woman) living during or immediately after the last interglacial c. 110,000 years ago. Maybe early Moderns visited the site from neighbouring Skhūl about 90,000 years ago and Neanderthals from Kebara may have camped there during the colder period 60,000 years ago. We do not know when the Neanderthals finally stopped using Tabūn for good, but judging from the evidence at Amud, it was perhaps 45,000 years ago – when the transition to the Upper Palaeolithic was beginning in the region. Evidence from the Lebanese site of Ksar Akil (such as the burial of a modern-looking child, nicknamed 'Egbert') suggests that, by 37,000 years ago, early Moderns were back in the Levant to stay.[23]

East and west: Moderns on the move

Comparing the Middle Eastern record with that of western Europe is both instructive and thought-provoking, because these two areas give us the best skeletal samples and archaeological evidence for the period between 120,000 and 50,000 years ago. For the relatively good skeletal evidence we can presumably thank the introduction of the common practice of burial; preservation of the archaeological evidence is largely due to the presence of many caves, whose sediments not only contained and protected the bodies, but also preserved the materials left behind from countless visits and occupations by these hominids.

But interpreting the evidence gives us quite different impressions of what is happening in the two regions. Despite the dramatic climatic changes affecting western Europe, there is a certain similarity between all the populations of humans in this area, and a relative likeness too between the preserved remnants of their behaviour over the 70,000-year period. This was probably because western Europe was a cul-de-sac at the end of the inhabited world, with only fairly narrow access routes from the east, none from the west or the glaciated

north, and none from the south before humans could navigate the Mediterranean. In contrast, the Middle East has been a long-lasting corridor and crossroads between three continents, where distinct populations of animals and humans have constantly alternated or coexisted in occupation. It is perhaps no coincidence that modern humans first appeared here accompanied by some species of mammals characteristic of North African and Arabian areas.

Conditions in the Middle Eastern corridor 100,000 years ago may have provided the springboard for a colonization of the globe by modern humans, which had started with the exodus of modern-looking humans from Africa. This springboard involved changes in both behaviour – which would have the incidental result of territorial expansion – and anatomy. Ultimately, this successful combination would lead modern humans all the way to Australia (between 60,000 and 50,000 years ago), the western Pacific (at least 32,000 years ago) and the Americas (some time between 30,000 and 13,000 years ago – Chapter 6). A phase of dispersals beginning over 40,000 years ago finally led the Moderns to push into the Neanderthals' cul-de-sac of western Europe. We will look at the encounter between the European Neanderthals and the Moderns in Chapters 8 and 9, but first we will take the road south from the crossroads and enter the dark continent of Africa.

CHAPTER 6

The Dark Continent and Beyond:
The Origin of *Homo Sapiens*

Where did we evolve? The last century has seen many suggestions, including submerged continents in the Indian Ocean, the Pampas of Argentina, the outback of Australia, the Arctic circle in Siberia and the continent of Europe where earlier types of hominid were supposedly refined. The list of possibilities is almost as extensive as the range and variety of evidence used by each region's archaeologists to support their particular claim to the cradle of modern humanity. We will now look at the continent of Africa, which we believe has the strongest claim to be the original home of modern people – people who eventually displaced the Neanderthals in Europe and Asia.

A continent comes of age

Although Africa long caught Western imaginations as the primeval continent, its central role in the story of human evolution was eclipsed until relatively recently by the rival claims of Europe and the Far East. The case for the Far East was established in the last century by Dubois' discovery in Java of *Pithecanthropus* (*Homo erectus*), while Europe had the Neanderthals, followed by the Mauer (Heidelberg) finds and the fraudulent remains from Piltdown. The Broken Hill (Rhodesian man) specimen found in 1921 was the first significant ancient African to be identified, but even the subsequent australopithecine find from Taung which followed three years later did little to focus European and American attention on Africa.[1] The general feeling at this time was that Darwin could conceivably have been right about Africa being the *original* hominid homeland since it was also the homeland of our close relatives, the African apes. But it was thought that once early hominids had spread from Africa, this continent would always have lagged behind Europe and Asia, isolated and backward. Even the archaeological evidence which began to emerge in the 1930s from sites such as Olduvai Gorge in Tanzania failed to change such preconceptions because – before the advent of radiometric dating techniques – it was not known that some of the hand axes discovered by the Leakeys at Olduvai were in fact over twice the age of those found in the terraces of the Thames and Somme rivers. At a much later date, the Middle Stone Age of southern Africa was correlated with the Upper Palaeolithic of Europe, to which it seemed a rather poor relation, whereas we will see in Chapter 7 that it is more appropriately correlated with the Middle Palaeolithic (Mousterian) to the north, and is certainly no poor relation.

It is only since the 1960s that Africa has begun to claim its rightful place in human evolutionary history. First came the absolute dates for the Olduvai hominid finds of '*Zinjanthropus boisei*' (now known as *Paranthropus boisei*, see Chapter 3) and *Homo habilis*, and then followed the remarkable series of discoveries at fossil and archaeological sites such as East Turkana and Hadar.[2] But the feeling still persisted that all the key events in the story of modern human origins took place elsewhere.

Middle Pleistocene Africans

Until as recently as 1977, some scholars maintained that the Broken Hill find from Zambia dated to only 50,000 years ago (pl. 60).[3] It is now believed to be about 200,000 years old or more, and thus belongs to the middle Pleistocene. The middle Pleistocene record of Africa also includes related hominids from sites such as Bodo in Ethiopia and Elandsfontein (Saldanha) in South Africa, which are perhaps double the age of Broken Hill.[4] These hominids, like their approximate contemporaries in Europe, are often assigned to 'archaic *Homo sapiens*' or the subspecies '*Homo sapiens rhodesiensis*' (*rhodesiensis* was the species name which Arthur Smith Woodward originally gave to the Broken Hill skull in 1921).[5] Like their European counterparts from Arago in France and Petralona in Greece (Chapter 3), these ancient Africans are neither *sapiens* in the modern sense, nor are they true *erectus*. They have sometimes been regarded as African Neanderthals, and while this is a little more plausible, they are not Neanderthal in the European sense either.

What the African fossils share is a brain size larger than typical *erectus*, housed in a flat, long but more elevated braincase, expanded higher up in the parietal region. In rear view they resemble the outline of a conventional house as opposed to the rather sagging tent shape of *erectus*, the slightly squashed sphere of Neanderthals, and the distinctive modern form of a house wider across the roof than the ground floor.[6] The very strong bar of bone across the occipital in *erectus* is somewhat reduced but still present, and some individuals e.g. Bodo retained very thick skull walls (pl. 61). The face, known from the Bodo and Broken Hill fossils, is huge and especially wide across the orbits, which tend to be low and more rectangular than those of Neanderthals and many Moderns. The nose is wide as in Neanderthals but, more like *erectus*, it is flatter and lower, taking up less of the total facial height. The face projects overall, especially in Bodo, but in Broken Hill (as in Petralona) it is tucked in under the braincase to resemble the Neanderthals or Moderns. The brow ridge is bigger than in Neanderthals but, much as Petralona and the Neanderthals, it is hollowed over much of its width by an extensive frontal sinus (air chamber). This seems to indicate that these Ancients needed large brow ridges more for their outside dimensions than for their inner strength and bone mass (see Chapter 4).

We have little information about the rest of the skeleton, although some of the other human bones from Broken Hill may belong with the 1921 skull or a

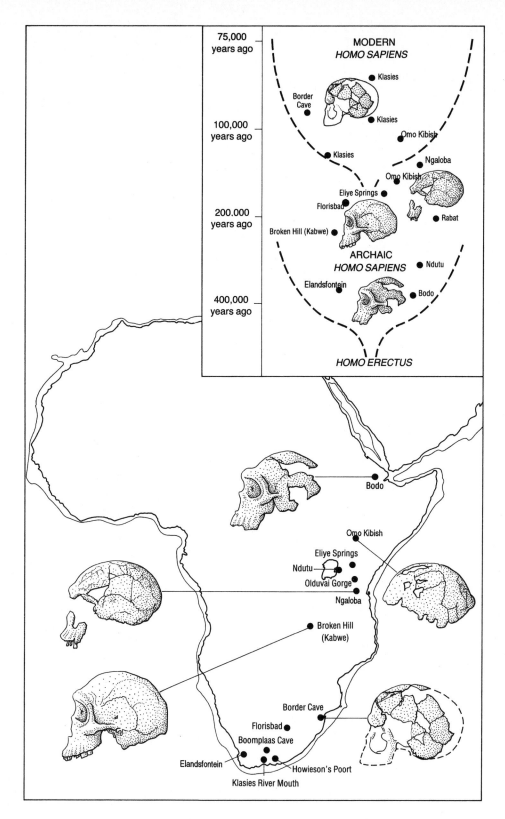

MODERN
HOMO SAPIENS

75,000 years ago

Klasies
Border Cave
Klasies

100,000 years ago

Klasies
Omo Kibish
Ngaloba
Omo Kibish
Eliye Springs
Florisbad

200.000 years ago

Broken Hill (Kabwe)
Rabat

ARCHAIC
HOMO SAPIENS

Ndutu
Elandsfontein

400,000 years ago

Bodo

HOMO ERECTUS

Bodo

Omo Kibish

Eliye Springs
Ndutu
Olduvai Gorge
Ngaloba

Broken Hill (Kabwe)

Border Cave
Florisbad
Boomplaas Cave
Elandsfontein
Howieson's Poort
Klasies River Mouth

42 Map of Africa showing some important middle and late Pleistocene hominid sites; the diagram above it shows the possible evolutionary position of these hominids.

member of the same general population.[7] Most notably a thick midshaft of a femur and a complete shin bone (tibia) were found near the skull. They show a very interesting combination of features because, even though they are both thick-walled, the femur fragment is shaped more like a modern than a Neanderthal one. This means it is widest front to back, rather than nearly circular in cross-section as it is in Neanderthals. The tibia indicates that it belonged to a very tall individual, probably over 1.8 m (6 ft) tall, with body proportions more similar to the 1.6 million-year-old West Turkana boy (known variously as *Homo erectus* or *Homo ergaster*) and modern Africans, than to Neanderthals or more recent populations in temperate or cold areas.

The Broken Hill remains therefore have a special significance. For example, despite the robusticity of the bones and their large joint surfaces, when scaled against height they indicate a more linear and narrower physique than that of Neanderthals.[8] Unfortunately, neither of the two pelvic fragments from Broken Hill can be clearly associated with the main skull. One is from a male, the other a female. They are also too incomplete to indicate how much they differed from those of Neanderthals, although one does show a clear primitive feature in the vertical bar of bone running up from the hip socket. This is also found in far more ancient African fossil hip bones and in the early European pelvis from Arago in southern France (Chapter 3).[9] In summary we can say that these middle Pleistocene Africans were strongly built by modern standards, in some ways more primitive anatomically than us or the Neanderthals, yet there are hints in the limb bones that in certain respects they are a little closer to us than the Neanderthals were. Only more complete skeletons will sharpen our conclusions, but since these African Ancients did not seem to practice cave burial, we will have to depend on the sort of preservation and lucky discovery which yielded the much older, marvellously well-preserved West Turkana skeleton already mentioned.

There are other African fossils that date from the period 500,000–200,000 years ago, but they are more difficult to relate to the fossils we have already discussed.[10] These include two partial jaws from Baringo in Kenya, which resemble such European fossils as Mauer and Arago 13, particularly in their thick bone and lack of chin. Rather more puzzling is the partial skull from Ndutu in Tanzania, which is perhaps 400,000 years old. While this might have been from a contemporary of the Bodo male, the skull seems quite different in shape and more modern.[11] The brow ridge was certainly prominent, and the skull quite thick. Yet the braincase is rather shorter and apparently less flattened. The face is very incomplete, but it is smaller and the cheek region is more delicate than in Broken Hill or Bodo. One explanation is that this is merely due to variation in the population through time and space, or to differences in gender. According to the latter view, Ndutu would be a female. This theory is supported by a second fragment of upper jaw from the Broken Hill cave which is uncertainly dated, but is less robust than that of the skull, and has a more modern-looking cheek region. Further north, in Morocco, there is evidence of a similar middle Pleistocene population from the sites of Salé and

the Thomas Quarries, although here they seem to have comparatively small brains and large teeth for an otherwise anatomically advanced form.[12]

Family relationships

If the Broken Hill remains are indeed distinct from true *Homo erectus*, modern *sapiens*, *and* the Neanderthals, can they be grouped with any other fossil specimens? This is a very difficult question, but there is no doubt that there are strong resemblances to their European counterparts represented by the Mauer, Petralona and Arago finds.[13]

Perhaps all these remains can be assigned to *Homo heidelbergensis* (named after the site of the Mauer discovery, as we saw in Chapter 3). This species would have been a descendant of the original African early *Homo erectus* or *Homo ergaster*, and a probable ancestor for both the Neanderthals in the north and modern *sapiens* in Africa. The evolutionary split must have been under way by 200,000 years ago to judge by the Neanderthal-like Ehringsdorf remains and perhaps even earlier according to some Swanscombe dates. If this widespread Ancient, *Homo heidelbergensis*, evolved into *Homo sapiens* in Africa, where is the evidence of that transition?

The transition to modern humans

Southern Africa

We can trace this evolutionary process in various parts of Africa and perhaps even in the Middle East, at Zuttiyeh.[14] From South Africa there is the Florisbad 'skull' (really only fragments) which has a broad flat forehead, moderate brow ridge, and a short, flat and broad face. The braincase is thick, but overall it seems to have a reasonable 'transitional' shape. Its age is uncertain, but appears to lie between 200,000 and 100,000 years; archaeological associations are with a late hand axe industry or the early Middle Stone Age. A damaged lower jaw from the Cave of Heaths, Makapansgat, South Africa is similar in age, quite small, and has a hint of a chin at the front. From Tanzania, close to Olduvai Gorge, the Ngaloba site at Laetoli produced a rather odd skull in 1978 (pl. 64). This has retained part of the lower face, and is sufficiently complete to indicate a brain size of about 1,350 ml (fully modern in size), a rounded rear, and a rather small but continuous brow ridge. Yet the forehead is very flattened and narrow, and the braincase relatively long and low. The ear region is even reminiscent of that of Neanderthals. The lower face, like Florisbad and the Broken Hill fragment, is broad and flat, with hollowed cheek bones. This Ngaloba skull is dated at about 130,000 years old and is associated with very early Middle Stone Age artifacts. Some researchers actually regard Ngaloba as an early Modern, but we prefer to call it a borderline Modern.

North Africa

Also close to the borderline are the specimens from a Moroccan cave at Jebel Irhoud. Here five different specimens have been found: a nearly complete skull

(Irhoud 1); a braincase (Irhoud 2); a child's mandible (Irhoud 3); a humerus – upper arm – fragment (Irhoud 4); and a fragment of hip bone (Irhoud 5). The humerus fragment is small but very robust, and the jaw combines big teeth with a rather delicate framework and a slight chin. The two skulls show strange blends of characteristics (pls. 66–68). The most complete skull (Irhoud 1) has a rather primitive braincase with a big broad face, but nevertheless looks quite modern in shape. The second skull (Irhoud 2) is so 'transitional' that it was originally believed to be from two different individuals, one with a modern front, the other with a primitive rear. Eventually enough of the parts in between were found to show that there was only one braincase, apparently a genuine example of evolution caught in the act of turning an Ancient into a Modern.

Until recently these Irhoud pieces had no reliable age estimate. All that could be said was that they seemed to belong with stone tools which would not have been out of place among the Neanderthals or the early Moderns of Israel. Traditionally such tools were dated to the early part of the last glacial cycle, but we saw in Chapter 5 that these estimates are often very inaccurate; this may also have been the case at Jebel Irhoud. The ESR results from animal teeth unearthed in levels near the human fossils suggest a date of between 100,000 and 200,000 years.[15] Such age estimates place the fossils firmly back into the earlier Middle Palaeolithic/Middle Stone Age.

ESR techniques have also been applied to animal teeth found near the Singa braincase from the Sudan, giving a similar age range to Jebel Irhoud. This strange fossil was discovered encased in limestone in the banks of the Blue Nile. Because of its bizarre shape it had been regarded as that of an early 'Bushman' or Khoisan, and was believed to prove that this southern African 'race' was once widespread across Africa. Now it seems that the Singa skull was a peculiar member of a population like the one at Jebel Irhoud. The owner of the skull seems to have been a long-term sufferer of a disease which affected bone growth (perhaps a blood disorder), and this made the parietal region grow thicker and broader than normal. The skull base and ear region also bear peculiarities.

East Africa

East Africa has produced three further examples of these early borderline people.[16] From Omo Kibish in southern Ethiopia comes a braincase (Omo 2, pl. 63) supposedly about 130,000 years old which, like the Irhoud specimen, has a more Modern front and an Ancient back. But here the back is not so much 'primitive' in the sense of being like a Neanderthal or Ndutu, but rather bears a more direct resemblance to the much older Ancient, *Homo erectus*. The brain size, however, was at least 1,400 ml and the shape from the rear is like a heightened version of Broken Hill. Although the front is damaged there is hardly a brow ridge at all. Further south, just over the Kenyan border on the eastern side of Lake Turkana, a fragmentary upper jaw, and the front and back of a skull have been found at Guomde. This skull, called by its find number KNM-ER 3884, has a shape in rear view like the Omo braincase, but the profile of the skull is distinctly more modern and curved, although the brow ridge is

strong. Separately, a modern-looking femur (KNM-ER 999) was also found. Not far away, another skull was found by some tourists on the western shore of Lake Turkana at Eliye Springs. The face was somewhat eroded, but clearly resembles those from Irhoud, Ngaloba and Florisbad. In this fossil (KNM-ES 11693), the braincase is large but very broad, and could hardly be called modern. Like the Guomde skull, its age is uncertain.

The first appearance of early modern humans

The transitional group or borderline Moderns we have just discussed display modern characteristics in a disparate way: they are not all combined in any single specimen. It is not until around 100,000 years ago that the shorter, rounder skull, smaller brow ridge and face, prominent chin, and lighter skeletal build – the hallmarks of modern human populations – appear consistently together.[17] Let us examine some examples.

East Africa

We saw in Chapter 5 that modern characteristics were combined in certain skeletons from the Middle East (e.g. Skhūl and Qafzeh), but perhaps the oldest of all such specimens is a partial skeleton from Omo Kibish in Ethiopia (pl. 63).[18] We have already mentioned a braincase (Omo 2) found in the same region, but the skeleton was discovered in 1967 at a similar level, about 2 km away. It was one of Richard Leakey's first important fossil finds, although it has since been overshadowed by his later spectacular successes in the Turkana area of Kenya. Nevertheless, with an age of well over 40,000 years, and perhaps as much as 130,000 years, this fossil is in some ways as significant as any of his other discoveries. The skull is quite complete at the back, and is large and rather thick-boned. However, it is very modern in shape – both in side and rear views. The front of the skull is less complete, but there is enough bone to show a broad and rather flat forehead, and a brow ridge which is thick at the centre but thin at the sides. The face is missing save for a piece of modern-looking cheek bone, and there are fragments of the lower jaw which show a clear chin. There are also fragments of various limb bones which indicate a tall, well-built male individual who was not significantly different in body form from East Africans of today.[19] Exactly how the Omo skeleton relates to the more primitive Omo 2 braincase found such a short distance away is likely to remain unclear until further work can be carried out at the site or it becomes possible to date the fossils more directly. However, the Guomde skull mentioned earlier could be from a related population of early modern people; it combines features of both specimens, and the femur from Guomde looks quite modern.

Southern Africa

At the southern tip of Africa, human occupation of the complex of caves at Klasies River Mouth stretches back to the last interglacial, 120,000–130,000 years ago.[20] The early inhabitants lived on top of marine and wind-blown sand

deposits, where they made Middle Stone Age artifacts, lit fires, and processed meat, plants and shellfish (Chapter 7). Fragmentary human bones only give us glimpses of what these people looked like. A forehead piece from the site has a brow ridge of completely modern type and there are thin-boned skull and jaw pieces and elements of modern-looking arm and foot bones. The jaw bones vary greatly in size, probably reflecting gender differences, and there is also variation in the extent of chin development. Overall, however, these pieces – ranging in age from 70,000 to about 120,000 years old – are very close to an anatomically modern pattern. The fragmentary nature of the bones and the burning and cut marks on some of them have led to suggestions of cannibalism at Klasies; such theories, however, are very difficult to confirm.

Four additional human fossils believed to date from the South African Middle Stone Age are those from Border Cave.[21] Unfortunately, an incomplete skull and parts of limb bones (Border Cave 1, pl. 65) and a lower jaw (Border Cave 2) were found by archaeologists in a dump created by a farmer who mistakenly thought that the cave sediments would make good fertilizer! Although the dumps were also full of Middle Stone Age artifacts, it cannot now be shown whether the human fossils originally came from the same level as the artifacts because the bones contain insufficient collagen to give an accurate radiocarbon date. The skull and limb bones are from a well-built individual by comparison with most present-day South African blacks or Khoisan. The jaw is much more delicate and very like those of modern populations, which is also true of two further finds excavated under better conditions from Middle Stone Age levels: a partial infant's skeleton (Border Cave 3) and another partial lower jaw (Border Cave 5). (Incidentally, Border Cave 4 was an Iron Age skeleton from the uppermost levels of the cave deposits.) Assuming that the remains were attributed to the correct levels, the radiocarbon and ESR dates for the Middle Stone Age levels suggest that the fossils are probably all more than 50,000 years old, and Border Cave 1, 2 and 3 could be more than 80,000 years old.[22] The possibility still persists, however, that the Border Cave bones may have been intrusive burials in the Middle Stone Age levels.[23] Only much more sophisticated direct dating of the bones or the discovery of more human remains from indisputable Middle Stone Age contexts can solve the problems of Border Cave. But regardless of the lingering question mark over the true age of the Border Cave human remains, the site itself has been a very significant source of information about the Middle Stone Age from the tens of thousands of artifacts already found there.

North Africa

The date of the first appearance of modern humans in North Africa has been very difficult to establish, partly due to the scarcity of fossils more recent than the Jebel Irhoud remains, and partly because of doubts about the age of the distinctive Aterian industry found over much of the area (Chapter 7).[24] The tanged projectile points so characteristic of the Aterian are believed by some workers to date from well over 70,000 years ago and are therefore equivalent to

the earlier European Middle Palaeolithic. This is based on a series of absolute dates from sites such as Bir Tarfawi in the Egyptian Sahara. Other scholars, however, especially French ones, subscribe instead to radiocarbon and TL dates for the Aterian which suggest that it is 40,000 years old or less, equivalent to the earliest Upper Palaeolithic. Perhaps the final answer to the age of the Aterian will be similar to the revised estimates of the duration of the African Middle Stone Age and the European Middle Palaeolithic. If that is so, we may be looking at a stone-working complex spanning 100,000 years and associated with a variety of fossil hominids: Ancients, borderlines and Moderns.

All this may seem rather peripheral to the question of when modern people appeared in North Africa, but it is not, because the Aterian site of Dar-es-Soltan in Morocco has produced the remains of several robustly built but modern-looking individuals.[25] Most of the fossils are still unpublished, but the Dar-es-Soltan 5 skull and lower jaw have been the subject of a preliminary description, and are in various ways said to resemble the more primitive Irhoud fossils, the later Moderns in North Africa and Europe, and even recent sub-Saharan populations. If these Dar-es-Soltan fossils really date from more than 70,000 years ago, they would be of great importance in the story of modern human origins. But whatever their age, they hint at long-term regional continuity in North Africa, seeming to link the borderline Moderns of Irhoud with the late Pleistocene Afalou and Taforalt populations. The latter groups, along with a 33,000-year-old skull from Nazlet Khater in Egypt, are the North African equivalents of the European Cro-Magnons: robustly built and showing mixtures of 'racial' features which are nowadays found scattered across the populations of the world. Their teeth and limb proportions, however, seem to mark them clearly as Africans.

Beyond the bones

The fossil evidence we have discussed so far in this chapter builds a case for a morphological transition right across Africa between Ancients and early Moderns via the borderline Moderns some time before 100,000 years ago, and certainly well before the Upper Palaeolithic (or Late Stone Age) which began c.40,000 years ago. We have seen throughout the last few chapters that we can no longer expect (as others before us did) that anatomy and behaviour – as indicated in the archaeological record – go hand in hand. The earliest anatomically modern specimens of Africa and the Levant may have looked like us in many ways, but they were not us. They lack the 100,000 years of change which have made us what we are today. This leaves us with one of the big questions concerning our origins, why then *did* these populations look so much like us?

Evidently they must have found ways to reduce the heavy demands made on the skeletons of the Ancients in their everyday activities (stresses which probably resulted, in populations such as the Neanderthals, in the evolutionary

pressure to develop and maintain robusticity).[26] Maybe the pattern of modern behavioural complexity, supported by better memory, language and planning depth, had already moved from the drawing board to the prototype stage. If this is granted, it becomes possible to imagine how cultural behaviour fostered solutions to survival which were previously solved by muscular means and high activity. Thus physical endurance and strength would have been replaced by mental anticipation and problem-solving through social and technical means.

Whether or not this was the mechanism for the evolution of modern human anatomy we simply do not know. The driving forces behind the evolutionary transition to modern-looking people could also have involved climatic change, geographical isolation, behavioural or social innovations, or some combination of these and other influences. Teasing out the critical factors is going to require both new discoveries and new thinking. We present our thoughts on this crucial question in Chapter 9.

The genetic revolution in modern human origins

In fact, new discoveries and new thinking have already had a great impact on the field of human genetics. When the Out of Africa 2 theory began to take shape from the emerging fossil and dating evidence around 1980, there was little support from studies of living peoples (whether from their bones, teeth or their hereditary material, the genes). The bones and teeth studied from large samples of skulls and dentitions by such scholars as William Howells and Christy Turner respectively, suggested that all living peoples were closely related, but showed an approximate north/south division.[27] Europeans, Mongoloids (East Asians) and native Americans were similar and formed one group, while Africans and Australians formed another. The geneticists on the other hand, working with the limited data about inherited characteristics available at the time (predominantly that of blood groups), proposed a primary east/west division, that is Africa and Europe versus the Far East.[28]

In 1974, the geneticists Masatoshi Nei and Arun Roychoudhury advanced yet another theory. They found that differences between the protein and enzyme material of Europeans and Mongoloids were fairly small, suggesting that the two populations were quite closely related. Differences between these peoples and black African populations, however, were much greater; this indicated that Africans had a longer evolutionary history.[29] Nei and Roychoudury even proposed a date for the original split between Africans and the rest (about 110,000 years ago) and a date of $c.$40,000 years ago for the European/Mongoloid split. Hardly anyone took any notice. But thirteen years later, research originating at Berkeley in California drew comparable conclusions, this time with a much greater impact.

Human mitochondrial DNA
Our hereditary material is made up of chains of genes consisting of a chemical called deoxyribonucleic acid (DNA). Mitochondria (the tiny structures which

Some Characteristics of Mitochondrial DNA

- Mitochondria are small units which generate energy.
- They exist independently of the cell nucleus, and have their own DNA (mtDNA).
- This mtDNA has a rapid rate of evolution that is apparently quite constant over time; recombination with other genes does not occur.
- Moreover most or all mtDNA is inherited from the mother; the mtDNA of a male generally dies with him.
- Since new variation only occurs through mutation, at a seemingly constant rate, and through one parent only, mtDNA is a good candidate for charting population histories.

power our cells) contain a special form of DNA, known as mitochrondrial DNA or mtDNA. The large mtDNA molecule was singled out as a promising tool for studying short-term evolutionary changes because of its peculiar mode of inheritance: this DNA, unlike any other in our bodies, is not inherited equally from both parents via the chromosomes in the nuclei of our cells, but largely or wholly from the mother, from the egg. This means that the origin of our mtDNA potentially stretches without interruption via a whole series of mothers into the distant past.

As mtDNA is copied it sometimes suffers mutations or changes, accumulated at about ten times the rate of our normal DNA. Since these distinct mutations are copied from mother to child, they can be used to trace particular lineages. As time passes, each lineage will accumulate more and more mutations; the number of mutations or differences between them can therefore provide a theoretical measure of evolutionary antiquity i.e. the greater the diversity of mtDNA, the greater the amount of evolutionary change has taken place. Following the mutations back along the family lineages must eventually lead to a common, hypothetical ancestress for all people alive today, often known as Eve or 'our lucky mother'.

When human mtDNA began to be studied in detail during the 1970s, it became clear that all human mtDNA was basically very similar, suggesting that only a few mutational differences had had time to build up between the major geographical populations or 'races'. This implies that their common origin could not have been far back in the past. When defined genetically, therefore, modern humans seem to be recent in origin. To demonstrate that modern humans originated within the Pleistocene, University of California at Berkeley biochemists Rebecca Cann (pl. 98) and Allan Wilson proposed that mtDNA in all animals changed at a constant rate of about 3 per cent per million years. Initial studies suggested, working backwards from today, that the original

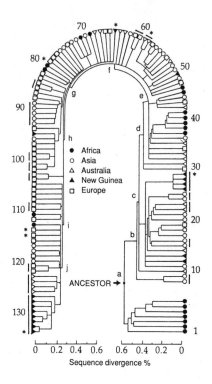

43 *The controversial tree of mitochondrial DNA relationships published by Cann, Stoneking and Wilson in* Nature, *1987. It shows in diagrammatic form the genetic divergence between modern humans, whose ancestors came from Africa, Asia, Australia, New Guinea and Europe. As well as suggesting a clear split between African and non-African groups, it reconstructed a hypothetical female ancestor for all modern mtDNA types; she was African and lived around 200,000 years ago.*

common ancestress of all people lived about 400,000 years ago, during the last days of the species *Homo erectus*.[30] Thus, the subsequent evolution of modern people was probably a world-wide, multiregional process.

Subsequent, more detailed research, however, has not only more than halved the estimated age of Eve, but has also indicated that she most probably came from Africa. For African lineages revealed more diverse types of mtDNA than any other present-day populations, which suggests that they had more time to develop such mutations.[31] The lineages of Europeans, Asians, New Guineans and Australians seemed to show far fewer mutations and therefore a much younger date of differentiation. This conformed neatly with the Out of Africa 2 model, although an origin of roughly 200,000 years ago and a dispersal from there about 100,000 years ago seemed too ancient compared with the fossil evidence. The date of the earliest known modern humans in Africa still appears too early to match the mtDNA estimate (since the oldest fossil remains probably date to 130,000 years); but we now have ESR and TL dates from Skhūl and Qafzeh which *do* seem to show early modern people in western Asia, adjacent to Africa at around 100,000 years ago, as we saw in Chapter 5.[32] Thus we have evidence of a genetic migration from the African centre.

Second thoughts on mtDNA

Genetic support for the Out of Africa 2 model of modern human origins has, not surprisingly, been attacked by supporters of multiregional evolutionary continuity. Their arguments against mtDNA calibration have mostly focused

on the accuracy and consistency of the rate of genetic mutation. Different parts of the mtDNA molecule evolve at different rates, meaning there is much debate about the appropriate rate to use, and indeed whether it is even very constant. (The use of chimpanzee mtDNA data to calibrate human DNA divergences has also been challenged.) Given the uncertain rate of change, multiregionalists argue that the pattern of dispersals could just as well fit the spread of *Homo erectus* from Africa 1 million years ago as that of modern humans from Africa much more recently.[33]

Furthermore, the computer program PAUP (Phylogenetic Analysis Using Parsimony) used by Cann, Wilson and their colleagues is unable to prove conclusively an African origin from present mtDNA data. Much more information will be needed to be able to demonstrate this, although the results of PAUP and other analytical techniques continue to favour an African origin over any other.

On the other hand, new analyses of mtDNA derived from chimpanzee data and from recent human colonizations (for example in New Guinea) suggest that the human mtDNA ancestor most probably lived between 140,000 and 130,000 years ago (although it is admitted that a wide range of dates is possible – from as long ago as 400,000 years ago to as recently as 60,000 years ago), which does concur reasonably well with the available fossil evidence for the earliest modern fossils.[34]

Nuclear DNA

The conclusions from mtDNA databases on a total of some 5,000 modern individuals are strongly supported by the even larger one now building up for

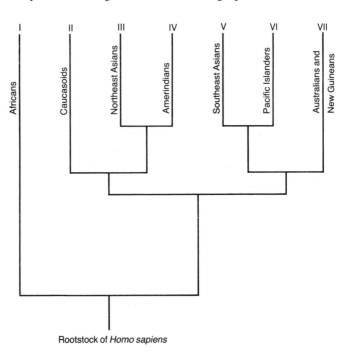

44 Scientist Luigi Luca Cavalli-Sforza and his colleagues compiled a family tree on the basis of the products of nuclear DNA. They found that modern humans are divided into seven major groups, with a primary split between Africans and non-Africans and another Eurasian/South Asian split.

normal (nuclear) DNA and its products (such as blood groups and enzymes).[35] This work generally shows hierarchical clustering (that is, nested clusters) which indicate a primary African/non-African split and a secondary Eurasian/ Southeast Asian split (fig. 44). In other words, the implication is that modern humans originated in Africa, and a population later dispersed from there which in turn split in Asia. One descendant group gave rise to present-day Europeans, Mediterranean peoples, Indians, native Americans, Inuits and East Asians, and the other group to Southeast Asians and Polynesians as well as Australians and New Guineans. According to this research, the origin of all the diversity in the nuclear DNA of modern humans could be even more recent than that of the mtDNA: the ancestral population would probably have lived in Africa about 100,000 years ago, much in line with Nei and Roychoudhury's 1974 estimate.[36] So this calibration, also, suggests an African genetic origin for modern people, long after the time of *Homo erectus*, and even after the differentiation of the Neanderthals. Once again, supporters of multiregional evolution question the calibration, but none of them have so far produced any alternative evidence that can convincingly tie the relationships of the middle Pleistocene Europe and Asia fossils to the genetic patterns now reconstructed for recent human evolution.

A final point about nuclear DNA calibrations is that in several analyses, the genetic differentiation within areas such as Australia and New Guinea is about 40 per cent of the total human variation, and the Americas about 20 per cent. Since Australia and New Guinea were probably colonized about 60,000– 50,000 years ago and the Americas probably less than 30,000 years ago, and assuming a constant rate of genetic diversification, the whole of human variation could have arisen in the last 150,000 years. This is consistent with the Out of Africa 2 model (rather than an origin 1 million years ago or more as proposed by the multiregional camp).

New light on the dark continent

To summarize, we have seen how Africa has moved from a marginal position in the story of modern human origins to a central one. An excellent fossil sequence records an evolutionary metamorphosis from ancient specimens such as Bodo and Broken Hill, through transitional ones such as Ngaloba and Jebel Irhoud, to early modern forms like those from Klasies, Border Cave and Omo Kibish. The dating of these fossil samples is now more accurate, apparently indicating that the transition to modern humans had happened by 100,000 years ago, during the African Middle Stone Age (equivalent to the European Middle Palaeolithic). But was this transition unique to the African continent as the Out of Africa 2 model would imply, or was it part of a world-wide multiregional transformation? The greater age now being assigned to African transitional specimens such as Ngaloba, Singa and Irhoud certainly hints at an evolutionary precedence for Africa, and this is supported by the lack of evidence for comparably early transitions in other regions of the world.

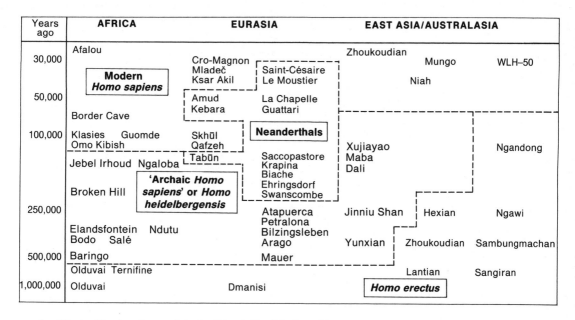

45 *Possible classification of some of the fossil hominids of the later Pleistocene.*

Genetic data provide an independent source of information and largely favour an Out of Africa 2 interpretation; the calibration is critical in differentiating between the original dispersal out of Africa of *Homo erectus* and the much later exodus of early modern people. The larger genetic diversity between Africans is certainly suggestive of a relatively greater antiquity for African differentiation, while the overall low level globally of genetic diversity in humans (in both mtDNA and nuclear DNA) favours a recent origin, most probably within the last 150,000 years. So, even though there is still much to explain concerning the rate and mechanism of mutation in nuclear and mitochondrial DNA, the weight of genetic evidence is very much on the side of the Out of Africa 2 model.[37] While mtDNA has been used (very controversially) to suggest that there was a complete replacement by the Moderns of populations of Ancients such as Neanderthals and the Asian descendants of *Homo erectus* following an Out of Africa 1 dispersal,[38] the nuclear DNA results cannot be used so definitively. We do not know, and may never know, to what extent there was intermixture between the new peoples and the Ancients – though the European evidence, as we will see in Chapter 8, does help to illuminate the answer to this question.

Modern humans in the Far East and Australia

We have seen in this chapter that Africa has yielded evidence of the anatomical transition between ancient and modern humans, and we will discuss the

Racial Features and the Epicanthic Fold

Modern humans around the world vary greatly in physical appearance, and this can be partly related to the environment in which their ancestors lived.[39] We have already discussed how differences in human body shape can be correlated with hot or cold environments; such characteristics are inherited, so that after forced or voluntary migration Afro-Americans still retain an 'African' physique, while white Australians retain their basic European body shape. Although individual skin colour is subject to some variation (for example from sun tanning) this too is predominantly an inherited characteristic, as we can see from the same Afro-American and Australian examples. So variations in modern skin colour are undoubtedly related to the different levels of ultraviolet (UV) light in sunlight to which populations were exposed in the past. Although excessive exposure causes skin cell damage, which can lead to skin cancers (the highest reported level today is in white Australians), UV light is used by special cells under the skin to synthesize essential vitamin D, which may not always be obtained in sufficient quantities from the diet (leading to diseases such as rickets). Different human pigmentation levels (and therefore skin colours) are the result of compromises between the need for protection from excess UV (in intense sunlight) and the requirements of the body for vitamin D synthesis (towards the poles sunlight and UV levels are reduced). Tropical populations thus need higher protection from UV damage and can afford to be dark-skinned because they should still receive sufficient UV for vitamin D production, while high-latitude populations need to be relatively unpigmented to get the full benefit from reduced UV levels, with little risk of skin damage.

A more puzzling 'racial' feature is the epicanthic eye fold found on the upper eyelids of most East Asian people (Mongoloids). This

European evidence in Chapters 8 and 9; but what of other regions of the world? Vast areas of India and Southeast Asia are still virtually *terra incognita* to the palaeoanthropologist, but China, Java and Australia *have* produced important data on modern human origins.

China
The fossils from Dali (pl. 76) and Maba, which may date from between 200,000 and 100,000 years ago, are certainly not borderline Moderns of the sort known from Africa at the same period, but neither are they as primitive as Peking Man or as specialized as the Neanderthals.[40] We do not know when modern people first appeared in China, but the remains of several individuals excavated from the Upper Cave at Zhoukoudian, and now believed to be about 25,000 years

extra fold of skin obscures part of the eye surface nearest to the nose. The fold is also common in native Americans and Polynesians (presumably indicating a close genetic relationship to East Asians) and in Khoisan peoples of southern Africa (where it definitely does not). One theory has been that the Asian eye fold was selected to provide protection against the cold, since the skin fold contains a potentially insulating layer of fat, as well as protecting the eyes from the glare (reflected sunlight and UV) of snow-covered ground. However, this idea does not account for the Khoisan eyefold (unless it is for protection from desert sun glare), nor for its general presence in Down's Syndrome children – of whatever race – who have abnormal chromosomes which affect facial growth before birth. An important clue to the origin of the feature is that most foetuses have an epicanthic fold which gradually disappears before birth or during the first years of life, but in Down's Syndrome children and in the adults of certain populations the eyefold persists. The most clearly correlated feature is upper facial flatness and minimal development of a prominent nasal bridge between the eyes. As European children develop after birth, the nose and middle of the face become more prominent, but this does not happen in Down's Syndrome individuals or oriental populations, so it seems that the eyefold may just represent the normal form of the eye in humans whose upper nose is very flat. Facial flatness itself could be related to climatic adaptation, or it may simply be a feature retained from the earliest modern humans and their immediate African ancestors who had very flat faces. We surmise, therefore, that epicanthic folds were common in early modern people and our African ancestors, but were almost certainly not found in the Neanderthals with their beaky noses.

old, do not look like intermediates between ancient and modern Chinese. Instead, they look more like the Cro-Magnons (pl. 75). If these remains do represent early Mongoloids, then most of the distinctive modern Mongoloid features must have evolved during the last 25,000 years.[41] This is a far shorter timescale than is generally believed, but it is not an impossible one.

Java and Australia

In Java, the descendants of '*Pithecanthropus*' (*Homo erectus*) were probably still living on the banks of the Solo River 100,000 years ago, near present-day Ngandong where a number of their skulls and a couple of leg bones have been found.[42] These Javanese Ancients may have lived on in splendid isolation until their world was disturbed by the arrival of early modern people about 60,000–

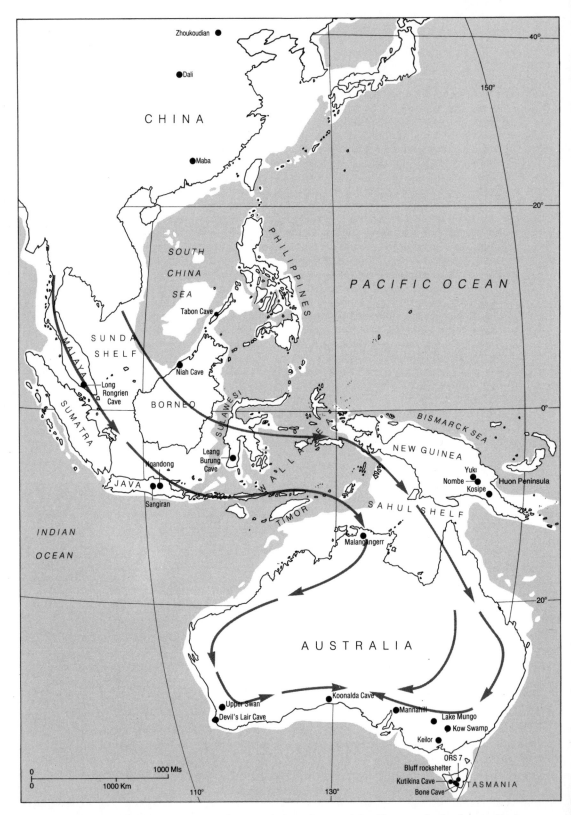

46 *Possible migration routes to New Guinea and Australia at periods of lower sea level, when the Sunda and Sahul land shelves were exposed, and some important sites of early human occupation.*

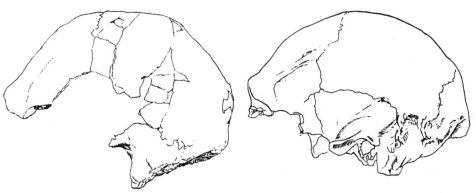

47 *A comparison of the robust Willandra Lakes braincase (WLH–50, left) and the Ngandong cranium XI from Java.*

50,000 years ago. But whether their genes could be found in modern Australians is still uncertain.

Australia was probably colonized by sea crossings about 55,000 years ago, although the exact anatomical nature of these pioneers remains unknown. By 30,000 years ago, southeastern Australia was inhabited by peoples showing a wide range of skeletal characteristics.[43] Some (such as those from Lake Mungo – one of the Willandra lakes – and Keilor) were as gracile as the contemporaneous Cro-Magnons of Europe, while others (such as the poorly dated Willandra Lakes 50 [WLH 50] braincase and the later Kow Swamp fossils) were distinctly more robust: pls. 77, 78. These latter remains can be interpreted in a variety of ways. Some scholars, for instance, believe they resemble the primitive Moderns of Africa and Asia whereas proponents of multiregional evolution have pronounced them reminiscent of the Java and Ngandong peoples, from whom they could have evolved.

There are two main views about the causes of this skeletal variety. One, supported by multiregionalists Alan Thorne and Milford Wolpoff, argues that the variation reflects two separate evolutionary origins: the gracile line having entered from mainland Asia via an eastern island-hopping route; and the robusts representing descendants of people like those known from Ngandong in Java, who entered via a western route.[44] The latter robust lineage would thus have stretched back to Dubois' '*Pithecanthropus*'. The two populations gradually mixed to produce a highly variable population which, even today, has been claimed to retain 'the mark of ancient Java': the flattening of the frontal bones above the brows. The alternative view is that of researchers like Peter Brown, who argues that a physically varied Australian population could have evolved *within* Australia, as human populations diversified in behaviour and local adaptations during the late Pleistocene.[45] The bulk of the genetic data for Australia tends to support the idea of one basic origin for native Australians, with a continuing input of some new genes from the north. But whether a contribution from the Ancients of Java was added to that of the descendants of the Out of Africa 2 pioneers is still unclear.

One possibility that emerges from recent genetic, fossil and archaeological data is that there was in fact more than one modern human dispersal into the Far East. The early one could have been carried out by descendants of people like those at Skhūl and Qafzeh from western Asia. This early eastwards dispersal would have been at a Middle Palaeolithic technological level and retained more of the rather primitive features of the ancestral populations (for example relatively strong brows, big faces and big teeth). These could even have been added to by local evolution or by contact with the last archaic peoples of Southeast Asia during the dispersal into Australasia some 60,000–50,000 years ago. Then there was a second dispersal with the spread of Upper Palaeolithic technologies in Asia after 50,000 years ago. These more Cro-Magnon-like populations are perhaps represented by fossils such as those from the Zhoukoudian Upper Cave in China and Lake Mungo in Australia. Such a model would account for the early physical variation in Australia and the supposed Ngandong-like features of WLH 50. However, a fundamental problem with this and any multiple migration scenario into Australia is that there is no supporting evidence for the existence of separate migrations from the archaeological evidence (e.g. stone tool typologies).

Having briefly reviewed the anatomical evidence from the Far East and Australia, it is now time to see what light the behavioural (archaeological) evidence can throw on the question of modern human origins, by first returning to the homeland of the Neanderthals.

CHAPTER 7

The Archaeology of the Ancients

In this chapter we will discuss the archaeology of the Neanderthals and their contemporaries elsewhere in the Old World. As a record of material culture, this archaeological evidence can provide an enormous amount of information about the behaviour of the Ancients. We will use studies of the Neanderthals (whose homelands – Europe and the Middle East – have been the focus of more research than any other region in the Old World) as a framework with which to build a wider picture of the Ancients in general. Our main aim is to establish the similarities and differences in behaviour between the various populations of Ancients, patterns which we can then contrast in Chapter 9 with those of the Moderns, allowing us finally to examine the arguments for behavioural continuity or replacement.

The Middle Palaeolithic, the era of the later Ancients including the Neanderthals, probably started between 250,000 and 200,000 years ago. It was followed in many parts of the world some 40,000 to 30,000 years ago by the Upper Palaeolithic, a period marked by different techniques of stone working, additions to the cultural inventory such as art and architecture, and evidence for population expansion into new lands and continents[1] – all associated exclusively as a cultural package with the Moderns.

Over the lengthy duration of the Middle Palaeolithic – at least 10,000 generations – and across the vast regions of the world inhabited by the Ancients, there were local differences in settlement, technology and the organization of survival and social life. These differences are often subtle and can only be detected through the detailed study of the techniques of flaking stone, or butchering and transporting animal carcasses. Studies of such diversity within the uniformity[2] of the archaeology of the Middle Palaeolithic have replaced earlier views that either trends in technological progress could be traced within this period[3] or alternatively that no change took place at all.[4]

Our enquiry into the archaeology of the Neanderthals (and the Ancients in general) will begin with a review of the chronology of the Middle Palaeolithic and its division from the Lower Palaeolithic. We will then turn to evidence for the ever-increasing complexity of life, starting with the most readily available data: that from the stone tools (introduced in Chapter 3). The typology of stone tools has been largely superseded by models of behaviour that concentrate more on the 'biography' of the implement – how it was made, used, resharpened, recycled, changed shape and finally thrown away. Rather than classifying tools into types (such as points and scrapers) and quantifying the proportions of each type in an excavated assemblage, the current practice is

Stone Tool Typology of the Middle Palaeolithic

The shapes of stone tools are compared and classified in what is known as typological analysis. Once a stone flake has been knapped (see box pp. 56–57) it can either be used without further modification or it can be retouched to change the shape and angle of the working edge, or resharpened to obtain a fresh cutting edge of unmodified flint. In the process of retouch the flake in effect becomes the core, and through controlled flaking of the edge it can be thinned or the edges shaped. These retouched flakes are often described as tools and a representative selection is shown in fig. 48. Distinctive Middle Palaeolithic flake tools include points, scrapers and denticulates (notched pieces), and tanged tools. Within these broad classes are a variety of forms and it is the business of the typologist to order and classify them.

We owe much of our present thinking on Middle Palaeolithic typology and technology to François Bordes (1919–1981), who standardized procedures and introduced a quantitative approach to the discipline. Bordes' study focused on the lithic material from southwest France, consisting of 63 tool types.[5] He made comparisons between the tool assemblages from different levels – within and between sites – on the basis of certain simple technological indices. He also quantified the different methods of tool manufacture, including the Levallois technique (see box on p. 149), and the extent of blade production.

Bordes had expected to find enormous variation between the tool types and techniques from different levels and sites, but he

48 Eight common types from François Bordes' list of 63 Middle Palaeolithic stone tools. 3 Levallois point. 6 Mousterian flake point. 17 Convex-concave side scraper. 23 Transverse side scraper. 30 End scraper. 32 Burin (the arrows point to the chisel-like facets). 38 Naturally backed knife. 43 Denticulate.

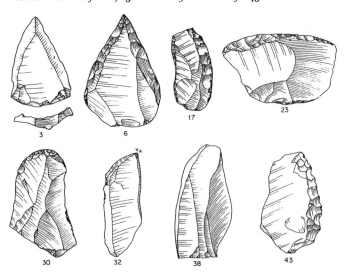

discovered to his great surprise that the proportions of tools and methods of manufacture within each assemblage almost always fell into one of five groups:

1 La Quina: low in Levallois technique (<10%)
2 La Ferrassie: high in Levallois technique (14–30%)
3 Typical
4 Mousterian of Acheulean Tradition: A with hand axes; B without hand axes
5 Denticulate

He concluded that these five types of assemblage were manufactured by five different Neanderthal tribes, that coexisted but had very little contact with each other. We will return to Bordes' theory later.

The names for many of the retouched flakes reflect their apparent function. We can usually make no more than an intuitive guess as to their function, although studies of the damage to edges from utilization have shown that some of the pieces we call scrapers were indeed most probably used for that task.[6]

Elsewhere in the Middle Palaeolithic world these same functional descriptions are commonly used and, as might be expected, added to. From the Sahara and Maghreb of northern Africa come many examples of tanged tools known as Aterian points, some of which at c.100,000 years old might represent the oldest examples of deliberate retouching to increase the effectiveness of hafted projectiles.[7] The East African assemblages have pieces known as sinew-frayers.[8] Large core tools have been found in Middle Stone Age contexts in the Zaïre basin. The Lupemban pick and lanceolate are distinctive elements in what is termed the heavy duty component of such assemblages.[9] In contrast the light duty component is made up of scrapers and flake tools.[10]

*49 Middle Stone Age artifacts from Africa: **a** Lupemban pick; **b** lanceolate Lupemban pick; **c** sinew frayer; **d** Aterian point.*

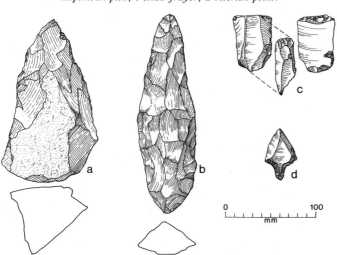

thus to concentrate on the raw materials used and the variety of edges produced by the many different techniques.

From the artifact we will proceed to an examination of the Ancients' use of campsites. How were these organized? Is there any evidence for the systematic construction of hearths? What can we tell from the spatial patterning of stone and bone material? And what evidence is there for houses and shelters? At this level of analysis we can also see the contribution of other animals, such as hyenas and bears, to the accumulation of animal bones in those locations used at other times by the Ancients. We will also examine claims for the appearance of the first symbolic burials by the Neanderthals, and the arguments for the emergence of cultural behaviour e.g. the variation in the shape of stone tools to express cultural identity.

From the campsite we will move out to the landscape. The Middle Palaeolithic world, like the modern world, was highly varied in terms of habitats, food and natural resources (such as suitable stone for knapping), and we will study how these different landscapes were used by the different populations of Ancients. Obtaining raw materials and provisioning campsites with food are just two of the major aspects of Ancient life for which evidence has survived. The animal bones and stone tools which allow us to reconstruct such behaviour are pointers to that all-important human attribute: mobility. When we combine mobility with the ability to adjust group size to the season and the prevailing Pleistocene climate (Chapter 2) we have two of the most powerful means by which all hominids have survived. A third element, the forward planning through the storage of food and equipment, is also important, and a discussion of the evidence for all three – mobility, variations in group size and storage – will bring us closer to answering the question of how similar or not the survival behaviour of the Ancients was from that of the Moderns.

The final section of the chapter looks at the limits of the Ancients' world (fig. 1). The Neanderthals were the first colonizers of certain habitats, such as the north European plain and the mountains of Central Asia. However, much of the Old World, and all of Australia and the Americas, remained uninhabited. By considering the geographical extent of their territory, the range of environments they lived in, and the effect of climate on long-term occupation, we have another line of evidence for establishing similarities with and differences from ourselves.

The chronology of the Middle Palaeolithic

As we saw in Chapter 2, the middle Pleistocene was once described by Glyn Isaac as 'the muddle in the middle'. This unflattering term could have been applied with equal justification to the chronology of the Middle Palaeolithic (and its equivalent in Africa – the Middle Stone Age[11]). One reason for this was the lack of absolute dates for this period compared with the Lower Palaeolithic of East Africa (where Isaac worked) and the Upper Palaeolithic world-wide. But this is now changing and the chronological muddle is beginning to unravel.

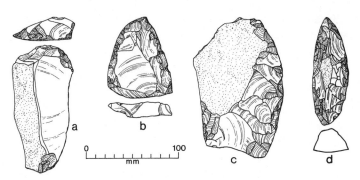

50 Some of the tools recovered from High Lodge in England. In apparent contradiction to traditional Palaeolithic chronologies, these implements are very Middle Palaeolithic in appearance but have been dated to the Lower Palaeolithic, c. 500,000 years ago. a End scraper; b convergent scraper; c convex side scraper; d steep scraper or limace.

As it does so, however, we are discovering that some long cherished notions about the ages of sites and stone tool industries will have to be rethought.[12]

The most fundamental issue to be challenged was the division between the Lower and Middle Palaeolithic. As we discussed in Chapter 2, the Lower Palaeolithic (best known in Europe through Acheulean industries) was traditionally defined by the widespread occurrence of large bifacially worked implements known as hand axes. These are usually of ovate or pointed form, and scrapers are also common. The Middle Palaeolithic was characterized by retouched (modified) tools such as scrapers, and hand axes in this period tended to be rare. (The Mousterian is one such Middle Palaeolithic stone industry in Europe, and is generally associated with the classic Neanderthals.) The concept, embodied in these definitions, of technological progress – whereby tools gradually became smaller and finer through time – has long been abandoned. But few were expecting it to be quite so comprehensively overturned as it has been by recent work.

Chronological confusions in northwest Europe

The two English sites of High Lodge and Boxgrove in eastern and southern England respectively were among the first to upset traditional beliefs. Geological evidence suggests that these sites were two of the earliest in England, dated according to the revised deep-sea chronology to about 500,000–400,000 years old. Such antiquity implies they should belong to the Lower Palaeolithic. But the flints found at High Lodge are very Middle Palaeolithic in form. They consist of well-struck flakes retouched into a limited range of scraper and point forms (see figure above). And furthermore, hand axes are missing. At Boxgrove the surprise is of a rather different nature. Hand axes *were* found at this site, so there is no doubt about its traditional Lower Palaeolithic credentials, but the axes are finely made ovates. Previously, such 'advanced' artistry would have been assigned a much later date.[13]

Another site to upset traditional Palaeolithic chronologies was the site of Pontnewydd Cave in north Wales. We saw in the box on pp. 58–59 that this site

51 A hard rock hand axe, made on a fine siliceous tuff. About 200,000 years old, and 12 cm tall, it was excavated from Pontnewydd Cave.

has been dated to about 200,000 years ago. And yet the hand axes, cores and flakes found at Pontnewydd are made on coarse-grained raw materials such as rhyolites and volcanic tuffs.[14] The crude appearance of the hand axes would once have suggested that they were much older than their actual date now indicates.

At the opposite extreme is the open site of Swanscombe in the Thames Valley. In the Barnfield pit site, a complex stratigraphy contains a series of river loams and gravels with an interglacial age of *c*.420,000–360,000 years ago.[15] The lower loam contains no hand axes, but an assemblage of chopping tools and thick irregular flakes. (This assemblage is known as Clactonian after similar material excavated from an old stream channel at the holiday resort of Clacton on the east coast of England.)[16] There could hardly be any greater difference than with the Acheulean industry from the upper loam, which contains many highly refined ovate hand axes. Both industries are probably much older than the coarse-looking Pontnewydd material.

The rich and complex site of La Cotte on Jersey (in the Channel Islands) yielded similarly contradictory material to the traditional schemes. Dated to about 238,000 years ago,[17] the site is dominated by flake tools such as side scrapers. Hand axes are either rare or absent, while the Levallois technique (see below) is common. Such artifactual evidence would firmly suggest that the site belonged to the Middle Palaeolithic. Yet La Cotte is very similar in age to the 'Lower' Palaeolithic material from Pontnewydd, and it more closely resembles the stone artifacts from High Lodge than the classic Lower Palaeolithic site of Swanscombe, to which it is nearer in age.

These discoveries have made it very difficult to say exactly when the Middle Palaeolithic began. We must realize that we are still trying to use a classification that was devised some time ago with very different assumptions about how the Pleistocene and the Palaeolithic were organized, assumptions determined in large part by the limited techniques then available for dating sites of such antiquity. Perhaps a term such as Earlier Palaeolithic – which combines the Lower and Middle Palaeolithic of Europe prior to the Upper Palaeolithic, 40,000 years ago – should be adopted to avoid any further confusion that absolute dates will bring (as they become increasingly available) to the traditional divisions.[18] But for the sake of consistency with earlier discussions in the book we shall continue to use the Lower and Middle Palaeolithic terminology.

We will adopt the date of 250,000–200,000 years ago that many other scholars now favour for the start of the Middle Palaeolithic. This date was partly chosen because after this time hand axes appear to decline in numbers, while a distinctive new method of preparing stone nodules to produce large prepared flakes and blades – the Levallois technique (see box opposite) – becomes much more common. The changeover was a slow process. Using the long sequence from the granite headland site of La Cotte, Paul Callow has argued that by 200,000 years ago the Middle Palaeolithic was firmly established. During the 50,000 years over which this development took place,

there are now absolute dates which show a great deal of variability in the composition of stone assemblages. It is impossible to see a clear sequence from one tool industry to the next. Progress – with the implication of a relentless drive to get better, faster – could not be a more inappropriate description.

The transition to the Middle Palaeolithic elsewhere

This variability is not confined to the British Isles. At the travertine site of Ehringsdorf in eastern Germany, for instance, a date of about 225,000 years has been assigned to an assemblage of stone tools that lacks both hand axes and large bifacial tools.[21] It contains instead a series of finely made, bifacially worked points and scrapers. Before the site was given an absolute date, the material was thought to be a likely ancestral industry – from the last interglacial (i.e. c.120,000 years ago) – for the later Mousterian. Now we can see that the picture is more complex. The stone industry from another travertine site, Vértesszöllös in Hungary, consists of small pebble tools and irregularly retouched flakes. Such implements are usually considered 'crude' in compari-

0 20
mm

55 Chopping tools from Tata, Hungary.

son with the Acheulean hand axes and prepared core techniques such as Levallois. Consequently Vértesszöllös is usually spoken of as a classic Lower Palaeolithic pebble tool site, and it was originally thought to be at least 350,000 years old.[22] However, recent uranium-series dates indicate that the thick travertines were laid down over a period of 50,000 years, between 210,000 and 160,000 years ago – in other words, much later than the 'refined' flake tool assemblages from High Lodge and Ehringsdorf and the ovate and pointed hand axe assemblages of sites such as Boxgrove and Swanscombe. (This appears to conflict with some of the mammal remains, which indicate an earlier date.)

On the eastern edge of the Neanderthals' world (map pp. 10–11), in Tadzhikistan in Central Asia, are the sites of Karatau and Lakhuti. Thermo-luminescence dating of simple flakes and pebble tools from loesses at the two sites has yielded dates of 194,000–210,000 and 150,000–130,000 years respectively.[23] And to the south, in sub-Saharan Africa, a number of so-called late Acheulean sites (meaning that large hand axes were still common) have been dated e.g. to 260,000 years ago at Isimila and 230,000 years ago at Kapthurin in northern Kenya. Desmond Clark has argued that the transition to the Middle Palaeolithic/Middle Stone Age took place about 200,000 years ago in Africa, since the site of Gademotta in the Ethiopian Lakes section of the East African rift valley has a Middle Stone Age assemblage below a volcanic tuff dated to about 235,000 years ago.[24]

Diversity in the Middle Palaeolithic

The earliest Middle Palaeolithic that we have just reviewed was therefore a period of transition. Within the period 250,000–200,000 years ago we find considerable variety in the composition and technology of assemblages. This variety may arise partly from the differences in raw materials that were available. But this cannot be the whole explanation, since the Levallois technique is employed on the coarse rocks of Pontnewydd Cave and

throughout the volcanic areas of Africa, as well as in areas where fine-grained flints and cherts are a readily available raw material.

The diversity in the *proportions* of the different types of stone tools found in Middle Palaeolithic assemblages, however, is based on only a very limited range of tool types themselves. Hand axes, flakes, Levallois flakes and blades, side scrapers, points, cores and pebble/chopping tools make up the bulk of the artifactual material. Once established, the pattern of assemblage types appears to continue throughout the period 200,000 to 130,000 years ago.

The later Middle Palaeolithic in Europe lasts from about 130,000 to 35,000 years ago. It therefore spans the last interglacial and both climatic phases of the early glacial (see table p. 45) and coincides with the period of the classic Neanderthals in southwest Europe and the Middle East. There is some overlap with the earliest Upper Palaeolithic industries, such as the Aurignacian (Chapters 8 and 9), which appear by 40,000 years ago. The period is also marked by additional variety in the lithic material. Recent TL dating at important French cave sites such as the Grotte Vaufrey, Combe Grenal, Le Moustier and Pech de l'Azé has shown that these classic Mousterian assemblages belong in this later phase of the Middle Palaeolithic (Appendix 1).[25]

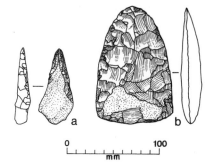

56 Tools from the later Middle Palaeolithic. a Micoquian knife or hand axe. b Mousterian of Acheulean Tradition knife or hand axe.

0 100
mm

The 100,000 years of the later Middle Palaeolithic also saw the introduction of distinctively shaped stone tools whose chronological position is better understood than the previous 150,000 years. These include the small Micoquian hand axes and knives and the classic triangular hand axes/knives found in the later Middle Palaeolithic of England and France. In France, the latter occur in assemblages known as the Mousterian of Acheulean Tradition (MAT), so named because of the reappearance in a Middle Palaeolithic (Mousterian) industry of large, hand axe-like implements similar to those that characterize the Acheulean. Such assemblages can be dated to the early part of the last glaciation after 75,000 years ago. The Micoquian, named after level 6 from the cave of La Micoque in southwest France, is widely used to describe a variety of assemblages of this age in other parts of Europe. A number of regional variations have been recognized, for example the distinctive asymmetrical knives from Bockstein Cave in southern Germany or the Pradnik 'knives' from Poland.

New Research on Stone Tools: a Focus on Edges

57 Drawing of a scraper, with the previous stages of its production shown. The implement changes shape as a result of continuous retouch, from a single-edged side scraper to a transverse scraper.

The traditional typologies of the European Middle Palaeolithic treat each tool type as a distinct artifact that the flint knapper had set out to make. However, this takes no account of the retouching process. Harold Dibble has recently shown that differences between tools are in fact more accurately a measure of the continuous process of utilization and resharpening (fig. 57).[26] As the scraper is reduced in size the retouch tends to get heavier and the piece passes, typologically, from a straight-edged, single-sided scraper to a convex form, and finally becomes a transverse scraper. The biography of the implement is therefore determined by a host of factors governing the intensity with which it was used and at what stage it was thrown away.

As a result, the edges of a tool are now becoming more important for understanding stone technology than its overall shape. In a study of Middle Palaeolithic collections from Spain, Michael Barton concludes that irrespective of tool shape there were only two basic edges.[27] The first are those found on notches and denticulates (fig. 48). They are one-offs, expediently made and used, comparable to the rare examples of Middle Palaeolithic burins and piercers. The second set of edges are found on points and scrapers ; they vary continuously in size and shape as a result of the nature and intensity of their use.

Instances of recycling raw materials have been noted by scholars previously,[28] but only recently have they assumed significance. For example, specialized resharpening is known from La Cotte in Jersey where over 2,000 sharpening flakes have been found.[29] Of these only one could be refitted back to the tool from which it had been struck (fig. 58).[30] Recycled flakes are most common in those assemblages at La Cotte where flint sources had become rare due to such factors as rising sea levels.

The link between a reduction technique and changes in the environment at La Cotte warns us against a stolid view of Middle Palaeolithic knappers – bound by tradition and limited in their choices by low intellects. The idea that they held a mental template,

58 A refitted sharpening flake from the Middle Palaeolithic site of La Cotte, Jersey.

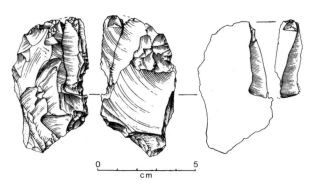

a sort of knapper's blueprint, in their head when making tools is too simplistic. The range of tool types may have been limited and the proportions between assemblages repetitive, but the sequence of reduction was dynamic, related to a complicated web of decisions about survival. Furthermore, the demonstration by Lawrence Keeley and other experimental edge-wear specialists, that many 'tools' were just sharp-edged, unmodified flakes has further questioned the significance of typological analysis for understanding behaviour.

Contradictions to traditional European chronologies

The Middle East and southern Africa, both occupied by the Ancients, have provided quite a different picture of Middle Palaeolithic stone technology and typologies. As we saw in Chapter 5, the Middle East has yielded evidence which contradicts the long-established European association between hominid fossils and types of stone tools. For many years European archaeologists believed that Middle Palaeolithic stone tools would be made by Neanderthals and Upper Palaeolithic implements by Cro-Magnon, modern people. That this theory can no longer be supported is indicated by the discovery of a Neanderthal skeleton at Kebara Cave in Israel and the anatomically modern skulls and skeletons from the much older Qafzeh cave. Both sites, irrespective of their fossils, have Middle Palaeolithic tools.[31]

A second contradiction to the European chronology of the Palaeolithic concerns what tools were made when. In Europe the technological divisions created for the Middle and Upper Palaeolithic had always assumed a measure of advance, if not progress, from a flake-based to a blade-based stone technology. Thus, Upper Palaeolithic blades were slender and lightweight, often far more than twice as long as they were wide (the criterion for distinguishing blades from flakes). In Europe, the division between the two periods could be demonstrated stratigraphically by the many sites, such as La Ferrassie or El Castillo, at which Middle Palaeolithic assemblages were overlain by Upper Palaeolithic industries. The Middle/Upper Palaeolithic division was therefore a chronological statement about which technological and typological system was older.

But outside Europe this chronological distinction has never been so clear cut. Ever since Dorothy Garrod's excavations at Tabūn cave in Mount Carmel and Alfred Rust's investigations of the Yabrud rockshelter in Syria it has been apparent that the stone technology of the Upper Palaeolithic appears and disappears in the long stratigraphies of these caves, well before the genuine Upper Palaeolithic is established.[32] These assemblages are known as Amudian, after the Wadi Amud where the same sequence has been found. Thus, blades and some other Upper Palaeolithic tool types appear in the archaeological

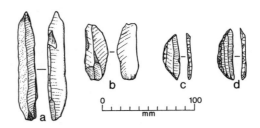

59 Pre-Upper Palaeolithic tools from north and south Africa.
a Awl burin (north Africa). b Notched blade (north Africa).
c,d Backed blades, probably hafted (south Africa).

record at these sites, only to be followed by thick deposits of Middle Palaeolithic, Mousterian assemblages, often with heavy use of the Levallois technique. A similar pattern occurred at the Libyan cave of Haua Fteah, while at a corresponding latitude (but 7,600 km to the south) the huge deposits in the caves at Klasies River Mouth also contain a rich Upper Palaeolithic blade technology stratified within a long Middle Stone Age sequence.[33] This assemblage, known as the Howiesons Poort, was not only dominated by blades made on stone imported some distance from the site, but also contained geometric microliths, including triangles and trapezes which some believe were most probably hafted as barbs in arrows.[34] These microliths are dated to between 50,000 and 70,000 years ago. The contrast between this assemblage and the flake technologies of the under- and over-lying Middle Stone Age is very marked indeed.

Avraham Ronen has called the various early appearances of Upper Palaeolithic technology the pre-Upper Palaeolithic, or PUP for short. The dating of these assemblages is not always definite, but most of them are probably of a similar age to the PUP at Klasies River Mouth. Which type of hominid or hominids made them is uncertain (Chapter 8). But what *is* clear is that the stone-working techniques of the Upper Palaeolithic, far from sweeping the board as they did in Europe after 40,000 years ago, elsewhere met an indifferent or short-lived response when first used at an earlier time. Of course, this discovery really tells us most about the way we believe Palaeolithic technology should change i.e. from crude to fine, with the assumption that what is closest in time to the present *must* be an advance. The widespread phenomenon of the PUP provides us with an alternative to traditional classification of the Middle and Upper Palaeolithic. Another alternative is to consider the variation between assemblages of stone tools not so much in the broad terms of Middle and Upper Palaeolithic technology and typology, but instead in relation to their function (see box on p. 152).

CAMPSITES

The main characteristic of the Ancients' campsites is a negative one: the lack of features. Until well into the later Middle Palaeolithic, some 60,000 years ago,

Settlement Types

A model of Middle Palaeolithic settlement was first put forward 20 years ago by Lewis and Sally Binford.[35] They argued that the starting point for understanding the limited variability in assemblages of Mousterian stone tools, as revealed by Bordes (pp. 144–45), must be to view them as components in a regional system. The model which they proposed was very simple. Settlements were divided into two main types: *base camps*, where food was prepared and consumed, and tools manufactured and repaired; and *work camps*, where food and raw materials were obtained. They argued for the mobility of Middle Palaeolithic people in the landscape since food resources were not evenly distributed, and would vary not only in the long term as climate changed but also seasonally. This mobility produced a third type of camp, the *overnight stop*.

The originality of their approach lay in testing this model by analysing the combination of tool types in Mousterian assemblages. Their study is known as a functional approach since they assigned functions to the tools before carrying out a computer-assisted factor analysis on the material from a small number of sites in Europe and the Middle East.[36] Their analysis suggested that base camps could be identified with two of Bordes' five Mousterian groups whereas those assemblages dominated by denticulate tools and side scrapers (fig. 48) were the result of activities carried out at work camps.[37]

there is an absence of such obvious campsite items as structured hearths (rather than just a concentration of ash), post holes for tents, pits for storage, or trenches from house construction.

In northern Europe there are a number of sites with exceptional preservation. These include Biache-St-Vaast in northeast France, Maastricht-Belvédère in the Netherlands, and the English sites of Boxgrove, Hoxne, Clacton and the loams at Swanscombe. But what is striking about all these sites which have bones and stone tools in primary contexts, is how unstructured they appear. Nowhere do we find built hearths, pits, post holes or even arrangements of stones and bones as windbreaks. Poor preservation cannot be blamed, because these sites are better preserved than many from the much later Bronze Age or Roman periods. Yet campsites stubbornly refuse to be found. As Catherine Farizy has concluded, the uniform nature of remains at these sites suggests that only a limited range of activities was carried out.[38] She believes that behaviour at this time did not link different functions to different places.

'Site' therefore becomes an inappropriate term to describe such unstructured locations. They are pieces of the landscape which happen to have had a

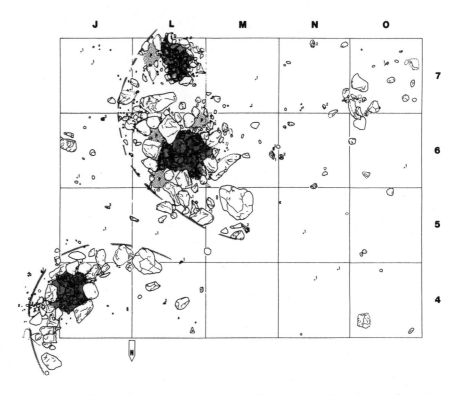

60 *Some of the earliest known constructed hearths, dating from the end of
the Middle Palaeolithic, have recently been excavated at Vilas Ruivas in Portugal.*

higher than average number of flints and bones deposited upon them. The only
patterns we can safely interpret are the activities of butchering animals and
stone knapping, where we can, on occasion, see where the person knelt from the
spaces in the waste flakes they left behind. In the case of the latter activity, it
was very much a 15-minute culture that lasted in Europe for at least half a
million years.

While substantial hearths are absent, thick ash deposits, burnt bone and
charcoal are very common in both open and cave sites. Ash deposits are found
throughout the Klasies sequence in South Africa where many layers with ash
lenses occur, and similar evidence for burning is known from La Cotte in the
Channel Islands and Vértesszöllös in Hungary. Archaeologist Ofer Bar-Yosef
makes the same observation for the Levantine sites.[39] Middle Palaeolithic
people it seems had fire but they did not build elaborate hearths. The most
complex hearths consisted of small scoops in the cave floor.

The first examples of features and structures at the Ancients' campsites
come towards the end of the Middle Palaeolithic about 60,000 years ago. A
well-built hearth has been excavated by Luis Raposo at Vilas Ruivas in
Portugal.[40] It is associated with a late Mousterian tool assemblage. Hearths of
similar age are known from the multi-level sites of Molodova on the Dnestr

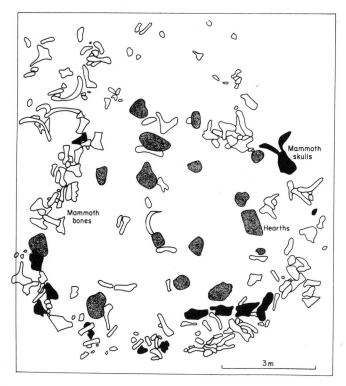

61 *A Mousterian level at Molodova yielded piles of mammoth bones that are thought once to have formed part of a very early hut or windbreak.*

River in Russia, although they are not stone-built.[41] However, their frequency in a single occupation horizon and their novel association with windbreaks made from piles of mammoth bones is worth noting.

The artificial structures at Molodova are the earliest yet documented which have stood the test of critical scrutiny. There have been many claims for older huts and cabins but none are convincing. Perhaps the best known is the supposed series of huts with internal hearths that Henry de Lumley excavated at Terra Amata in Nice.[42] Work on refitting the flints by Paola Villa has shown that the site was more disturbed than previously thought.[43] Inspection of the few published plans reveals an all too familiar low-density scatter of stone and animal bone with localized patches of burning. These are most definitely not a series of beach huts as so commonly speculated.[44]

There are other ways to examine the fireside differences in the behaviour of the Ancients. At the Grotte Vaufrey in France, Jan Simek has investigated the patterns revealed by the meticulous excavations undertaken by Jean-Philippe Rigaud.[45] A lens 8 cm thick found in level VIII contains a rich Mousterian assemblage, dated to more than 132,000 years ago. The artifacts and bones form clusters around a rock fall. The lack of hearths results in very little formal structure and no focus for activity. The contents of these clusters of material are

very repetitive (unlike those in the Upper Palaeolithic levels at the nearby site of Le Flageolet), and may point to the repeated occupation of the shelter by a small group. Simek interprets the Grotte Vaufrey patterns according to Lewis Binford's theory that Middle Palaeolithic foragers frequently moved their residential base camps, whereas Upper Palaeolithic peoples operated out of permanently occupied home bases and only used rockshelters as special purpose sites to exploit strategic resources (see box on p. 155).

Two other issues about Middle Palaeolithic campsites need to be discussed. These are the much debated topics of art and burial, and the extent to which they were practised by the Ancients.

Burials

The so-called Middle Palaeolithic burials only occurred consistently in Europe, the Middle East and Central Asia.[46] Just one has been unambiguously identified in Africa: the child burial at Border Cave, which may be as old as 80,000 years. None come from open sites. Strictly speaking it is more accurate to refer to these finds as complete or nearly complete skeletons rather than burials, however closely they seem to foreshadow current practice.[47] What is most interesting about the distribution of these finds is their concentration in western Europe and the Middle East (fig. 1). The greatest number occur in southwest France, with a notable outlier at Spy in Belgium. The only fairly complete skeleton ever to come from central Europe was the first from the Feldhofer Cave in the Neander Valley, found as we have seen by workmen in 1856. Elsewhere in central and eastern Europe the Neanderthal material is fragmentary – bits of skull and limb bones. At Kiik-Koba in the Crimea, two bodies – an adult male and infant – were found during excavations between 1924 and 1926. Let us now conduct a brief survey of the evidence for burials.

In the Middle East fairly complete bodies have been excavated at Kebara, Tabūn, and Amud, and modern humans at Qafzeh and Skhūl. In Iraq, the cave site of Shanidar has produced a series of important Neanderthal remains, including the one referred to as the flower burial (fig. 62).[48] The pollen grains in the sediments surrounding the body were interpreted as garlands of flowers strewn across the corpse. But not everyone believes this interpretation, preferring instead the more prosaic explanation that the grains percolated through the sediments or were deposited by animal burrowing.[49]

Further east at Teshik Tash, horn cores of the Siberian mountain goat were found with their points apparently driven into the ground around the partial skeleton of a child. Whether this was to protect the corpse from scavengers or represented some rite is still open to question. Indeed, wild goat is the most abundant species in the faunal remains from the site and the association between the skeleton and the horn cores may be entirely fortuitous.

None of the European burials are directly associated with red ochre,[50] although some bodies in the Middle East have the occasional lump.[51] This pigment (an iron oxide or hematite) occurs naturally, and is undoubtedly

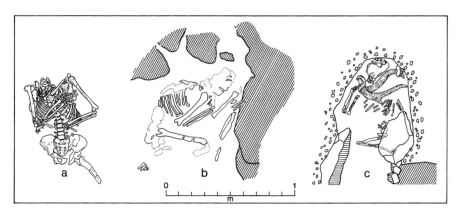

*62 Scholars are currently locked in debate as to whether these fairly complete skeletons represent deliberate burials: **a** Kebara 2 Neanderthal; **b** Shanidar 4 Neanderthal; **c** Qafzeh 11 anatomically modern human.*

associated with Upper Palaeolithic burials, for example the 'Red Lady' from Paviland Cave in south Wales. It is thought to have had a symbolic function.[52]

Many of the Neanderthal bodies are in a crouched position, sometimes with the head pillowed on an arm. Whether they were arranged or just died in their sleep and were quickly covered over is difficult to determine. At La Ferrassie in France there was no clear evidence for grave pits, although an adult male and female were found head to head.[53] To make matters more difficult, many of these finds were excavated a long time ago, when the accurate recording of important details such as the sedimentological evidence for the presence of a grave pit was not carried out. The recent find at Saint-Césaire shows no evidence for a pit. The pit containing the Chapelle-aux-Saints body, on the other hand, was very clear to the excavator, Abbé Bouyssonie, in 1908. Here was an intentional burial, but whether it was a burial in the modern sense or more akin to rubbish disposal is the point at issue. With other finds we have to be more careful. Sometimes, and most notably at Le Moustier, a body was buried and re-excavated several times to provide visiting dignitaries with the thrill of discovery.[54] These stories, while rare, make it difficult to accept claims for such grave goods as intentionally placed stone tools or joints of meat. The goods are just as probably part of the general stone and bone assemblages rather than have any special significance. However, the lower jaw of a wild boar was apparently clasped in the hands of the anatomically modern burial of Skhūl V, while a fallow deer skull with antlers turned up in the hands of the Qafzeh 11 child.

Despite all the difficulties of interpretation, finding quite complete bodies is of great interest, especially since they are very early in northern latitudes (Chapter 3). But if they are not burials in the modern sense, what else could account for the sudden increase in complete or near complete bodies? Clive Gamble has recently pointed out that as a general rule, complete Neanderthal skeletons have been found only in those regions where carnivores did not make

great use of caves, indicated by the very small number of carnivore bones recovered from the sites.[55] Such sites are particularly common in Israel and southwest France (fig. 1), for instance Le Moustier, Tabūn, Shanidar and Teshik Tash. In those areas of central and eastern Europe where finds of Neanderthals are very fragmentary (as at Ganovcé in Czechoslovakia and Krapina and Vindija in Croatia), there are abundant carnivore remains either at the sites or in the general area. The presence in winter of bears digging their hibernation 'beds' in the cave floor and, in spring, of wolves and hyenas using the caves and rockshelters as dens, must have provided only a slim chance for the survival of complete bodies, irrespective of any protection – symbolic or practical – in the form of pits or a 'fence' of horns.

We argue therefore that Neanderthal burials appear when and where they do because of local shifts in carnivore behaviour away from using caves and rockshelters, and not as a consequence of the birth of symbolic behaviour.[56] It is noteworthy, for instance, that not one Neanderthal burial/complete body comes from an open site anywhere in Europe. Yet such open-site burials are common in the Upper Palaeolithic, when deep grave pits were dug (Chapter 9). It is also worth noting that in central Europe, where no Neanderthal cave burials have yet been found, there are open site burials dating to the Upper Palaeolithic, for instance at Dolní Věstonice in Czechoslovakia. Carnivores were present during both periods in this region. We conclude that the preservation of complete bodies in open sites during the Upper Palaeolithic indicates a deliberate custom, closer in concept to what we regard as a burial than the Neanderthal practice, which was probably more akin simply to corpse disposal; in the latter instance, complete skeletons only survived in exceptional circumstances.

Middle Palaeolithic art and symbolic expression

Similar caution has to be exercised over the claims for art and ritual objects dating from the Middle Palaeolithic. Such items include a diverse collection of scratched and polished bones, as well as pierced objects (see table opposite). Among the latter are some reindeer phalanges (toe bones) which have a neat hole in them. E. Lartet and H. Christy interpreted these bones as whistles as long ago as 1864, but it has since been pointed out many times that such perforations are almost certainly due to gnawing by carnivores.

Other items in the list are not easily explained away by butchery marks or accidental happenings. But whatever caused them, they remain a very small and heterogeneous sample.[58] This fact alone makes it difficult to assess claims such as those by Alexander Marshack that the pieces with zigzag scratches from Pech de l'Azé and Bacho Kiro (pl. 92) prefigure an entire code of symbolic motifs that became widespread later in the Upper Palaeolithic.[59] Some of the Middle Palaeolithic marks may well have been made intentionally, but they most probably lacked any symbolic rationale. We believe they should be compared in this respect to the repeated shapes of hand axes, scrapers and

Site	Object	Industry	Age (years ago)
La Quina	Drilled fox tooth	Mousterian	
La Quina	Pierced reindeer phalanx	Mousterian	
La Ferrassie	Bone with fine incised parallel lines	Mousterian	
Bacho Kiro	Bone with engraved zigzags	Mousterian	> 43,000
Tata	Mammoth molar lamellar, modified	Mousterian	116,000–78,000
Pech de l'Azé	Rib fragment with incised lines	Acheulean	123,000–103,000
Pech de l'Azé	Pierced bone fragment	Mousterian	
Cueva Morín	Bone fragment with incised lines	Mousterian	
Sclayn	Bear tooth with grooves	Middle Palaeolithic	
Berekhat Ram	?? Figurine	Acheulean	> 230,000
Kebara	Incised bones	Mousterian	
Klasies River Mouth	Bone with parallel grooves	Middle Stone Age	
Klasies River Mouth	Ribs with serrated edges	Middle Stone Age	

63 Examples of early symbolism? Listed here are Middle Palaeolithic artifacts with apparently deliberate marking; probable ages, when available, are given.

Levallois points. There is no reason to suppose that such limited, repetitious forms were determined by symbolic codes; instead, we argue, they probably simply resulted from imitation, as one Ancient learnt the art of stone knapping by copying another. We will return to this important debate about the birth of symbolic behaviour in Chapter 9, where we will discuss early language.

LANDSCAPE

A key issue in our understanding of the Ancients during the Middle Palaeolithic regards the extent of their organizational complexity. How did they make a living in the prevailing open environments? Were they as complex as modern fisher-hunter-gatherers or did they have very different strategies of survival? Archaeologists often believe that if they can resolve the question of how subsistence was obtained, they will have a clearer understanding of the general behavioural capabilities of the Ancients.

At present, however, there is no consensus about the subsistence of Neanderthals. The results can be used to support arguments for either hunting or scavenging, or – as we suggest here – a combination of both strategies. What we would like to know is how the Neanderthals varied in complexity and degree of organization and planning from Upper Palaeolithic foragers. This question is currently the focus of much research, particularly with the analysis of associated animal bones (see box overleaf). Nevertheless, one point on which most scholars do agree is that, in the northern world of the Neanderthals, the exploitation of plant foods formed only a minor component in subsistence (Chapter 2).

Before we discuss such complex issues, it is first of all necessary to define the slippery terms, hunting and scavenging. For our purposes, hunting is

Some Examples of 'Hunting' by the Ancients

Archaeologists all too frequently discuss hunting simply as an exercise in killing. What is more, the social prestige today associated with hunting often means that Palaeolithic hunting is regarded as evidence for more complex behaviour than scavenging. We believe, however, that it is far more useful to look at both strategies in terms of planning, mobility, group size and storage, for analysis of the organization involved in provisioning campsites can often reveal much more information than a straightforward quantitative study of animal bones. Indeed, we will show that many cherished notions about specialist and big-game hunting fail to stand up to a broader approach to the evidence.[60]

Specialist hunting undoubtedly existed in the Middle Palaeolithic. At the Channel Island site of La Cotte, for instance, two piles of bones containing mammoth and rhino were found preserved beneath a rock overhang in Middle Palaeolithic levels dated to 180,000 years ago (fig. 64). Katherine Scott interpreted the bones as the result of hunting drives across the granite headland. And at Combe Grenal in France, François Prat and – more recently – Philip Chase examined in detail the changes in animal species during the

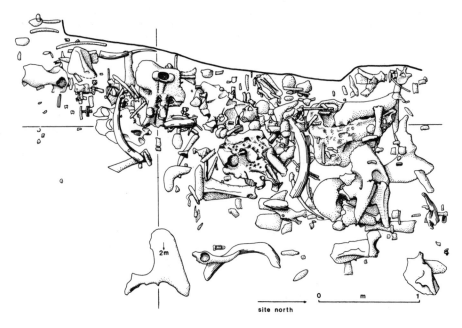

site north

64 *Two piles of bones were excavated beneath the shelter of a rock overhang at La Cotte; they are thought to be the result of a hunting drive. Here, in level 3, the remains included parts of at least seven mammoths and two woolly rhinos.*

last interglacial/glacial cycle.[61] Here, levels dating to the temperate phase contained large numbers of red deer, whereas the dominant species in later strata, about 75,000 years ago, was the reindeer. Chase interprets these data as evidence for specialist hunting governed by climatic controls on animal numbers.

But the presence of a single dominant species does not always signify the pursuit of specialist hunting. For example, the Hortus cave in southern France (excavated by Henry de Lumley) was the site of a narrow fissure containing animal bones, fragmentary Neanderthal remains and a Mousterian industry. The animal bones were dominated by ibex, and the location of the site beneath a large cliff has led scholars to interpret it as a specialist hunting camp.[62] But the cave fissure was also used by lynxes and leopards, and later as a hibernation den by cave bear. The large quantities of ibex bones might therefore have been deposited there by the big cats rather than by specialist Neanderthal hunters.

Similar doubts have been voiced about the open-air Mousterian site of Érd in Hungary, excavated by Gabori-Csank.[63] Here the rich animal fauna was dominated by cave bear, leading researchers to propose that the site was geared in particular to hunting these huge, dangerous omnivores. However, the presence of bones from new-born bear cubs strongly suggests that it was also a hibernation site (possibly an earth or snow bank den), meaning that the Middle Palaeolithic artifacts may have related to entirely different animals in the deposits.

Much more convincing as specialist hunting sites are the open-air sites recently discovered in southwest France. At one of these, La Borde in the Lot valley, the remains of *Bos primigenius* (aurochs or primitive cattle) make up 93 per cent of the animal bones. Females and young were hunted at different times throughout the year. On the other hand, carnivores were very rare, causing the excavators to infer well-planned and systematic hunting on the part of the Neanderthals, who were killing these animals during a temperate phase, possibly 120,000 years ago.[64]

So what about big-game hunting? While there are innumerable artists' reconstructions of Neanderthals throwing rocks at mammoths and killing adult male bison and woolly rhinos with flimsy-looking spears and gnarled clubs, we believe there is scant evidence that this was either a regular occurrence or the likely method of killing such large animals. The long sequences spanned by sites in the Middle East contain evidence that medium- and small-sized animals formed the mainstay of hunting strategies from the Middle through to the end of the Upper Palaeolithic. As Ofer Bar-Yosef has summarized, the presence at some sites of large animals such as *Bos primigenius* and megafauna like rhino and hippo is probably the result of scavenging.[65] Opportunities for such activities must have been common, but were not always seized upon due to constraints of time, labour and – conversely – the availability of hunting staples such as red deer, horse, gazelle and fallow deer. ▶

▶ Such was the case at Combe Grenal, where the Neanderthals focused their attention on the smaller herd animals such as horse, red deer and reindeer.

As the table on p. 53 indicates, small animals were available at all sites; species of large prey varied across the Neanderthal world. It is clear that, wherever possible, small animals were preferred; hunting of megafauna was not the norm. This conclusion is supported by the massive bone structure and repeated stress fractures on several Neanderthal skeletons (Chapter 4), which suggests that these hominids were involved in close-quarter killing of medium to small herd species, rather than a showdown with a 4-ton mammoth.[66]

In summary, evidence for the subsistence strategies of the Neanderthals is still far from clear. Animals of various sizes were being killed and some of these, as at La Borde, were hunted in a manner that implies a degree of planning and organization rather than a chance encounter. In other instances, however, such specialist hunting cannot as yet be disentangled from the activities of other animals – such as wolves and hyenas – that accumulate bones.

concerned not so much with killing animals as with *planning*. Neither is scavenging just about picking up bits of dead animals. Both hunting and scavenging involve making decisions about where to move in the landscape in order to stand the best chance of intercepting game, dead or alive. The planning involves thinking ahead in terms of making and using technology. Most importantly, hunting in northern latitudes has to take into account those lean seasons of the year when prey migrate elsewhere. An alternative to using the natural stores from animal mortalities as they occur during the winter is to make a living from stores built up artificially after successful hunts at other times of the year. This would mean intensive processing, as well as the provision of storage facilities for caches of meat. In organizational terms, the end result would be greater security and the opportunity to occupy areas where natural mortalities alone were not sufficiently plentiful to sustain seasonal foraging for frozen meat. Such planning, if the Ancients possessed it, would qualify as complex behaviour.

It is reasonable to expect that forward planning will be reflected as much in the record of settlement location as in the types and ages of the hunted animals and the parts which were brought back to feeding sites. The degree of planning depth has been isolated by Lewis Binford as the key to understanding the different archaeological records of the Ancients and Moderns.[67]

A fully planned hunting strategy depends on far-flung social contacts. These can serve several purposes. Networks of obligation and partnerships are established by exchanging goods and gifts, objects which then represent a form

of social storage against future hardships. During local food shortages, for example, foraging groups can obtain vital resources from the more fertile neighbouring territories occupied by kin or exchange partners. Contacts can also provide other commodities, such as marriage partners. These networks of exchange, therefore, are part of a much wider survival strategy essential in a harsh environment. In fact, people are often bound together by widespread systems of alliance which extend well beyond the geographical limits maintained simply through visiting and personal contact.

A regional example of Neanderthal subsistence

How can we analyse or quantify the subsistence strategies of scavenging and hunting? In particular, can we take advantage of the presence of carnivores in the same sites to learn something about Neanderthal behaviour?

We believe that bones alone (see box above) will not give us the whole picture; a wider, landscape approach to the question needs to be adopted instead. The region is the appropriate unit for examining subsistence since it was at this level that resources were distributed, and the Neanderthals – as well as other Ancients – had to match their group size and mobility to the predictability, abundance and seasonal availability of food.

The example we have chosen will also demonstrate the advantages of a regional, landscape approach to that crucial question of the depth of planning displayed by the Ancients. The study, by Mary Stiner and Steven Kuhn, is of two Neanderthal cave sites on the Tyhhrenian coast of west-central Italy: Guattari Cave at Monte Circeo and the Grotta di Sant'Agostino near Gaeta.[68] Stiner and Kuhn demonstrate that it is possible to reconstruct patterns of both scavenging and hunting at these sites. But their study also emphasizes that, in the end, such definitions are less important for understanding Neanderthal behaviour than are the insights (afforded by the transportation and selection of animal carcasses and stone materials) into the degree of planning exercised by these hominids as they provisioned their cave sites.

Stiner conducted an examination of animal bones, and found very different patterns at the two sites. The upper levels at Guattari (levels 1 and 2) contained many gnawed animal bones and a head and hooves assemblage characteristic of animal scavengers, clearly indicating that the cave had been a hyena den, rarely visited by humans. In the lower levels 4 and 5, on the other hand, there were fewer gnaw marks on the bones and not many hyena bones, suggesting that at this time the cave was little used as a den. But the assemblage is still dominated by heads, which leads Stiner to argue that when it came to choosing which parts of the carcass to transport to the cave from a scavenging location, the Guattari Neanderthals behaved in a similar manner to hyenas. The Sant'Agostino bones, however, indicate that a very different strategy was being followed by the Neanderthals. Here, red and fallow deer were hunted rather than scavenged, and most of the carcass was transported back to the cave. Cut marks on the bones outnumber carnivore tooth scratches.

The different patterns of faunal remains at the sites suggest that these Neanderthals varied the strategies they used to obtain food. They were neither dedicated specialist hunters nor specialist scavengers, neither opportunists nor careful strategic planners. Rather, they pursued a goal of subsistence security and met this with a range of behavioural solutions. They may not have used storage to reduce the risk of subsistence failure, but the fact that they moved around the landscape, making different decisions about what food to move where and at what time of the year, does suggest that the Neanderthals were able to plan to a certain degree.

The faunal evidence can also provide clues as to the detailed behaviour of the Neanderthals. For instance, Stiner studied the question of why head and hooves assemblages should exist at all, since these parts of the carcass are usually poor in meat. Moreover, heads with horns and antlers are very bulky and heavy to carry any distance.[69] Stiner deduced that the Neanderthals were under great nutritional stress, scavenging those parts of the carcass which still contained vital fat reserves. During the lean winter seasons, animals in poor condition use up the fat reserves from their body and marrow. These are first depleted from the legs and trunk, while the head retains its fat resources longer in order to support brain functions. Even an animal that has died of starvation will have some remnant fat supplies in its skull. This is probably the resource the Neanderthals were after.

Northern Foragers

Let us consider the problems faced by northern foragers. Here the main survival problem facing the Ancients was how to get through the winter since they did not create stores of food. One solution might have been as follows.

The large animal communities of glacial northern Europe (Chapter 2) would have experienced a high rate of natural attrition. Starvation, old age, accidents and carnivore kills would have annually resulted in a heavy cull of species ranging in size from woolly mammoths to saiga antelope. One survival strategy for the Ancients would have been foraging for and scavenging parts of large carcasses from the open tundras. When the natural mortality of these animals coincided with cold conditions, the carcasses would freeze. The frozen mammoths, horses, bison and many other species preserved for many millennia in the permafrost of Siberia and the Yukon show that the meat is edible, if you hold your nose, once the carcasses have melted. Obviously the Neanderthals would have had to have found them long before they were frozen into the land surface, and no doubt most of the time the hominids would only find carcasses that had already been partially devoured by carnivores. The pay-off for searching for such resources during the lean months of a long glacial winter (when the herds of horse,

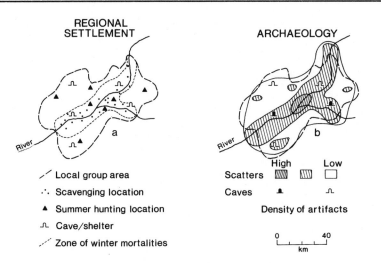

REGIONAL SETTLEMENT

a

River

ARCHAEOLOGY

b

River

	High	Low
Scatters	▨	▨
Caves	▲	⊓

Density of artifacts

0 40
km

/ Local group area

∴ Scavenging location

▲ Summer hunting location

⊓ Cave/shelter

⁓ Zone of winter mortalities

65 The concentration of artifacts in some caves and river valleys in the cold northern world of the Neanderthals seems to be directly related to the location of food. This suggests that stone tools (represented in the archaeological record either as scatters across the landscape or as denser patches in caves and foraging locations) were used and discarded most frequently at the spots where food was regularly to be found. Compare this with the pattern at southern sites (fig. 69).

red deer and reindeer had migrated far away to their winter grazing grounds) would have been that these frozen carcasses were uncontested. Even hyenas with their massive bone-crushing jaws could not get at them once they were frozen. The control of fire by humans would allow them to defrost and use such resources.

This might explain why caves were used over and again for brief visits. They were not necessarily home bases, but rather somewhere to build a fire, raise the temperature and defrost such resources; well-built hearths, lined with stones, were not a requirement for such thawing. This may account for the repeated use of La Cotte and many other cave and rockshelter sites in the glacial northern latitudes. These fixed points in the landscape were simply places to transport food for further processing, as Stiner has also suggested following her study of animal heads brought back to the Grotta Guattari. To succeed, the strategy required that sufficient quantities of megafauna consistently died in some parts of the landscape. Finding them depended on nothing more than mobile search parties and the ability to bring the right number of people together to match the type and amount of food that had been found. Using these natural stores might well have provided an important way of getting through the winter, only returning to close-quarter hunting when the all-important herds appeared again in the spring. Rather than referring to such behaviour as scavenging, with has connotations of merely ekeing out an existence, we prefer to see it as *foraging* for fixed resources where searching skills were paramount.[70] An alternative strategy, possibly adopted by southern foragers, is discussed on pp. 172–73.

Since it takes some time to break open animal heads and extract the food within, they were transported back to a refuge such as Guattari Cave. These terminal fat reserves would have had a special significance for pregnant females and children, particularly during the winter when often all that was available would have been natural animal mortalities. We have seen no evidence that the Ancients adopted any alternative, more complex solution to the problem of seasonal shortages such as the creation of stores of meat, marrow and grease from well-planned hunting (when animals would have been intercepted at known locations).[71] Their campsites are devoid of the elementary features associated with survival strategies of this kind.

The faunal assemblages at the sites of Guattari and Sant'Agostino were consistently related either to scavenging or hunting. This suggests that during the Middle Palaeolithic, the two subsistence strategies took place in different parts of the landscape. Further analysis may reveal that the different foraging patterns were determined by gender. For instance, female groups may have been responsible for scavenging, while the males obtained most of their food by hunting; both sexes would have been responsible for feeding themselves. This, however, is still highly speculative.

Whatever the explanation for such patterns, the contrast with faunal material from the later Upper Palaeolithic sites is very marked. For it is quite clear that the Moderns, presumably the males, were provisioning their camps with both hunted *and* scavenged material. The caves may have been occupied throughout a season or for much shorter periods of time, but they were certainly a form of 'home base'. In the Middle Palaeolithic, however, such base camps did not exist; the group, perhaps split into males and females, fed itself and moved on. The short, expedient nature of Middle Palaeolithic occupation probably explains why Guattari and Sant'Agostino only contain evidence for either scavenging or hunting.

Simply to classify the Neanderthals as either hunters *or* scavengers, however, would be to miss much potential information about their regional organization. Conditions throughout the Ancients' world were diverse, and they were met with a variety of solutions (some of which are considered in the boxes on pp. 167 and 172–73). It is clear that the Neanderthals could plan, but only with limited depth and provision for the future. They relied on the abundance of prey, dead or alive, rather than clever technology to increase their chances of success against less predictable resources. The intricate matching of personnel to resources in the highly seasonal habitats of glacial Europe seems to have been beyond their organizational abilities; their modern successors, on the other hand, sent small work parties to specific points in the landscape in order to take advantage of less important foods as they briefly became available. Such an elaborate planning system would work only if the returns from separate foraging parties were stored and shared at a future date. We can find no evidence that either the Neanderthals or the other Ancients were capable of such complex behaviour.

Landscapes and raw materials

Materials can often be identified to particular sources, so it is possible to trace the distances over which objects have been transported. The analysis of raw materials and the manufacture of stone tools can therefore provide another way of investigating how the Neanderthals and other Ancients used the landscape. We will illustrate our discussion, again, with reference to the Italian study. But let us first examine in general terms the relations between artifacts and their raw materials.

The Dibble and Rolland model of tool manufacture

Archaeologists Harold Dibble and Nicholas Rolland have recently constructed a simple model to predict the effect of distance from source on the manufacture and use of stone tools.[72] They decided to take a fresh look at the five Mousterian assemblages from southwest France first examined by François Bordes (see box pp. 144–45). It will be recalled that Bordes believed the differences between the Middle Palaeolithic assemblages to result from five different cultural traditions. Dibble and Rolland, however, suggest that raw material played a greater role.

When raw material is close at hand, they argue, artifacts are less well finished. Tools are made when they are needed and soon thrown away; this is known as an expedient technology. Where some effort has been expended in obtaining suitable raw material from a distance, on the other hand, the extra 'cost' is reflected in the larger numbers of retouched or recycled implements: a so-called curated technology. With this model in mind, let us now return to Stephen Kuhn's analysis of the Italian Middle Palaeolithic.

Stone tools and land use in Italy

The lithic assemblages from Guattari and Sant'Agostino are part of a well-known regional industry known as the Pontinian. The closest source for large flints was at least 50 km (31 miles) from the two caves, so their Middle Palaeolithic inhabitants tended to rely on the locally available small, rolled flint pebbles. Access to these was somewhat easier at Guattari so – in accordance with the Dibble/Rolland model – one would expect this to be reflected in the extent to which the cores were worked into implements. Kuhn found that this was indeed the case, with a higher frequency of casually worked cores at this site than at Sant'Agostino. Unexpectedly, however, the availability of the flint pebbles seemed to have no influence on the intensity with which tools were retouched or further modified. Indeed, the number of retouched tools is actually lower at Sant'Agostino, where raw material was not present on site. Kuhn's results are presented in the table overleaf.[73]

Kuhn deduced that the frequency with which tools were retouched must have been more closely related to the sorts of activities for which they were being used than the distance of a site from the closest source of flint. The

	Guattari levels 1 & 2	Guattari levels 4 & 5	Sant'Agostino all levels
Age (years ago)	c.57,000	c.76,000	43,000–55,000
Duration of Neanderthal occupations	Very short	Probably short	Relatively long
Animal parts brought back to the cave	Heads and hooves	Heads	All body parts
Neanderthal subsistence	Unknown	Scavenging	Hunting and some scavenging
Season of human use	Unknown	Unknown	Winter
Carnivore use	Hyena den	Slight	Wolf den in spring
Reduction of tools	Moderate/light	Heavy	Light
Frequency of retouch on tools	Moderate	High	Low
Frequency of transported artifacts	Moderate	Low	Low

66 *Patterns of hunting and artifact use at Guattari and Sant'Agostino: a summary of the Stiner-Kuhn studies.*

different patterns of tool wear can therefore tell us something about the role of a site within a larger system of land use.

As we have seen, Sant'Agostino yielded the remains of fairly complete animal carcasses which strongly suggest that its inhabitants were involved in hunting. Evidence also indicates that the cave was occupied for relatively long periods, meaning that raw materials could have been stockpiled at the site, thus counteracting the influence of absolute distance to the source. Kuhn surmised, therefore, that the Neanderthals at Sant'Agostino made relatively short sorties from the cave, during which they could obtain raw materials at relatively little cost, thus accounting for the infrequent and light retouch of tools at the site. The scarcity of faunal material at Guattari 4 and 5, on the other hand, suggests that its Neanderthal occupants would have depended less on hunted material and more on gathered resources such as plants and shellfish. The manufacture of wooden implements needed to collect such foods often involved heavy-duty stone tools which required frequent resharpening. The high level of tool modification at Guattari might therefore relate to the subsistence strategy of gathering and scavenging adopted by the Neanderthals living there. Such a conclusion is supported by the nature of the tools themselves, which are thick and large in comparison to the thin, delicate flakes found at Sant'Agostino. The latter would have been much more suitable for processing softer animal meat.

The Neanderthals, like any group of mobile foragers, would have been faced with many competing claims as to how best to organize their limited labour and locational tactics to achieve subsistence security. Perhaps, for instance, they would sometimes make do with the raw materials to hand because other factors – such as the presence of prey and the size of the human group in need of feeding – were more pressing. The Italian study has shown us that patterns of tool use can be an invaluable source of information about the complexity of

behaviour at the regional level.[74] We will now take a look at the organization of groups in the landscape.

Peoples in the landscape

Having discussed the different patterns of movement across the landscape by various Ancients, and the variety of ways in which they obtained subsistence and raw materials, we can finally dispense with a model that long dominated the interpretation of Neanderthals: François Bordes' theory of the five distinct, sedentary Neanderthal tribes.[75] According to this view, the five tribes lasted for many millennia. They did not evolve culturally so much as mark time, pushing into and being pushed out of the most desirable rockshelters of the region. He believed that these populations had very low regional densities, but that they were also very sedentary, with each group using one cave at a time. For Bordes this was the hallmark of the Middle Palaeolithic world: 'A man must often have lived and died without meeting anyone of another culture, although he knew "that there are men living beyond the river who make hand axes".'[76]

But sitting in one spot, not talking to the neighbours and just exploiting the immediate countryside would be a sure route to extinction. To survive as a hunter or scavenger in temperate latitudes, especially under glacial conditions, depends to a large extent on mobility. This is the means by which people constantly adjusted to the available resources. Mobility in search of food also brings benefits in terms of acquiring information about other resources such as

67 A provocative comparison, by Lewis Binford, of the size of territories used by modern foragers (above) and Middle Palaeolithic foragers in the Dordogne. François Bordes' idea that the Neanderthal tribes who lived in the caves led separated, isolated lives from their near neighbours seems very unlikely when mobility must have been the key to survival.

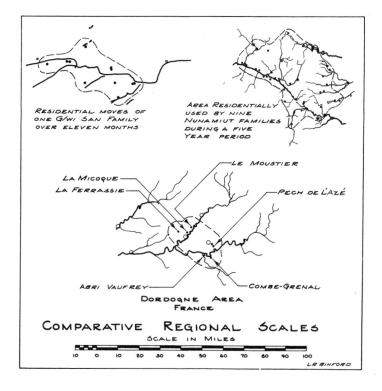

Southern Foragers at Klasies River Mouth

The caves at Klasies River Mouth, perched on the northern edge of the now submerged continental shelf of southern Africa, were occupied for at least 60,000 years during the late Middle Palaeolithic. The climate during this time changed from interglacial to early glacial conditions, but the abundant faunal remains excavated at the site do not reflect these environmental shifts. Nor are the changes in the lithic material – from the Middle Stone Age to pre-Upper Palaeolithic (the Howieson's Poort) and back – reflected in any significant differences in the animal bones. (This is particularly interesting if, as John Wymer has suggested, the geometric microliths in the Howieson's Poort were being tipped with poison and hafted in arrows.[77])

The rich faunal assemblages yielded over 10,000 bones, which were then identified to particular animal species. In a detailed study of these remains, Richard Klein commented on the different uses which were made of animals belonging to five different size classes.[78] Animals in class IV, weighing between 600 and 900 kg (0.6 and 0.9 tons), were numerically dominant. Among these, the eland and Cape buffalo were represented by only a very selective number of anatomical elements, mainly heads and feet. This was in marked contrast to the smaller species – such as steenbok, bushbuck and blue antelope – whose complete carcasses had been carried back to the cave. Klein interpreted these differences as the outcome of field butchery decisions. Large animals were butchered into manageable parcels and heavy limb bones thrown away. Once butchered, the meat was piled inside the skin and dragged home. Such a practice is often referred to as the 'schlepp' or drag effect. Leaving the foot bones in the skin provided a set of handles, although this does not adequately explain why so many teeth and horn cores from skulls are found at the sites.[79] Small animals, on the other hand, were easily transportable to the cave intact.

Klein studied the numerous animal teeth found at the site in order to examine the different strategies used for hunting small and large species. The ages of the prey can be reconstructed by analysing the eruption of their teeth, i.e. from the height of the tooth above the jaw line. In this way a profile of the population is built up. The eland remains came mainly from prime-aged adults: good evidence,

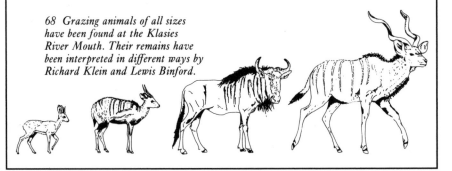

68 Grazing animals of all sizes have been found at the Klasies River Mouth. Their remains have been interpreted in different ways by Richard Klein and Lewis Binford.

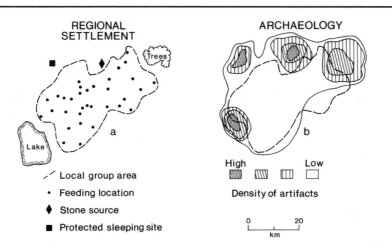

REGIONAL SETTLEMENT

ARCHAEOLOGY

Trees

a

Lake

b

High Low

Density of artifacts

0 20
km

⌐ Local group area

• Feeding location

♦ Stone source

■ Protected sleeping site

69 The archaeology of foraging by the Ancients in warmer southern latitudes, based on reconstructions of subsistence at Klasies River Mouth. Territories were smaller than in the Neanderthals' northern world (fig. 65), while plant foods provided more of the diet. Here the densest concentrations of artifacts are to be found outside the foraging areas, at waterholes and sleeping sites.

according to Klein, that herds were driven either into traps or over cliffs where the healthy adults (which would otherwise have been difficult to catch) were killed. On the other hand, the age profile of the Cape buffalo, one of the largest animals in the collection, is very different. These animals are mostly represented by very young and old individuals, a pattern best explained in terms of scavenging parts of animals that have died from natural causes or were killed by carnivores.

Lewis Binford agrees with Klein that the smaller prey, below 40 kg (88 lb) in weight, were probably hunted opportunistically. But he has argued that *all* the large animals, including eland, were scavenged.[80] His view is that the bones brought back to the caves were not evidence of the schlepp effect, but instead still had some meat on them or contained marrow resources. The bones, he suggests, had been picked up from carcasses already ravaged by hyenas, Cape hunting dogs, leopards and lions. But Binford's theory fails to take account of the large number of prime adult eland. We therefore suggest that a mix between the hunting and foraging scenarios of Klein and Binford is much more likely.

firewood, raw materials and people. Among modern hunters, such information is the key to survival in very harsh climates. For example, a modern group of Inuit families would annually travel great distances, equivalent say to the area covered by the classic Middle Palaeolithic sites of the Périgord (fig. 67).

The study of raw materials can again help us to build up a picture of the mobility of the Ancients. Recent research by Wil Roebroeks, Jan Kolen and Eelco Rensink has reconstructed the patterns of raw material usage in the earlier Middle Palaeolithic of Europe.[81] The greatest distance traced over which raw materials were transported during this time, some 200,000 years ago, is about 100 km (62 miles), but this was an exception. In the later Middle Palaeolithic (130,000–40,000 years ago) the situation is different, and occasionally distances of up to 300 km (186 miles) have been recorded. Distances were generally greater in central and eastern Europe because conditions during the last glacial cycle were harsher, increasing the size of territories over which groups had to forage and hunt. There may even have been some rudimentary alliance networks between groups and individuals, as described earlier. But these social networks were still very limited in scale and complexity, and most of the time raw materials for making stone tools only travelled local distances.

A detailed study by Jean-Michel Geneste of raw materials during the Middle Palaeolithic in Aquitaine, southwest France, also emphasizes the local nature of the use of lithic resources.[82] The table below indicates that raw materials in Aquitaine were rarely obtained from more than 80 km (50 miles) away.[83]

	Radius from site (km)	Percentage of flint on a site	Percentage of flint used i.e. made into tools
Local	>5	55–98	1–5
Region	5–20	2–20	10–20
Exotic	30–80	<5	74–100

70 Table to show the relation between the availability of raw material and the extent to which it was used.

Local is thus truly local, the majority of flint coming from within a 5-km radius of a site. The further away flint was obtained, the more likely it was to be introduced to the site as a retouched tool.[84] Some equipment – such as spears tipped with points, flakes, or a reduced piece with a retouched edge – was obviously being carried around the landscape, presumably in anticipation of future use. So their behaviour was not completely expedient; not, in other words, always a case of find the material, knap it, use it, throw it away all in the same place. But the question remains, to what extent does it compare with the planning of the Moderns in the Upper Palaeolithic?

The Neanderthals, and Ancients generally, appear to have used the landscape in different ways from the Moderns. As we shall see in Chapter 9, not only is there evidence after 40,000 years ago for structured campsites with

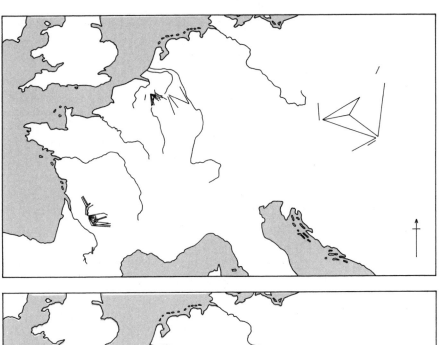

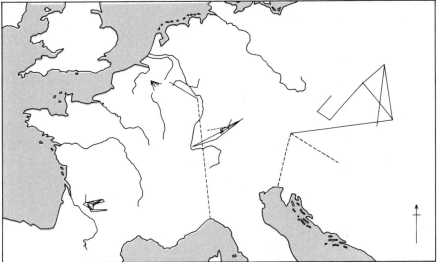

71 Raw material routes for stone in the later Middle Palaeolithic (top) and the early Upper Palaeolithic (above). The dashed line indicates the distances over which shells and other objects were obtained. Clearly raw materials travelled much greater distances during the Upper Palaeolithic.

storage pits and base camps (which are properly called villages), but the distance over which raw materials – now including shells and lumps of fossil resin – were transported was much greater. Moreover, the emphasis in the Upper Palaeolithic on small, standardized, light, stone blade and bladelet elements adds hafting and composite tools to the assessment of planning from the archaeological evidence. Such components are only regularly found in the few pre-Upper Palaeolithic assemblages of the Middle Palaeolithic. These, as we have seen, are geographically restricted to parts of the Middle East, north

and southern Africa. They were not part of the cultural package, including art, ornament and display items generally, that betokens the widespread social networks universal after 40,000 years ago (Chapter 9).

EXPANSION INTO NEW HABITATS

Hominids first left Africa, in the Out of Africa 1 dispersal, more than a million years ago. By half a million years ago they had reached as far north as the British Isles; but the next 450,000 years saw little additional expansion, especially when we consider that the continents of the Americas and Australia were accessible for colonization. Yet some authorities have made the case for the origins during this period of truly cultural behaviour, linked to geographical expansion. Why?

Gerhard Bosinski points out that it was only during the late Middle Palaeolithic (after 130,000 years ago) that the north European plain was settled for the first time. In his opinion, this geographical expansion marks a great threshold in human development.[85] Before this period, he argues, artifact assemblages varied according to situation, such as the function of a tool or the availabilty of raw materials. But the Middle Palaeolithic saw the appearance of *Formengruppe*, distinct lithic industries which suggest that cultural traditions had replaced environmental factors in the determination of stone tool manufacture.

A similar conclusion was reached by Desmond Clark in his discussions of East Africa in particular and the Middle Stone Age of Africa in general.[86] He cites the expansion of Middle Stone Age populations into a variety of new habitats in Africa, ranging from areas today covered by desert to those of high rainfall. According to Clark, the colonization of new territories indicates an advance from the previous Early Stone Age Palaeolithic, and signals the beginning of regional cultural identities and biological differentiation.[87]

The Ancients also expanded into the steppes of Central Asia, at the easternmost limits of the Neanderthal world. This is evident from the widespread finds of Mousterian artifacts over formerly uninhabited territory, and also from the occupation (e.g. at Teshik Tash) of extremely rugged terrain at altitudes of up to 1,500 m (*c.* 5,000 ft). Further northwest too, on the steppes of the Ukraine, it is noticeable that the earliest occupation is associated with Middle Palaeolithic artifacts along the major rivers of the Dnepr and Dnestr. This is probably an extension of the pattern of new settlement observed by Bosinski for the North European Plain. The dating of these sites is placed in the last glaciation, about 60,000 years ago.

But for all the apparent geographical gains made by the Neanderthals and Ancients, we would argue that their world remained limited. We find nothing to support the Bosinski/Clark theory that the Middle Palaeolithic was a great cultural watershed. We believe that, compared with the expansion of the Moderns after 40,000 years ago, the Ancients were doing nothing more than opportunistically filling up some of the less attractive landscapes in their world.

Among these would be the areas of the eastern Sahara which are hyperarid today but were wetter 120,000 years ago, and so offered the opportunity for settlement. These opportunities were often brief. Such expansions by the Ancients, moreover, were very closely determined by the climate: populations ebbed and flowed from marginal habitats as the climatic cycles ran their course. While such fluctuations had probably occurred ever since *Homo erectus* left Africa over 1 million years ago, the significance of settlement gains made after 200,000 years ago is that new territories (previously unsettled even under optimum climates) were now used for the first time. But this did not lead to the dramatic and rapid expansion of population into new continents. So, far from being released from the shackles of environment by major developments in culture, Neanderthal populations – like all the Ancients – were still governed by changes in climate and resources. As a result the hand axes, scrapers and points which they used strike us not as cultural items signifying and symbolizing group membership, but rather as the items which assisted the hominids in their survival over many hundreds of thousands of years. In this respect, the stone tools were versions of the unmodified pebbles that wild chimps have been observed using to crack open nuts in the forests of West Africa. We can see no convincing evidence from the campsites of the Ancients, from their use of resources or the varieties of stone tool assemblages they chipped, or from the limited geographical expansion they undertook, that the change from being a hominid assisted by tools (an Ancient) to a hominid with behaviour organized symbolically (a Modern) took place during the Middle Palaeolithic. This great shift in behaviour, we believe, only came later, after 40,000 years ago (Chapter 9).

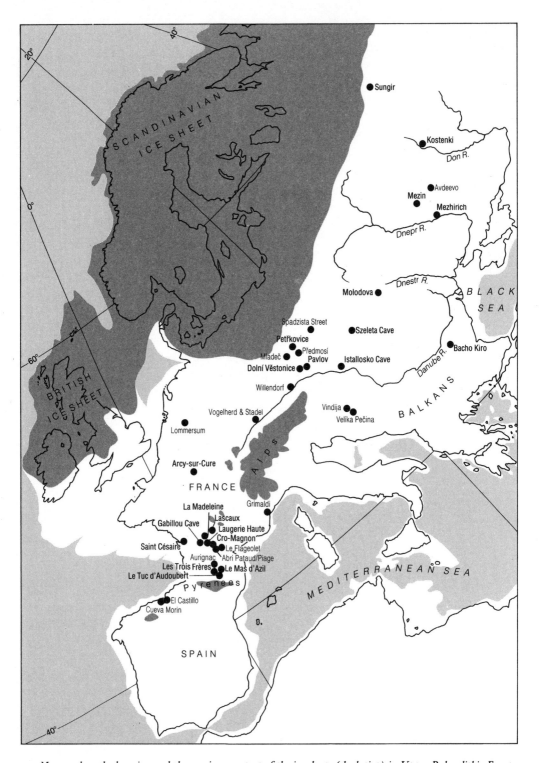

Map to show the key sites and the maximum extent of the ice sheets (dark tint) in Upper Palaeolithic Europe.

The following labels appear on the map:

SCANDINAVIAN ICE SHEET

BRITISH ICE SHEET

Sungir

Kostenki

Don R.

Avdeevo

Mezin

Mezhirich

Dnepr R.

Dnestr R.

Molodova

BLACK SEA

Spadzista Street

Szeleta Cave

Petřkovice

Předmosí

Pavlov

Mladeč

Dolní Věstonice

Istallosko Cave

Bacho Kiro

Willendorf

Danube R.

BALKANS

Vogelherd & Stadel

Vindija

Velíka Pečina

Lommersum

ALPS

Arcy-sur-Cure

FRANCE

Grimaldi

La Madeleine

Lascaux

Gabillou Cave

Laugerie Haute

Cro-Magnon

Saint Césaire

Le Flageolet

Aurignac

Abri Pataud/Piage

Les Trois Frères

Le Mas d'Azil

Le Tuc d'Audoubert

Pyrenees

El Castillo

Cueva Morin

SPAIN

MEDITERRANEAN SEA

72 *Map to show the key sites and the maximum extent of the ice sheets (dark tint) in Upper Palaeolithic Europe.*

CHAPTER 8

The Fate of the Neanderthals

As we have seen, we can trace early modern humans in Africa and the Middle East from at least 100,000 to 90,000 years ago, but if they then expanded further north and west from Israel, their trail goes cold. This may be partly due to the lack of informative sites excavated over much of Asia, but even those that are known have produced evidence only of Neanderthal fossils as far east as Teshik Tash. For areas as large as the Indian subcontinent we have virtually no data at all. It is not until about 40,000 years ago that evidence appears of people other than Neanderthals in western Eurasia. At about the same time, and probably in association with this, we find the first true European Upper Palaeolithic industry, which is known as the Aurignacian after the cave in France (Aurignac) where it was initially identified. Not only does the Aurignacian have a preponderance of tools made on long slender blades, but bone, antler and ivory artifacts, jewellery, ornaments and art in the form of figurines and engravings are also now found within well-organized campsites.

The earliest Moderns in Europe: the anthropological evidence

The site of Staroselye in the Crimea has yielded part of the skeleton and skull of an infant aged about two. The child looks modern in both skull and skeleton, but the associated artifacts are Middle Palaeolithic. It is not clear whether this skeleton is a later intrusion into the Middle Palaeolithic levels, or whether it is a Ukrainian equivalent of the association between Moderns and the Middle Palaeolithic observed at Skhūl and Qafzeh. This might then represent an early Modern in western Eurasia. Other possible early Moderns are represented by a few jaw and tooth fragments associated with the earliest Upper Palaeolithic level at the Bulgarian cave of Bacho Kiro, and radiocarbon dated to more than 43,000 years ago. The shadowy nature of the earliest European Moderns is manifested at the Spanish site of Cueva Morin, where two pseudomorphs (soil traces of buried bodies) dated at about 34,000 years indicate a very non-Neanderthal stature of over 1.8 m (about 6 ft) for the vanished bodies.

We can put more substantial flesh on the early Moderns in Europe from about 34,000 years ago.[1] A frontal bone from Velíka Pečina in Croatia has a high forehead, small brows and a radiocarbon date from an overlying artifact level of more than 34,000 years, while a similarly fragmentary but more robust frontal bone from Hahnöfersand, Germany, has been directly dated at about 33,000 radiocarbon years. The latter specimen is robust enough to have led some scholars to suggest that it is from a transitional Neanderthal-Modern

73 One of the first illustrations (from Lartet and Christy 1875) of the early modern skull known as the 'Old Man' of Cro-Magnon found in a rockshelter in the Dordogne in 1868.

individual, either an evolutionary intermediate or an actual hybrid. But it seems more likely that it is just from a very strongly built early Modern. Unfortunately, it was recovered from a river bed without any associated materials.

Similar claims of affinities with the Neanderthals have been made for the large sample of human fossils from the cave of Mladeč in Czechoslovakia. Here, the remains of several males, females and a child show considerable variation in size and robusticity. The adult assumed males have very strong but modern brow ridges, whereas the females have little or no brow development. The skulls are relatively long and some have bulging occipital bones at the rear, which are reminiscent of those of some Neanderthals. Yet the preserved facial parts indicate a flat face with forward placed cheek bones, contrasting strongly with the Neanderthals (pl. 71). Probably dating from about 33,000–30,000 years ago, these Mladeč people were undoubtedly primitive compared with modern Europeans, but primitive does not necessarily mean especially like, or derived from, Neanderthals. The strong build of the Mladeč skulls, particularly the males, is matched today in the most rugged individuals from areas as far from Europe as South America and Australia, where there is no suggestion of a Neanderthal connection. Of a similar age (about 32,000 years), the cranial vault from Stetten (Vogelherd) in Germany is almost a twin of one of the female Mladeč skulls.

Various fragmentary early modern humans were found with Aurignacian stone tools in western Europe, some of which are convincingly modern. The most famous specimens are the remains found in the Cro-Magnon rockshelter in the Dordogne in 1868 (pl. 69). These remains, as we have already discussed, gave their name to the whole European Upper Palaeolithic race, and probably come from the later Aurignacian about 30,000 years ago. The 'old man' of Cro-Magnon (Cro-Magnon 1) is often contrasted with the 'old man' of La Chapelle (who we saw was probably no more than 40 years old at death) and the contrast is startling (pl. 80). Although their dissimilarity is somewhat exaggerated by the tooth loss in their jaws (which shortens the Cro-Magnon's face even more) the differences are real enough, particularly in the high forehead, small brows, low square orbits, wide, short and flat face, small nose and prominent but hollowed cheek bones of the Cro-Magnon. These differences extend through the rest of the skeleton, which is better represented at Cro-Magnon than at Mladeč. The

Cro-Magnon skeletons, especially of male individuals, were strongly built, but they were tall with long lower parts to the arms and legs. These features contrast with the apparently cold-adapted physique of the Neanderthals (Chapter 4) and would suggest, if we did not know that these individuals came from Europe, that they were in fact from tropical or subtropical areas. This unusual physique (seemingly so inappropriate for the cold conditions then prevailing in Europe) was apparently inherited by successive generations of Cro-Magnons until the peak of the last glaciation, which suggests an impressive ability to cope culturally with the worst effects of the cold. However, from the glacial maximum (about 18,000 years ago) onwards, later Cro-Magnons seem to have developed the sort of physique one would expect for their temperate or cold habitats, and in this sense they became more like the Neanderthals as well as modern Europeans. It has been suggested by Milford Wolpoff that the differences in limb proportions between the Neanderthals and the Cro-Magnons occurred as the latter took up longer distance walking and running, following changes in hunting patterns or the development of wider social networks. But this does not explain why such a long-legged physique should have appeared as long ago as 1.6 million years in the skeleton of the West Turkana boy, or in the 100,000-year-old skeletons from Skhūl and Qafzeh, which were found in a Middle Palaeolithic context. We believe instead that climatic adaptation was responsible for these differences in physique.

By 26,000 years ago complex burials, often accompanied by red ochre powder, are known throughout western and eastern Europe, from Paviland cave in Wales to Dolní Věstonice and Předmostí in Czechoslovakia. In one of the most tragic scientific losses of the Second World War, the entire collection of over 25 skeletons from Předmostí was lost in an arson attack, along with some of the Mladeč remains.

The last Neanderthals

After 30,000 years ago there is no longer any trace of the Neanderthals, but archaeology provides some further clues as to their fate. It is now widely believed that a regional industry in southwest France and Spain, the Châtelperronian, was made by Neanderthals, based on the fossil remains associated with it at Saint-Césaire and Arcy-Renne in France. The Saint-Césaire find, made in 1979, has been especially important. Now dated to about 36,000 years ago by TL techniques, it consists of the partial skeleton and skull of an undoubted Neanderthal, in the higher of two Châtelperronian levels at the rockshelter.[2] The best evidence of the industry comes from the site of Saint-Césaire. The Châtelperronian has some Middle Palaeolithic features, but many of the tools are made on well-struck blades. The characteristic Châtelperronian point or knife has a curved back with blunting retouch (similar to the blade of a modern penknife), a shape very reminiscent of the naturally backed knives of the Mousterian of Acheulean Tradition B (MAT B). In the latter, the blunted edge was formed by the cortex or outer layer of the flint. These similarities led

François Bordes to trace the lithic ancestry of the Châtelperronian back to the MAT B.

There are similar indications of the last Neanderthals elsewhere in Europe taking up new technological ways, for instance the Uluzzian industry in Italy and the Szeletian complex in eastern Europe. Both of these are similar in age and form to the Châtelperronian, and consist of a mixture of Middle and Upper Palaeolithic techniques and types. Unfortunately, only very fragmentary fossil remains are associated with either of these industries, but what little evidence does exist is consistent with a Neanderthal origin. Several scholars have argued that these industries – like the Châtelperronian in France – were derived from a local late Mousterian.[3] However, we saw in Chapter 7 that pre-Upper Palaeolithic (PUP) blade-based industries appeared and disappeared much earlier, at sites in the Middle East and southern Africa. In our opinion, therefore, the European industries were not the result of local evolution, the independent invention by Neanderthals of Upper Palaeolithic technology, but rather an imitation of technology of the incoming Moderns. One reason for this view is that – in contrast to the PUP – all the European industries are either contemporary with or postdate the appearance of the earliest Aurignacian industry, which is firmly associated with anatomically modern people.

If the Neanderthals *were* responsible for the Châtelperronian, we can date their demise by the disappearance of their industry. We can deduce, therefore, that the Neanderthals were gone from western Europe by 31,000 years ago.[4] Apart from Saint-Césaire, there is little other physical evidence of the very last Neanderthals but this does include a lower jaw from Zaffaraya Cave in southeastern Spain, some teeth from one of the Arcy caves (Renne) in France, an adolescent skeleton and the remains of a child from Le Moustier, and various skeletal parts from the cave of Vindija in Croatia. Sadly, the Vindija remains seem to have suffered badly before excavation since some show signs of burning and cut marks; and the Le Moustier fossils suffered badly afterwards – the child's remains were lost soon after their discovery and the adolescent skeleton was partially destroyed by the allied bombing of Berlin in 1945. The Vindija remains are especially controversial, because it is claimed that some were found in a level containing an Aurignacian bone point.[5] If this were so, it would be the only such association between the Neanderthals and the Aurignacian, but there are too many uncertainties in the excavation to guarantee the association; direct radiocarbon accelerator dating might help to establish the respective ages of the bone point and the hominids.

The Vindija finds are also interesting in their own right because, compared with Saint-Césaire, they suggest that a less robust late Neanderthal population was living there. However, it is unclear whether these Neanderthals were less robust because they were physically smaller than average; as a result of gene flow from contemporaneous early Moderns; or because they were evolving beyond the 'typical' Neanderthal morphology. If the last were the case, the multiregionalists could claim the Vindija individuals as intermediates between the Neanderthals and early Moderns; but we believe the remains are too

incomplete (and seemingly rather late) to make any convincing case. The Neanderthal remains from La Ferrassie in France, which some archaeologists believe came from a family cemetery, might also be relatively late in time, since they are not necessarily associated with the 'La Ferrassie' variant of the Mousterian also found at the site.

Close encounters of a European kind

So, the picture we have of Europe between 40,000 and 30,000 years ago is of an encounter between long-established natives and an incoming population. The newcomers were one step ahead technologically, and were fully modern anatomically. But that does not mean, as is often assumed, that they were fully European-looking: in fact they were physically unlike their successors of the last 10,000 years. Their faces were flatter, with more prominent cheek bones and lower, less prominent noses. Their skulls were larger, longer and relatively lower. As we have mentioned, some of them – especially the males – had rather bulging occipital bones, reflecting the large occipital lobes of the brain within. Because this area is also particularly prominent in the Neanderthals, it is one of the reasons put forward for including the Neanderthals in modern European ancestry; but the feature is also found in Moderns well away from the Neanderthal zone (in Africa, South America and Australia), so it may reflect a parallel development in modern humans rather than a significant evolutionary link to the Neanderthals. The same may be said for the common presence of a mandibular foramen in both Neanderthals and Cro-Magnons. The teeth and jaws of the Cro-Magnons are larger than in modern Europeans, as was average stature and (probably) lean body weight. Estimates put early Cro-Magnon height at about 1.84 m (6 ft 1 in) in males and 1.67 m (5 ft 6 in) in females, with lean body weight at perhaps 70 and 55 kg (154 and 121 lb) respectively. So while body weight was comparable with that of Neanderthals, the weight was distributed differently, and the body proportions certainly contrasted strongly, an indication of possible warm adaptation in the ancestors of the Cro-Magnons. Compared with modern European body weights – about 70 kg (154 lb) in males and 58 kg (128 lb) in females – the Cro-Magnons were quite similar, but they were tall in comparison with their modern European counterparts, who average about 1.75 m (5 ft 8 in) in males and 1.62 m (5 ft 4 in) in females. There was also a whole range of differences between Cro-Magnon and Neanderthal skeletons, in such details as femoral shape and pelvic shape. One thing the Neanderthals and early Moderns did share, however, was a larger average brain size than present-day humans, including modern Europeans. As we discussed in Chapter 4, this may be related to the heavy body size of both the early European groups.

So where did the Cro-Magnons come from? Apparently not from the Neanderthals, who went their own way in evolutionary terms over a 200,000-year period or more, a trajectory which took them away from the Cro-Magnons in features such as face and nose shape, and body proportions, but parallel to

them or towards them (if you are a multiregionalist) in characteristics such as increased brain size and smaller teeth. If, as we suspect, the early modern people came into Europe bringing an early form of the Aurignacian tool industry (such as the one known at Bacho Kiro in Bulgaria), could they have evolved from people like the early Moderns of Skhūl and Qafzeh? That seemed a reasonable enough proposition to the scholars who dubbed these finds 'proto-Cro-Magnons',[6] but if they are 60,000 years older than the Cro-Magnons, as suggested by the TL and ESR dates (Chapter 5), what happened in between? If the Skhūl and Qafzeh samples represent a brief and premature Out of Africa 2 expansion which came to nothing, there is no necessary connection between them and later anatomically modern humans. But if populations like Skhūl and Qafzeh moved northwards and eastwards, they could have continued dispersing all the way to Australia, where humans may have arrived by 55,000 years ago (Chapter 6). Apparently they did not move westwards into Europe for some considerable time after this, which leaves open the question of their relationship to the Cro-Magnons. According to the geneticists, modern Europeans and east Asians are closely related, with a possible divergence date of less than 60,000 years ago. If this is accurate, there may have been a post-Skhūl/Qafzeh ancestral population for modern Eurasians and native Americans, probably separate not only from Africans, but from Australians as well. Whether these proto-Eurasians lived in Asia (e.g. in the Middle East or the Indian subcontinent) or North Africa is unclear, but all the evidence suggests that the Neanderthals were not challenged on their home territory in Europe until after 45,000 years ago.

If we can accept, as seems likely, that the Aurignacian was associated with the spread of Cro-Magnons into Europe, then the timing and direction of their colonization can be reconstructed.[7] The earliest Aurignacian sites, more than 40,000 years old, are found in the centre and east of Europe. The next oldest are in the northernmost Iberian peninsula, suggesting an initial southern extension of their range. By 36,000 years ago we find Aurignacian industries in southern Germany and by 34,000 years ago they are well established in southwest France. This pattern of dates emphasizes the refuge in which the last French Neanderthals lived and the marginal nature of peninsular Europe within the wider picture of human evolution. How different this is from the complex anatomical and archaeological sequences we have seen in the Middle East (Chapters 5 and 7)!

We also have a good idea of the climatic background to the appearance of modern humans in Europe, from data such as French and Greek pollen cores.[8] Around 60,000 years ago, Europe was relatively warm and wet. But over the next 20,000 years, the climate deteriorated markedly, reaching a cold, dry minimum by 45,000 years ago. For the following 15,000 years (until about 30,000 years ago), the climate continued to fluctuate, but overall it improved. Some French sites record brief periods of mixed oak forests replacing more open vegetation, matching episodes of weathering in European caves; both indicate short, warmer interstadials during this time.

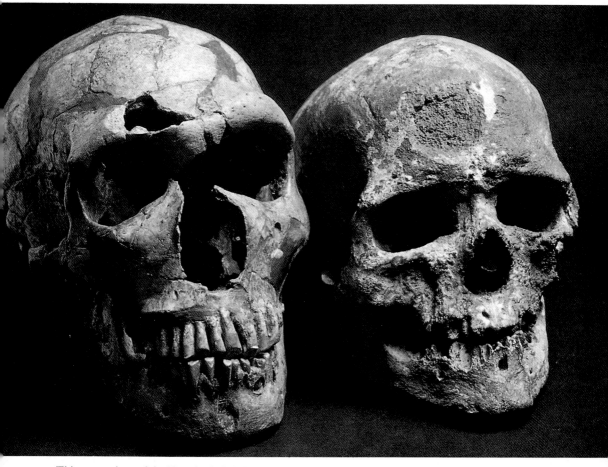

79 This comparison of the Neanderthal skull from La Ferrassie (left) and the early modern skull from Cro-Magnon emphasizes just how different the two peoples were.

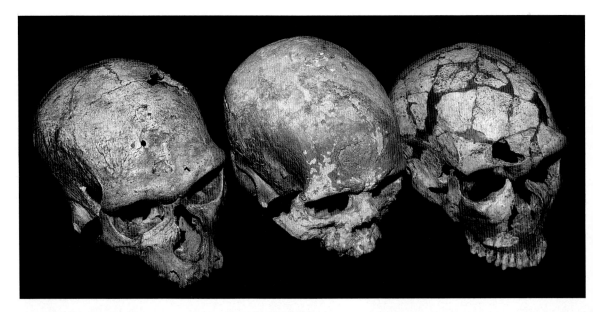

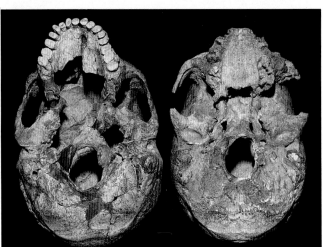

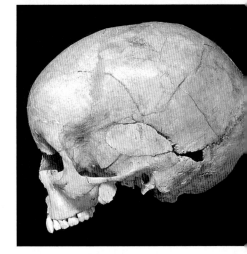

Comparing Neanderthals and Moderns

80 (*Top*) Photograph of two French Neanderthals (La Chapelle-aux-Saints, left and La Ferrassie, right) with Cro-Magnon 1, illustrating their facial dissimilarities.

81 (*Above*) Basal view of the Ferrassie Neanderthal (left) and Cro-Magnon 1. The skulls are of similar overall size, but the Neanderthal has a flatter cranial base with retreating cheek bones and the upper jaw positioned forwards.

82 (*Above right*) Neanderthal features are already apparent in the nine-year-old Neanderthal child from Teshik Tash in Uzbekistan (cast, right). Compared with that of a slightly younger modern child, the Neanderthal skull is longer and wider, with a developing brow ridge and a large face and nose.

83 (*Right*) A comparison of the Amud (cast, left) and Saint-Césaire fossils. Both represent relatively late Neanderthals in their regions.

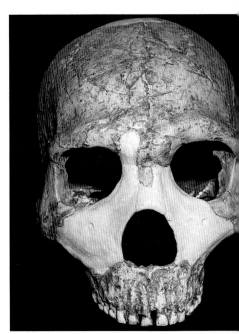

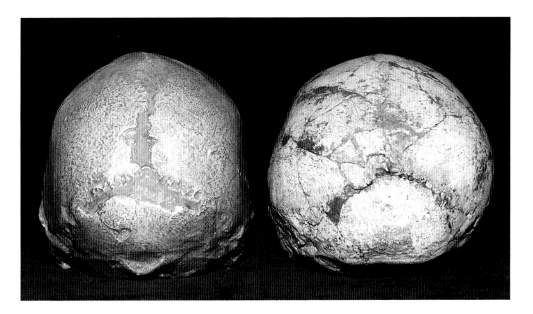

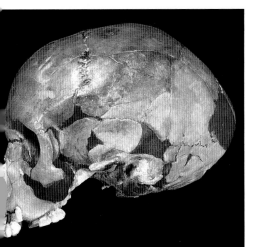

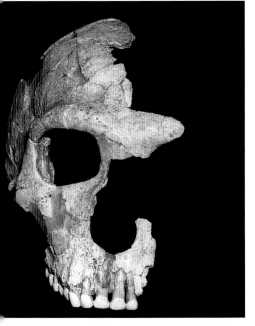

84 (*Above*) The rear profiles of an early modern skull (Předmostí 3, cast, left) and a Neanderthal (La Ferrassie).

85 (*Below*) Comparison of casts of the Jebel Irhoud (left) and Qafzeh 6 skulls. Although Irhoud 1 has a more primitive vault, their facial proportions are very similar.

86 (*Bottom*) The Qafzeh 9 early Modern (cast, left) and Tabūn Neanderthal may have been near contemporaries in the Middle East about 100,000 years ago.

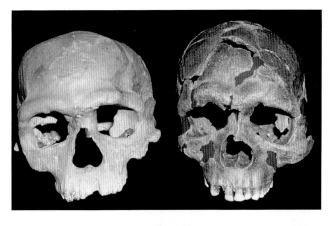

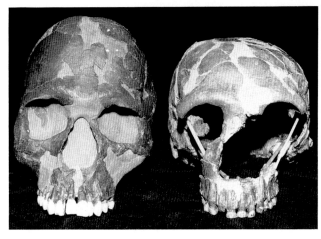

87 (*Above*) Life-size reconstruction of a man using a spearthrower. Developed by the Cro-Magnons, this device represented a major advance in hunting technology, since it could propel spears further and with a much greater speed and accuracy than hitherto.

88 (*Below*) Art, ornament, dress codes and jewelry were significant developments during the Upper Palaeolithic. This (reconstructed) necklace was made from pierced fox teeth, dentalia shells and fossils which may, on occasion, have been traded over large distances.

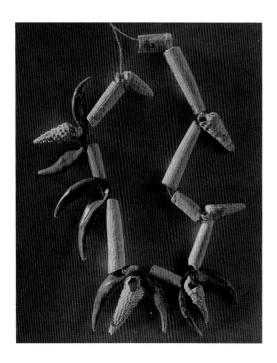

The cultural explosion of the Upper Palaeolithic

89,90 The structured organization of living areas and the construction of huts was unknown before the Upper Palaeolithic. (*Above left*) Some 385 mammoth bones, including over 95 mandibles, were excavated at the site of Mezhirich in the Ukraine, dating from about 18,000 years ago. The bones are thought to have formed the walls of a hut, reconstructed here. A mammoth skull painted with hematite was also discovered at the site. (*Above right*) Reconstruction of a hypothetical Upper Palaeolithic domestic dwelling. There is no evidence that the Neanderthals built complex structures such as these.

91 (*Left*) The most famous Venus figurine, carved in limestone, from Willendorf in Austria. Most of these statuettes date to between 23,000 and 21,000 years ago, at a time when the climate was deteriorating due to the onset of the last glacial maximum 18,000 years ago.

92 (*Right, above*) Evidence for Middle Palaeolithic art and symbolism is extremely rare. This piece of bone from Bacho Kiro in Bulgaria bears heavily incised lines, but it probably lacked any symbolic meaning.

93,94 (*Right*) A lion-headed anthropomorphic statuette, one of the earliest known works of art. Carved from a small mammoth tusk this figure dates to the Aurignacian (early Upper Palaeolithic) more than 32,000 years ago. It was found in the Stadel Cave of southern Germany.

95 Franz Weidenreich was one of the creators of the model of multiregional evolution. Here he is pictured amongst remains from Zhoukoudian. Referred to as Peking Man, these fossils formed an important part of his theory.

Protagonists in the Neanderthal debate

96 The participants of a 1986 conference at the School of American Research in Santa Fe included a number of prominent figures in the debate on modern human origins: (back row, from left) Fred Smith, Ofer Bar Yosef, Jean-Philippe Rigaud, Milford Wolpoff and Lewis Binford; (front row) Jean Auel (a conference sponsor), Chris Stringer, Erik Trinkaus (conference organizer), Randall White and Jane Buikstra (conference moderator).

97 Bernard Vandermeersch has excavated and studied many important fossil hominids, including those from Qafzeh, Kebara, Biache and Saint-Césaire.

98 Rebecca Cann, one of the pioneers of the use of mitochondrial DNA in the reconstruction of human evolution.

99 Milford Wolpoff, a champion of multiregional evolution, meets the Sangiran 17 skull of *Homo erectus* from Java, which he believes could be ancestral to present-day indigenous Australians.

100 Chris Stringer with the Jebel Irhoud 1 skull from Morocco, a possible ancestor he believes for all modern humans.

It was during the fluctuating climates of 45,000–30,000 years ago that modern humans seemingly arrived in Europe and must have coexisted in a general way with the last Neanderthals. However, we do not have the detailed archaeological, fossil and chronological records to ascertain exactly how closely the two biologically distinct groups lived. Did they, for instance, share the same environments, the same valleys or even the same caves? We will look at this question from the behavioural point of view in the next chapter, but here we will consider whether the Cro-Magnons could have acted as 'Killer Africans' (to use Milford Wolpoff's choice phrase) and wiped out the Neanderthals they encountered.

In an area as large as Europe, with its varied environments and over a timespan of perhaps 10 millennia, many different kinds of interactions could have occurred (and probably did occur), ranging from avoidance to tolerance to interbreeding, and from conflict and economic competition to friendship and an exchange of ideas. As Paul Graves has suggested, if the Cro-Magnons passed on some of their technological innovations to the Neanderthals, perhaps the Neanderthals reciprocated by sharing their long experience of dealing with the Ice Age environments of Europe.[9] As we have already mentioned, there are occasional hints of interbreeding between the two populations of hominids e.g. the bulging occipital bone of one of the Cro-Magnon skulls, or the projecting mid-face of one of the Moderns from Předmostí. We are not sure that such features do in fact represent the result of interbreeding, but even assuming they do, we believe that such instances were exceptions, and that there was minimal gene flow (interbreeding) between the two populations.

The question of whether the Neanderthals represented a distinct species from modern humans depends on whether the anatomical and behavioural differences between them and us are emphasized, or the features they share with us. Their anatomy certainly suggests to us that they should not be classified within our species, as does that of comparable samples from Asia and Africa (e.g. Dali, Zuttiyeh, Broken Hill). But excluding a fossil human from *Homo sapiens* on the basis of its anatomy does not necessarily imply that the individual was unable to interbreed with modern humans. Closely related biological species are often interfertile, and may or may not produce fertile offspring when they hybridize. Neanderthals and Cro-Magnons would have been quite closely related, and genetically there may have been no barrier to Neanderthal/Cro-Magnon interbreeding. It would probably have been predominantly behavioural barriers that kept them distinct from one another. The two populations would have contrasted physically, and may have had major differences in language and gestural expressions. Hybrids, if they existed and were fertile, may have been discriminated against by the parent populations, ensuring that the flow of genes between the parent populations was restricted.

If the Cro-Magnons became more skilled at coping with and exploiting the European environments than the Neanderthals, the Cro-Magnon populations and ranges would have increased. With only finite resources, the Neanderthals

would have suffered from economic competition unless they withdrew to more marginal areas (such as, in this context, the southern Iberian and northern British peninsulae). If the Cro-Magnons occupied the more favourable and sheltered lowland valleys, the Neanderthals would have had to occupy higher or less-sheltered ground. In a normal summer this would have posed them few problems, but in more inclement weather their populations would have been put under severe stress. They would have suffered from higher infant mortality rates and shorter lifespans. Repeated across various parts of Europe and over many centuries or even millennia, this attrition would probably have caused Neanderthal populations gradually to decline towards extinction.

In fact, using a computer-simulated model, archaeologist Ezra Zubrow has shown how rapidly the Neanderthals could have become extinct.[10] Assuming interaction between stable populations of Neanderthals and Moderns, a Neanderthal mortality rate only 2 per cent higher than that of the Moderns could have resulted in Neanderthal extinction within about 1,000 years. So, when run through the computer, we see unfolding the possible long-term demographic history of the interaction between the two populations. In Zubrow's words, the demographic fate of the Neanderthals thus simulated 'is not a photograph but the trail of death'.

None of this, of course, explains exactly what took place as the local populations of Neanderthals were replaced. It is improbable, as Paul Graves has recently pointed out, that anything resembling a clash from recent colonial history took place, with one side packing all the resources, fire-power and know-how to triumph in an unequal contest.[11] But it *is* evident that the days of the Neanderthal era in Europe were numbered when the Cro-Magnons first arrived. The Neanderthals did not evolve into modern Europeans and their role in the shape of Europeans to come was minimal.

The exact relationship of Cro-Magnons to modern Europeans is, as we have said, still unclear. If their skull measurements are compared with data from different modern populations, they are scattered in their affiliations. While the Mladeč 1 woman seems European enough, many others (such as those from Předmostí and Cro-Magnon) seem allied to distant populations in Asia, Africa, Australia or the Americas. This does not mean that the Cro-Magnons were the ancestors of all these populations, but it may indicate that the Cro-Magnons were either racially undifferentiated, or that they represented a race or races with their own combination of features unlike any found today.

CHAPTER 9

Close Kin or Distant Relatives?

Right at the beginning of the book we asked whether the Neanderthals were close kin or distant relatives, direct lineal ancestors to modern humans or not. In order to answer this question we needed not only to examine the origins of the Neanderthals, what they looked like, where they lived and under what conditions, and how they survived, but also to look at their more primitive predecessors, *Homo erectus*, and the rise of their modern successors, *Homo sapiens*. We saw in Chapter 8 that the Neanderthals were probably extinct by 30,000 years ago and we discussed their fate from an anatomical point of view. In this chapter we will investigate the question from a behavioural perspective, comparing the behaviour of the Moderns with what we know of the behaviour of the Neanderthals (Chapter 7). But first let us take a brief look at two popular accounts of the Neanderthal demise.

Two popular fates for the Neanderthals

In Chapter 1 we saw some of the many, changing faces of the Neanderthals in art, science and fiction. Not surprisingly, the Neanderthal story has also received many different endings, although most of these ultimately seem to favour either replacement or continuity, in some guise or other. According to H.G. Wells (*The Grisly Folk*), for instance, the Neanderthals were brought to bay over the long millennia of the Ice Age by the 'First True Men', who invaded their lands and slaughtered them. Similar endings, in which the savage is subjugated by the civilized, have been repeated many times in fiction. For example, at the same time that Wells was writing *The Grisly Folk*, Marjorie and C.H.B. Quennell produced their children's book, *Everyday Life in the Old Stone Age*. First published in 1921 they summed up the extinction of the Neanderthals in the following terms: 'He had done as much as was possible for him. His large head, with the thick frontal bones, must have been very good for butting a brother Neanderthal, but it was no use against the stone wall of advancing civilization, and like the Tasmanian and Bushman, the Red Indian and Australian of nowadays, he fades out of the picture, and his place is taken by a cleverer people.'[1] With evolutionary 'dead ends', such 'mercy' killings apparently came as something of a relief. The fate of the Neanderthals symbolized what many then saw not only as the inevitable but also as the desirable removal of other so-called primitives from the earth – an everyday story of colonial folk.

The popular alternative to an abrupt replacement of the Neanderthals is the

argument for survival. For example, Milford Wolpoff, a leading exponent of the multiregional model, likes to tell conference audiences that he sees a Neanderthal every morning in his shaving mirror. Even if the Neanderthals are not to be found on the bus or football field, there are many who believe they roam the margins of the civilized world. For example, in her book entitled (in the US) *Still Living?: Yeti, Sasquatch and the Neanderthal Enigma* the former archaeologist Myra Shackley makes the case that the strange creatures supposed to live in the mountains of the Old World – the Almas, Yetis and Abominable Snowmen – are in fact refuge pockets of Neanderthals.[2] The idea, purporting to be based on scientific evidence, was widely circulated in the *Sunday Times* magazine of 23 January 1983, where one of Maurice Wilson's paintings appeared under the headline 'Are these prehistoric people living today?'

But Shackley's evidence is as illusory as a melting footprint. In trying to link the Almas of the Caucasus and Pamirs of Outer Mongolia to the Neanderthals, she remarks: 'The characteristic skull shape – a long, low-vaulted cranium with prominent brow ridges and jutting jaw [sic] – is curiously reminiscent of descriptions of Almas, *as is the recorded Neanderthal height of about 5 ft 6 in* [our emphasis].'[3] This could just as easily be interpreted to mean that Neanderthals are alive and well and living wherever such features can be found. In reply to her assertion that 'it is certainly curious that 'wild men' in some shape or form crop up so consistently, associated with almost everybody who had a recorded culture',[4] we point out that the concept of primitiveness is the necessary invention of all civilizations. It is part of the inherited cultural baggage of the last 4,000 years: there is nothing curious about it. Such portmanteaux contain no half truths about human evolution, only a potential source for shaping cultural attitudes towards distant relatives and other cultures. Wilson's painting is a good example of presenting an argument about the past as an image; it is most certainly not evidence, as used by Shackley.

A scientific fate

Why are we so convinced that there is no place for Neanderthals in modern European and Middle Eastern ancestry? How can we be so sure that the major contribution to our present physical appearance and behaviour, whether we are European or Japanese, African or Inuit, came from a second wave of hominids out of Africa, this time of anatomically modern humans?

We believe there are two compelling lines of evidence. In the first place we have seen repeatedly in earlier chapters the evidence from our own *biology*, be it limb length or mtDNA, which points to a swamping of the Old World Ancients by Moderns who came from Africa. Africa is the only continent where the equivalent of a 'Neanderthal phase' in modern human ancestry – one of the central beliefs of the proponents of multiregional evolution – can be supported by anatomical and genetic evidence. In all instances, the trail leads us back to Africa as the single continental centre for our physical origins.[5]

What must be made clear is that biological replacement does not imply genocide of the Neanderthals. As one of us (Chris Stringer) has recently pointed out, the Neanderthals probably went with a whimper rather than a bang.[6] The fate of the Neanderthals as we see it was one of a gradual displacement to more marginal and less favourable environments (Chapter 8) rather than defeat in some sort of territorial battle. Yet such colonial metaphors, as Wells elaborates in *The Grisly Folk*, are frequently used to portray the fate of the Neanderthals. The truth is that we do not (and probably never will) know the precise details of what occurred. We can only suppose that many different pathways led to the same result, in contrast to the frequently mistaken assumption that a common end must mean a single route.

This introduces our second line of evidence for replacement, the *behaviour* of Ancients and Moderns. In the first place we need to consider if modern behaviour and anatomy both originated in the same place, Africa. Certainly, archaeological evidence of the earliest anatomically modern humans in the Middle East, from such sites as Qafzeh, suggests a more complicated picture than a single centre for the origins of both modern physique *and* modern behaviour. Secondly, what do we expect behavioural replacement to have involved? Were Neanderthals, as an example of one regional population of Ancients, incapable of adopting any or all the patterns of modern behaviour? Or did they manage to incorporate into their existing routines some of the new ideas about technology and the use of the environment? If so, the adoption of how many new ideas would win the case for behavioural continuity? And would the speed of this adoption affect our decision whether continuity or replacement of behaviour best explains the archaeological record?

In Chapter 7 we set out the evidence for the behaviour of the Ancients, focusing in particular on the Neanderthals. In this chapter we will again concentrate on the European evidence, for it clearly illustrates that the behaviour of the Moderns was of a completely different order of complexity from that of their predecessors. We will argue that replacement of the Neanderthals by the Moderns can be the only plausible explanation for these differences in behaviour, given the absence of evidence for a gradual change from one way of life to the other.

We will investigate the major differences in behaviour between Ancients and Moderns at the three levels we discussed in Chapter 7: the construction of campsites, the use of the landscape, and expansion into new habitats. These changes are summarized in the table overleaf, which chronicles the appearance of some of the main elements of modern life, such as art, technology, houses and colonization. The crucial part of the table to focus on is the 20,000-year period (60,000 to 40,000 years ago) when a number of these important aspects developed – although by no means the entire cultural package that characterizes modern humans. In order to avoid concentrating too heavily on one small corner of the world (Europe), we have expanded the geographical coverage of the table to include the first recorded evidence, anywhere, for the traits which together define modern behaviour.

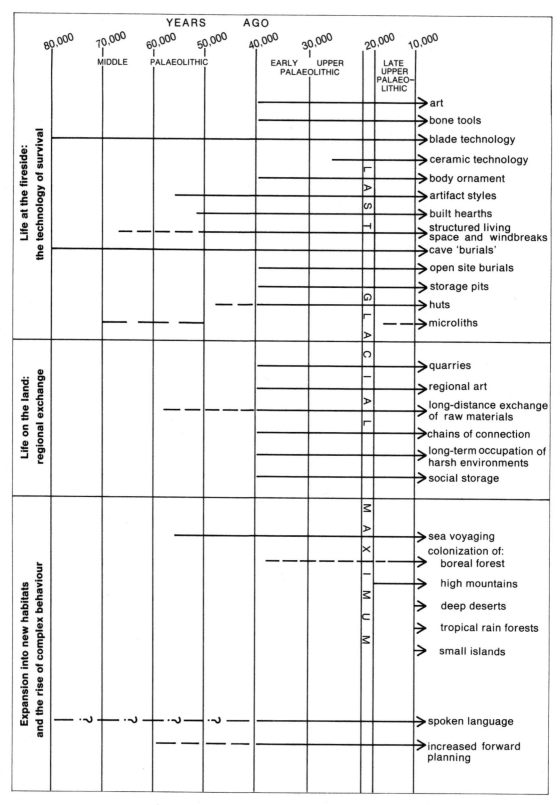

74 *The changes in behaviour between the Ancients and Moderns, as captured in the archaeological record. Clearly the period 60,000–40,000 years ago was a crucial one, for it is only after this point that so many of the elements associated with modern behaviour are to be widely found.*

What the table shows is that certain basic survival techniques at the campsite level show some continuity, among them stone blade technologies, 'burials' and rudimentary windbreaks. Blades and burials (e.g. Qafzeh and Tabūn) are found before the all-important period 60,000 to 40,000 years ago; the first artificial windbreaks only appear during it. But evidence for more intensive use of landscapes, such as the long-distance movement of raw materials like amber and shell is almost always found after 40,000 years ago. On the other hand, expansion outside those areas of the Old World inhabited by the Ancients probably did take place during the aforementioned 20,000-year period: dates of 50,000 or more years ago for the sea crossing to Australia and Papua New Guinea demonstrate that technological innovation (boats) and colonizing ability was taking place on a hitherto unknown scale. And this is a telling point, as we shall see later, since the first humans who reached Australia were almost certainly modern, both physically and behaviourally.

Our aim in the rest of the chapter will be to flesh out this table and to discuss the enormous changes in behaviour that took place in Europe 40,000 years ago – changes which we believe convincingly prove that replacement, rather than continuity, is the best explanation for current evidence.

LIFE AT THE FIRESIDE

The reader will recall from Chapter 7 that there is scant evidence for the structured organization of living areas among any of the Ancients – Neanderthals included. The Ancient's use of their living space, be it a rockshelter or an open site, is unfamiliar to us, and even something as basic as a permanent open-air, stone-lined hearth was absent in Europe until 60,000–40,000 years ago (see table). Evidence for the constructon of huts, as we saw, is even more elusive. We debated the issue of burial in Chapter 7; here we will discuss what further inferences can be drawn about ritual and religious behaviour. And finally, the absence until the Upper Palaeolithic of art, ornament or items of display is particularly striking. We cannot blame poor preservation for the scarcity of these 'modern' features, because some of the locations inhabited by the Ancients are among the best-preserved of the Palaeolithic. So, taken together, this evidence suggests that the life-style of the Ancients was very different from that of their successors.

The Ancient life-style was not simply confined to the Neanderthals or western Eurasians: throughout the Old World – from the Cape of southern Africa, across the Indian subcontinent and Central Asia to the archipelagos of Southeast Asia, and north again to China – we find a consistent archaeological record. There may be regional variety in the typology of stone tools, but current research suggests that the availability of raw materials and local patterns of land use are probably largely responsible for the variety that did exist. The Ancients, everywhere, displayed similar behaviour when it came to elementary spatial organization, while the fact that they did not elaborate their material culture makes it difficult to recognize that face in Wolpoff's mirror.

Let us contrast this for a moment with the behaviour of the Moderns after their arrival in Europe 40,000 years ago. It is very striking just how much spatial patterning there now is to the archaeological record. This is the case both in rockshelters such as Arcy-sur-Cure in northern France and at open sites as widely scattered as the early levels at Kostenki on the Don River, Dolní Věstonice in Moravia and the site of Lommersum near Köln.[7] The new organization of sites was clearly down to the Moderns for the most part, and even in those rare instances where the Neanderthals seem to have been responsible, we argue that the changes were influenced by the Moderns; they were not developed independently by the Neanderthals.

The Neanderthals and the Châtelperronian

75 A Châtelperronian point from Arcy-sur-Cure; possibly a Neanderthal imitation of Upper Palaeolithic technology.

Changes in stone tool technology have traditionally been used as one of the most important yardsticks with which to measure progress and development during the Palaeolithic, but in fact tool types are often an unreliable gauge of significant behavioural changes, as we shall now see.

Arcy-sur-Cure is a complex of caves in the Paris basin of which the Grotte du Renne (Reindeer Cave) was excavated by a great pioneer of Palaeolithic spatial archaeology, André Leroi-Gourhan. In this cave, he excavated a series of levels which spanned the late Mousterian and earliest Upper Palaeolithic. The oldest levels of the latter contained the distinctive points – with curved, steeply blunted backs – of the Châtelperronian industry. Radiocarbon dates for level VIII, in which these points were found, are of the order of 33,860 years ago, and associated with the tools were a few pieces of carved bone and drilled animal canines. In the lower level X, Leroi-Gourhan excavated a dozen living surfaces which contained mammoth tusks and traces of post holes left by stakes driven into the earth during hut construction.

Major excavations at the Grotte du Renne took place in the 1950s. At that time opinion was divided about the status of this and other Châtelperronian assemblages. As we saw in Chapter 8, for instance, French archaeologist François Bordes maintained that these distinctive points, and indeed the entire technological style of the industry, was derived from the so-called late Mousterian of Acheulean Tradition B. Other scholars were unconvinced, wishing to see the Châtelperronian as a later intrusion into the area since it contained a predominance of blanks struck from carefully prepared blade cores, rather than the characteristic flakes of the Mousterian.[8]

These blades are important. The prepared core techniques that must have been used to produce them are a departure from both the Levallois and disc core methods discussed in Chapter 7. Flaking the nodule to produce a core that can then be rotated to keep striking off slender, parallel-sided blades was a truly novel form of using raw material. But we have also seen that it was not an Upper Palaeolithic innovation in the old sense of such a term, so it is not a reliable indicator of the different flint-working techniques of the Ancients and Moderns. We have also discussed the Howiesons Poort assemblages of blades

and microliths from Klasies River Mouth and other South African sites which show that so-called Upper Palaeolithic technologies could exist in the Middle Palaeolithic.[9] The appearance and disappearance of comparable PUP (pre-Upper Palaeolithic) assemblages in the long sequences at Haua Fteah in Libya and the Mount Carmel cave of Tabūn adds a much wider geographical spread. We would not be surprised if future research yields similar instances of PUP assemblages sandwiched stratigraphically between regular Middle Palaeolithic strata in other parts of Asia.

A further complication comes from Anthony Marks' excavations at Boker Tachtit in the Negev Desert.[10] This open site has four levels, the earliest dated to 47,000 years ago. Within this one sequence is evidence for the shift from Middle to Upper Palaeolithic – flake to blade – technologies. However, one of the end-products, a projectile known as an Emireh point, remains constant. Indeed the careful refitting of flakes back to their original core shows that the knapper started by making such points with a thoroughly Middle Palaeolithic, Levallois technique. However, as the nodule was reduced in size the toolmaker changed to an Upper Palaeolithic blade technique to knap the remaining points. There is no clue as to which hominid produced this tool, and gave us a transitional nodule in a transitional industry. It would be nice to think that an Ancient began the knapping and a Modern finished it! So Boker Tachtit deals a further blow to the already crumbling edifice of traditional Palaeolithic theory, the demolition aided, as we have seen, by the discovery of the intermittent appearance of pre-Upper Palaeolithic industries and the association at Qafzeh and Skhūl caves of Middle Palaeolithic stone tools with modern humans. Similar contradictions to established notions have been raised by the colonization of Australia by Moderns who produced only rudimentary stone tools rather than a European-style, Upper Palaeolithic blade technology. The earlier appearances of blade technologies should not therefore be read as support for behavioural continuity.[11]

To continue the erosion of long-held views about technology and biology, we saw in Chapter 8 that the Châtelperronian of Europe is now widely thought to be the handiwork of Neanderthals. A careful review by Francis Harrold of the French material indicates that this can be supported stratigraphically,[12] while a flush of new dates for old sites and more recent discoveries have demonstrated the overlap between these assemblages and the first 'true' Upper Palaeolithic. Among these new finds is the important Neanderthal skeleton from the French cave of Saint-Césaire. It came from a Châtelperronian level which now has a thermoluminescence date of 36,300 years ago. The possible hut structure in one of the Châtelperronian levels at Arcy-sur-Cure may also have been erected by the Neanderthals.

It is interesting to observe that the transition in this area to a blade-based technology (the Châtelperronian) and the appearance of structures at campsites (Arcy-sur-Cure) only occurs long after the Moderns arrived in central Europe and the Iberian peninsula. Imitation rather than invention therefore seems the most plausible explanation for the change in Neanderthal behaviour.

The Moderns and the Aurignacian

The first 'true' Upper Palaeolithic industry – in the sense that it was made by anatomically modern humans and has all the technological features and artistic additions normally expected of the Moderns – is widely recognized to be the Aurignacian. Along with such memorably named tool types as strangled blades, nosed scrapers and the small edge-nibbled Dufor's bladelets, Aurignacian flint assemblages notably contained bone and ivory projectile points. Such items were absent in the earlier phases of the Middle Palaeolithic and are extremely rare in the world-wide pre-Upper Palaeolithic. These projectiles form a cultural marker of considerable significance for typologists.

The earliest dates for the Aurignacian in Europe come from excavations by Janusz Kozlowski in the Bacho Kiro cave in Bulgaria.[13] These have produced a distinctive blade-dominated assemblage now classified as Aurignacian, radio-carbon dated to more than 43,000 years ago. In eastern and central Europe Aurignacian assemblages are consistently earlier than in France, which seems to be one of the last strongholds of flake-based Mousterian industries and indeed, as the Saint-Césaire find shows, a last refuge of the Neanderthals themselves. In the Middle East, the earliest Levantine Aurignacian – at the Lebanese rockshelter of Ksar Akil – may be as early as 44,000 years old,[14] while we have already discussed the dates of 47,000 years ago for the transitional industries at Boker Tachtit. These dates point to an eastern origin for the European Upper Palaeolithic. Furthermore, we saw in Chapter 8 that the Aurignacian is associated with the spread of anatomically modern humans into Europe.

Currently, the earliest dates for the western Aurignacian come from Spain. At the impressive cave site of El Castillo, south of Santander, careful re-excavation by Victoria Cabrera Valdes has produced a detailed stratigraphy and dates of between 37,700 and 40,000 years ago for the Aurignacian levels. The cave site of l'Arbreda in Catalunya is dated to 38,500 years ago.[15] Early dates for the Aurignacian within France come from the Abri Pataud, 34,000 years ago, while the sites of Roc de Combe and Piage contain alternating levels of Châtelperronian and Aurignacian industries, further supporting our view of southwest France as a cultural and biological refuge for the Neanderthals. There is evidence from Zaffaraya Cave that southern Spain may have fulfilled the same role.

Also highly significant is the appearance of art in association with Aurignacian tools. The earliest examples take the form of small sculptures from the southern German sites of Stadel, Geissenklosterle and Vogelherd. At the first, an impressive lion-headed anthropomorph was painstakingly reconstructed by Joachim Hahn from many hundred pieces of a small broken mammoth tusk (pls. 93, 94). And in southwest France, limestone blocks engraved with signs interpreted as vulvae have been excavated from Aurignacian levels at the sites of La Ferrassie and the rockshelters at Castanet and Blanchard.

Pierced deer and fox canines, shells, and carefully made ivory beads are also

commonly found in Aurignacian levels (pl. 88). Building on research by Marcel Otte, archaeologist Randall White has made a detailed study of these, and demonstrated the range of different manufacturing techniques required to produce the ivory beads.[16] Interestingly, he concludes that some areas were obtaining the ivory from elsewhere. Southwest France was one of these. Although the distances involved cannot yet be determined, we know that mammoth remains were very rare at the sites in this region, whereas people in Germany generally had immediate access to ivory sources.

Art and symbolism

What is the significance of the appearance of art and ornament? We argued in Chapter 7 that earlier items are unconvincing as evidence for symbolic behaviour either because they lack a context where symbolism might be required (such as a burial) or because they are unique examples, unrelated to any wider system that used the repetition of design and shape as symbols for action. In our view, therefore, the emergence of art during the Aurignacian clearly suggests that replacement rather than continuity took place in this fundamental aspect of modern behaviour.

Geoff Clark and John Lindly, however, have argued conversely for a slow build-up in the use of art and the development of associated symbolic behaviour.[17] The artistic explosion, at least as measured by quantity, occurs according to them *after* the last glacial maximum 18,000 years ago, almost 20,000 years after the appearance in Europe of the Aurignacian. It is at this time that we find many more carved and engraved objects in Europe, as well as the painted caves of Franco-Cantabria. Prior to this period, Clark and Lindly see a continuity in this aspect of behaviour from the Ancients, with only a gradual accrual in the human artistic repertoire.

We believe that Clark and Lindly are mistaken in their interpretation. We disagree with their insistence that symbolic behaviour is something that can be turned up and down like a light on a dimmer switch. On the contrary, arranging behaviour according to symbolic codes is an all or nothing situation. The onset of symbolic behaviour can be compared to the flick of a switch or, as John Pfeiffer put it, a creative explosion.[18] Symbolism involves making mental substitutions and appreciating associations between people, objects and contexts; once established, symbolism cannot simply be dropped or forgotten. Furthermore, symbolic behaviour requires memory and periodic renewal through repeated ritual. The objects used in such rituals tend to be standardized, leading to the creation of a shared art form.

One of the interesting questions to emerge from this discussion is why such geographical variation exists in the quality and quantity of ritual art and ornament after 40,000 years ago (particularly since the symbolic behaviour associated with these objects was so clearly in practice). Why is this aspect of material culture so variable in parts of the Upper Palaeolithic world such as China or India? To debate this issue in the detail it requires would fill an entire

book. Suffice it to say here that as research continues in these areas, evidence for ritual-based art probably will turn up, as it has in Australia.

The Ancients, including the Neanderthals, therefore seem to have constructed their social worlds in a very different way from the Moderns. As Alexander Marshack has put it, the Ancients' capacity for communication and the construction of their social world 'were utilized in a historically, demographically and contextually different milieu than was present in the European Upper Palaeolithic'.[19]

Campsites as symbols

Having investigated the appearance of symbolic behaviour by examining the changes in art and technology, we will now take a look at the evidence from campsites. The first steps towards the more formal living spaces that began in the period 60,000–40,000 years ago became a gallop in the early Upper Palaeolithic. Hearths, huts and the ordered distribution of materials now became common. In many parts of Europe, the period from 40,000 to 20,000 years ago was one of great climatic stress and consequently low population densities (Chapter 2). Substantial sites were widely scattered. Several formed impressive open-air villages. Nowhere is this better demonstrated than at the Kostenki complex of Palaeolithic villages that nestle in a small, steep-sided ravine by the Don River. Fifty years of systematic excavation have unearthed a suite of villages. At Kostenki 11, dated to 19,900 years ago, the circular footings of a structure survive. This hut was built from neatly stacked mammoth bones and encloses an area of some 39 sq. m or 420 sq. ft (pl. 89). Storage pits surround the structure. Larger excavations have uncovered a different layout at the famous site of Kostenki 1 level 1 (Kostenki I/1), with dates from 24,100 to 21,300 years ago. Here two lines of regularly spaced hearths – each containing an impressive amount of bone coal considering they were used at a time of scant timber resources – are surrounded by subterranean pit dwellings and a lunar landscape of post holes and pits. The latter contain stored bone for fuel and possibly food. Bones of fur-bearing animals and large lumps of red ochre were also found in these pits, along with many carved animal and female statuettes. When one compares behaviour at this site with that at the open Mousterian site of Érd in Hungary or La Borde in France, or even with that at the relatively nearby site of Molodova on the Dnestr River during the period 60,000 to 40,000 years ago, there can be only one conclusion: that the huge changes in behaviour that took place in the early Upper Palaeolithic resemble the flick of a switch and *not* the slow upwards movement of a symbolic dimmer.

Not surprisingly, these differences seem greater in Europe than elsewhere in the world. At Kostenki the northern ice sheets were only 700 km (430 miles) away, and effective winter houses were a necessity. But these structures were no longer simply a place to keep warm: huts were grouped into small villages. Thus architecture now embodies cultural, symbolic behaviour and not purely expedient survival behaviour.

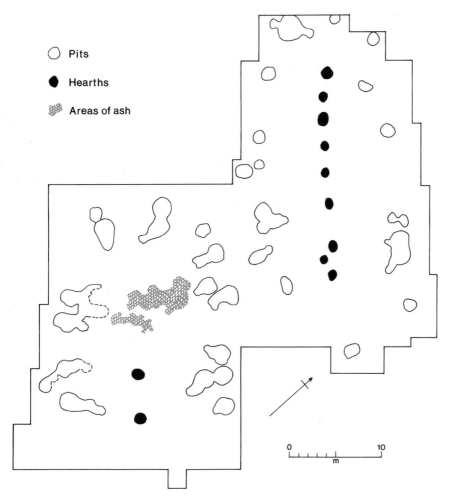

Pits

Hearths

Areas of ash

0 10
m

76 The oldest village on the Russian steppes was constructed c. 21,000 years ago at Kostenki, on the Don River. Storage pits and possibly dwellings surround two lines of hearths, where mammoth bones were burnt for fuel since timber was scarce.

Burials in the open

Throughout this period 40,000–20,000 years ago we find examples not only of impressive structures and campsite layouts, culminating in Kostenki I/1, but also the first open-air burials. The triple burial recently unearthed ahead of the bulldozers at Dolní Věstonice (fig. 77) is just the latest in a list of such discoveries, made all the more impressive by the lack of anything remotely resembling a burial from an open site in any earlier period. The cave sites also contain rich and complex burials. Margherita Mussi has studied a well-known group from the Italian riviera, drawing attention to the intricacy of grave goods in the early Upper Palaeolithic – for example the use of different dress codes to symbolize the different status of the deceased (fig. 78).

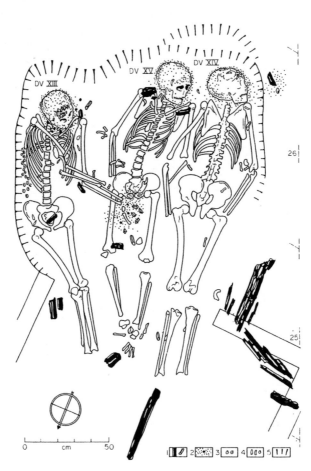

77 *A triple burial, 27,000 years old, found in 1985 at the open site of Dolní Věstonice, Moravia.*
The central individual (of uncertain sex) is flanked by two males, both of whom had ivory
pendants circling their skulls. A fire had been lit over the bodies and allowed to burn briefly before
the grave was filled.

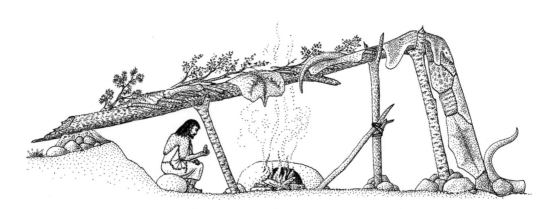

78 *A reconstruction of one of the huts excavated at Dolní Věstonice, probably 27,000 years old.*
The site has yielded the earliest evidence for a ceramic technology that produced artistic figurines
as well as pieces of fired clay.

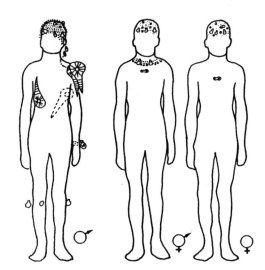

79 *Three richly adorned burials from the Italian Upper Palaeolithic, in which status and sex was codified in dress and ornament. The male on the left was excavated from Arene Candide, the two figures on the right from Barma Grande.*

Imitation and change

To summarize, life at the fireside changed substantially between the Ancients and the Moderns. It changed because symbolism in the Upper Palaeolithic suffused many elements of behaviour, determining such mundane aspects of life as the use of space and objects of everyday existence.[20] Does a comparison of campsites indicate that the Ancients had a symbolically organized culture? We think not. In our view, Châtelperronian stone tools and the rudimentary structures found at such sites as Molodova and Arcy-sur-Cure are evidence that the Neanderthals had the capacity for emulation, for change, but not for symbolism.

We explain this as follows: the Neanderthals were under selective pressure, both biological and cultural, to survive. Their decisions about making tools and building camps therefore changed according to expediency and efficiency, they were not simply bound by millennia-long traditions. The various choices made are reflected by variation in the archaeological record of the Ancients, particularly from the period between 60,000 and 40,000 years ago. However, when Neanderthals and Moderns came into contact in western Europe between 40,000 and 35,000 years ago, the Moderns changed the forces of selection on Neanderthal behaviour. The social world in which the European Neanderthals now participated was fundamentally different from the preceding 100,000 years, and the archaeological evidence clearly indicates that the Neanderthals imitated certain aspects of modern behaviour. But while they could emulate they could not fully understand. We suspect, for example, that the structures at Molodova and Arcy-sur-Cure more resembled 'nests' than the symbolic 'homes' of the Moderns at Kostenki or Dolní Věstonice.

So now let us turn to other aspects of life, to see whether here too we can find evidence both to support our case for replacement and to enhance our argument that the main structural difference distinguishing the Moderns from the Ancients was the practice of symbolically organized behaviour.

LIFE ON THE LAND

The distribution of raw materials – stone, amber, shell – and the appearance of widespread styles in projectile points, figurines and ornament provide another example of the huge differences between the behaviour of the Ancients and that of the Moderns.

The distances stone travelled

Recent work on the distribution of stone raw materials supplies a dramatic example of the different scale at which the Moderns used the glacial landscapes of Europe after 40,000 years ago. We saw in Chapter 7 that Middle Palaeolithic raw materials generally came from within a radius of 50 km (31 miles) of a site. There are instances of transport from further afield but these are the exceptions. But during the early Upper Palaeolithic, 40,000 to 20,000 years ago, these distances increased markedly. Janusz Kozlowski found in Aurignacian levels (somewhat older than 40,000 years ago) at Bacho Kiro that 53 per cent of the flint used to make the blades was imported from more than 120 km (75 miles) away. Elsewhere in early Upper Palaeolithic Europe, distinctive chocolate-coloured, high-quality flint was transported from quarry sites in the Holy Cross Mountains of Poland over distance of up to 400 km (250 miles).

The raw materials used to make ornaments and other items of dress and display travelled the greatest distances. Since such ornaments are absent prior to 40,000 years ago these distances are particularly significant. Marine and fossil shells used for ornaments are commonly found several hundred kilometres from their source, while fossil amber was traded from the Black Sea to sites up to 700 km (430 miles) away, on the central Russian plain.[21]

Although basic raw materials in the Upper Palaeolithic were still predominantly traded locally, the long distances increasingly covered indicate a far more complex and widespread system of contact than almost anything in operation prior to 40,000 years ago.

Artifact and art styles

Widespread distribution is not confined to raw materials. Distinctive styles of art and artifacts could also be diffused over large areas, and these styles – when well dated – can provide an indicator of the scale of the social system concerned. As we will see, an increase in scale occurred in the geographical range of artistic style after 40,000 years ago, which is best understood as a new link between people and the land. And this link in turn arose as a consequence of those all-important changes in symbolic behaviour that now influenced the shape, treatment and choice of objects.

In the period 60,000–40,000 years ago, we find distinctive projectile points with a wide regional distribution. These include the Aterian points of North Africa and the leaf points of northern and southeast Europe which we

encountered in Chapter 7. Among other such artifacts number the triangular hand axes of northwest Europe and perhaps the Lupemban picks of eastern and southern Africa (see figs. 48 and 49). However, these styles represent only very broad categories: considerable variation exists within each group, often over fairly short distances. For instance, Philip Allsworth-Jones has conducted an exhaustive analysis of the leaf points of Europe which demonstrates just how variable they are in terms of their dimensions, technique of manufacture, degree of retouch, and their associated flint assemblage.[22]

In contrast, stylistic forms during the early Upper Palaeolithic tended to be much more uniform. The split-base bone points of the Aurignacian, for example, are essentially alike throughout their European distribution, and many Gravettian stone artifacts display a similar homogeneity. A good example is provided by the shouldered projectile points dating to 23,000–21,000 years ago from Kostenki, Spadzista Street in Cracow and Willendorf on the banks of the Danube in lower Austria. While variation still exists, there is undoubtedly more standardization over these large distances. The uniformity further increased after the last glacial maximum about 18,000 years ago when population densities rose throughout this very broad territory, and is particularly marked for organic artifacts such as the antler sleeves (which served as mounts for flint gouges): these were scattered all the way between Poland and southern France in the late glacial.

The wider geographical spread of characteristic artifact types was also matched by the diffusion of art. To start with, the early Upper Palaeolithic in Europe was marked by regional styles, such as the small groups of animal and anthropomorphic carvings from southern Germany. As the climate begins the long drop to its nadir at 18,000 years ago, however, we find the first pan-continental art style: the so-called Venus figurines.[23] Although similar in overall design, a closer study of these figurines reveals some differences. The limestone figure from Willendorf, for instance, was covered in red ochre and has finely engraved bracelets on her wrists (pl. 91), whereas one of the Kostenki I/1 figurines was made of ivory, and had details of a necklace carved on her chest. Another fragmentary chalk figurine has a head decorated like the surface of a golf ball. Other figurines depict facial features in a rudimentary fashion.

Here, evidently, is a vibrant tradition. Yet for all the local differences in detail and treatment, this group of figurines (dated to between 23,000 and 21,000 years ago) shares a striking similarity in design and style. Recently, the Russian archaeologist Maria Gvozdover has undertaken a detailed analysis of the rich collections of Venus figurines from the neighbouring (in Russian terms) sites of Kostenki I/1 and Avdeevo.[24] She concludes that the decorative variety is linked to a female symbolism common throughout the Upper Palaeolithic at the time. A wide-ranging tradition thus existed which, in her words, 'transcends the bounds of the individual archaeological cultures' where these small figurines were found. Gvozdover very importantly argues, on the basis of the archaeological contexts in which these objects were recovered, that the variation reflected the multiplicity of roles for the female image.

0 50
mm

80 Shouldered projectile points from a. Cracow; b. Avdeevo, Russia; and c. Willendorf.

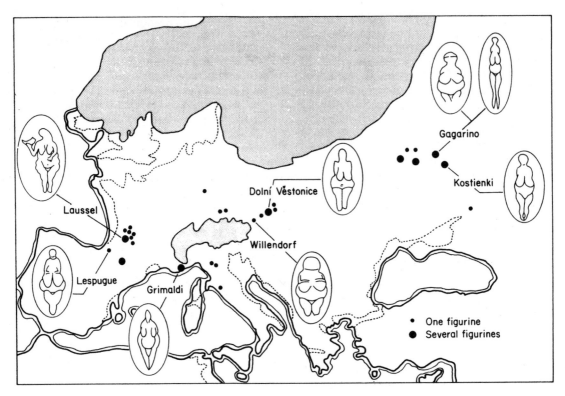

81 The distribution of 'Venus' figurines and bas-relief carvings.

Style and survival

In order to understand the stylistic similarities of Upper Palaeolithic art and artifacts, we must first appreciate how people use material culture to survive in harsh, unpredictable environments. One route to survival is obviously by improving technology, particularly houses and clothing. Another is to fine-tune hunting equipment to minimize the chances of failure when scarce prey is encountered. But these advances are inadequate by themselves if they are not backed up by social networks – alliances between relatives, trading partners, friends, peers and task groups. As we saw in Chapter 7, these alliances act as 'insurance policies' in habitats (such as today's Arctic) where the only certainty is that resources will sometimes fail.

We believe that these social and trading networks were only established by the Moderns. There are two major reasons for this. First, the objects that symbolize such alliances (i.e. the figurines and ornaments that seem to have no immediate utilitarian function), appeared only after 40,000 years ago. Second, populations after this time were apparently better equipped to survive worsening climates, suggesting the existence of social 'insurance policies' (in marked contrast to the Ancients who tended to become locally extinct during particularly harsh conditions). As a result, there was a reduction in the ebb and flow of settlement within regions under environmental stress.

Let us expand on these two themes. Style, the means by which objects are made distinctive, is a fundamental trait of modern human behaviour, especially when it is applied to objects of social value (such as necklaces and figurines) rather than to functional items (e.g. points and hand axes) alone. Through style, therefore, material culture can be used as a means of transmitting information in a visual manner. So, using the Venus figurines as an example, how can style assist social alliances? Well, art is a form of visual communication. Style can aid social communication and cooperation because distant relatives and strangers, individuals and groups identify with each other through sharing a common, recognizable symbolism. The vital meetings that took place between low-density populations on the steppe tundra of Ice Age Europe would have been infrequent and unpredictable, but they were a key to long-term survival. Having a shared material culture would have facilitated a successful outcome to such meetings.

The messages an 'art' object carries depends for their full interpretation on the contexts and rituals in which the object is used. Unfortunately we will never fully understand the particular messages denoted by Palaeolithic objects. But while we cannot specify how Venus figurines were used, or why females were always carved, or even why some of them show consistent, exaggerated proportions (all elements which define them as part of a stylistic, geographical group), their distribution and dating clearly point to their function in allowing people to navigate their way through critical negotiations. We believe it is no coincidence that the figurines appeared in central and eastern Europe at a time when climates were deteriorating and food resources dwindling, as the ice sheets expanded towards their maximum extent.[25] For without the social alliances which such objects symbolize, these areas would have been unoccupied during the period 23,000–21,000 years ago.

Patterns of settlement

Another way to test the contribution made by art and other forms of material culture to the expansion of human communities is to examine settlement distribution. Consider, for instance, the settlement history of a particularly harsh region of Ice Age Europe: Germany. The Middle Palaeolithic sites were abandoned during severe climatic phases whereas settlements during the early Upper Palaeolithic survived somewhat longer; and occupation only ceased during the harshest periods of the last glacial maximum.

The evidence we reviewed in Chapter 7 suggested that during the Middle Palaeolithic the Ancients achieved subsistence security by forming small, self-sufficient local units. It was rare for individuals or small task groups to operate at any great distance or for any length of time away from the local range in which most of the population was concentrated.

The environment continued to exert a stong influence on settlement during the Upper Palaeolithic. The use of the German region was probably specialized and infrequent during the early Upper Palaeolithic. It is unlikely, for example,

that any winter villages existed in this area. The archaeological traces are most probably those of small task groups visiting the region as part of their most distant reconnoitres from their home bases. These trips may have taken place during weak ameliorations in the Ice Age climate that lasted a few decades in most centuries.

So, as the Upper Palaeolithic demonstrates, a presence in a climatically severe region like Germany – as the ice sheets crept out from the north and south – depended as much on the ability to create very extensive social networks as it did on improvements in technology. After all, you can have the best-sewn skin and fur clothing, but without the social networks to back you up survival will be brief. It is worth remembering that the Neanderthals disappeared under similar conditions. Their reaction to environmental decline was not to intensify their self-help networks but instead to relocate to areas where the resources could still support existing life-styles at more favourable population densities.

Society and stone tools

We can draw two conclusions from the foregoing comparison of the changing use of the landscape. In the first place Neanderthals had much smaller societies than any Moderns who later came to use their habitats. To ensure biological reproduction there would have had to be a mating network of 175 to 500 people.[26] But beyond this biological limit Neanderthals seemingly showed little interest in establishing social ties. Group self-sufficiency in all things (food, mates, raw materials) was their basic strategy rather than using the alliances that could be built, through negotiation, to extend the length of occupation in a region now subject to difficult climatic conditions.

Our second conclusion is that the Neanderthals were essentially hominids *assisted* in their survival by tools. Their material culture, dominated by stone artifacts, was not symbolically organized. They did not have culture in the sense we understand it today and recognize it over the last 40,000 years. Artifacts may have been manufactured according to the same prototypes, but we doubt that style as defined above played much if any part in determining these shapes. Middle Palaeolithic hand axes and scrapers are certainly repetitive, but then so too are the elaborately constructed nests of birds. Just as birds are assisted in their survival by the nests they build, so too, we argue, were Neanderthals as tool-assisted hominids.

How can we be so sure of these two conclusions? On the one hand there is the long-term evidence for the ebb and flow of Middle Palaeolithic populations, especially as the climatic cycles ran their repetitive course in northern Europe. The distribution of Neanderthals appears to be environmentally determined: when faced with a climatic challenge they do not intensify, as the Moderns did, but instead disappear from the record until better times returned.

On the other hand there is the fundamental development, the creative explosion, of style as a means of shaping material culture. Style in this context is

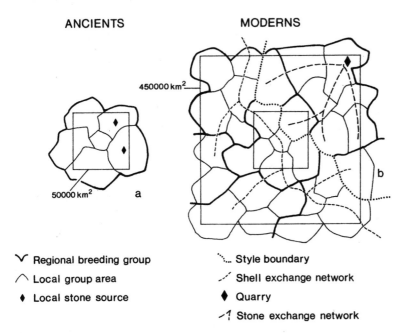

ANCIENTS MODERNS

450000 km²

50000 km² a

b

ᐯ Regional breeding group ᐟ᛫᛫ Style boundary

ᐱ Local group area ᛫⁄ Shell exchange network

♦ Local stone source ♦ Quarry

 ⁻ᐧ Stone exchange network

82 The social revolution. The main difference between the societies of the Ancients (including the Neanderthals) and the Moderns was one of scale and complexity. We interpret the archaeological evidence for increasingly far-flung exchange and social interaction as an indication that the emphasis of survival shifted from local self-sufficiency among the Ancients to a system of storage based on social ties and alliances, thus reducing the risk of starvation. With this leap in scale came the opportunity to expand territories and acquire raw materials over much greater distances. Colonization could then proceed rapidly as, perhaps unintentionally, social solutions were found to survival problems in the environment.

an expression of a more complicated social life. The messages it helps transmit gather their meaning from society, the relationships between people and the many different contexts where these are constructed. The Ancients, as tool-assisted hominids, clearly had societies but these were not as complicated as those of the Moderns since the former did not deal with people who were socially or spatially distant. As a result the Ancients never took out those 'insurance policies'. Consequently they did not cross the oceans or colonize the inhospitable interiors of continental Asia. This is why the Ancients remained Old World hominids.

Their lack of art is now understandable. There was no need for it to assist in ceremonies and negotiations. Equally, there may not have been the need for complex language. Their geographically small, self-sufficient societies did not need to further elaborate their social communication by visual means. Their use of raw materials is also entirely consistent with the local level of their existence. Why bother with distant imports when a serviceable local stone will probably do, especially since one of the reasons for using exotic stone is the ties that come with it? But all of this only makes sense if we begin to see that the fundamental difference between the Ancients and Moderns is social. The answer to our earlier question – did the Neanderthals have culture? – is now becoming clearer.

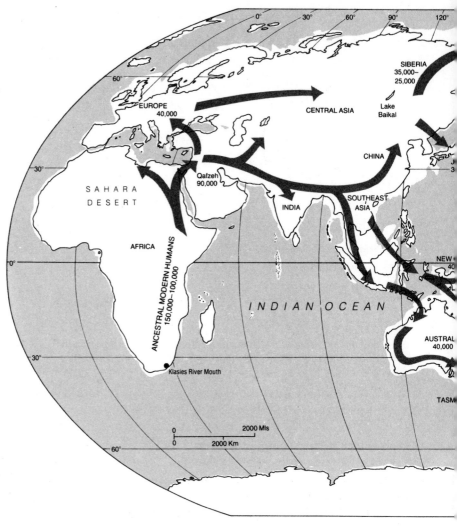

83 Around the world in 40,000 years. Very approximate dates of first settlement by anatomically mo

EXPANSION INTO NEW HABITATS

The final level of comparison provides a further opportunity to examine our case for replacement. One of the most distinctive aspects of modern humanity is the near global distribution of our species, which was achieved during prehistory.[27] For many years this was put down either to chance (given enough time everywhere will be settled eventually) or the fortunate invention of appropriate technology (such as boats). Neither of these explanations are satisfactory in the light of the pattern and timing of global colonization after 40,000 years ago. Charting this process has been one of the great achievements of contemporary archaeology. With the benefit of hindsight we can look back into the Palaeolithic and see more clearly the constraints on the Ancients which

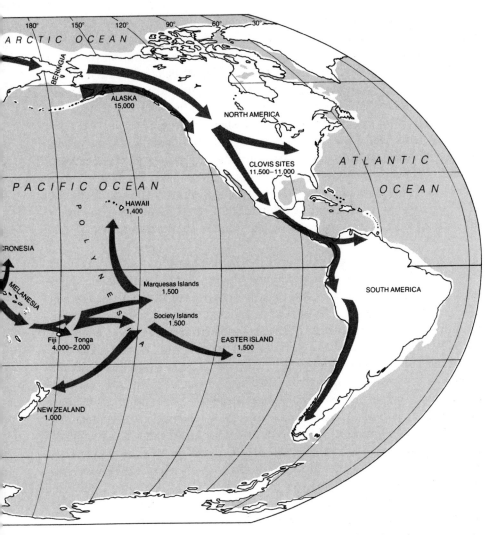

umans are indicated (in years before the present) for those regions where there is sufficient evidence.

resulted in their comparatively restricted Old World distribution. Once again the differences between the Ancients and Moderns – in terms of how rapidly and how many of the habitable parts of the earth they colonized – are too great for any model of continuity to be able reasonably to explain.

We can trace the consequences of having smaller societies throughout the Ancients' world. It was, in terms of hominid colonization, half a million years or more of inaction. The exit from sub-Saharan Africa just before 1 million years ago saw a fairly rapid colonization of many parts of the Old World. During this first African dispersal, however, several environments and landforms remained unsettled. Among these were islands and mountain chains, the large sand deserts and tropical rain forests, and the Siberian boreal forests. Perhaps this was partly due to the severe continental climates where –

even today, in an interglacial – the winter temperatures drop off the scale. But more significant is the uncertainty of food in such environments. It is possible to make a living, as the fisher-gatherer-hunters of Siberia and the Canadian sub-Arctic still do today; but their low population densities indicate just how difficult this is. Survival in these environments requires forward planning and the intricate scheduling of time and labour to catch fish and deer, and gather berries and plant foods. Inhabitants of such environments, as we have discussed, also need social networks to back up the periodic disasters. The absence of Ancients in eastern Siberia points very clearly to the mismatch between the food resources in that environment and the Ancients' society. Food was always available in these habitats, it was simply high-risk to exploit. This suggests that the barriers to colonization were determined primarily by the nature of the Ancients themselves, and not by the environment.

The colonization of Australia and the Americas

The surge of colonization achieved by the Moderns is quite remarkable. They crossed the Sunda trench to Australia and settled an unfamiliar continent inhabited by marsupials. The earliest dates range from possibly 55,000 years ago in the Malakunanja rockshelter in the northern territory, to 35,000 years ago at Warreen cave in southwest Tasmania. Recent work by Chris Gosden, Jim Allen and Matthew Spriggs in the Bismarck archipelago and Solomon islands on the western rim of the Pacific has shown that by 32,000 years ago people were making substantial ocean voyages.[28] The stone tools from excavations such as Matenkupkum on New Ireland are typologically amorphous and reminiscent of the Middle Palaeolithic. But we have already seen how unsatisfactory stone tools can be as a measure of modernity; colonization is a much better guide to fundamental changes in behaviour than stone tool typology and technology.

It is not until the Moderns appear that evidence is forthcoming for entry into the Americas, the timing of which is still hotly contested. We favour a late arrival, around 15,000 years ago, but a vociferous camp would more than double that figure. There are no serious suggestions, however, that any people but the Moderns crossed the Bering land bridge into North America. All these great bursts of colonization led eventually to the occupation of most of the continents and major islands in prehistory. Indeed, when the world was rediscovered by European explorers in the last 500 years, the only attractive lands they found uninhabited were remote areas such as some of the islands in the Atlantic and Indian Oceans. They had been beaten to it for the most part by the prehistoric Moderns. On the continents, the only vacant regions were above the permanent snowline.

Did they have culture? Could they speak?

Earlier in this chapter we characterized the Ancients, including the Neanderthals, as tool-assisted hominids. Technology was one of the varied

strategies adopted to solve the problems of survival. Artifacts and weapons, campsites and landscapes were never elaborated in the cultural ways that are so basic to any definition of what makes a modern human modern.

But for all their differences from us, it would be a mistake to write off the Ancients and particularly the Neanderthals in that period from 60,000 to 40,000 years ago. They did not do what Moderns did, but they were around for a long time and, but for the appearance of the Moderns, they would probably still be around today. They were not failures merely because they had no art and never visited the Great Barrier Reef. As we saw in Chapter 7, recent work on the organization of their stone technologies by Steven Kuhn has indicated diversity within uniformity. A narrow stereotype of the Neanderthals (or indeed any other regional population of Ancients) is clearly an unwarranted simplification. The Ancients existed within quite a different social order from our own, with only limited planning depth and organization. But this does not mean they were capable only of a single form of behaviour, found throughout the Old World, and modified exclusively by changes in the availability of animal and plant species.

Culture is a difficult word. Some have seen it as an archaeological grail, its investigation forming the focus of the discipline. Culture has been declared the means of human adaptation as well as the resource for demonstrating human diversity unrelated to mechanical survival. It looms large in any definition of what is, and what is not, modern. In a recent paper linking the first spoken languages with the appearance of art Iain Davidson and William Noble come to this conclusion: 'There can be no such thing as culture without language and the socially determined sharing of meaning and value. It will therefore be misleading to talk of culture for any hominids before fully modern humans.'[29]

We feel, however, that while spoken language adds incalculably to the elaboration of culture we should avoid pinning all definitions of modernity on one element, however significant it may seem to us. To do so is to run the risk either of simply fulfilling our initial assumptions or of failing to supply an adequately reasoned explanation for the major differences between the Ancients and the Moderns. The Neanderthal and Modern debate is very much a parable about insiders and outsiders in the modern world, those who are savage and those who are civilized.[30]

We examined in Chapter 4 the anatomical evidence for Neanderthal voice boxes. They could certainly communicate, as can all social animals, and they no doubt spoke, albeit simply and probably slowly. We argue that the Neanderthals lacked complex spoken language because they did not need it. We could not imagine life without it, but they did not have the social life to require it. Robert Whallon takes the view that language itself gradually evolved, rather than emerged fully formed.[31] He points out in particular that the part of language to develop last was probably the element (known as the tense-modality aspect) that refers to the future. This only appeared in the context of colonization, for long-term planning and extended social networks were needed to reduce the risks involved in migration and survival.

Where did modern behaviour originate?

Archaeology often likes to deal with questions of origin. Where did agriculture first evolve? Why did cities first appear in the Middle East? Where is the cradle for the origins of humankind?

We believe that the geographical origins of anatomically modern humans lie somewhere in Africa. We can be less certain about the source of modern behaviour. The time-lag between the earliest modern-looking humans in East Africa (Omo Kibish perhaps as much as 130,000 years old) and the Middle East (Qafzeh, Skhūl c.100,000 years old), and the appearance of Moderns in Australia (c.55,000 years ago?) plus the symbolic explosion in art and burials after 40,000 years ago makes it difficult to point to any one area as the centre. Perhaps the early dates from Australia suggest some region in Southeast Asia; early Moderns may have evolved cultural behaviour here which then – on the timescale of human evolution – quickly sped around the world. The Middle East (regarded by many as a crossroads) may also have been such a centre, exporting behaviour to existing populations of Moderns in the east and, as the Moderns themselves spread to the west, into continents such as Europe.

The source of modern behaviour will remain conjectural until we have a better understanding of which evolutionary forces and mechanisms actually shaped modern behaviour. What is quite clear, however, is that wherever new developments took place they did so rapidly (the flick of a switch), adapting to the anatomy of modern humans that had been around for perhaps 70,000 years. Such behaviour, based on the structural principles of symbolically organized culture, spread rather like a virus among the host population, and then spread further as the host itself now expanded. The rapidity of the process, which took place so many thousands of years ago, makes it difficult for archaeologists to study. But – like the remnant ripples of radiation that recently confirmed the Big Bang theory of the origins of the Universe without indicating exactly where it happened – we believe that the global expansion of humans which began some 60,000–40,000 years ago is evidence of replacement and not continuity as the mechanism of the human revolution.

Epilogue: The Lesson for Human Unity

Let us return once more to the question we posed at the beginning of the book: how can we best explain the evidence for human evolution? We hope that we have demonstrated convincingly that population replacement is the most plausible interpretation of the archaeological and anthropological record of the later Pleistocene. Our study has focused in particular on the differences between the Neanderthals and modern humans, and we determined that the

fundamental differences between the two populations lay in their society and culture as well as in their anatomy. We found that the two communities were supported by different capacities for communication – verbal, visual and symbolic – and that this in turn affected their organization of campsites, their exploitation of the landscape, and their colonization of new habitats. But to conclude that the Neanderthals were different from us is not to condemn them in the same way that earlier popularizers and scientists did. Our model of replacement does not carry the moral implications of, say, Boule's theories, nor the negative judgment implicit in the quotations opening this chapter from H.G. Wells and the Quennells. The Neanderthals were not ape-men, nor missing links – they were as human as us, but they represented a different brand of humanity, one with a distinctive blend of primitive and advanced characteristics. There was nothing inevitable about the triumph of the Moderns, and a twist of Pleistocene fate could have left the Neanderthals occupying Europe to this day. The 30,000 years by which we have missed them represent only a few ticks of the Ice Age clock.

Multiregionalists are often all too quick to attack studies such as this for being unscientific and contrary to the spirit of the times. Milford Wolpoff, for instance, has written:

> The spread of humankind and its differentiation into distinct geographic groups that persisted through long periods of time, with evidence of long-lasting contact and cooperation, in many ways is a more satisfying interpretation of human prehistory than a scientific rendering of the story of Cain, based on one population quickly, and completely, and most likely violently, replacing all others. This rendering of modern population dispersals is a story of 'making war and not love', and if true its implications are not pleasant.[32]

Thus according to Wolpoff, it is preferable to include than to exclude, to speak of differences simply as variation rather than to attempt to understand them or their significance.

We, on the other hand, feel that it is pointless to seek winners or losers in the story of human evolution, for each age will place its own gloss on history. Rather, we should accept that differences exist, and use them to broaden our definitions and discussions of humanity. For although the Neanderthals were, quite simply, 'not us', they – or rather their African kin – provided the basis from which we sprang; both they and the early Moderns have a place in our prehistory, whether or not they were our actual lineal ancestors. Many before us have dropped an impenetrable curtain between the Neanderthals and the Moderns. But we believe that, if a curtain exists at all, it 'has no near or far side, only a highly patterned warp and weft stemming from the rich potential of culture, however simple or complex, volatile or repetitive.'[33] In conclusion, therefore, we would urge an investigation of the curtain itself, for we should celebrate our rich and varied prehistory as a route to enhancing, in these multi-cultural times, our understanding of ourselves.

Appendix: Selected Absolute Dates

Site/Region	Dating method	Hominids	Archaeology	Date (000s years ago)	SD ± (000s)	Comments	Source
Mumba Cave Africa	14C			26.9		Bed III	Clark 1988
Bacho Kiro Europe	14C		Early Upper Palaeolithic	29.1		Layer 6a/7	Kozlowski 1982
Mumba Cave Africa	14C		MSA	≥30			Clark 1988
Nunamira Cave Australia	14C		Flakes and Cores	30.4	0.69	Unit 11/2	Cosgrove et al 1990
ORS 7 Australia	14C		Flakes and Cores	30.8	0.48	Layer 3	Cosgrove et al 1990
STAGE 2/3 BOUNDARY 32,000 years ago BP							
St Césaire Europe	TL		Early Upper Palaeolithic	32.1	3	Layer 6	Mercier et al 1991
Shanidar Middle East	14C		Early Upper Palaeolithic	32.3	3	Base C	Bar-Yosef 1989
Bacho Kiro Europe	14C	Modern	Early Upper Palaeolithic	32.7	0.3	Layer 6b	Kozlowski 1982
Shanidar Middle East	14C		Early Upper Palaeolithic	33.3	1	Lower C	Bar-Yosef 1989
Matenkupkum Pacific	14C		Flakes and Cores	33		Layer 7	Allen et al. 1988
Boker A Middle East	14C		Early Upper Palaeolithic	> 33.4			Bar-Yosef 1989
Boker A Middle East	14C		Early Upper Palaeolithic	> 33.6			Bar-Yosef 1989
Shanidar Middle East	14C		Early Upper Palaeolithic	33.9	0.9	Mid C	Bar-Yosef 1989
Shanidar Middle East	14C		Early Upper Palaeolithic	34	0.4	Mid C	Bar-Yosef 1989
L'Arbreda Europe	14C [AMS]		Mousterian	34.1	0.75	E2BE 116–3	Bischoff et al 1989
Border Cave Africa	ESR		MSA 3	34–57		Unit 2BS	Grün et al 1990
Shanidar Middle East	14C		Early Upper Palaeolithic	34.5	0.5	Lower C	Bar-Yosef 1989
Boker Tachtit Middle East	14C		Early Upper Palaeolithic	> 35		Level 4	Bar-Yosef 1989
Shanidar Middle East	14C		Early Upper Palaeolithic	35.4	0.6	Lower C	Bar-Yosef 1989
Geissenklösterle Cave Europe	14C		Early Upper Palaeolithic	36	3.6	IIb	Hahn 1982
St Césaire Europe	TL	Neanderthal	Early Upper Palaeolithic	36.3	2.7	Layer 8	Mercier et al 1991
El Castillo Europe	14C [AMS]		Early Upper Palaeolithic	37.7	1.8	18b2	Cabrera Valdes & Bischoff 1989
L'Arbreda Europe	14C [AMS]		Early Upper Palaeolithic	37.7	1	E2BE 111–1	Bischoff et al 1989
L'Arbreda Europe	14C [AMS]		Early Upper Palaeolithic	37.7	1	E2BE 111–2	Bischoff et al 1989
Boker A Middle East	14C		Early Upper Palaeolithic	37.9			Bar-Yosef 1989
St Césaire Europe	TL		Mousterian [Denticulate]	38.2	3.3	Layer 11	Mercier et al 1991
El Castillo Europe	14C [AMS]		Early Upper Palaeolithic	38.5	1.8	18b1	Cabrera Valdes & Bischoff 1989
Sclayn Cave Europe	14C		Mousterian	38.6	1.5	Level 1A	Huxtable 1988
L'Arbreda Europe	14C [AMS]		Early Upper Palaeolithic	38.7	1.2	E2BE 111–4	Bischoff et al 1989
Douara Middle East	14C		Mousterian	38.9	1.7	Top IVB	Bar-Yosef 1989
Combe Grenal Europe	14C		Mousterian [Denticulate]	39	1.5	12	Bowman & Sieveking 1983
L'Arbreda Europe	14C [AMS]		Mousterian	39.4	1.4	E2BE 116–1	Bischoff et al 1989
L'Arbreda Europe	14C [AMS]		Early Upper Palaeolithic	39.9	1.3	E2BE 111–3	Bischoff et al 1989
Abric Romani Europe	U series		Mousterian	39–60			Bischoff et al 1989
Midhishi 2 Africa	TL & 14C		MSA	40–70			Clark 1988

APPENDIX: SELECTED ABSOLUTE DATES

Site/Region	Dating method	Hominids	Archaeology	Date (000s years ago)	SD ± (000s)	Comments	Source
El Castillo Europe	14C [AMS]		Early Upper Palaeolithic	40	2.1	18c	Cabrera Valdes & Bischoff 1989
Le Moustier Europe	TL	Neanderthal	Mousterian [Typical]	40.3	2.6	J	Valladas et al 1986
Le Moustier Europe	TL		None	40.9	5	I	Valladas et al 1986
St Césaire Europe	TL		Mousterian [Denticulate]	40.9	2.5	Layer 10	Mercier et al 1991
L'Arbreda Europe	14C [AMS]		Mousterian	41.4	1.6	E2BE 116–3	Bischoff et al 1989
Amud Middle East	ESR	Neanderthal	?Mousterian	41.5	3	Layer B	Grün and Stringer 1991
St Césaire Europe	TL		Mousterian [Denticulate]	42.4	4.8	Layer 12	Mercier et al 1991
Le Moustier Europe	TL		Mousterian [MTA B]	42.5	2	H2–H9	Valladas et al 1986
Le Moustier Europe	ESR		Mousterian [MTA B]	39.7–41		H	Mellars and Grün 1991
Le Moustier Europe	TL		Mousterian	42.6	3.7	K	Valladas et al 1986
Border Cave Africa	ESR		Howiesons Poort	42–59		Unit 3BS	Grün et al 1990
Border Cave Africa	ESR	early Modern	Howiesons Poort	42–64		Unit 3WA	Grün et al 1990
Bacho Kiro Europe	14C	?Modern	Early Upper Palaeolithic	>43		Layer 11	Kozlowski 1982
Douara Middle East	14C		Mousterian	>43		Mid IVB	Bar-Yosef 1989
Douara Middle East	14C		Mousterian	>43.2		Mid IVB	Bar-Yosef 1989
Douara Middle East	14C		Mousterian	>43.2		Lower IVB	Bar-Yosef 1989
Ksar Akil Middle East	14C		Mousterian	43.3	1.2		Bar-Yosef 1989
Ksar Akil Middle East	14C		Mousterian	43.7	1.5	B?	Bar-Yosef 1989
Combe Grenal Europe	TL		Mousterian [Denticulate]	44	4	20	Bowman & Sieveking 1983
Sclayn Cave Europe	TL		Mousterian	44	5.5	Level 1A	Huxtable 1988
Guattari Europe	ESR	Neanderthal	Mousterian [Pontinian]	44.5–62		Surface deposit including cranium	Grün and Stringer 1991
Guattari Europe	ESR		Mousterian [Pontinian]	44–54		G1	Grün and Stringer 1991
Banyolas Europe	U series	Neanderthal	?	45	4	Matrix	Julia and Bischoff 1991
Boker Tachtit Middle East	14C		Early Upper Palaeolithic	≥45.5		Level 1	Bar-Yosef 1989
Malakunanja II Australia	TL		Flakes and Cores	46	9	2.3m depth	Roberts et al 1990
Le Moustier Europe	TL		Mousterian [MTA B]	46.3	3	H1	Valladas et al 1986
Boker Tachtit Middle East	14C		Early Upper Palaeolithic	46.9	2.4	Level 1	Bar-Yosef 1989
Shanidar Middle East	14C	?Neanderthal	Mousterian	46.9	1.5	Layer D	Bar-Yosef 1989
Boker Tachtit Middle East	14C		Early Upper Palaeolithic	47.2	9	Level 1	Bar-Yosef 1989
La Chapelle Europe	ESR	Neanderthal	Mousterian [Quina]	47–56		Bed 1	Grün and Stringer 1991
Bacho Kiro Europe	14C		Mousterian [Typical]	>47.5		Layer 13	Kozlowski 1982
Border Cave Africa	ESR		MSA 3	47–53		Unit 2WA	Grün et al 1990
Ioton Europe	TL		Mousterian [Quina]	48	3		Valladas et al 1987
Amud Middle East	ESR	Neanderthal	?Mousterian	49.5	4	Layer B	Grün and Stringer 1991
Fonseigner Europe	TL		Mousterian [MT A]	50.2	5.3	Level D upper	Valladas et al 1987
Le Moustier Europe	TL		Mousterian [MTA A]	50.3	5.5	G4	Valladas et al 1986
Le Moustier Europe	ESR		Mousterian [MTA A]	43–47		G	Mellars and Grün 1991
Shanidar Middle East	14C	?Neanderthal	Mousterian	50.6	3	Layer D	Bar-Yosef 1989
Guattari Europe	U series	Neanderthal	Mousterian [Pontinian]	51	3	Layer G0	Grün and Stringer 1991
Malakunanja II Australia	TL		Flakes and Cores	52	11		Roberts et al 1990
Douara Middle East	14C		Mousterian	>52		Lower IVB	Bar-Yosef 1989
Ras el Kelb Middle East	14C		Mousterian	>52		B	Bar-Yosef 1989
Fonseigner Europe	TL		Mousterian [Typical]	52.8	5.5	Level D middle	Valladas et al 1987

Site/Region	Dating method	Hominids	Archaeology	Date (000s years ago)	SD ± (000s)	Comments	Source
Douara Middle East	14C		Mousterian	>53.8		IIIB	Bar-Yosef 1989
Pech de l'Azé II Europe	ESR		Mousterian	54–59		Layer 2	Grün et al 1991
Le Moustier Europe	TL		Mousterian [MTA A]	55.8	5	G1	Valladas et al 1986
Fonseigner Europe	TL		Mousterian [Typical]	56.4	6.8	Level E	Valladas et al 1987
Guattari Europe	ESR	Neanderthal	Mousterian [Pontinian]	57	8	Stratum 1	Schwarz et al n.d. [Kuhn 1991]
Roquette II Europe	TL		Mousterian [Quina]	57.2	4.3	Levels 2 & 3	Valladas et al 1987
Kebara Middle East	TL	Neanderthal	Mousterian	≈60		Units XII–VI, 38 dates	Valladas et al 1987
Kebara Middle East	ESR	Neanderthal	Mousterian	60	6	Units Xi–Xii	Grün and Stringer 1991
Pech de l'Azé II Europe	ESR		Mousterian	60–72		Layer 3	Grün et al 1991
Combe Grenal Europe	TL		Mousterian [Typical]	61	7	Level 55	Bowman & Sieveking 1983
Combe Grenal Europe	TL		Mousterian [Typical]	62	7	Level 50	Bowman & Sieveking 1983
Malakunanja II Australia	TL		Flakes and Cores	62	13	2.6m depth	Roberts et al 1990
Border Cave Africa	ESR	early Modern	MSA 1	62–85		Unit 4BS	Grün et al 1990
Brugas Europe	TL		Mousterian [Quina]	63	5.8	Level 4	Valladas et al 1987
Kebara Middle East	ESR	Neanderthal	Mousterian	64	6	Units Xi–Xii	Grün and Stringer 1991

STAGE 3/4 BOUNDARY 64,000 years ago BP

Site/Region	Dating method	Hominids	Archaeology	Date (000s years ago)	SD ± (000s)	Comments	Source
Border Cave Africa	ESR		Howiesons Poort	64.5–80.5		Unit 1RGBS	Grün et al 1990
Mumba Cave Africa	U series	?early Modern	MSA	~65		Bed V	Clark 1988
Combe Grenal Europe	TL		Mousterian [Typical]	68	7	Level 49	Bowman & Sieveking 1983
Border Cave Africa	ESR		MSA 1	69.5–136		Unit 4WA	Grün et al 1990
Douara Middle East	Fission Track		Mousterian	70		IIIB	Bar-Yosef 1989
Abri Pié-Lombard Europe	TL		Mousterian [Typical]	70	7.7		Valladas et al 1987
La Chaise Europe	U series	Neanderthal	Middle Palaeolithic	71	6	Level 7 [Bourgeois Delaunay]	Laville et al 1986
Pech de l'Azé II Europe	ESR		Mousterian	71–87		Layer 4	Grün et al 1991
Canalettes Europe	TL		Mousterian [Typical]	73.5	6	Level 2	Valladas et al 1987

STAGE 4/5 BOUNDARY 75,000 years ago BP

Site/Region	Dating method	Hominids	Archaeology	Date (000s years ago)	SD ± (000s)	Comments	Source
Douara Middle East	Fission Track		Mousterian	75		IVB	Bar-Yosef 1989
El Kowm Middle East	U series		Yabrudian-Mousterian	76	16	Oumm 4	Bar-Yosef 1989
Guattari Europe	ESR	Neanderthal	Mousterian [Pontinian]	76	13	Stratum 5	Schwarcz et al n.d. [Kuhn 1991]
Abri Laborde Europe	TL		Mousterian [Ferrassie]	78.5	7.5	Layers 29–32	Huxtable 1988
Skhūl Middle East	ESR	early Modern	Middle Palaeolithic	81	15	Layer B	Grün and Stringer 1991
Zobiste Europe	TL		Middle Palaeolithic	85.5	8.5	Lowest level	Baumler 1989
Irhoud Africa	ESR	late archaic	Middle Palaeolithic	87–127		Level above Irhoud 4	Grün and Stringer 1991
Klasies River Mouth Africa	ESR	early Modern	MSA 1	88	8	Lower SAS	Grün and Stringer 1991
Tabūn Middle East	ESR		Mousterian	86–103		Layer B	Grün et al 1991
El Castillo Europe	U series		Lower/Middle Palaeolithic	89	1	Level 23 flowstone	Bischoff et al 1992
La Chaise Europe	U series	Neanderthal	Middle Palaeolithic	89.5	5	Level 7 [Bourgeois Delaunay]	Laville et al 1986
Qafzeh Middle East	TL	early Modern	Mousterian	92	5	Layers XXIII–XVII	Valladas et al 1988
Seclin Europe	TL		Levallois	93	9	Unit 7	Huxtable 1988
Klasies River Mouth Africa	ESR	early Modern	MSA 1	94	10	Lower SAS	Grün and Stringer 1991
La Chaise Europe	U series	Neanderthal	Middle Palaeolithic	94	22	Upper stalagmite [Abri Suard]	Laville et al 1986
Zuttiyeh Middle East	U series		Yabrudian-Mousterian	95	10	76ZU 1	Bar-Yosef 1989

Site/Region	Dating method	Hominids	Archaeology	Date (000s years ago)	SD ± (000s)	Comments	Source
Zuttiyeh Middle East	U series		Yabrudian-Mousterian	97	13	76ZU 6	Bar-Yosef 1989
Singa Africa	ESR	late archaic	?Middle Palaeolithic	97	15	From associated fauna	Grün and Stringer 1991
Zobiste Europe	TL		Middle Palaeolithic	97.5	7	Lowest level	Baumler 1989
Tata Europe	U series		Middle Palaeolithic	98	8		Hausmann and Brunnacker 1988
Asprochaliko Europe	TL		Mousterian	98.5	12	Layer 18	Huxtable 1988
El Kowm Middle East	U series		Yabrudian	99	16	Tell 6	Bar-Yosef 1989
Tata Europe	U series		Middle Palaeolithic	101	10		Hausmann and Brunnacker 1988
Qafzeh Middle East	ESR	early Modern	Middle Palaeolithic	100	10	Layers XV–XXI	Grün and Stringer 1991
Burgtonna Europe	U series		Taubachian	101			Svoboda 1989
La Chaise Europe	U series	Neanderthal	Middle Palaeolithic	101	7	Upper stalagmite [Abri Suard]	Laville et al 1986
La Chaise Europe	U series	Neanderthal	Middle Palaeolithic	101	12	Level 7 [Bourgeois Delaunay]	Laville et al 1986
Skhūl Middle East	ESR	early Modern	Middle Palaeolithic	101	12	Layer B	Grün and Stringer 1991
Tabūn Middle East	ESR	Neanderthal	Mousterian	102–109		Layer C	Grün et al 1991
Ehringsdorf Europe	U series	?early Neanderthal	Middle Palaeolithic	102–244			Brunnacker et al 1983
Pech de l'Azé II Europe	U series		Mousterian	103	27	Level 3	Laville et al 1986
Burgtonna Europe	U series		Taubachian	104			Svoboda 1989
Hummal Well, El Kowm Middle East	TL		Mousterian	104	9	Level 6b	Huxtable 1988
Combe Grenal Europe	TL		Acheulean	105	14	Layer 60	Bowman & Sieveking 1983
Combe Grenal Europe	TL		Acheulean	105	14	60	Bowman & Sieveking 1983
Irhoud Africa	ESR	late archaic	Middle Palaeolithic	106–190		Level above Irhoud 4	Grün and Stringer 1991
Abri Pié-Lombard Europe	TL		Mousterian [Typical]	108.4	9.8		Valladas et al 1987
Mumba Cave Africa	U series		MSA	109–131		Bed VIB	Clark 1988
Taubach Europe	U series		Taubachian	110			Svoboda 1989
Burgtonna Europe	U series		Taubachian	111			Svoboda 1989
La Chaise Europe	U series	Neanderthal	Middle Palaeolithic	112	5	Level 11 upper [B. Delaunay]	Laville et al 1986
Border Cave Africa	ESR		MSA 1	113–141		Unit 5BS	Grün et al 1990
Combe Grenal Europe	TL		Acheulean	113	13	Layer 60	Bowman & Sieveking 1983
La Chaise Europe	U series	Neanderthal	Middle Palaeolithic	114	7	Level 7 [Bourgeois Delaunay]	Laville et al 1986
Weimar Europe	U series		Taubachian	115			Svoboda 1989
Taubach Europe	U series		Taubachian	116			Svoboda 1989
La Chaise Europe	U series	Neanderthal	Middle Palaeolithic	117	8	Level 11 upper [B. Delaunay]	Laville et al 1986

STAGE 5d/5e BOUNDARY 115,000 years ago BP

Site/Region	Dating method	Hominids	Archaeology	Date (000s years ago)	SD ± (000s)	Comments	Source
Weimar Europe	U series		Taubachian	118			Svoboda 1989
Abri Vaufrey Europe	TL		Mousterian	120	13	Layer IV K11 & 12	Huxtable 1988
Qafzeh Middle East	ESR	early Modern	Middle Palaeolithic	120	8		Grün and Stringer 1991
Laetoli, Ngaloba Africa	K/Ar	late archaic	MSA	120–130			Clark 1988
Tabūn Middle East	ESR		Mousterian	122–166		Layer D	Grün et al 1991
La Chaise Europe	U series	Neanderthal	Middle Palaeolithic	123	17	Level 11 upper [B. Delaunay]	Laville et al 1986
La Chaise Europe	TL	Neanderthal	Middle Palaeolithic	126	15	Level 51 [Abri Suard]	Laville et al 1986

STAGE 5e/6 BOUNDARY 130,000 years BP

Site/Region	Dating method	Hominids	Archaeology	Date (000s years ago)	SD ± (000s)	Comments	Source
Omo Kibish Africa	U series	early Modern		130		Member I molluscs	Clark 1988

Site/Region	Dating method	Hominids	Archaeology	Date (000s years ago)	SD ± (000s)	Comments	Source
Sclayn Cave Europe	TL		Levallois	130	20	Layer 5b	Huxtable 1988
Lakhuti 1 Asia	TL		Pebble tools	130–150			Ranov 1984
Pech de l'Azé II Europe	ESR		Acheulean	130–162		Layer 6–9	Grün et al 1991
El Kowm Middle East	U series		Yabrudian	139	16	Oumm 3	Bar-Yosef 1989
La Chaise Europe	U series	Neanderthal	Middle Palaeolithic	146	16	Level 11 [Bourgeois Delaunay]	Laville et al 1986
Zuttiyeh Middle East	U series	late archaic	pre Yabrudian	148	6	76ZU4	Bar-Yosef 1989
Gadernotta/Kulkuletti Africa	K/Ar		MSA	149	13		Clark 1988
Ehringsdorf Europe	U series	?early Neanderthal	Middle Palaeolithic	150–250			Schwarz 1982
La Chaise Europe	U series	?early Neanderthal	Middle Palaeolithic	151	15	Level 11 lower [B. Delaunay]	Laville et al 1986
Tabūn Middle East	ESR		Yabrudian	151–168		Layer Eb	Grün et al 1991
Weimar Europe	U series		Taubachian	151			Svoboda 1989
Tabūn Middle East	ESR		Yabrudian	154–188		Layer Ea	Grün et al 1991
El Kowm Middle East	U series		Yabrudian	156	16	Humm 2	Bar-Yosef 1989
Hummal Well, El Kowm Middle East	TL		Yabrudian	160	22	Level Ib	Bar-Yosef 1989
Singa Africa	ESR	late archaic	?Middle Palaeolithic	160	27	From associated fauna	Grün and Stringer 1991
Zuttiyeh Middle East	U series	late archaic	pre Yabrudian	164	21	76ZU 1a	Bar-Yosef 1989
Biache-Saint-Vaast Europe	TL	?early Neanderthal	Middle Palaeolithic	175	13		Huxtable 1988
Tabūn Middle East	ESR		Yabrudian	176–199		Layer Ec	Grün et al 1991
Gadernotta/Kulkuletti Africa	K/Ar		MSA	181	6		Clark 1988
Tabūn Middle East	ESR		Yabrudian	182–213		Layer Ed	Grün el al 1991
Vértesszöllös Europe	U series	?H. heidelbergensis	Pebble tools, microlithic	185	25		Schwarz & Latham 1984
Karatau Asia	TL		Pebble tools	194	32		Ranov 1984

STAGE 6/7 BOUNDARY 186,000 years ago BP

Site/Region	Dating method	Hominids	Archaeology	Date (000s years ago)	SD ± (000s)	Comments	Source
Pontnewydd Cave Europe	TL	?early Neanderthal	Acheulean	200	25		Huxtable 1988
Karatau Asia	TL		Pebble tools	210	36		Ranov 1984
Southern Egypt Africa	U series		Acheulean	212		Minimum age	Szabo et al 1989
Maastricht-Belvédère Europe	TL		Middle Palaeolithic	218	24	Site K 7/203	Huxtable 1988
Maastricht-Belvédère Europe	TL		Middle Palaeolithic	220	20	Site G 46/105–10	Huxtable 1988
Bad Cannstatt Europe	U series		Pebble tools, microlithic	225			Svoboda 1989
Vértesszöllös Europe	U series	?H. heidelbergensis	Pebble tools, microlithic	225			Schwarz & Latham 1984
Kapthurin Africa	K/Ar		Late Acheulean	230			Clark 1988
Ehringsdorf Europe	U series	?early Neanderthal	Middle Palaeolithic	230			Blackwell & Schwarz 1986
Gadernotta/Kulkuletti Africa	K/Ar		MSA	235	5		Clark 1988
La Cotte Europe	TL		Middle Palaeolithic	238	35	Layers C–D	Aitken et al 1986
Maastricht-Belvédère Europe	TL		Middle Palaeolithic	238	25	Site G 49/106–2	Huxtable 1988
Malewa Gorge Africa	K/Ar		MSA	240			Clark 1988
El Kowm Middle East	U series		pre Yabrudian	245	16	Oumm 5	Bar-Yosef 1989
Vértesszöllös Europe	U series		Pebbletools, microlithic	>250			Schwarz & Latham 1984

STAGE 7/8 BOUNDARY 245,000 years BP

Notes to the Text

Preface *(pp. 7–9)*

1 Pagden 1986:44–45.
2 Murray 1987.

Chapter 1 *(pp. 12–38)*

1 Day 1989, Lewin 1987, Reader 1988.
2 Trinkaus and Howells 1979. Relative maturity of the individual fossils can be judged where material is fairly complete or teeth are preserved. Assignment of sex is more difficult without well-preserved hip bones, but is usually judged from factors such as size and robusticity.
3 G. de Mortillet 1883.
4 Boule 1911–13.
5 Such studies were given much credence in the early years of this century. However, the same techniques supposedly revealed all manner of 'primitive' features in the endocast of the Piltdown skull which we now know was probably less than a thousand years old.
6 Boule and Vallois 1957.
7 See Gould 1981 for a provocative discussion of the uses and abuses of cranial measurements in the history of physical anthropology.
8 Boule and Vallois 1957:252.
9 Laing 1895:395.
10 Richards 1987:42.
11 Contrast, for example, the treatment of Neanderthals by Isaac Asimov in *The Ugly Little Boy* (1958) and Philip-José Farmer's *The Alley Man* (1959). Graves 1991 provides a detailed view of the Neanderthal metaphors.
12 Moser 1989.
13 Friedman 1981.
14 Osborn 1915:xii.
15 Friedman 1981:33.
16 Rosny-Aíné 1911 (1982:16).
17 ibid 1911 (1982:143).
18 Wells 1921 (1927:287).
19 Wells 1921:682.
20 Golding 1955:219.
21 Asimov 1958 (1989:280).
22 ibid:312.
23 Auel 1980:450.
24 ibid 1980:20.
25 Smith 1984.
26 Hrdlička 1927.
27 Wolpoff et al 1984.
28 Coon 1962.
29 ibid.
30 Brace 1964, G. Clark 1992.
31 Graves 1991.
32 Wolpoff et al 1984, Wolpoff et al in press.
33 Brace 1979.
34 Howell 1958.

35 Campbell 1963.
36 Vallois 1954.
37 Howells 1976.
38 Stringer and Andrews 1988; Mellars 1989a.
39 Cavalli-Sforza 1991.

Chapter 2 *(pp. 39–60)*

1 Agassiz 1840, Lyell 1847, Geike 1874.
2 Prestwich 1873.
3 Fagan 1987.
4 It has never proved easy to correlate the Alpine system with the moraines left behind on the North European plain, let alone with other areas such as western Russia or North America. The traditional picture is often summarized as follows:

Alps	NW Europe	Britain	Western Russia
Würm	Weichselian	Devensian	Waldai
Riss/Würm	Eemian	Ipswichian	Mikulino
Riss	Warthe	Wolstonian	Moscow
Mindel/Riss	Holstein	Hoxnian	Odintzovo
Mindel	Saale	Anglian	Dnepr
Günz/Mindel	?	Cromerian	Lichwin
Günz	Elster	Beestonian	Oka

Using the Alpine system, Pleistocene geologists emphasized the differences between each glacial and interglacial stage since this increased the timekeeping value of the system. When this involved four main ice ages separated by three interglacials it was not difficult. There were sufficient differences between the species of mammoth, elephant, rhino, horses, deer and carnivores to draw up distinctive animal communities for each of these seven climatic and now chronological phases.
5 See Zeuner 1959, Oakley 1969, Bordes 1972, Renault-Miscovsky 1991.
6 Laville 1975, Laville, Rigaud and Sackett 1980:fig. 6.1.
7 The Penck and Brückner (1909) model became the orthodox view because it supported this view of progress very well. The importance of their system was such that for over 60 years geologists in many other countries searched for and made their evidence fit the model of four cold and three warm phases. Closer to the equator these were represented by pluvials and interpluvials or moist and arid conditions (Oakley 1969).
8 Imbrie and Imbrie 1979, Roberts 1984.
9 Emiliani's 1955 paper 'Pleistocene Temperatures' was, as it turned out, incorrectly titled. The $^{18}O{:}^{16}O$ ratio in his deep-sea cores was not primarily and directly measuring, as he thought, the surface temperature of the Pleistocene sea but instead indicating its volume compared with that of global ice.
10 For a full explanation of scientific dating techniques in archaeology see Aitken 1990.

11 In core V28–238 the magnetic reversal marking the lower to middle Pleistocene transition, 730,000 years ago, occurs at a depth of 1,200 cm. The ages in the core are then worked out by dividing depth into age and calculating the actual rate of sediment accumulation. Within the Matuyama epoch there are two reversal events. The Olduvai event at 1.6 to 1.8 million years ago is the agreed boundary between the Pleistocene and Pliocene periods while the Jaramillo event at 0.9 million years ago is an important marker for investigating when hominids dispersed from Africa.

12 There have been recent suggestions that this date should be revised to c.790,000.

13 Shackleton and Opdyke 1973.

14 Stages 5 to 2. Stage 5 is further subdivided into five sub-stages, 5e–5a.

15 Brain 1981, Roberts 1984, Vrba 1985, Prentice and Denton 1989.

16 Roberts 1984.

17 For example Woillard's work at Grande Pile in the Vosges mountains (1978).

18 Gamble 1986:table 3.5.

19 Gamble 1987:83.

20 For example, taurodontism in the teeth from Pontnewydd Cave, Wales (Chapter 3).

21 Mercier et al 1991 dated the Neanderthal skeleton from Saint-Césaire in western France by thermoluminescence (see Box 2.2). They calculated the mean age from seven samples in level 8, where the skeleton was found with a Châtelperronian stone industry, as 36,300 ± 2,700 years ago.

22 Stage 7 is sharply divided into two peaks by a short cold snap that lasted for some 10,000 years and ended about 220,000 years ago. The magnitude of the curves indicating the volume of ice cap to ocean bears close comparison with the early glacial stages (5d–3) in the last cycle (van den Bogaard et al 1989).

23 Only three other peaks, 1 (the present interglacial), 9 and 11, in the deep-sea core get close to 5e (fig. 18) in their degree of expression. Stages 9 and 11 are both short-lived at 300,000 and 400,000 years ago respectively (Shackleton 1987). One very clear finding from the deep-sea cores is that the ice cap:ocean ratio changes very rapidly indeed.

24 Dennell 1983.

25 Gascoyne et al 1981, Stuart 1982.

26 Sutcliffe 1985:fig. 6.2.

27 These short sharp shocks are vividly shown in the Camp Century cores from Greenland (Dansgaard et al 1970, Johnsen et al 1992).

28 Kukla 1975, 1977.

29 In Europe these interstadials are known from local sequences. Two of the most important are Hengelo c.39,000–37,000 and Denekamp 32,000–29,000 radiocarbon years ago.

30 Behre 1989.

31 Gilead and Grigson 1984.

32 Marks 1983.

33 H. Allen 1990.

34 Hopkins et al (eds) 1982.

35 van Andel 1989.

36 Gamble and Soffer 1990.

37 Cosgrove et al 1990.

38 Weniger 1990.

39 Otte 1990, Jacobi 1980.

40 The upturn in the low latitudes (Jones 1990) and even southern Europe was underway by at least 16,000 years ago. In northern Europe there was a slower response and it is not until 13,000 years ago that the climatic upturn is clearly noticeable (Gamble 1991a). Beetle studies indicate that climatic warming was underway some time before the trees recolonized (Coope 1977). Such time lags are to be expected.

41 Two interstadials known as Bølling and Allerød are particularly important for tracing this process (Barton et al 1991, Johnsen et al 1992).

42 Martin and Klein (eds) 1984.

43 Combe Grenal, Bordes and Prat 1965; La Borde, Slott-Moller 1990; Stadel, Gamble 1979; Guattari, Piperno 1976–77, Stiner 1991; Érd, Gabori-Csank 1968; Kudaro I and III, Lioubine and Barichnikov 1984; Il'skaya, Hoffecker et al 1989; Tabūn, Garrod and Bate 1937, Bar-Yosef 1989; Shanidar, Perkins 1964, Trinkaus 1983; Teshik Tash, Movius 1953.

44 Gamble 1984 and 1986. See Chapter 7 for full discussion.

45 This is best seen in the intricate schemes which the Abbé Breuil, doyen of French Palaeolithic studies, devised for the Lower Palaeolithic artifacts collected from the various terraces of the Somme (Breuil 1939 and Breuil and Kozlowski 1932).

46 Goodwin and van Riet Lowe 1929.

47 Hrdlička 1927. He was following standard thinking about the interpretation of an archaeological culture as representing a prehistoric people.

48 Many other rocks can be, and were, used. In the African Rift valley it is common to find artifacts made of obsidian, volcanic glass. This hard, black stone is also fine grained and very different from other raw materials that are common in sub-Saharan Africa such as lavas, basalts and quartzites. These coarse-grained rocks make perfectly serviceable stone tools although on occasion it is not possible to achieve the same standard of finishing as for example is sometimes found when flints, cherts and obsidians were used. They should not, however, be interpreted as a poor person's flint. As Francis Wenban-Smith has pointed out (personal communication), the coarse edge functions like a serrated knife and is particularly useful for cutting. This feature of the raw material might have been useful when scavenging dried, desiccated carcasses after carnivores had finished with them.

49 Newcomer 1971.

50 In a comprehensive list of types drawn up by Bordes (1961a,b), 21 different forms were recognized. See also Wymer 1968, Roe 1964 and 1968.

51 Odell 1975.

52 Keeley 1980.

53 Copeland 1988.

54 Evernden and Curtis 1965.

55 The deep-sea record has obviously forced a rethink of this basic chronology based on Penck and Brückner's scheme. Previously the Lower Palaeolithic occupied their Gunz and Mindel glaciations and in particular the great Mindel-Riss interglacial (Zeuner 1959). It was at this time that the genial forest conditions of western Europe were thought to have given rise to an advanced hand axe culture. The Middle Palaeolithic has always been difficult to pin down to its point of origin but some date in either the Riss glaciation or the last interglacial, the Riss-Würm, was normally favoured. The Mousterian cultures of the Middle

Palaeolithic were usually dated to the early part of the last Würm glaciation. The Upper Palaeolithic occurred after the central Würm interstadial as registered in cave sediments.

56 Accelerator mass spectrometry (Aitken 1990, Gowlett and Hedges 1986) has not yet really extended the limits of radiocarbon dating but has made the procedure more precise.

57 Both Gamble 1986 and Wymer 1982 have argued that the terms should be collapsed to form a single stage – the Earlier Palaeolithic – prior to the Upper Palaeolithic.

58 Claims for earlier occupation are numerous, e.g. Bonifay and Vandermeersch (eds) 1991.

Chapter 3 *(pp. 61–72)*

1 Shipman 1992, Bosinski 1992.
2 Tobias 1991.
3 Tobias 1991.
4 Stringer 1986b, Wood 1991, Wood 1992.
5 Johanson et al 1987.
6 Wood 1992.
7 Groves 1990.
8 Leakey and Walker 1989, Ruff 1991.
9 Rightmire 1990.
10 Shipman 1992, Dzaparidze et al 1989.
11 Dennell et al 1988a and 1988b.
12 Rightmire 1990.
13 Claims for very early occupation in southern Europe have been made for sites such as Soleihac, Chillac and Orce. These do not command widespread support. More convincing are the estimates for the age of artifacts at Ubeidiya at 900,000 years in the Jordan rift valley. See Ackerman 1989, Bonifay and Vandermeersch 1991.
14 Rightmire 1990.
15 Stringer et al 1984, Rightmire 1990.
16 Grün and Stringer 1991.
17 Stringer et al 1984.
18 Orban 1991.
19 Stringer et al 1979, Stringer 1983.
20 Wolpoff 1980.
21 Stringer et al 1984, Stringer 1989.
22 Only one is published as yet: Stringer et al 1984.
23 Smith 1984.
24 Trinkaus and Howells 1979:96.
25 The four main concepts of species recognition used for the fossil record are the Biological Species Concept and the Recognition Concept (both based on modern analogies), the Evolutionary Species Concept and the Phylogenetic Species Concept (both based on a judgment of ancestor-descendant relationships). For detailed reviews see Kimbel and Martin in press.
26 Mayr 1942, 1963, 1976, Foley 1987.
27 Wolpoff 1989.
28 Stringer 1989, Foley 1989.
29 The tall, rather narrow-hipped body shape of the first modern skeletons from both the Middle East and Europe indicate a warm-adapted physique which would coincidentally be ideal for long-distance travel. However, apart from differences in robusticity, this sort of physique seems to have been maintained in Africa for the previous million years or more, so it was probably a retained ancestral character. See Stringer 1984 and 1989, Mellars 1989 and 1992, Klein 1989, Clark 1989 and 1992, Ruff 1991, Foley 1989.

Chapter 4 *(pp. 73–95)*

1 For reviews of Neanderthal anatomy see e.g. Stringer 1978, Stringer and Trinkaus 1981 and Trinkaus 1986.
2 Compare Russell 1985 and Hylander et al 1991.
3 Coon 1962.
4 Franciscus and Trinkaus 1988.
5 Jelinek et al 1989.
6 Bermúdez de Castro et al 1988.
7 Trinkaus 1987.
8 Stringer 1978, Rak 1986.
9 Smith 1982.
10 Stringer 1984, Holloway 1985.
11 Holloway 1985.
12 Holloway 1985.
13 Hublin 1988.
14 Bromage and Dean 1985, Stringer et al 1990.
15 Bromage and Dean 1985.
16 Tillier 1982.
17 Dean et al 1986, Stringer et al 1990.
18 Trinkaus 1984a.
19 Rosenberg 1987.
20 Trinkaus and Tompkins 1990.
21 Rak 1990.
22 Trinkaus and Thompson 1987.
23 Lieberman 1984.
24 Arensburg et al 1987.
25 Arensburg et al 1987.
26 Lieberman 1989.
27 Lieberman and Crelin 1971.
28 Lieberman 1984.
29 Eveleth and Tanner 1990.
30 Harrison et al 1988.
31 Trinkaus 1983.
32 Trinkaus 1981.
33 Trinkaus et al 1991.
34 Trinkaus 1975 and 1989.
35 Trinkaus 1986.
36 Trinkaus 1983.
37 Boule 1911, Straus and Cave 1957.
38 Trinkaus 1985.

Chapter 5 *(pp. 96–122)*

1 Renfrew 1988.
2 Trinkaus 1984b, Vandermeersch 1989.
3 Trinkaus 1984b.
4 Garrod and Bate 1937, McCown and Keith 1939.
5 Vandermeersch 1981, Trinkaus 1984b.
6 Trinkaus 1983.
7 Bar-Yosef and Vandermeersch 1991.
8 Ruff 1991.
9 Suzuki and Takai 1970, Trinkaus 1984b.
10 Bar-Yosef et al 1988.
11 Trinkaus 1983 and 1984b, Stringer and Trinkaus 1981.
12 Stringer 1978, Vandermeersch 1981, Stringer and Trinkaus 1981, Trinkaus 1984b, Rak 1990.
13 Jelinek 1982.
14 Grün and Stringer 1991.
15 Valladas et al 1988, Stringer 1988.
16 Grün and Stringer 1991.
17 Grün and Stringer 1991.
18 Bar-Yosef 1992.
19 Wolpoff 1991, Kramer 1992.

20 Stringer et al 1989.
21 Mercier et al in press.
22 Grün et al 1991, Grün and Stringer 1991.
23 Bergman and Stringer 1989.

Chapter 6 *(pp. 123–142)*

1 Reader 1988, Lewin 1987.
2 Reader 1988, Lewin 1987, Johanson and Edey 1981.
3 Protsch 1975, Oakley et al 1977. This was certainly partly due to circular reasoning. Because some workers were committed to the idea that Africa was backward, it seemed quite reasonable that an evidently primitive specimen such as Broken Hill could have lingered on so late. In turn, other workers felt that because the Broken Hill skull was apparently so young in age, Africa must have lagged behind other areas in the evolution of modern humans!
4 Klein 1989, Bräuer 1992, Rightmire 1989.
5 Woodward 1921.
6 The 'house' and Neanderthal shapes are known by French workers as 'en maison' and 'en bombe' respectively.
7 Stringer 1986a.
8 Ruff 1991, Stringer 1986a.
9 Stringer 1986a.
10 Klein 1989, Bräuer 1992, Rightmire 1989.
11 Clarke 1990.
12 Hublin 1985, 1992.
13 Stringer 1983, Rightmire 1990. If these also represent a different species from *erectus*, moderns and the Neanderthals, the name given to the Mauer jaw, *Homo heidelbergensis* (1907) would take historical priority over the name given to the Broken Hill skull, *Homo rhodesiensis* (1921). See also Chapter 3.
14 Bräuer 1992, Rightmire 1989, Klein 1989.
15 Grün and Stringer 1991.
16 Bräuer 1992, Rightmire 1989.
17 Stringer 1989, Bräuer 1992, Rightmire 1989.
18 Day and Stringer 1991.
19 Day et al 1991.
20 Deacon 1992, Rightmire and Deacon 1991, Klein 1989, Bräuer 1992.
21 Beaumont 1980, Bräuer 1992, Rightmire 1989, Klein 1989.
22 Grün et al 1990.
23 Klein 1989.
24 Klein 1989, Clark 1992.
25 Klein 1989, Bräuer and Rimbach 1990.
26 Trinkaus in press.
27 Howells 1973, Howells 1989, Turner 1987.
28 Bodmer and Cavalli-Sforza 1976.
29 Nei and Roychoudhury 1974.
30 Cann et al 1984.
31 Cann et al 1987, Vigilant et al 1991, Merriweather et al 1991.
32 Grün and Stringer 1991.
33 Wolpoff 1989.
34 Stoneking et al 1992.
35 Long et al 1990, Cavalli-Sforza 1991, Cavalli-Sforza et al 1988, Nei and Ota 1991, Mountain et al 1992. It would be wise to bear in mind that cluster diagrams produced from gene frequency data do not necessarily correspond to evolutionary trees, since factors such as uneven evolutionary rates and gene flow will affect the degrees of similarities of populations being sampled.

36 Cavalli-Sforza 1991, Mountain et al 1992.
37 Rouhani 1989.
38 Cann et al 1987.
39 Harrison et al 1988.
40 Wu and Wu 1985, Stringer 1990.
41 Stringer 1992a.
42 Santa Luca 1980, Bartstra et al 1988.
43 Wolpoff et al 1984, Brown 1992.
44 Wolpoff et al 1984.
45 Brown 1992, Pardoe 1991.

Chapter 7 *(pp. 143–177)*

1 Gamble 1993, Fagan 1991.
2 Kuhn 1991.
3 Macalister summed it up in his list of five 'certainties' for the period:

1 Middle Palaeolithic Man dwelt in caves; the inhabitants of these formed communities which must have been organized on some social system.
2 In some respects [technology] he shows an advance, in others a retrogression, from the Acheulean level.
3 He possessed fire.
4 He had a religion.
5 Like his predecessor, he was a hunter. (1921:342).

4 Sometimes referred to as part of 'the million years of boredom' which followed the dispersion of *Homo erectus* out of Africa.
5 The simplified account by Bordes can be found in *A Tale of Two Caves* (1972).
6 Experimental work on use wear and edge damage was pioneered for the Upper Palaeolithic by Semenov 1964 and for the Lower and Middle Palaeolithic by Keeley (1980). Blind tests and rigorous experimental procedures are necessary (e.g. Keeley and Newcomer 1977). Recent work has been critical of the approach.
7 Clark, J.D. (1982:fig.4.4:298).
8 Clark, J.D. (1988:6) These have been struck from a further variety of prepared cores.
9 Clark, J.D. (1988:fig.11).
10 This separation is favoured in the classification of African assemblages south of the Sahara where less use has been made of typological schemes such as those of Bordes.
11 In sub-Saharan Africa the term Middle Stone Age (MSA) was first used by A.J.H. Goodwin and C. van Riet Lowe in 1929 to describe the stone age cultures of South Africa. The term is synonymous with the European Middle Palaeolithic although it has only recently become clear that the MSA is also time-equivalent to the Middle Palaeolithic. Previously, many regarded it as a later relic and a sign of African 'backwardness'. The lack of art, ornament and extreme rarity of bone tools supports an equivalence to the Middle Palaeolithic package as first recognized in Europe.
12 Classifications of assemblages of stone tools are not always self-evident. Assemblage usually refers to a collection of artifacts from a specific segment of an archaeological site. An industry is a distinctive complex or configuration of artifact types and type frequencies that recurs among two or more assemblages, while tradition is used to describe a group of industries whose similarities suggest they belong to some wider culture-historical block of technological ideas and practices (Laville et al 1980:13–14).

13 Roberts 1986. Retouched flake tools have been excavated from the almost undisturbed beach surface at Boxgrove as well as animal bones.

14 Green 1984.

15 Bowen et al 1989. Burnt flints in the upper and lower loams at Swanscombe have given dates of 202,000 ± 15,000 and 228,000 ± 23,000 years ago respectively. On faunal as well as TL grounds these seem to be much too young. The loams sandwich the middle gravels which produced the famous partial skull (Chapter 3).

16 Singer et al 1973.

17 Callow and Cornford 1986.

18 Gamble 1986 has already proposed this nomenclature following Wymer 1982.

19 Bradley 1977.

20 Marks 1983.

21 Schwarz et al 1988.

22 Kretzoi and Vertes 1965, Hausmann and Brunnacker 1988.

23 Davis et al 1980. The earliest occupation of this region may be 750,000 years ago at Kuldara (Ranov 1991).

24 J.D. Clark 1989.

25 Several travertine sites in eastern Germany and Hungary also belong to this stage although the flake, chopping tool element in the Taubachian of eastern Germany is very different indeed to the contemporary scraper dominated assemblages then common in southwestern France.

26 Dibble 1987 and 1989, Rolland and Dibble 1990, Dibble and Rolland 1992.

27 Barton 1988.

28 Rust made the perceptive observation that in the Amudian levels at Yabrud there was a great deal of recycled raw material (Ronen et al n.d: 3). This involved reusing hand axes from much earlier levels as cores from which flakes and blades were then detached. Jelinek has noticed the same economizing behaviour in the PUP levels at Tabūn (1990).

29 Cornford 1986.

30 The Pradnik knives that are common in the Polish Micoquian (late Middle Palaeolithic) show resharpening. A substantial sharpening flake is removed from the edge of the bifacially flaked knife. Over time the shape of the piece can change from one typological form to another.

31 In general terms the Middle Palaeolithic of the Levant starts between 150,000 and 100,000 years ago where it is marked by the appearance of small hand axes and abundant scrapers in the artifact assemblages. According to Ofer Bar-Yosef (1989) this Acheulo-Yabrudian phase succeeds the earlier Upper Acheulean.

32 Garrod and Bate 1937, Rust 1950.

33 McBurney 1967, Singer and Wymer 1982, Deacon 1989. The MSA deposits at Klasies are 22 m thick and are divided into four main occupations the oldest starting c.130,000 years ago. More than a quarter of a million pieces of flaked stone came from the main site. John Wymer, who first excavated and analyzed the material, was struck by the overall similarities throughout this long MSA sequence. During this time there were considerable climatic changes but the proportions of tool types, dimensions of flakes and the use of local as opposed to non-local rocks were very comparable between the levels which made up the three earliest MSA stages.

34 Carter 1969 (Carter and Vogel 1974) also excavated geometric microliths at early dates in the high Drakensberg

mountains of Lesotho.

35 Binford and Binford 1966 and 1969.

36 These results have sometimes been spoken of as pointing to Middle Palaeolithic 'tool kits'. This is an unfortunate term since it misrepresents the organization of Middle Palaeolithic technology as well as ignoring the all-important issue of how the assemblages were created (Gamble 1986:13–16). In the Binfords' view the requirements of survival governed such aspects of behaviour as which tools to make and where to use and throw them away.

37 The Typical and Mousterian of Acheulean Tradition A and B for maintenance activities carried out at base camps and Charentian (Ferrassie and Quina variants) and Denticulate for extractive tasks such as hunting and acquiring raw materials. Mellars has made a powerful argument that some of the variability is related to time rather than to function (1969, 1970, 1986, 1992).

38 Farizy and David 1992.

39 Bar-Yosef 1989.

40 G.E.P.P. 1983.

41 Ivanova and Chernysh 1965, Goretsky and Ivanova 1982.

42 Lumley 1969.

43 Villa 1982.

44 We confidently predict, however, that our protective instinct to shelter our ancestors will no doubt ensure these 'huts' continue in the literature for many years to come even though we do not reproduce them here.

45 Simek 1987 and 1988, Rigaud and Geneste 1988.

46 S. Binford 1968, Rowlett and Schneider 1974, Harrold 1980, Gargett 1989, Smirnov 1989 and 1991.

47 This has not stopped finds such as the isolated cranium from Monte Circeo in Italy being called a burial (see Toth and White 1991, Stiner 1991).

48 Solecki 1971.

49 Turner and Hannon 1988.

50 Chase and Dibble 1987:280.

51 Bar-Yosef 1989.

52 Knight 1991 for an extended and highly provocative account of the origins of symbolism and culture.

53 Chase and Dibble 1987:275.

54 S. Binford 1968:140.

55 Gamble 1989.

56 Perhaps some of the fragmentary Middle Stone Age hominids from Africa which include Klasies River Mouth, Lake Eyasi, Laetoli, Omo Kibish, and the Mumba and Porc Epic rockshelters might be explained in a similar manner. However, White (1987) has reported cut marks on the Klasies frontal bone and other human fragments are supposedly burnt.

57 Davidson and Noble 1989:127.

58 Moreover, what is to be made of the pile of 60 round stones found resting on a narrow ledge at the bottom of a fossil spring at El-Guettar? These varied in diameter from 4.5 to 18.0 cm while in amongst the pile were bone fragments, stone tool debris and a single but typical Aterian tanged point. Similar finds are also known from Windhoek and Esere in Namibia. At Windhoek there were 36 spheroids also in a fossil spring. A small groove had been pecked into their surface rather like the grip on a bowling ball. Interpretations range from magical cairns dedicated to the spirits of the spring to pounders for processing bones and plant foods (Clark 1988).

59 Marshack 1990.
60 Geist 1981, Chase 1989, Gamble 1986:table 9.1.
61 Bordes and Prat 1967, Chase 1989.
62 Lumley 1972.
63 Gabori-Csank 1968.
64 Jaubert et al 1990. The dating is uncertain and older estimates of 200,000 years may be in order.
65 Bar-Yosef 1989.
66 Geist has drawn attention to the brutal efficiency of short stabbing spears which might have carried those Levallois points. These would cause massive haemorrhaging in the prey. It would have been an advantage, judging from their physique, for Neanderthals to make sure the animal died quickly rather than pursue it for long, exhausting distances.
67 Binford 1985 and 1989.
68 Stiner 1991, Kuhn 1991.
69 Preservation might be a factor since teeth are highly resistant to decay, but this explanation can be ruled out in the Italian study.
70 Gamble 1987.
71 Binford 1978 provides an extended example of intercept hunting and meat storage among a modern group of Arctic hunters.
72 Rolland and Dibble 1990, Dibble and Rolland 1992.
73 After Kuhn 1991: table 14.
74 A further example of mobility patterns is provided by Mark's work on changing settlement systems in the Negev desert (1988).
75 In many of the rockshelters it is possible to see that the assemblages change through time (Mellars 1969, 1986, 1992). Nowhere is this clearer than at Combe Grenal, excavated by Bordes, where no less than 55 separate Middle Palaeolithic levels were identified. All the five Mousterian varieties are present in this long sequence which dates predominantly to the early part of the last glaciation. The stratigraphic position of the MAT at the top of the sequence is repeated in other sites where it is followed by Châtelperronian and other Upper Palaeolithic industries.
76 Bordes 1968:145.
77 Wymer 1982:209.
78 Klein 1976, Binford 1984.
79 Stiner's (1991) conclusion for the Mediterranean foragers at Grotta Guattari emphasized the importance of the fat reserves in the head. This is a more attractive solution than postulating a premium on trophies to explain why elements, which might otherwise be left behind at the kill, were transported.
80 Binford's analysis (1984) of Klasies River Mouth has been criticized for studying only a small part of the total faunal assemblage.
81 Roebroeks et al 1988.
82 Geneste 1988a and b.
83 Geneste 1988a and b.
84 Geneste comments (1988a) that the use of raw material in this area during the Middle Palaeolithic is similar to the later Upper Palaeolithic. The major differences are that the absolute distances increase (see Chapter 9) and the greater proportion of total flint coming from the exotic distances. For example in the Solutrean, c.19,000 years ago, 90 per cent of all lithics at the sites in Aquitaine derived from sources at least 40 km away.
85 Bosinski 1982:324.
86 Clark 1988:237.
87 The interest in the PUP assemblages can in part be explained by the support their appearance might give to Bosinski's interpretation of the Middle Palaeolithic as a cultural watershed. The differences between such 'floating' Upper Palaeolithic industries and the Middle Palaeolithic have usually been interpreted as incursions of different peoples with different cultural traditions into such sites as Klasies River Mouth, Haua Fteah and Tabun (see Wymer 1982:107).

Chapter 8 *(pp. 179–194)*

1 Smith 1984, Stringer et al 1984, Gambier 1989.
2 Lévèque and Vandermeersch 1981, Stringer et al 1984, Harrold 1989, Mercier et al 1991.
3 Allsworth-Jones 1986 and 1990, Palma di Cesnola 1982, Mellars 1989, Mellars 1992a and b, Harrold 1989.
4 Harrold 1989.
5 Smith 1984.
6 Howell 1958.
7 Mellars 1989, Mellars 1992.
8 Pons et al 1991.
9 Graves 1991.
10 Zubrow 1989:217.
11 Graves 1991.

Chapter 9 *(pp. 195–218)*

1 1945:66–67.
2 Shackley 1983.
3 ibid.
4 *Sunday Times* 23 January 1983:24.
5 Elements such as shovel-shaped incisors, which have in the past been used as evidence for continuity in other continents, are also a feature in australopithecine and early *Homo* fossils when our ancestors were confined to Africa below the Sahara. It is therefore unsurprising at a much later date to see some proportion of these distinctive traits among the Ancients of the Ice Age world. Their variable presence among modern populations is either due to differential retention of the ancestral condition or its redevelopment in some areas – it is not yet clear which is the more appropriate explanation.
6 Stringer and Grün 1991.
7 Arcy-sur-Cure (Leroi-Gourhan and Arl 1964), Kostenki (Praslov and Rogachev 1982), Dolní Věstonice/Pavlov (Klima 1963), Lommersum (Hahn 1982).
8 Harrold 1989:691, Farizy 1990:317.
9 Deacon 1989, Parkington 1990.
10 Marks 1983 and 1990.
11 It has to be emphasized that the significance of blade technology as a cultural marker is very much a feature of the European Palaeolithic. Since this evidence set the expectations for the pattern of technological change (Mellars 1973, 1989) it is taking some time to revise the deeply entrenched views that have formed over 150 years of research in this continent.
12 Harrold 1989:705.
13 Kozlowski 1982.
14 Mellars and Tixier 1989:766.
15 Bischoff et al 1989.
16 R. White 1989.
17 Clark and Lindly 1989, G. Clark 1992.

18 Pfeiffer 1982.

19 Marshack 1990:459.

20 Clark and Lindly (1989, Lindly and Clark 1990) have also resurrected an idea from Loring Brace that gradual changes in stone tools had implications for the reduction of teeth. Over time, the noise of Neanderthals, and Ancients everywhere, tearing at their food with their powerful incisors was eventually replaced by the more cultured sound of purpose-made stone blades neatly slicing food which had been cooked till tender in those new hearths and then chewed by much smaller teeth. This endearing scenario, Brace's so-called Culinary Revolution, implies a gradual evolution, or rather reduction in noise levels at the dinner table, of culture.

21 Soffer 1985.

22 Allsworth-Jones 1986.

23 Gamble 1982.

24 Gvozdover 1989:89.

25 Gamble 1991a.

26 Wobst 1974, 1976 and 1977.

27 Gamble 1993.

28 Allen, Gosden and White 1989, Wickler and Spriggs 1988.

29 Davidson and Noble 1989.

30 See Graves 1991 for full discussion.

31 Whallon 1989.

32 Wolpoff 1989:98.

33 Gamble 1991b:416.

Further Reading and Bibliography

The bibliography that follows contains a number of highly detailed and technical papers, so for readers seeking a general introduction to the subject we recommend the following books: Richard Klein's *The Human Career*, *Missing Links* by John Reader, Roger Lewin's *Bones of Contention*, Paul Mellars and Chris Stringer's *The Human Revolution*, and *The Palaeolithic Settlement of Europe* by Clive Gamble.

Ackerman, S. 1989. 'European prehistory gets even older', *Science*, 246:28–30.

Agassiz, L. 1840. *Études sur les Glaciers*. Neuchatel, Jent and Gassman.

Aitken, M. 1990. *Science-based Dating in Archaeology*. London, Longman.

Allen, J.A. 1877. 'The influence of physical conditions in the genesis of species', *Radical Review* vol. 1: 108–40.

Allen, F.J., C. Gosden and J.P. White. 1989. 'Human Pleistocene adaptations in the tropical island Pacific: recent evidence from New Ireland, a Greater Australian outlier', *Antiquity* 63:548–61.

Allen, H. 1990. 'Environmental history in southwestern New South Wales during the late Pleistocene' in C.S. Gamble and O. Soffer (eds), *The World at 18,000 BP*, Vol. 2: Low Latitudes, pp. 296–321. London, Unwin Hyman.

Allsworth-Jones, P. 1986. *The Szeletian and the Transition from Middle to Upper Palaeolithic in Central Europe*. Oxford, Clarendon Press.

— 1990. 'The Szeletian and the stratigraphic succession in Central Europe and adjacent areas: main trends, recent results, and problems for resolution' in P. Mellars (ed.), *The Emergence of Modern Humans*, pp. 160–242. Edinburgh, Edinburgh University Press.

Andel, T. van. 1989. 'Late Pleistocene sea levels and the human exploitation of the shore and shelf of southern South Africa', *Journal of Field Archaeology* 16:133–55.

Arensburg, B. et al. 1989. 'A Middle Palaeolithic human hyoid bone', *Nature*, vol. 338: 758–60.

Asimov, I. 1958. 'The Ugly Little Boy' in I. Asimov, *The Best Fiction of Isaac Asimov*. London, Grafton.

Auel, J. 1980. *The Clan of the Cave Bear*. Toronto, Bantam Books.

Bar-Yosef, O. 1989. 'Geochronology of the Levantine Middle Palaeolithic' in P. Mellars and C. Stringer (eds), *The Human Revolution: Behavioural and Biological Perspectives on the Origins of Modern Humans*, pp. 589–610. Edinburgh, Edinburgh University Press.

— 1992. 'The role of western Asia in modern human origins', *Philosophical Transactions of the Royal Society*, Series B, vol. 337: 193–200.

Bar-Yosef, O. and B. Vandermeersch (eds). 1991. *Le Squelette Mousterien de Kebara*. Paris, CNRS.

Bar-Yosef, O. et al. 1988. 'Le sépulture néandertalienne de Kébara (unité XII)' in M. Otte (ed.), *L'Homme de Néandertal*, Vol. 5: La Pensée, pp. 17–24. Liège, ERAUL.

Barton, C.M. 1988. *Lithic Variability and Middle Palaeolithic Behaviour*. Oxford, BAR International Series 408.

Barton, N., D.A. Roe and A. Roberts. 1991. *The Late Glacial in North-west Europe*. London, CBA.

Bartstra, G. et al. 1988. 'Ngandong man: Age and artifacts', *Journal of Human Evolution*, vol. 17:325–37.

Beals, K.L. et al. 1984. 'Brain size, cranial morphology, climate, and time machines', *Current Anthropology*, vol. 25: 301–30.

Beaumont, P.B. 1980. 'On the age of Border Cave Hominids 1–5', *Palaeontologia Africana*, vol. 23:21–33.

Bergman, C. and C.B. Stringer. 1989. 'Fifty years after: Egbert, an early Upper Palaeolithic juvenile from Ksar Akil, Lebanon', *Paléorient*, vol. 15:99–112.

Bergmann, C. 1847. 'Über die Verhältnisse der Wärmeökonomie der Thiere zu ihrer Grösse', *Gottinger Studien*, vol. 8.

Bermúdez de Castro, J.M. et al. 1988. 'Buccal striations on fossil human anterior teeth: evidence of handedness in the middle and early Upper Pleistocene', *Journal of Human Evolution* 17:403–12.

Binford, L.R. 1978. *Nunamiut ethnoarchaeology*. New York, Academic Press.

— 1983. *In Pursuit of the Past*. London and New York, Thames and Hudson.

— 1984. *Faunal remains from Klasies River Mouth*. New York, Academic Press.

— 1985. 'Human ancestors: changing views of their behaviour', *Journal of Anthropological Archaeology* 4:292–327.

— 1989. 'Isolating the transition to cultural adaptations: an organizational approach' in E. Trinkaus (ed.), *The Emergence of Modern Humans: Biocultural Adaptations in the Later Pleistocene*, pp. 18–41. Cambridge, Cambridge University Press.

Binford, L.R. and S.R. Binford. 1966. 'A preliminary analysis of functional variability in the mousterian of levallois facies', *American Anthropologist* 68(2):238–95.

— 1969. 'Stone tools and human behaviour', *Scientific American*, 220:70–84.

Binford, S. 1968. 'A structural comparison of disposal of the dead in the Mousterian and Upper Palaeolithic', *Southwestern Journal of Anthropology* 24:139–54.

Bischoff, J.L., N. Soler, J. Maroto and R. Julia. 1989. 'Abrupt Mousterian/Aurignacian boundary at c.40 ka bp: accelerator 14C dates from L'Arbreda cave (Catalunya, Spain)', *Journal of Archaeological Science* 16:563–76.

Blackwell, B. and H.P.Schwarz. 1986. 'U-series analysis of the lower travertine at Ehringsdorf, DDR', *Quaternary Research* 25:215–22.

Bodmer, W.F. and L.L. Cavalli-Sforza. 1976. *Genetics, Evolution and Man*. San Francisco, Freeman.

Bogaard P. van den, C.M. Hall, H.-U. Schmincke and D. York. 1989. 'Precise single-grain 40Ar/39Ar dating of a cold to warm climate transition in Central Europe', *Nature* 342:523–25.

Bonifay, E. and B. Vandermeersch (eds). 1991. *Les premiers Européens*. Paris, editions du C.T.H.S. Actes du 114ᵉ Congrés National des Sociétés Savantes.

Bordes, F. 1961a. *Typologie du Paléolithique ancien et moyen*. Publications de l'Institut de Préhistoire de l'Université de Bordeaux, Mémoire No. 1, 2 vols.

— 1961b. 'Mousterian cultures in France', *Science* 134:803–10.

— 1968. *The Old Stone Age*. London, Weidenfeld and Nicholson.

— 1972. *A Tale of Two Caves*. New York, Harper and Row.

Bordes, F. and F. Prat. 1965. 'Observations sur les faunes de Riss et du Würm I en Dordogne', *L'Anthropologie* 69:31–45.

Bosinski, G. 1982. *Die Kunst der Eiszeit in Deutschland und in der Schweiz*. Bonn, Habelt.

Boule, M. 1911–13. 'L'homme fossile de la Chapelle-aux-Saints', *Annales de Paléontologie* (1911) 6:1–64, (1912) 7:65–208, (1913) 8:209–79.

Boule, M. and H. Vallois. 1957. *Fossil men*. London, Thames and Hudson.

Bowen, D.Q., S. Hughes, G.A. Sykes and G.H. Miller. 1989. 'Land-sea correlations in the Pleistocene based on isoleucine epimerization in non-marine molluscs', *Nature* 340:49–51.

Brace, C.L. 1964. 'The fate of the "classic" Neanderthals: a consideration of hominid catastrophism', *Current Anthropology* 5:3–43.

— 1979. 'Krapina, "classic" Neanderthals, and the evolution of the European face', *Journal of Human Evolution* 6:527–50.

Bradley, B. 1977. *Experimental lithic technology with special reference to the Middle Palaeolithic*. Cambridge University, Ph.D. dissertation.

Brain, C.K. 1981. *The hunters or the hunted?* Chicago, Chicago University Press.

Bräuer, G. 1992. 'Africa's place in the evolution of Homo sapiens' in G. Bräuer and F.H. Smith (eds), *Continuity or Replacement: Controversies in Homo sapiens Evolution*, pp. 83–98. Rotterdam, Balkema.

Bräuer, G. and K.W. Rimbach. 1990. 'Late archaic and modern *Homo sapiens* from Europe, Africa, and southwest Asia: craniometric comparisons and phylogenetic implications', *Journal of Human Evolution*, vol. 19:789–807.

Breuil, H. 1939. 'The pleistocene succession in the Somme Valley', *Proceedings of the Prehistoric Society* 5:33–38.

Breuil, H. and L. Kozlowski. 1932. 'Études de stratigraphie paléolithique dans le nord de la France, la Belgique et l'Angleterre', *L'Anthropologie* 42:27–47, 291–314.

Bromage, T.G. and M.C. Dean. 1985. 'Re-evaluation of the age of death of immature fossil hominids', *Nature*, vol. 317:525–27.

Brown, P. 1992. 'Recent human evolution in East Asia and Australasia', *Philosophical Transactions of the Royal Society*, Series B, vol. 337:235–42.

Callow, P. and J.M. Cornford (eds). 1986. *La Cotte de St Brelade 1961–1978: Excavations by C.B.M. McBurney*. Norwich, Geo Books.

Campbell, B.G. 1963. 'Quantitative taxonomy and human evolution' in S.L. Washburn (ed.), *Classification and Human Evolution*, pp. 50–74. London, Methuen.

Cann, R. 1988. 'DNA and human origins', *Annual Review of Anthropology*, vol. 17:127–43.

Cann, R., M. Stoneking and A. Wilson 1987. 'Mitochondrial DNA and human evolution', *Nature* 325:31–6.

Cann, R. et al. 1984. 'Polymorphic sites and mechanisms of evolution in human mitochondrial DNA', *Genetics*, vol. 106:479–99.

Carter, P.L. 1969. 'Moshebi's shelter: excavation and exploitation in eastern Lesotho', *Lesotho* 8:1–11.

Carter, P.L. and J.C. Vogel. 1974. 'The dating of industrial assemblages from stratified sites in eastern Lesotho', *Man* 9:557–78.

Cavalli-Sforza, L. 1991. 'Genes, peoples and languages', *Scientific American*, vol. 265 (5):71–78.

Cavalli-Sforza, L.L, A. Piazza, P. Menozzi and J. Mountain. 1988. 'Reconstruction of human evolution: bringing together genetic, archaeological, and linguistic data', *Proceedings of the National Academy of Sciences of the USA* 85:6002–6.

Cave, A.J.E. and W.L. Straus. 1957. 'Pathology and posture of neanderthal man', *Quarterly Review of Biology* 32:348–63.

Champion, T., C. Gamble, S. Shennan and A Whittle. 1984. *Prehistoric Europe*. London, Academic Press.

Chase, P. 1989. 'How different was Middle Palaeolithic subsistence?: a zooarchaeological perspective on the Middle to Upper Palaeolithic transition' in P. Mellars and C. Stringer (eds), *The Human Revolution: Behavioural and Biological Perspectives on the Origins of Modern Humans*, pp. 321–37. Edinburgh, Edinburgh University Press.

Chase, P. and H.L. Dibble. 1987. 'Middle palaeolithic symbolism: a review of current evidence and interpretations', *Journal of Anthropological Archaeology* 6:263–96.

Clark, G.A. 1992. 'Continuity or replacement? Putting modern human origins in an evolutionary context' in H.L. Dibble and P. Mellars (eds), *The Middle Palaeolithic: adaptation, behavior, and variability*, pp. 183–206. Philadelphia, University Museum.

Clark, G.A. and J. Lindly. 1989. 'The case for continuity: observations on the biocultural transition in Europe and western Asia', in P. Mellars and C. Stringer (eds), *The Human Revolution: Behavioural and Biological Perspectives on the Origins of Modern Humans*, pp. 626–76. Edinburgh, Edinburgh University Press.

Clark, J.D. 1982. 'The cultures of the Middle Palaeolithic/ Middle Stone Age' in J.D. Clark (ed.), *The Cambridge History of Africa. Volume I: From the earliest times to c.500 BC*, pp. 248–341. Cambridge, Cambridge University Press.

— 1988. 'The Middle Stone Age of East Africa and the beginnings of regional identity', *Journal of World Prehistory* 2:235–305.

— 1989. 'The origin and spread of modern humans: a broad perspective on the African evidence' in P. Mellars and C. Stringer (eds), *The Human Revolution: Behavioural and Biological Perspectives on the Origins of Modern Humans*, pp. 565–88. Edinburgh, Edinburgh University Press.

— 1992. 'African and Asian perspectives on the origins of modern humans', *Philosophical Transactions of the Royal Society*, Series B, vol. 337:201–15.

Clarke, R.J. 1990. 'The Ndutu cranium and the origin of Homo sapiens', *Journal of Human Evolution*, 19:699–736.

Coon, C. 1939. *The Races of Europe*. New York, Macmillan.

— 1962. *The Origin of Races*. New York, Alfred Knopf.

Coope, G.R. 1977. 'Fossil coleopteran assemblages as sensitive indicators of climatic changes during the Devensian (Last) cold stage', *Philosophical Transactions of the Royal Society of London*, B, 280:313–40.

Copeland, L. 1988. 'Environment, chronology and Lower-Middle Palaeolithic occupations of the Azraq basin, Jordan', *Paléorient* 14:66–75.

Cornford, J. 1986. 'Specialised resharpening techniques and evidence of handedness' in P. Callow and J.M. Cornford (eds), *La Cotte de St Brelade 1961–1978: Excavations by C.B.M.McBurney*, pp. 337–51. Norwich, Geo Books.

Cosgrove, R., J. Allen and B. Marshall. 1990. 'Palaeo-ecology and Pleistocene human occupation in south-central Tasmania', *Antiquity* 64:59–78.

Dansgaard, W., S.J. Johnsen, H.B. Clausen and C.C. Langway. 1970. 'Ice cores and palaeoclimatology' in I.U. Olsson (ed.), *Radiocarbon Variations and Absolute Chronology*, pp. 337–51. Stockholm, Almquist and Wiksell.

Davidson, I. and W. Noble. 1989. 'The archaeology of perception: traces of depiction and language', *Current Anthropology* 30:125–55.

Davis, R.S., V. Ranov and A.E. Dodonov. 1980. 'Early man in Soviet Central Asia', *Scientific American* 243:92–102.

Day, M. 1989. *Guide to Fossil Man*. 4th edn. London, Cassells.

Day, M. and C. Stringer. 1991. 'Les restes crâniens d'Omo-Kibish et leur classification à l'intérieur du genre *Homo*', *L'Anthropologie*, vol. 95:573–94.

Day, M.H. et al. 1991. 'Les vestiges postcrâniens d'Omo I (Kibish)', *L'Anthropologie*, 95:595–610.

Deacon, H. 1989. 'Late Pleistocene palaeoecology and archaeology in the Southern Cape, South Africa' in P. Mellars and C. Stringer (eds), *The Human Revolution: Behavioural and Biological Perspectives on the Origins of Modern Humans*, vol. I, pp. 547–64. Edinburgh, Edinburgh University Press.

— 1992. 'Southern Africa and modern human origins', *Philosophical Transactions of the Royal Society*, Series B, vol. 337:177–83.

Dean, M.C. et al. 1986. 'Age at death of the Neanderthal child from Devil's Tower, Gibraltar and the implications for studies of general growth and development in Neanderthals', *American Journal of Physical Anthropology*, vol. 70:301–9.

Dennell, R.W. 1983. *European Economic Prehistory*. London, Academic Press.

Dennell, R.W., H. Rendell and E. Hailwood. 1988a. 'Late Pliocene artefacts from Northern Pakistan', *Current Anthropology* 29:495–98.

— 1988b. 'Early tool making in Asia: two million year old artefacts in Pakistan', *Antiquity* 62:98–106.

Dibble, H.L. 1987. 'The interpretation of Middle Palaeolithic scraper morphology', *American Antiquity* 52:109–17.

Dibble, H.L. and N. Rolland. 1992. 'On assemblage variability in the Middle Palaeolithic of western Europe: history, perspectives, and a new synthesis' in H.L. Dibble and P. Mellars (eds), *The Middle Palaeolithic: Adaptation, Behavior, and Variability*, pp. 1–28. Philadelphia, University Museum.

Dzaparidze, V. and G. Bosinski et al. 1989. 'Der altpaläo-lithische Fundplatz Dmanisi in Georgien (Kaukasus)', *Jahrbuch des Römisch-Germanischen Zentralmuseums Mainz* 36:67–116.

Emiliani, C. 1955. 'Pleistocene temperatures', *Journal of Geology* 63:538–78.

Eveleth, P.B. and J.M. Tanner. 1990. *Worldwide Variation in Human Growth*. Cambridge, Cambridge Univ. Press.

Evernden, J.F. and G.H. Curtis. 1965. 'The potassium-argon dating of late Cenozoic rocks in East Africa and Italy, *Current Anthropology* 6:343–85.

Fagan, B.M. 1987. *The Great Journey: The Peopling of Ancient America*. London and New York, Thames and Hudson.

— 1991. *The Journey from Eden*. London and New York, Thames and Hudson.

Farizy, C. 1990. 'The transition from Middle to Upper Palaeolithic at Arcy-sur-Cure (Yonne, France): technological, economic and social aspects' in P.Mellars (ed.), *The Emergence of Modern Humans*, pp. 303–26. Edinburgh, Edinburgh University Press.

Farizy, C. and F. David. 1992. 'Subsistence and behavioural patterns of some Middle Palaeolithic local groups' in H.L. Dibble and P. Mellars (eds), *The Middle Palaeolithic: Adaptation, Behavior and Variability*, pp. 87–96. Philadelphia, University Museum Monograph 78.

Farmer, Philip-José. 1959. 'The Alley Man', *The Magazine of Fantasy and Science Fiction*.

Foley, R. 1987. *Another unique species: Patterns in human evolutionary ecology*. London, Longman.

— 1989. 'The ecological conditions of speciation: a comparative approach to the origins of anatomically modern humans' in P. Mellars and C. Stringer (eds), *The Human Revolution: Behavioural and Biological Perspectives on the Origins of Modern Humans*, vol. I, pp. 298–318. Edinburgh, Edinburgh University Press.

Franciscus, R.G. and E. Trinkaus. 1988. 'Nasal morphology and the emergence of *Homo erectus*', *American Journal of Physical Anthropology*, vol. 75:517–27.

Friedman, J. 1981. *The monstrous races in medieval art and thought*. Cambridge, Mass., Harvard University Press.

Gabori-Csank, V. 1968. *La station du Paléolithique Moyen d'Érd, Hongrie*. Budapest, Akademiai Kiado.

Gambier, D. 1989. 'Fossil Hominids from the early Upper Palaeolithic (Aurignacian) of France' in P. Mellars, and C. Stringer (eds), *The Human Revolution: Behavioural and Biological Perspectives on the Origins of Modern Humans*, pp. 194–211. Edinburgh, Edinburgh University Press.

Gamble, C.S. 1979. 'Hunting strategies in the central European Palaeolithic', *Proceedings of the Prehistoric Society* 45:35–52.

— 1982. 'Interaction and alliance in palaeolithic society', *Man* 17:92–107.

— 1984. 'Regional variation in hunter-gatherer strategy in the upper Pleistocene of Europe' in R. Foley (ed.), *Hominid Evolution and Community Ecology*, pp. 237–60. London, Academic Press.

— 1986. *The Palaeolithic Settlement of Europe*. Cambridge: Cambridge University Press.

— 1987. 'Man the shoveller: alternative models for middle pleistocene colonization and occupation in northern latitudes' in O. Soffer (ed.), *The Pleistocene Old World: Regional Perspectives*, pp. 81–98. New York, Plenum.

— 1989. 'Comment on R. Gargett, "Grave shortcomings: the evidence for Neanderthal burial"', *Current Anthropology* 30:181–82.

— 1991a. 'The social context for European palaeolithic art', *Proceedings of the Prehistoric Society*, 57:3–15.

— 1991b. 'Raising the curtain on modern human origins', *Antiquity* 65:412–17.

— 1992. 'Figures of fun: theories about cavemen', *Archaeological Review from Cambridge*.

— 1993 (in press). *Timewalkers: the prehistory of global colonization*. Harmondsworth, Penguin.

Gamble, C.S. and O. Soffer (eds). 1990. *The World at 18,000 BP*. Volume 2: Low Latitudes. London, Unwin Hyman.

Gargett, R. 1989. 'Grave shortcomings: the evidence for Neanderthal burial', *Current Anthropology* 30:157–90.

Garrod, D.A.E. and D.M.A. Bate. 1937. *The Stone Age of Mount Carmel*, vol 1. Oxford, Clarendon Press.

Gascoyne, M., A.P. Currant and T.C. Lord. 1981. 'Ipswichian fauna of Victoria Cave and the marine palaeoclimatic record', *Nature* 294:652–54.

Geike, J. 1874. *The Great Ice Age*. London, Isbister.

Geist, V. 1981. 'Neanderthal the hunter', *Natural History* 90:26–36.

Geneste, J-M. 1988a. 'Systemes d'approvisionnement en matières premières au paléolithique moyen et au paléolithique supérieur en Aquitaine' in M. Otte (ed.), *L'Homme de Néandertal*, vol. 8, pp. 61–70. Liège, ERAUL.

— 1988b. 'Les industries de la Grotte Vaufrey: technologie du débitage, économie et circulation de la matière première lithique' in J-P. Rigaud (ed.), *La Grotte Vaufrey à Cenac et Saint-Julien (Dordogne), Paleoenvironments, chronologie et activités humaines*. Mémoires de la Société Préhistorique Française 19:441–518.

Gilead, I. and C. Grigson. 1984. Far'ah II: a Middle Palaeolithic open air site in the northern Negev. *Proceedings of the Prehistoric Society* 50:71–98.

Golding, W. 1955. *The Inheritors*. London, Faber and Faber.

Goodwin, A.J.H. and C. van Riet Lowe. 1929. 'The Stone Age cultures of South Africa', *Annals of the South African Museum, Cape Town* 27:1–289.

Goretsky, G.I. and I.K. Ivanova. 1982. *Molodova I: Unique mousterian settlement on the middle Dniestr region*. Moscow, Nauka.

Gould, S.J. 1981. *The Mismeasure of Man*. Harmondsworth, Penguin.

Gowlett, J.A.J. and R.E.M. Hedges (eds). 1986. *Archaeological results from accelerator dating*. Oxford, Oxford University Committee for Archaeology.

Graves, P.M. 1991. 'New models and metaphors for the Neanderthal debate', *Current Anthropology* 32:513–41.

Green, H.S. 1984. *Pontnewydd Cave: a lower palaeolithic hominid site in Wales, the first report*. Cardiff, National Museum of Wales.

Groves, C.P. 1990. *A theory of human and primate evolution*. Oxford University Press, Oxford.

Grün, R. and C.B. Stringer. 1991. 'Electron spin resonance dating and the evolution of modern humans', *Archeometry*, vol. 33:153–99.

Grün, R., P.B. Beaumont and C.B. Stringer. 1990. 'ESR dating evidence for early modern humans at Border Cave in South Africa', *Nature*, vol. 344: 537–39.

Grün, R., C.B. Stringer and H.P. Schwarcz. 1991. 'ESR dating of teeth from Garrod's Tabun cave collection', *Journal of Human Evolution* 20: 231–48.

Grupo para o estudo do Paleolítico Portugues. 1983. 'A estaçao paleolítica de Vilas Ruivas (Ródao) Campanha de 1979', *O Arquelólogo Portugues* IV:15–38.

Gvozdover, M.D. 1989. 'The typology of female figurines of the Kostenki Palaeolithic culture', *Soviet Anthropology and Archaeology* 27 (4):32–94.

Hahn, J. 1974. 'Die jungpaläolithische station Lommersum, Gemeinde Weilerswist, Kreis Euskirchen', *Rheinische Ausgrabungen* 15:1–49.

Harrison, G.A. et al. 1988. *Human Biology*. Oxford, Oxford University Press.

Harrold, F.J. 1980. 'A comparative analysis of Eurasian palaeolithic burials', *World Archaeology* 121:195–211.

— 1989. 'Mousterian, Chatelperronian and early Aurignacian in western Europe: continuity or discontinuity?' in P. Mellars and C. Stringer (eds), *The Human Revolution: Behavioural and Biological Perspectives on the Origins of Modern Humans*, pp. 677–713. Edinburgh, Edinburgh University Press.

Hausmann, R. and K. Brunnacker. 1988. U-series dating of Middle European travertines' in *L'homme de Neanderthal*, vol.1: La Chronologie, pp. 47–51. Liège, ERAUL.

Higgs, E.S. 1961. 'Some Pleistocene faunas of the Mediterranean coastal areas', *Proceedings of the Prehistoric Society*, 27:144–54.

Hoffecker, J.F., G.F. Baryshnikov and O.R.Potapova. 1989. 'Mousterian bison hunters of the northern Caucasus: analysis of faunal remains from Il'Skaya I', *Current Research in the Pleistocene* 6:69–72.

Holloway, R.L. 1985. 'The poor brain of *Homo sapiens neanderthalensis*: See what you please' in E. Delson (ed.), *Ancestors: The hard evidence*, pp. 319–24. New York, Alan R. Liss.

Hopkins, D., J.V. Matthews, C.E. Schweger and S.B. Young (eds). 1982. *Palaeoecology of Beringia*. New York, Academic Press.

Howell, F.C. 1958. 'Upper Pleistocene men of the southwest Asian Mousterian' in G.H.R. von Koenigswald (ed.), *Hundert Jahre Neanderthaler*, pp. 185–98. Utrecht, Kemink en zoon.

Howells, W.W. 1973. *Cranial Variation in Man*. Cambridge, Mass., Harvard University Press.

— 1976. 'Explaining modern man: evolutionists versus migrationists', *Journal of Human Evolution* 5:477–95.

— 1989. *Skull Shapes and the Map*. Cambridge, Mass., Harvard University Press.

Hrdlička, A. 1927. 'The Neanderthal phase of man', *Journal of the Royal Anthropological Institute* 67:249–69.

Hublin, J.-J. 1985. 'Human fossils from the North African Middle Pleistocene and the origin of *Homo sapiens*' in E. Delson (ed.), *Ancestors: the hard evidence*, pp. 283–88. New York, Alan Liss.

— 1988. 'Caractères derivés de la region occipito-mastoïdienne chez les Néandertaliens' in M. Otte (ed.), *L'Homme de Néandertal*, vol. 3: L'anatomie, pp. 67–73. Liège, ERAUL.

— 1992. 'Recent human evolution in northwestern Africa', *Philosophical Transactions of the Royal Society*, Series B, vol. 337:193–200.

Hylander, W.L. et al. 1991. 'Function of the supraorbital

region of Primates', *Archives of Oral Biology*, vol. 36 (4):273–81.

Imbrie, J. and K.P. Imbrie. 1979. *Ice Ages: Solving the Mystery*. London, Macmillan.

Ivanova, I.K. and A.P. Chernysh. 1965. 'The Palaeolithic site of Molodova V on the middle Dniestr (USSR)', *Quaternaria* 7:197–217.

Jacobi, R.M. 1980. 'The Upper Palaeolithic in Britain, with special reference to Wales' in J.A. Taylor (ed.), *Culture and environment in prehistoric Wales*, pp. 15–99. Oxford, BAR British Series 76.

Jaubert, J. et al. 1990. *Les chasseurs d'aurochs de la Borde*. Paris, Documents d'Archéologique Française 27.

Jelinek, A.J. 1982. 'The Tabun cave and prehistoric man in the Levant', *Science* 216:1369–75.

— 1990. 'The Amudian in the context of of the Mugharan tradition at the Tabun Cave (Mount Carmel), Israel' in P. Mellars (ed.), *The Emergence of Modern Humans*, pp. 81–90. Edinburgh, Edinburgh University Press.

— et al. 1989. 'A preliminary report on evidence related to the interpretation of economic and social activities of Neanderthals at the site of La Quina (Charente), France' in M. Otte (ed.), *L'Homme de Néandertal*, vol. 6: La Subsistance, pp. 99–106. Liège, ERAUL.

Johanson, D.C. and M. Edey. 1981. *Lucy: the Beginnings of Mankind*. New York, Simon and Schuster.

Johanson, D.C. et al. 1987. 'New partial skeleton of *Homo habilis* from Olduvai Gorge, Tanzania', *Nature*, vol. 327:205–9.

Johnsen, S.J. et al. 1992. 'Irregular glacial interstadials recorded in a new Greenland ice core', *Nature* 359:311–13.

Jones, R. 1990. 'From Kakadu to Kutikina: the southern continent at 18,000 years ago' in C.Gamble and O. Soffer (eds), *The World at 18,000 BP*, vol. 2: Low Latitudes, pp. 264–95. London, Unwin Hyman.

Julia, R. and J.L. Bischoff. 1991. 'Radiometric dating of quaternary deposits and the hominid mandible of Lake Banyolas, Spain', *Journal of Archaeological Science* 18:707–22.

Keeley, L.H. 1980. *Experimental determination of stone tool use: a microwear analysis*. Chicago, U. of Chicago Press.

Keeley, L.H. and M.H. Newcomer. 1977. 'Microwear analysis of experimental flint tools: a test case', *Journal of Archaeological Science* 4:29–62.

Kimbel, W. and L. Martin (eds). In press. *Species, Species Concepts and Primate Evolution*. New York: Plenum.

Klein, R.G. 1976. 'The mammalian fauna of the Klasies River Mouth sites, southern Cape Province', *South African Archaeological Bulletin* 31:75–98.

— 1989. *The Human Career*. Chicago, Univ. of Chicago Press.

Klíma, B. 1963. *Dolní Věstonice*. Prague, Czechoslovak Academy of Sciences.

— 1988. 'A triple burial from the Upper Palaeolithic of Dolní Věstonice, Czechoslovakia', *Journal of Human Evolution* 16:831–35.

Knight, C. 1991. *Blood relations: menstruation and the origins of culture*. New Haven, Yale University Press.

Koenigswald, G.H.R. von (ed.). 1958. *Hundert Jahre Neanderthaler*. Utrecht, Kemink en zoon.

Kozlowski, J.K. (ed.). 1982. *Excavation in the Bacho Kiro cave, Bulgaria (Final Report)*. Warsaw, Paristwowe Wydaruictwo, Naukowe.

Kramer, A. 1992. 'Morphological diversity in the Upper Pleistocene hominids of the Levant: two species?' in *Abstracts Third International Congress of Human Palaeontology*, p. 65. Jerusalem.

Kretzoi, N. and L. Vértes. 1965. 'Upper Biharian (intermindel) pebble-industry site in western Hungary', *Current Anthropology* 6:74–87.

Kuhn, S.L. 1991. '"Unpacking" reduction: lithic raw material economy in the mousterian of West-Central Italy', *Journal of Anthropological Archaeology* 10:76–106.

Kukla, G.J. 1975. Loess stratigraphy of central Europe' in K.W. Butzer and G. Isaac (eds), *After the Australopithecines*, pp. 99–188. The Hague, Mouton.

— 1977. 'Pleistocene land-sea correlations: I, Europe', *Earth Science Review* 13:307–74.

Laing, S. 1895. *Human origins*. London, Chapman and Hall.

Laville, H., J-P. Rigaud, and J.R. Sackett. 1980. *Rock Shelters of the Périgord*. New York, Academic Press.

Leakey, R.E. and A. Walker. 1989. 'Early *Homo erectus* from West Lake Turkana, Kenya' in G. Giacobini (ed.), *Hominidae, Proceedings of the 2nd International Congress of Human Paleontology*, pp. 209–15. Milan, Jaca Book.

Leroi-Gourhan, A. and Arl. 1964. 'Chronologie des grottes d'Arcy-sur-Cure (Yonne)', *Gallia Préhistoire* 7:1–64.

Lévèque, F. and B. Vandermeersch. 1981. 'Le néandertalien de Saint-Césaire'. *Recherche*, vol. 12:242–44.

Lewin, R. 1989. *Bones of Contention: Controversies in the Search for Human Origins*. London, Penguin (New York, Simon and Schuster).

Lieberman, P. 1984. *The biology and evolution of language*. Cambridge, Mass., Harvard University Press.

— 1989. 'The origins of some aspects of human language and cognition' in P. Mellars and C. Stringer (eds), *The Human Revolution*, pp. 391–414. Edinburgh, Edinburgh University Press.

Lieberman, P. et al. 1989. 'Folk physiology and talking hyoids', *Nature*, vol. 342:486.

Lindly, J. and G.A. Clark. 1990. 'Symbolism and modern human origins', *Current Anthropology* 31:233–40.

Lioubine, V.P. and G.F. Baryshnikov. 1984. 'L'activité de chasse des plus anciens habitants du Caucase (Acheuléen, Moustérien)', *L'Anthropologie* 88:221–29.

Long, J. et al. 1990. 'Phylogeny of human Beta-Globulin haplotypes and its implications for recent human evolution', *American Journal of Physical Anthropology*, vol. 81:113–30.

Lubbock, Sir. J. 1865. *Pre-Historic Times*. London, Williams and Norgate.

Lumley, H. de. 1969. 'A Palaeolithic camp site at Nice', *Scientific American* 220:42–50.

— (ed.) 1972. *La grotte Moustérienne de l'Hortus*. Marseille, Études Quaternaires, 1.

Lyell, C. 1847. *Principles of geology: or, the modern changes of the earth and its inhabitants considered as illustrative of geology*. 7th edn. London, Murray.

Macalister, R.A.S. 1921. *A text-book of European archaeology: Vol.1 the Palaeolithic period*. Cambridge, Cambridge University Press.

Marks, A.E. 1983. 'The Middle to Upper Palaeolithic transition in the Levant', *Advances in World Archaeology* 2:51–98.

— 1988. 'The Middle to Upper Palaeolithic transition in the southern Levant: technological change as an adaptation to increasing mobility' in M. Otte (ed.), *L'Homme*

de Néandertal, Vol. 8: La Mutation, pp. 109–24. Liège, ERAUL.

— 1990. 'The Middle and Upper Palaeolithic of the Near East and the Nile Valley: the problem of cultural transformations' in P. Mellars (ed.), *The Emergence of Modern Humans*, pp. 56–80. Edinburgh, Edinburgh University Press.

Marshack, A. 1990. 'Early hominid symbolism and evolution of the human capacity' in P. Mellars (ed.), *The Emergence of Modern Humans*, pp. 457–98. Edinburgh, Edinburgh University Press.

Martin, P.S. and R.G. Klein (eds). 1984. *Quaternary extinctions: a prehistoric revolution*. Tucson, University of Arizona Press.

Mayr, E. 1942. *Systematics and the Origin of Species*. New York, Columbia University Press.

— 1963. *Animal Species and Evolution*. Cambridge, Mass., Harvard University Press.

— 1976. *Evolution and the Diversity of Life*. Cambridge, Mass., Harvard University Press.

McBurney, C.B.M. 1967. *The Haua Fteah (Cyrenaica) and the stone age of the south east Mediterranean*. Cambridge, Cambridge University Press.

McCown, T.D. and A. Keith. 1939. *The Stone Age of Mount Carmel II: the fossil human remains from the Levalloiso-Mousterian*. Oxford, Clarendon Press.

Mellars, P.A. 1969. 'The chronology of Mousterian industries in the Périgord region of south-west France', *Proceedings of the Prehistoric Society* 35:134–71.

— 1970. 'Some comments on the notion of "functional variability" in stone tool assemblages', *World Archaeology* 2:74–89.

— 1973. 'The character of the Middle-Upper Palaeolithic transition in south-west France' in C. Renfrew (ed.), *The Explanation of Culture Change: Models in Prehistory*, pp. 255–76. London, Duckworth.

— 1986. 'A new chronology for the French Mousterian period', *Nature* 322:410–11.

— 1989a. 'Major issues in the emergence of modern humans', *Current Anthropology*, vol. 30:349–85.

— 1989b. 'Technological changes at the Middle-Upper Palaeolithic transition: economic, social and cognitive perspectives' in P. Mellars and C. Stringer (eds), *The Human Revolution*, pp. 338–65. Edinburgh, Edinburgh University Press.

— 1992a. 'Technological change in the Mousterian of southwest France' in H.L. Dibble and P. Mellars (eds), *The Middle Palaeolithic: Adaptation, Behavior and Variability*, pp. 29–44. Philadelphia, University Museum.

— 1992b. 'Archaeology and the population-dispersal hypothesis of modern human origins in Europe', *Philosophical Transactions of the Royal Society*, Series B, vol. 337:225–34.

Mellars, P. and R. Grün. 1991. 'Comparison of the Electron Spin Resonance and Thermoluminescence Dating Methods: Results of ESR Dating at Le Moustier (France)', *Cambridge Archaeological Journal* 1:269–76.

Mellars, P. and C. Stringer. 1989. *The Human Revolution: Behavioural and Biological Perspectives on the Origins of Modern Humans*, Edinburgh, Edinburgh Univ. Press.

Mellars, P. and J. Tixier. 1989. 'Radiocarbon-accelerator dating of Ksar Aqil (Lebanon) and the chronology of the Upper Palaeolithic sequence in the Middle East', *Antiquity* 63:761–68.

Mercier, N., H. Valladas, J-L. Joron, J-L. Reyss, F. Lévèque and B. Vandermeersch. 1991. 'Thermoluminescence dating of the late Neanderthal remains from Saint Césaire', *Nature* 351:737–39.

Mercier, N. et al. In press. 'Thermoluminescence date for the Mousterian burial site of Es-Skhul, Mount Carmel', *Journal of Archaeological Science*.

Merriweather, D.A. et al. 1991. 'The Structure of Human Mitochondrial DNA Variation', *Journal of Molecular Evolution*, vol. 33:543–55.

Mortillet, G. de. 1883. *Le Préhistorique, origine et l'antiquité de l'homme*. Paris, Reinwald.

Moser, S. 1989. *A history of reconstructions*. BA Thesis. Dept. of Archaeology, LaTrobe University, Melbourne.

— 1992. 'The visual language of archaeology', *Antiquity*, vol. 66:831–44.

— In press b. *Gender stereotyping in pictorial reconstructions of human origins*.

Mountain, J.L. et al. 1992. 'Evolution of modern humans: evidence from nuclear DNA polymorphisms', *Philosophical Transactions of the Royal Society*, Series B, vol. 337:159–65.

Movius, H. 1953. 'The Mousterian Cave of Teshik-Tash, southeastern Uzbekistan, Central Asia', *American School of Prehistoric Research* 17:11–71.

Murray, T. 1987. *Remembrance of things present: appeals to authority in the history and philosophy of archaeology*. PhD thesis, University of Sydney.

Mussi, M. 1990. 'Continuity and change in Italy at the last glacial maximum' in O. Soffer and C. Gamble (eds), *The World at 18,000 BP*. Vol. 2: High Latitudes, pp. 126–47. London, Unwin Hyman.

Nei, M. and A.K. Roychoudhury. 1974. 'Genic variation within and between the three major races of Man, Caucasoids, Negroids, and Mongoloids', *American Journal of Human Genetics*, vol. 26:421–43.

Nei, M. and T. Ota. 1991. 'Evolutionary relationships of human populations at the molecular level', in S. Osawa and T. Honjo (eds), *Evolution of life: fossils, molecules and culture*, pp. 415–28. Tokyo, Springer.

Newcomer, M.H. 1971. 'Some quantitative experiments in handaxe manufacture', *World Archaeology* 3:85–94.

Oakley, K.P. 1969. *Frameworks for dating fossil man*. 3rd edn. London, Weidenfeld and Nicholson.

Oakley, K.P. et al. 1977. *Catalogue of fossil hominids*. Part I: Africa. London, British Museum (Natural History).

Odell, G.H. 1975. 'Micro-wear in perspective: a sympathetic response to Lawrence H. Keeley', *World Archaeology* 7:226–40.

Osborn, H.F. 1915. *Men of the Old Stone Age*. London, Bell.

Otte, M. 1990. 'From the Middle to the Upper Palaeolithic: the nature of the transition' in P. Mellars (ed.), *The Emergence of Modern Humans*, pp. 438–56. Edinburgh, Edinburgh University Press.

Pagden, A. 1986. *The fall of natural man*. Cambridge, Cambridge University Press.

Palma di Cesnola, A. 1982. 'L'Uluzzien et ses rapports avec le Protoaurignacien en Italie' in L. Banesz and J.K. Kozlowski (eds), *Aurignacien et Gravettien en Europe*, pp. 271–88. Liège, ERAUL.

Pardoe, C. 1991. 'Competing paradigms and ancient human remains: the state of the discipline', *Archaeology in Oceania* 26:79–85.

Parkington, J.E. 1990. 'A critique of the consensus view on

the age of Howieson's Poort assemblages in South Africa' in P. Mellars (ed.), *The Emergence of Modern Humans*, pp. 34–55. Edinburgh, Edinburgh University Press.

Penck, A. and E. Brückner. 1909. *Die Alpen in Eiszeitalter.* Leipzig.

Perkins, D. 1964. 'Prehistoric fauna from Shanidar, Iraq', *Science* 144:1565–66.

Pfeiffer, J. 1982. *The creative explosion.* New York, Harper and Row.

Piperno, M. 1976–77. 'Analyse du sol moustérien de la Grotte Guattari au Mont Circé', *Quaternaria* 19:71–92.

Pons, A. et al. 1991. 'Le pollen remonte le temps climatique', *Recherche*, 22:518–20.

Praslov, N.D. and A.N. Rogachev (eds). 1982. *Palaeolithic of the Kostenki-Borshevo area on the Don river, 1879–1979.* Leningrad, NAUKA.

Prentice, M.L. and G.H. Denton. 1988. 'The deep-sea oxygen record, the global ice sheet system and hominid evolution' in F.E. Grine (ed.), *Evolutionary history of the 'robust' australopithecines*, pp. 383–403. New York, Aldine de Gruyter.

Prestwich, J. 1873. 'Report on the exploration of Brixham Cave', *Philosophical Transactions of the Royal Society* 163:471–572.

Protsch, R. 1975. 'The absolute dating of Upper Pleistocene sub-Saharan fossil hominids and their place in human evolution', *Journal of Human Evolution*, vol. 4:297–322.

Putman, J. 1988. 'In search of modern humans', *National Geographic Magazine*, vol. 174:438–47.

Quennell, M. and C.H.B. Quennell. 1945. *Everyday Life in the Old Stone Age.* London, Batsford.

Rak, Y. 1986. 'The Neanderthal: A new look at an old face', *Journal of Human Evolution*, vol. 15:151–64.

— 1990. 'On the differences between two pelvises of Mousterian context from the Qafzeh and Kebara caves, Israel', *American Journal of Physical Anthropology*, vol. 81:323–32.

Ranov, V.A. 1991. 'Les sites très anciens de l'âge de la pierre en U.R.S.S' in E. Bonifay and B. Vandermeersch (eds), *Les Premiers peuplements humains de l'Europe*, pp. 209–16. Paris, Actes du 114ᵉ Congrès National de Sociétés Savantes.

Reader, J. 1988. *Missing Links.* Harmondsworth, Penguin.

Renault-Miskovsky, J. 1991. *L'environnement au temps de la préhistoire.* Paris, Masson.

Renfrew, C. 1988. *Archaeology and language.* London, Cape.

Richards, G. 1987. *Human evolution.* London, Routledge, Kegan and Paul.

Rigaud, J-P. and J-M. Geneste. 1988. 'L'utilisation de l'espace dans la grotte Vaufrey' in J-P. Rigaud (ed.), *La Grotte Vaufrey à Cenac et Saint-Julien (Dordogne): Paleoenvironments, chronologie et activités humaines.* Mémoires de la Société Préhistorique Française 19:593–611.

Rightmire, G.P. 1989. 'Middle Stone Age humans from eastern and southern Africa' in P.A. Mellars and C.B. Stringer (eds), *The Human Revolution*, pp. 109–122. Edinburgh, Edinburgh University Press.

— 1990. *The evolution of Homo erectus.* Cambridge, Cambridge University Press.

Rightmire, G. and H. Deacon. 1991. 'Comparative studies of Late Pleistocene human remains from Klasies River Mouth, South Africa', *Journal of Human Evolution*, vol. 20:131–56.

Roberts, M.B. 1986. 'Excavation of the lower palaeolithic site at Amey's Eartham Pit, Boxgrove, West Sussex: a preliminary report', *Proceedings of the Prehistoric Society* 52:215–46.

Roberts, N. 1984. 'Pleistocene environments in time and space' in R. Foley (ed.), *Hominid Evolution and Community Ecology*, pp. 25–54. London, Academic Press.

Roe, D.A. 1964. 'The British Lower and Middle Palaeolithic: some problems, methods of study and preliminary results', *Proceedings of the Prehistoric Society* 30:245–67.

— 1968. 'British Lower and Middle Palaeolithic handaxe groups', *Proceedings of the Prehistoric Society* 34:1–82.

Roebroeks, W., J. Kolen and E. Rensink. 1988. 'Planning depth, anticipation and the organization of Middle Palaeolithic technology: the "archaic natives" meet Eve's descendants', *Helinium* 28:17–34.

Rolland, N. and H.Dibble. 1990. 'A new synthesis of middle palaeolithic variability', *American Antiquity* 55:480–99.

Ronen, A., M. Lamdan and L. Shmookler. n.d. 'Pre-upper Palaeolithic occurences of isotope stage 5'.

Rosenberg, K.R. 1988. 'The functional significance of Neandertal pubic length', *Current Anthropology*, vol. 29:595–617.

Rosny-Aîné, J.H. 1911. *La Guerre du Feu.* (Reprinted as *Quest for Fire*, 1982.) Harmondsworth, Penguin.

Rouhani, S. 'Molecular Genetics and the Pattern of Human Evolution: Plausible and Implausible Models' in P. Mellars and C. Stringer (eds), *The Human Revolution: Behavioural and Biological Perspectives on the Origins of Modern Humans*, pp. 47–61. Edinburgh, Edinburgh University Press.

Rowlett, R.M. and M.J. Schneider. 1974. 'The material expression of Neanderthal child care' in M. Richardson (ed.), *The human mirror*, pp. 41–58. Bâton Rouge, Louisiana State University Press.

Ruff, C.B. 1991. 'Climate and body shape in hominid evolution', *Journal of Human Evolution*, vol. 21:81–105.

Russell, M.D. 1985. 'The supraorbital torus: "A most remarkable peculiarity"', *Current Anthropology*, vol. 26:337–60.

Rust, A. 1950. *Die Höhlenfunde von Jabrud (Syrien).* Neumunster, Karl Wachholtz.

Santa Luca, A.P. 1980. *The Ngandong fossil hominids.* Yale University Publications in Anthropology vol. 78:1–175.

Schwarcz, H.P., R. Grün, A.G. Latham, D. Mania and K. Brunnacker. 1988. 'The Bilzingsleben archaeological site: new dating evidence', *Archeometry* 30:5–17.

Semenov, S.A. 1964. *Prehistoric technology.* London, Cory, Adams and Mackay.

Shackleton, N.J. 1987. 'Oxygen isotopes, ice volume and sea level', *Quaternary Science Review* 6:183–90.

Shackleton, N.J. and N.D. Opdyke. 1973. 'Oxygen isotope and palaeomagnetic stratigraphy of equatorial Pacific core V28–238', *Quaternary Research* 3:39–55.

Shackley, M. 1983a. *Wildmen: Yeti, Sasquatch and the Neanderthal enigma.* London, Thames and Hudson (published in New York as *Still Living?*).

— 1983b. 'Are these prehistoric people living today?' *The Sunday Times*, January 23.

Shipman, P. 1992. 'Human ancestor's early steps out of Africa', *New Scientist*, vol. 1806:24.

Simek, J. 1987. 'Spatial order and behavioural change in the French palaeolithic', *Antiquity* 61:25–40.

— 1988. 'Analyse de la réparation spatiale des vestiges de la

couche VIII de la grotte Vaufrey', in J-P. Rigaud (ed.), *La Grotte Vaufrey à Cenac et Saint-Julien (Dordogne): Paleoenvironments, chronologie et activités humaines.* Mémoires de la Société Préhistorique Française 19:569–92.

Singer, R. and J. Wymer. 1982. *The Middle Stone Age at Klasies River Mouth in South Africa.* Chicago, University of Chicago Press.

Singer, R., J. Wymer, B.G. Gladfelter and R.G. Wolf. 1973. 'Excavation of the Clactonian industry at the golf course, Clacton-on-Sea, Essex', *Proceedings of the Prehistoric Society* 39:6–74.

Smirnov, Y.A. 1989. 'Intentional human burial: Middle Palaeolithic (Last Glaciation) beginnings', *Journal of World Prehistory* 3:199–233.

— 1991. *Mousterian burials.* Moscow, Nauka.

Smith, F.H. 1978. 'Evolutionary significance of the mandibular foramen area in Neanderthals', *American Journal of Physical Anthropology* 48:523–32.

— 1984. 'Fossil hominids from the Upper Pleistocene of Central Europe and the origin of modern Europeans' in F.H. Smith and F. Spencer (eds), *The origins of modern humans*, pp. 137–209. New York, Alan Liss.

Soffer, O. 1985. *The Upper Palaeolithic of the Central Russian Plain.* New York, Academic Press.

Solecki, R.S. 1971. *Shanidar – the first flower people.* New York, Knopf.

Stiner, M.C. 1991. 'The faunal remains at Grotta Guattari: a taphonomic perspective', *Current Anthropology* 32(2):103–17.

Stoneking, M. and R.L. Cann. 1989. 'African origin of human mitochondrial DNA' in P. Mellars and C. Stringer (eds), *The Human Revolution*, pp. 17–30. Edinburgh, University of Edinburgh Press.

Stoneking, M. et al. 1992. 'New approaches to dating suggest a recent age for the human mtDNA ancestor', *Philosophical Transactions of the Royal Society*, Series B, vol. 337:167–75.

Straus, W.L. and A.J.E. Cave. 1957. 'Pathology and posture of Neanderthal Man', *Quarterly Review of Biology* 32:348–63.

Stringer, C.B. 'Some problems in Middle and Upper Pleistocene hominid relationships' in D.J. Chivers and K. Joysey (eds), *Recent Advances in Primatology*, vol. 3: Evolution, pp. 395–418. London, Academic Press.

— 1983. 'Some further notes on the morphology and dating of the Petralona hominid', *Journal of Human Evolution*, vol. 12:731–42.

— 1984. 'Human evolution and biological adaptation in the Pleistocene' in R. Foley (ed.), *Hominid evolution and community ecology*, pp. 55–83. New York, Academic Press.

— 1985. 'Middle Pleistocene hominid variability and the origin of late Pleistocene humans' in E. Delson (ed.), *Ancestors: the hard evidence*, pp. 289–95. New York, Alan Liss.

— 1986a. 'An archaic character in the Broken Hill innominate E.719', *American Journal of Physical Anthropology*, vol. 71:115–20.

— 1986b. 'The credibility of *Homo habilis*' in B. Wood, L. Martin and P. Andrews (eds), *Major Topics in Primate and Human Evolution*, pp. 266–94. Cambridge, Cambridge University Press.

— 1988. 'The dates of Eden', *Nature* vol. 331:565–66.

— 1989. 'Documenting the origin of modern humans' in E.

Trinkaus (ed.), *The Emergence of Modern Humans*, pp. 67–96. Cambridge, Cambridge University Press.

— 1990. 'The Asian connection', *New Scientist*, vol. 1743:33–37.

— 1992a. 'Reconstructing recent human evolution', *Philosophical Transactions of the Royal Society*, Series B, vol. 337:217–24.

— 1992b. 'Replacement, continuity, and the origin of *Homo sapiens*' in G. Bräuer and F. Smith (eds), *Continuity or Replacement: Controversies in Homo sapiens Evolution*, pp. 9–24. Rotterdam, Balkema.

Stringer, C. and P. Andrews. 1988. 'Genetic and fossil evidence for the origin of modern humans', *Science* 239:1263–68.

Stringer, C. and R. Grün. 1991. 'Time for the last Neanderthals', *Nature* 351:701–2.

Stringer, C.B. and E. Trinkaus. 1981. 'The Shanidar Neanderthal crania' in C.B. Stringer (ed.), *Aspects of Human Evolution*, pp. 129–65. London, Taylor and Francis.

Stringer, C.B. et al. 1979. 'The significance of the fossil hominid skull from Petralona, Greece', *Journal of Archaeological Science*, vol. 6:235–53.

— 1984. 'The origin of anatomically modern humans in western Europe' in F.H. Smith and F. Spencer (eds), *The origin of modern humans: a world survey of the fossil evidence*, pp. 51–135. New York, Alan Liss.

— 1989. 'ESR dates for the hominid burial site of Es Skhul in Israel', *Nature* vol. 338:756–58.

— 1990. 'A Comparative Study of Cranial and Dental Development Within a Recent British Sample and Among Neandertals' in C. Jean DeRousseau (ed.), *Primate life history and evolution*, pp. 115–52. New York, Wiley-Liss.

Stuart, A.J. 1982. *Pleistocene vertebrates in the British Isles.* London, Longman.

Sutcliffe, A.J. 1985. *On the track of ice age mammals.* London, British Museum (Natural History).

Suzuki, H. and F. Takai. 1970. *The Amud man and his cave site.* Tokyo, University of Tokyo Press.

Tillier, A.M. 1982. 'Les enfants néanderthaliens de Devil's Tower (Gibraltar)', *Zeitschrift für Morphologie und Anthropologie*, vol. 73:125–48.

Tobias, P.V. 1991. *Olduvai Gorge.* Volume 4: The skulls, endocasts and teeth of *Homo habilis*. Cambridge, Cambridge University Press.

Trinkaus, E. 1975. 'Squatting among the Neandertals: A problem in the behavioral interpretation of skeletal morphology', *Journal of Archaeological Science*, vol. 2:327–51.

— 1981. 'Neanderthal limb proportions and cold adaptation' in C.B. Stringer (ed.), *Aspects of human evolution*, pp. 187–224. London, Taylor and Francis.

— 1983. *The Shanidar Neandertals.* New York, Academic Press.

— 1984a. 'Neandertal pubic morphology and gestation length', *Current Anthropology*, vol. 25:509–14.

— 1984b. 'Western Asia' in F.H. Smith and F. Spencer (eds), *The origins of modern humans: a world survey of the fossil evidence*, pp. 251–293. New York, Alan Liss.

— 1985. 'Pathology and the posture of the La Chapelle-aux-Saints Neandertal', *American Journal of Physical Anthropology*, vol. 67:19–41.

— 1986. 'The Neandertals and the origins of modern

humans', *Annual Review of Anthropology*, 15:193–218.
— 1987. 'The Neandertal face: Evolutionary and functional perspectives on a recent hominid face', *Journal of Human Evolution*, vol. 16:429–43.
— (ed.) 1989. *The Emergence of Modern Humans: Biocultural Adaptations in the Later Pleistocene*. Cambridge, Cambridge University Press.
— In press. 'Palaeontological perspectives on Neanderthal behaviour' in M. Toussaint (ed.), *Actes du Colloque 5 millions d'Années, l'Aventure Humaine*. PACT Journal.
Trinkaus, E. and W.W. Howells. 1979. 'The Neanderthals', *Scientific American* 241:118–33.
Trinkaus, E. and P. Shipman. 1993. *The Neanderthals: Changing the Image of Mankind*. New York, Knopf.
Trinkaus, E. and D.D. Thompson. 1987. 'Femoral diaphyseal histomorphometric age determinations for the Shanidar 3, 4, 5 and 6 Neandertals and Neandertal longevity', *American Journal of Physical Anthropology*, vol. 72:123–29.
Trinkaus, E. and R.L. Tompkins. 1990. 'The Neandertal Life Cycle: The Possibility, Probability, and Perceptibility of Contrasts With Recent Humans', in C. Jean DeRousseau (ed.), *Primate life history and evolution*, pp. 153–80. New York, Wiley-Liss.
Trinkaus, E. et al. 1991. 'Robusticity versus Shape: The Functional Interpretation of Neandertal Appendicular Morphology', *Journal of the Anthropological Society of Nippon*, vol 99 (3):257–78.
Turner, C.G. 1987. 'Late Pleistocene and Holocene population history of East Asia based on dental variation', *American Journal of Physical Anthropology* 73: 305–21.
Turner, C. and G.E. Hannon. 1988. 'Vegetational evidence for late Quaternary climatic changes in southwest Europe in relation to the influence of the North Atlantic Ocean', *Philosophical Transactions of the Royal Society of London* B, 318:451–85.
Valladas, H. et al. 1988. 'Thermoluminescence dating of Mousterian "Proto-Cro-Magnon" remains from Israel and the origin of modern man', *Nature*, vol. 331:614–16.
Vallois, H. 1954. 'Neanderthals and presapiens', *Journal of the Royal Anthropological Institute* 84:1–20.
Vandermeersch, B. 1981. *Les hommes fossiles de Qafzeh (Israël)*. Paris, CNRS.
— 1989. 'The evolution of modern humans: Recent evidence from South-west Asia' in P. Mellars and C.B. Stringer (eds), *The Human Revolution*, pp. 155–64. Edinburgh, Edinburgh University Press.
Vigilant, L. et al. 1991. 'African populations and the evolution of human mitochondrial DNA', *Science*, vol. 253:1503–7.
Villa, P. 1982. 'Conjoinable pieces and site formation processes', *American Antiquity* 47:276–90.
Vrba, E.S. 1985. 'Ecological and adaptive changes associated with early hominid evolution' in E. Delson (ed.), *Ancestors: the Hard Evidence*, pp. 63–71. New York, Alan Liss.
Wells, H.G. 1921. *The Grisly Folk*. [Reprinted in H.G. Wells, *Selected Short Stories*, 1958] . Harmondsworth, Penguin.
Weniger, G.C. 1990. 'Germany at 18,000 BP' in O. Soffer and C.S. Gamble (eds), *The World at 18,000 BP*. Vol. 2: High Latitudes, pp. 171–92. London, Unwin Hyman.
Whallon, R. 1989. 'Elements of cultural change in the later palaeolithic' in P. Mellars and C. Stringer (eds), *The*

Human Revolution: Behavioural and Biological Perspectives on the Origins of Modern Humans, pp. 433–54. Edinburgh, Edinburgh University Press.
White, R. 1989. Production complexity and standardization in early Ausrignacian bead and pendant manufacture: evolutionary implications' in P. Mellars and C. Stringer (eds), *The Human Revolution: Behavioural and Biological Perspectives on the Origins of Modern Humans*, pp. 366–90. Edinburgh, Edinburgh University Press.
White, T.D. 1987 'Cannibalism at Klasies?' *Sagittarius* 2:6–9.
Wickler, S. and M. Spriggs. 1988. 'Pleistocene human occupation of the Solomon Islands, Melanesia', *Antiquity* 62:703–6.
Wobst, H.M. 1974. 'Boundary conditions for Palaeolithic social systems: a simulation approach', *American Antiquity* 39:147–78.
— 1976. 'Locational relationships in Palaeolithic society', *Journal of Human Evolution* 5: 49–58.
— 1977. 'Stylistic behaviour and information exchange' in C.E. Cleland (ed.), *Papers for the Director: research essays in honor of James B. Griffin*, pp. 317–42. Anthropological papers, Museum of Anthropology, University of Michigan No. 61.
Woillard, G.M. 1978. 'Grande Pile peat bog: a continuous pollen record for the last 140,000 years', *Quaternary Research* 9:1–21.
Wolpoff, M.H. 1980. 'Cranial remains of Middle Pleistocene European hominids', *Journal of Human Evolution* 9:339–58.
— 1989. 'Multiregional evolution: the fossil alternative to Eden' in P. Mellars and C. Stringer (eds), *The Human Revolution: Behavioural and Biological Perspectives on the Origins of Modern Humans*, vol. I, pp. 62–108. Edinburgh, Edinburgh University Press.
— 1991. 'Levantines and Londoners', *Science* 255:142.
Wolpoff, M. et al. 1984. 'Modern *Homo sapiens* origins: a general theory of hominid evolution involving the fossil evidence from East Asia' in F.H. Smith and F. Spencer (eds), *The origin of modern humans: a world survey of the fossil evidence*, pp. 411–83. New York, Alan Liss.
— In press. 'The case for sinking *Homo erectus*: a hundred years of *Pithecanthropus* is enough!' in J. Franzen, *Proceedings of the Pithecanthropus Centenary Conference, Frankfurt*.
Wood, B. 1991. *Hominid cranial remains – Koobi Fora Research Project*, vol. 4. Oxford, Clarendon Press.
— 1992. 'Origin and evolution of the genus *Homo*', *Nature*, vol. 355:783–90.
Woodward, A.S. 1921. 'A new cave man from Rhodesia, South Africa', *Nature*, 108:371–72.
Wu, X.Z. and M. Wu. 1985. 'Early *Homo sapiens* in China'. in Wu, Rukang and J.W. Olsen (eds), *Palaeoanthropology and Palaeolithic Archaeology in the People's Republic of China*, pp. 91–96. Orlando, Academic Press.
Wymer, J. 1982. *The Palaeolithic age*. London, Croom Helm.
Zeuner, F.E. 1959. *The Pleistocene period*. London, Hutchinson.
Zubrow, E. 1989. 'The Demographic Modelling of Neanderthal Extinction' in P. Mellars and C. Stringer (eds), *The Human Revolution: Behavioural and Biological Perspectives on the Origins of Modern Humans*, pp. 212–31. Edinburgh, Edinburgh University Press.

Sources of Illustrations

Plates

1 John Reader
2,3 With kind permission from the *Illustrated London News* picture library
4 From H.F. Osborn, 1915, *Men of the Old Stone Age*
5 From H.R. Knipe, 1905, *Nebula to Man*
6 Reconstruction painting by Zdeněk Burian; courtesy Artia, Prague
7 Reconstruction Mikhail Gerasimov
8 Reconstruction Mikhail Gerasimov
9 Reconstruction Gerhard Heberer
10 From Boule and Vallois 1952
11 Field Museum of Natural History, Chicago
12–16 From 'The Human Story' exhibition, Commonwealth Institute
17,18 Maurice Wilson
19,20 John Reader
21,22 Chris Stringer
23 Milford Wolpoff
24–30 Chris Stringer
31 John Reader
32–37 Chris Stringer
38 David Hart
39–41 Chris Stringer
42 Erik Trinkaus
43 Chris Stringer
44–46 Erik Trinkaus
47 Chris Stringer

48,49 David Hart
50,51 Chris Stringer
52 John Reader
53,54 David Hart
55 Chris Stringer
56 Chris Stringer/Natural History Museum
57 Chris Stringer
58 Natural History Museum
59 Chris Stringer
60 John Reader
61,62 Chris Stringer
63 M.H. Day
64 Chris Stringer
65 G. Bräuer
66–78 Chris Stringer
79 John Reader
80,81 Chris Stringer
82 Natural History Museum
83–86 Chris Stringer
87–89 Colin Ridler
90,91 Alexander Marshack
92 Archaeological Institute of the Czechoslovak Academy of Sciences, Prague; photo K. Kleibl
93,94 Ulmer Museum
95 John Reader
96 School of American Research
97–100 David Hart

Text illustrations

1 Drawing Annick Petersen
2 From Thomas Huxley 1863, *Man's Place in Nature*
4,5 After Boule and Vallois 1952
6,7 After J. Friedman 1981
8 Drawing H. Shaaffhausen 1888, *Der Neanderthaler Fund*
9 After K. Henderson 1927, *Prehistoric Man*
10 D. Davison 1927
11 After Carleton Coon 1939
12,13 After G.H.R. von Koenigwald 1958
14 After Sidney Harris
15 THE FAR SIDE © 1988 Far Works, Inc. Reprinted with permission of Universal Press Syndicate. All rights reserved
16 After G.H.R. von Koenigwald 1958
17 After T. Champion et al 1984
18 Drawing Rob Read; after J. Hays et al 1976, 'Variations in the Earth's Orbit: Pacemaker of the Ice Ages', *Science* 194
21 Drawing Annick Petersen; after J. Renault-Miskovsky 1991

22 After E. Higgs 1961
25 After A. Leroi-Gourhan 1957, *Prehistoric Man*, New York, Philosophical Library
26 After M. Roberts 1986 and J. Wymer 1982
27 After M. Aitken 1990
28 Drawing Annick Petersen; adapted from R. Foley and R. Dunbar 1989, *New Scientist*, p.40
29,30 Drawing Annick Petersen; adapted from R. Klein 1989
31 Chris Stringer
32 After Boule
33 Drawing Annick Petersen; adapted from R. Klein 1989
34 After Giovanni Caselli
35,36 Drawing Annick Petersen; adapted from R. Klein 1989
37 Drawing Annick Petersen; adapted from P. Lieberman 1984
38 Redrawn from C. Stringer 1984
39 Drawing Annick Petersen; adapted from R. Klein 1989

40 After T.D. McCown and A. Keith 1939
41 Drawing Annick Petersen; after C. Stringer 1990
42 Simon S.S. Driver after Bräuer
43 After R. Lewin 1989, *Human Evolution*, Oxford and Cambridge, Mass., Blackwell Scientific Publications
44 Simon S.S. Driver
45 Drawing Annick Petersen after C. Stringer
46 Simon S.S. Driver and Annick Petersen
47 After C. Stringer 1992b
48 After T. Champion et al 1984
49 After J.D. Clark 1988
50 After J.E. Marr et al 1921, *Proceedings of the Prehistoric Society of East Anglia* 3
51 After H. Green 1984
52 After T. Champion et al 1984
53 Drawing Annick Petersen
54 After F. Bordes 1980, *Bulletin Societé Préhistorique Français* 77
55 After M. Gabori, *Les civilizations du Paléolithique moyen entre les Alpes et l'Ourale*, Budapest
56 After G. Bosinski 1967 and D. Roe 1981
57 After H. Dibble 1987
58 After P. Callow and J.M. Cornford (eds) 1986
59 After A. Ronen et al n.d.

60 After Grupo para o estudo do Paleolítico Portugues 1983
61 After G. Goretsky and I. Ivanova 1982
62 Drawing Rob Read; adapted from Smirnov 1991
64 After P. Callow and J.M. Cornford (eds) 1986
65 Drawing Rob Read, after C. Gamble
67 After L. Binford 1983
68 After L. Binford 1984; drawing R. Klein
69 Drawing Rob Read; after L. Binford 1984
70 After J-M. Geneste 1988
71 After W. Roebroeks et al 1988
72 Simon S.S. Driver
73 After Lartet and Christy 1875
74 Drawing Annick Petersen, after C. Gamble
75 After A. Leroi-Gourhan 1964
76 After N. Praslov and A. Rogachev 1982
77 After Klima 1988
78 After J. Wymer 1982
79 After M. Mussi 1990
80 After J. and S. Kozlowski 1979
81 After T. Champion et al 1984
82 Drawing Rob Read
83 Simon S.S. Driver

Acknowledgments

Chris Stringer and Clive Gamble would like to thank the following for discussions, visits, papers, hospitality, forbearance and assistance over the years: Erik Trinkaus, Bernard Vandermeersch, Yoel Rak, Jean-Louis Heim, Henry de Lumley, Jean-Jacques Hublin, Bill Howells, Yves Coppens, Brigitte Senut, Amilcare Bietti, John Melentis, Jonathan Musgrave, Don Brothwell, Rainer Grün, Henry Schwarcz, Peter Andrews, Chris Dean, Leslie Aiello, Rob Foley, Ian Tattersall, Gunter Bräuer, Richard Wright, Colin Groves, Jakov Radovčić, Jan Jelínek, Andy Currant, Robert Kruszynski, Clark Howell, Wu Rukang, Wu Xinzhi, Bob Martin, Alan Thorne, Bernard.Wood, Joe Zias, Rosie Stringer, Tim Bromage, Michael Day, Stephen Aldhouse-Green, Geoffrey Harrison, Roger Jacobi, Dietrich Mania, Fred Smith, Alexander Marshack, Olga Soffer, Milford Wolpoff, Randy White, Iain Davidson, Geoff Bailey, Francis Wenban-Smith, Elaine Morris, Paul Mellars, Mary Stiner, Steven Kuhn, Paul Graves, Lewis Binford, John Wymer, Andrew Lawson, Richard Klein, Jim Allen, Wil Roebroeks, Gerhand Bosinski, Joachim Hahn, Stephanie Moser, David Lordkipanidze, Nikolai Praslov, Vadim Ranov, Mark Roberts, Brian Fagan, and the students at the Universities of Southampton and La Trobe. We also gratefully acknowledge all those who kindly provided photographs, especially John Reader and the Natural History Museum Photo Unit; Rob Read who drafted many of the line illustrations; Mary Iles for her work on the index; and the editorial staff at Thames and Hudson for all their work.

Index

Numerals in *italics* refer to line drawings; numerals in **bold** refer to plates